PERRY ELLIS

AN AMERICAN ORIGINAL

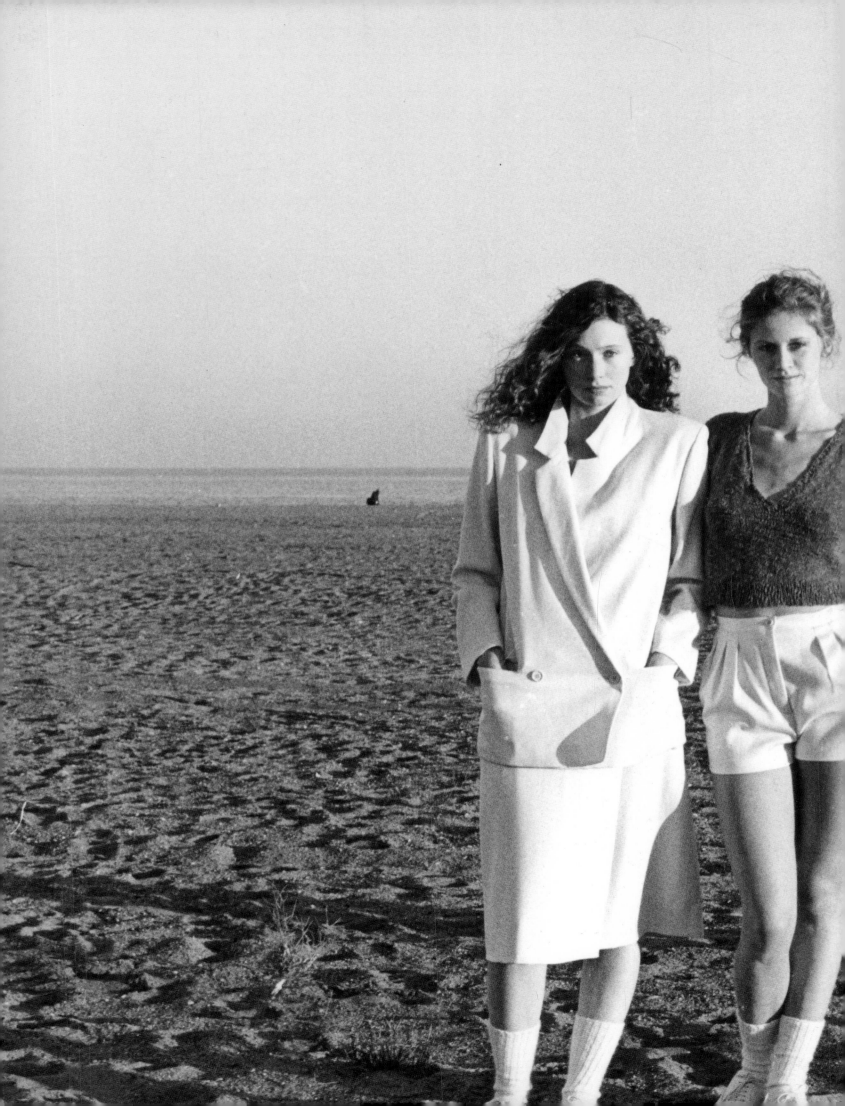

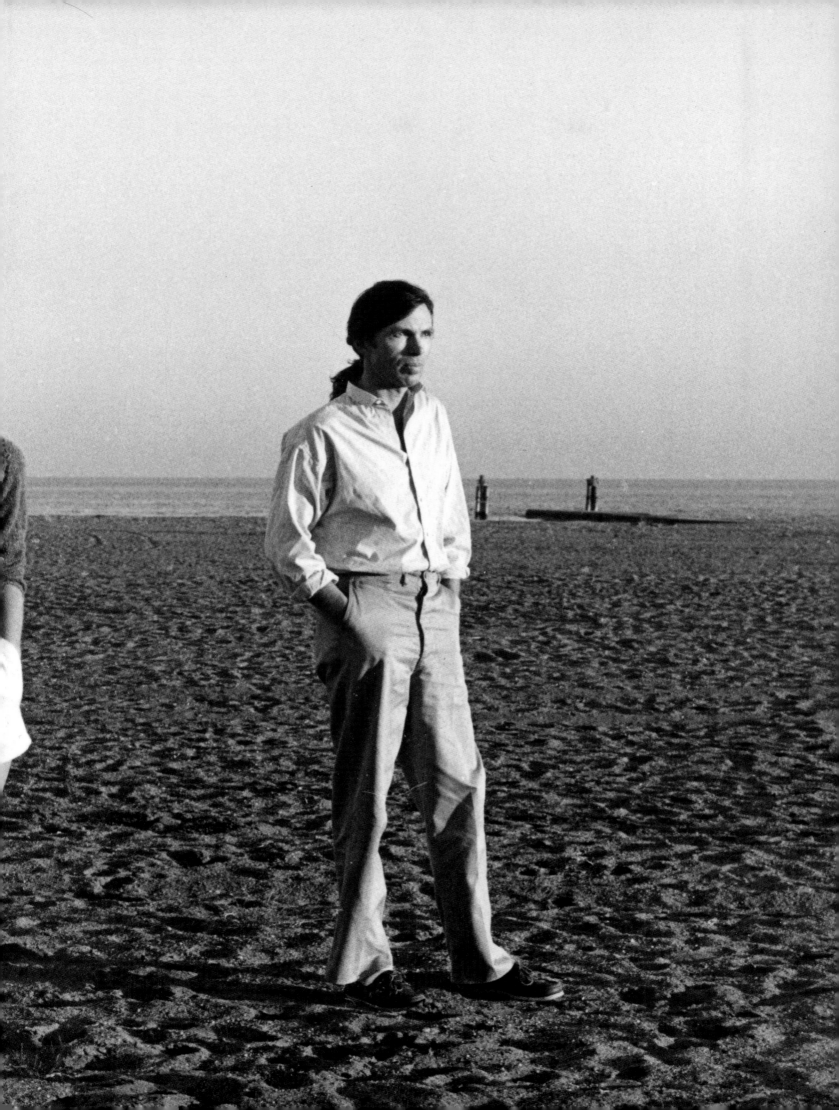

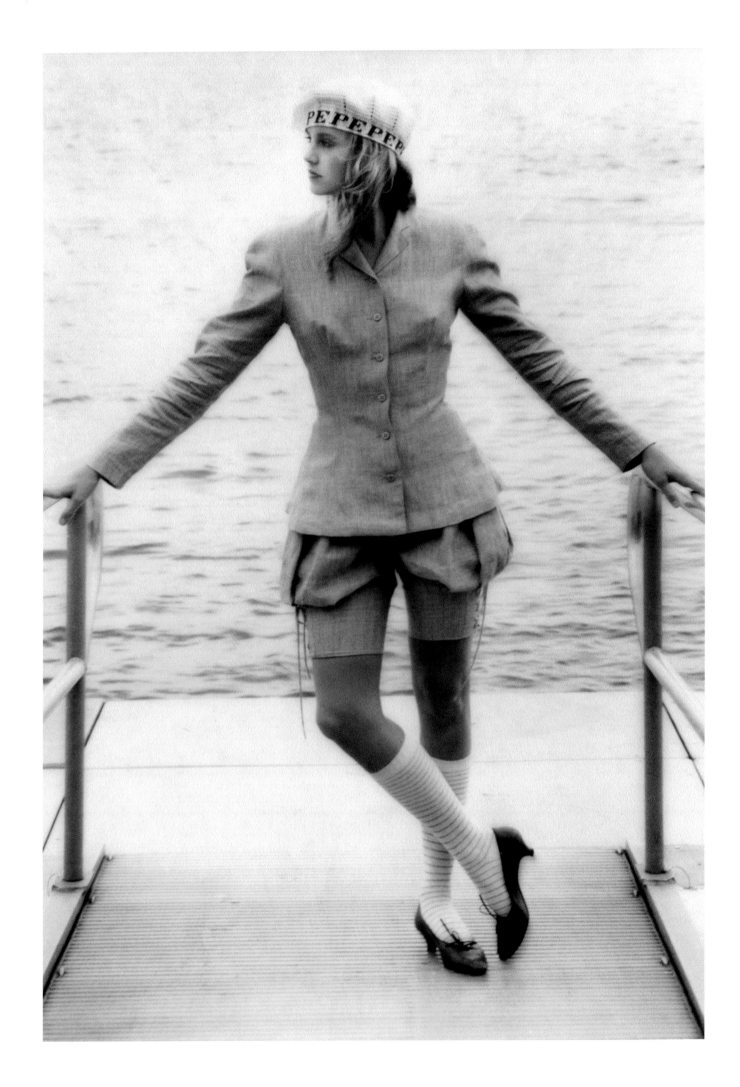

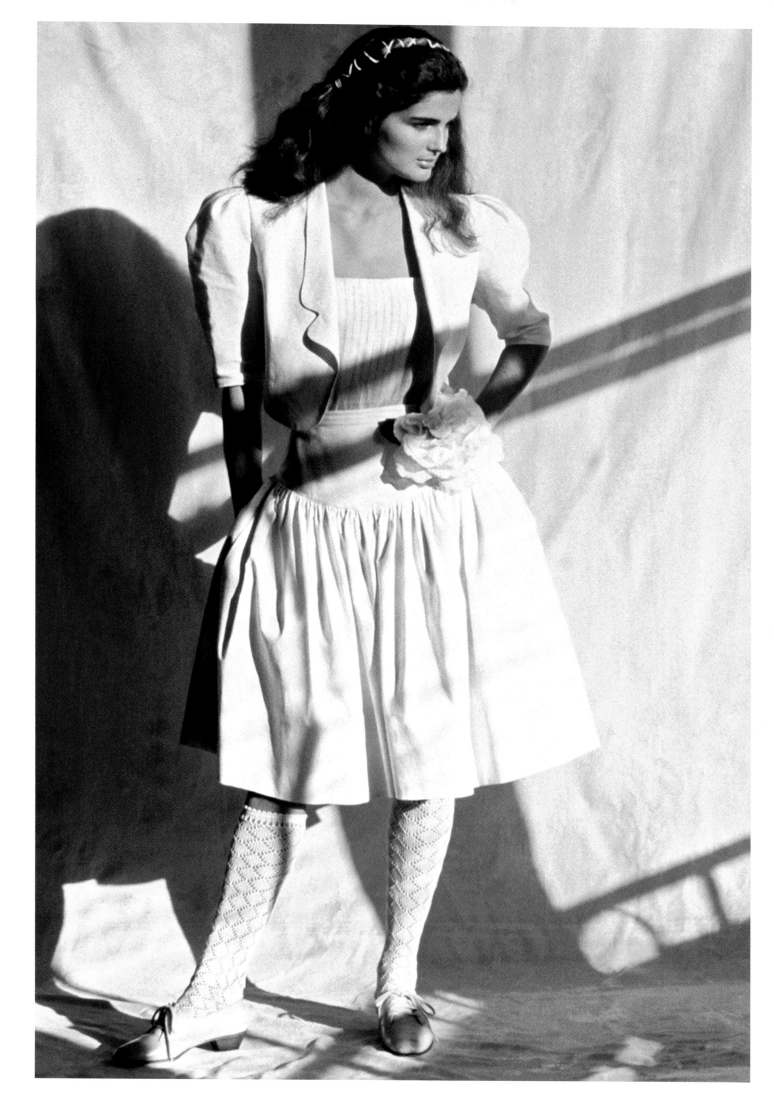

"I was determined to change the course of fashion, to move away from what I call the pretentiousness of clothes—to design clothes that are more obtainable, more relaxed, but ultimately more stylish and witty."

–Perry Ellis

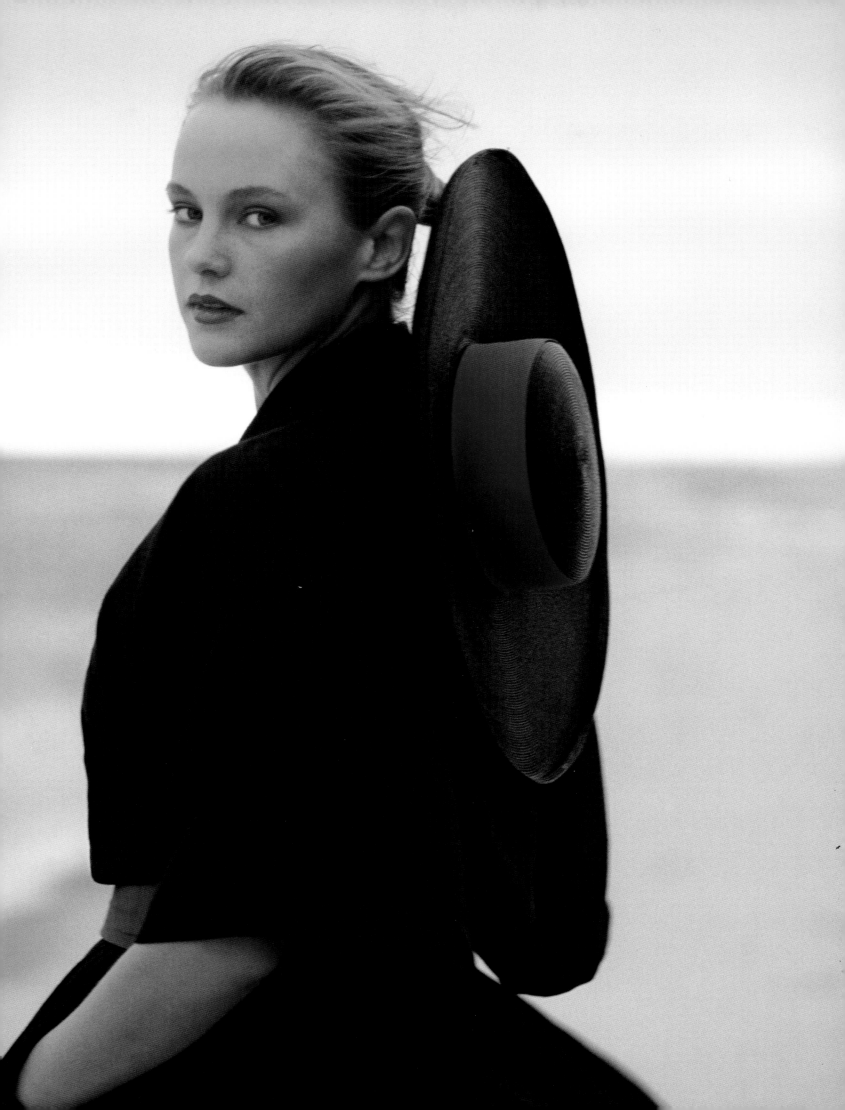

"I don't make fashion; I make clothes."

--Perry Ellis

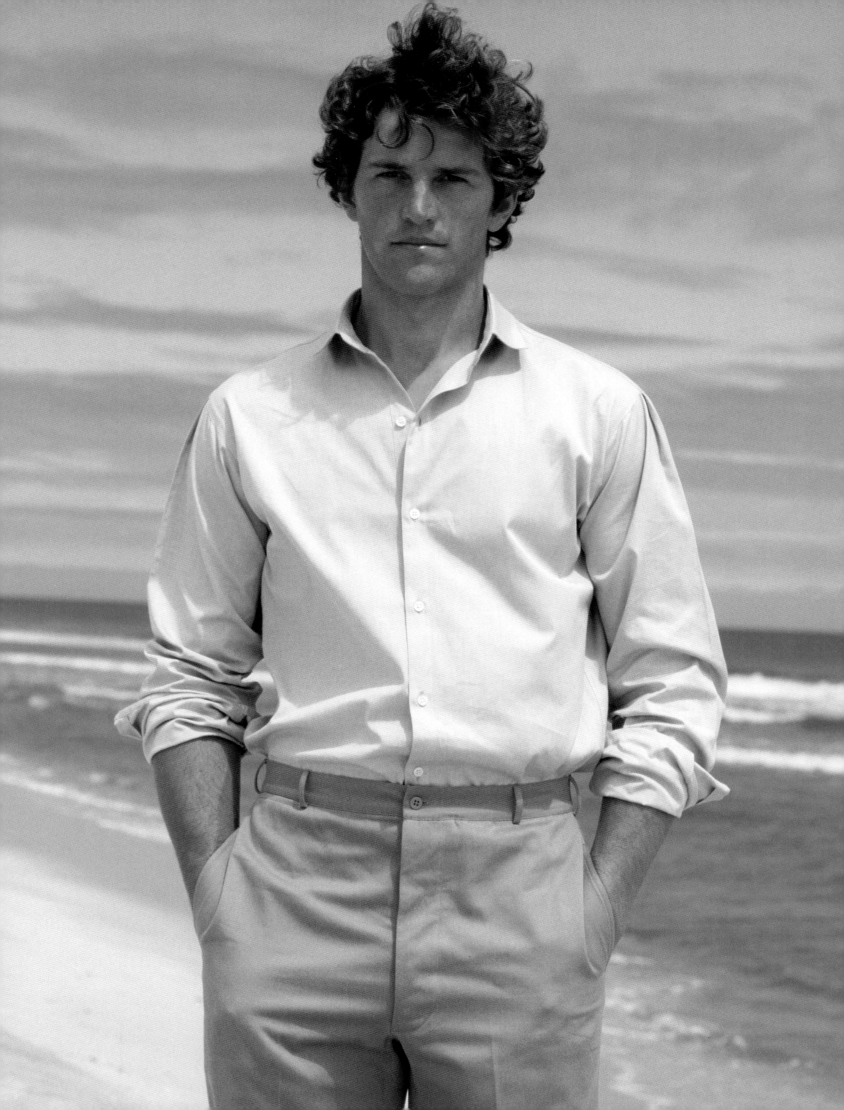

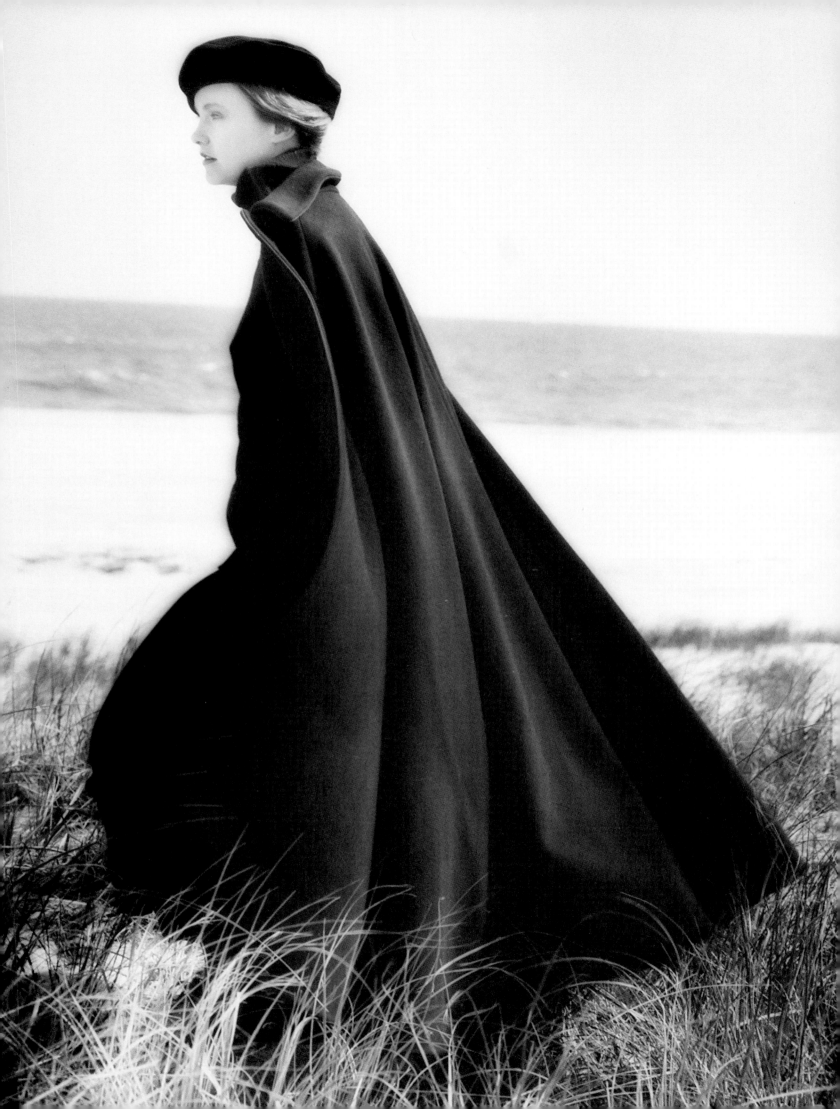

PERRY ELLIS

AN AMERICAN ORIGINAL

JEFFREY BANKS ERICA LENNARD DORIA DE LA CHAPELLE

RIZZOLI
NEW YORK

New York · Paris · London · Milan

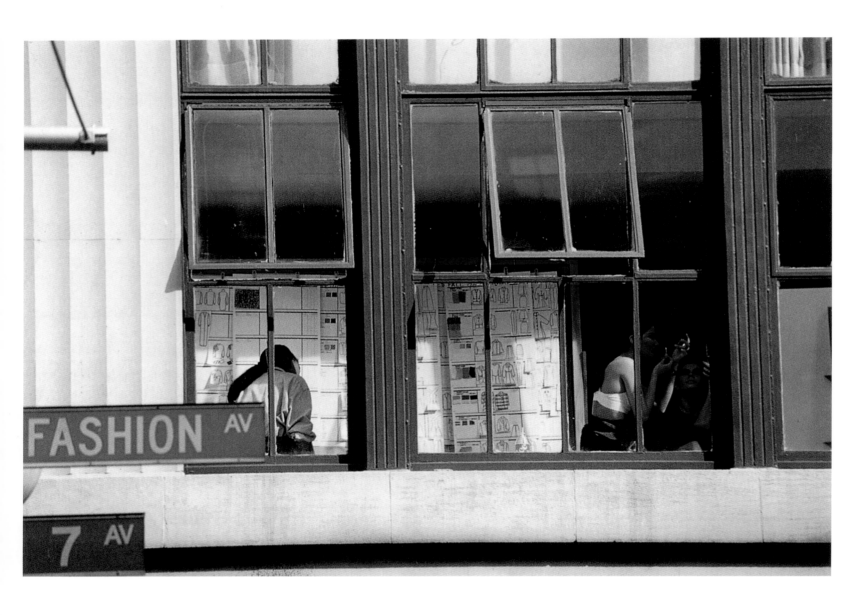

A window to Perry's
backstage pre-Fall/
Winter 1979 show at
575 Seventh Avenue.

CONTENTS

Primary photography by Erica Lennard
All text by Doria de La Chapelle unless otherwise noted

Following pages, left:
Sketches and swatches
by Marc Jacobs for his Fall
Senior Project at Parsons
School of Design for which
he received the Perry Ellis
Gold Thimble Award in
1984.

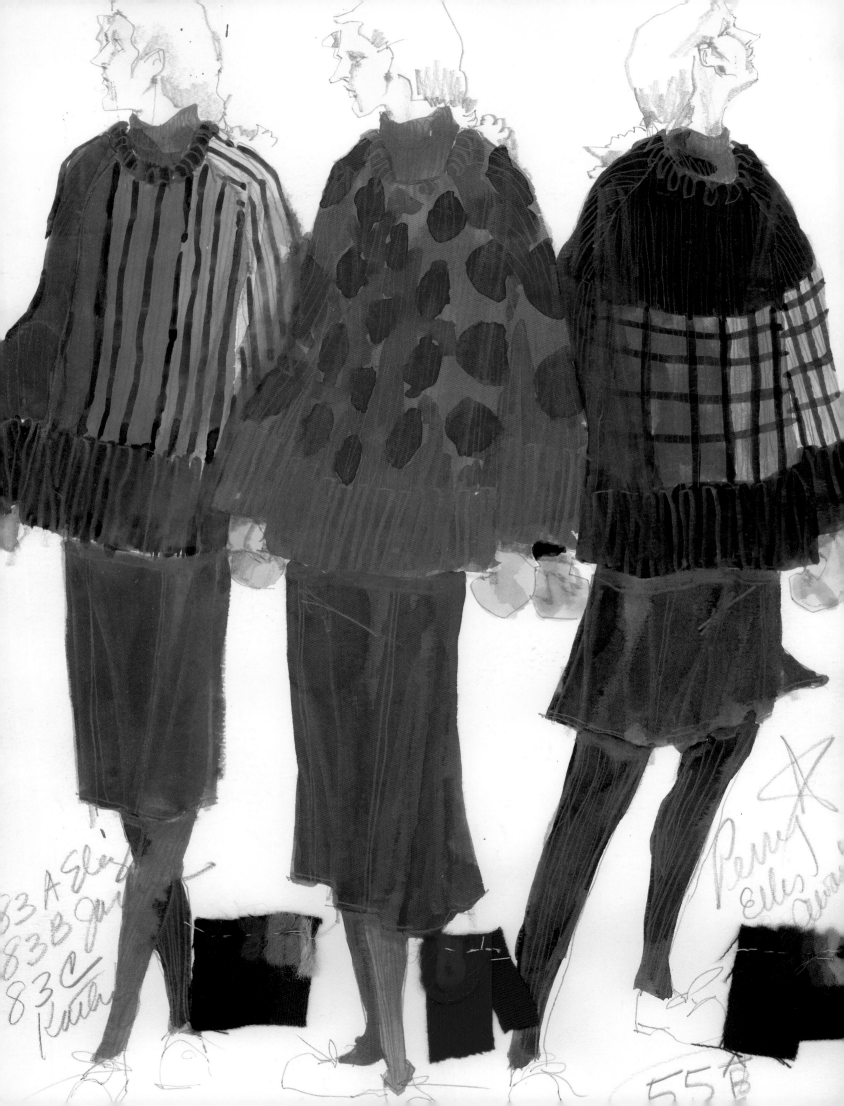

83 A Sec
83 B gw
83 C
Rue

Perry
Ellis
Ann

55 B

FOREWORD

MARC JACOBS

I don't know if I believe in fate, but I'm pretty sure it was fate that brought Perry Ellis into my life . . . the timing was always perfect.

When I was a kid, Perry Ellis was my favorite American designer. He made fashion romantic and whimsical and young. His clothes looked different from anyone else's. Perry's own look—handsome and long-haired, with a cool, relaxed attitude, made him seem younger and more romantic than anyone else. Even the imagery in his advertising had that emotional quality.

You can imagine my excitement when Perry walked into Charivari, the Upper West Side store where I was working as a stock boy. I never had a problem approaching people, so I went up to him and told him I was a huge fan. He mentioned that he was going to be making a personal appearance at Saks Fifth Avenue in a few days, and I cut out of school early to see him. I told him that I wanted to be a designer and asked him how he thought I should go about it. Perry suggested that if I were really serious, I should go to Parsons School of Design, where his top assistants, Patricia and Jed, had gone. I followed his instructions. Isaac Mizrahi and William Frawley were ahead of me at Parsons and were already working part-time for Perry, so I occasionally was asked to help dress a couple of Perry's fashion shows.

As luck—or fate—would have it, for my fall senior project at Parsons, Perry was assigned to me as my critic. I showed him my sketches of the three oversized, hand-knit smiley-face sweaters that I intended to produce, and he was reluctant to let me do them all. "I don't know how you are going to finish them," he said. But I was adamant that I could complete the job, and I think Perry was surprised by both my determination and the fact that I was so organized with all my colors, yarns, and fabric swatches. He seemed to appreciate the fact that, unlike some of the other students, I had confidence in my choices. In the end, I was given the Perry Ellis Gold Thimble Award and I was incredibly proud to have received it from Perry himself.

At my graduate show, I met Robert Duffy (still my business partner today), who enlisted me to design sweaters for a company called Reuben Thomas, and the following year, I designed my first collection under my own label. By this time, sadly, Perry had died. But somehow, fate again favored me with another Perry Ellis gift: in 1987, I was the first recipient of the CFDA's Perry Ellis Award for New Fashion Talent.

Occasionally, I would run into Robert McDonald, one of Perry's oldest friends and business associates, in my neighborhood on the Upper West Side and we would always exchange greetings. One day, out of the blue, Robert rang me up and asked if I would consider designing the Perry Ellis Collection. I had truly come full circle.

Perry, for me, offered the possibility that American fashion could be fashion as I imagined it. It could have a voice: young, personal, whimsical, emotional, creative—something that pulls at your heart.

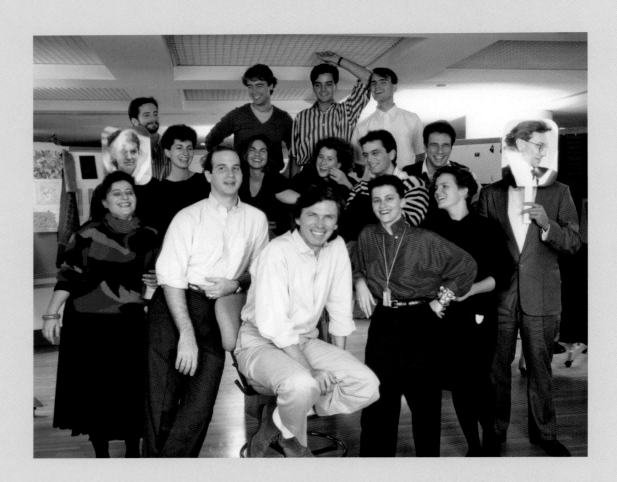

Perry and his team in the showroom,
1984. Center front, Perry Ellis. Next
to him are his two vice-presidents for
design: Jed Krascella (left) and Patricia
Pastor (right); Back row, left to right:
Brian Bubb, Patrick Long, David Witkiewicz,
Randy Meyers; Middle row: Karen Golden,
Laura Marolakos, Jackie Spaniel, Susan
Martin, William Frawley, Nick Gjovik, Rob
Sullivan; Back row: Elizabeth Kurtzman and
Beth Bowley. Photograph by Dustin Pittman.

EX ANIMO

He was in a class by himself, all right.
That much we knew on sight.

Dear God, what a potent mix:
. . . wild maned, well-mannered . . . elegant, so soft-spoken, khaki clad,
not a shirt cuff in sight . . . smart, sharp, witty, worldly . . . charisma by the bucket,
incisively irreverent, a tad raunchy . . . *young* . . . those long fingers, the wide-set eyes,
infinitely interesting . . . *he could see right through you* . . . he seemed so secure.
And let's not forget that *bella figura*:
. . . so slim, sensuous . . . swear to God he looked like the fantasy issue of
an improbable Jackson Browne / Frank Langella / Rudolf Nureyev love triangle.
Intimidating?
Well . . . *yeeees* . . . but he was *so* easy to talk to—oddly, seriously simpatico.
Green as we were (and we were very), we could see he wasn't your run-of-the-mill,
magazine-thumbing, ascot-clad, shopaholic fashion designer.
There was the distinct promise that *something* was going to be different with PE.
And so it was.
On many fronts.

For, you see . . . Darling (we always called him this—and he, us) . . .
Darling had some *rad* thoughts.
At those very first meetings (and forever after) it was quite apparent that
this charmer *had a spine*—and a cause.
He saw IT ALL differently. All of it.
"Darling," he would whisper with a trace of a drawl . . .
. . . "Darling—one CANNOT be a frightened designer."
Tongue in cheek, but make no mistake—he meant it. He wasn't.
He was not fond of fashion's arm's-length artifice, and he told
anyone within earshot.
He famously declared that clothing was pretty far down on his
list of priorities— incredible for a fashion designer.
He dispensed with creativity-crushing rules, geographic biases,
industry strictures, outmoded reverence . . . *boundaries* . . .
even buttons!
Through a very spirited, very casual, very *young* lens of his
own invention, he foresaw the alternative path that his beloved
American classics should take:
fresh and fun, slyly subversive, wrapped in his own brand of romance, layered with that bracing slap
of humor for which he quickly became famous.
Familiar—but not at all.
Darling wanted NEW.

He was nothing if not absolutely bedrock-solid sure of his unique vision and taste,
and tellingly this confidence *opened doors*, never shut them.
And this . . . *rebel* . . . wanted to push us right on through.
Who could resist?
We couldn't. We didn't. None of us.

And so . . . the seduction began.

"Get your ducks in a row!" was his clarion call to order before the encroaching chaos.
Pencils poised, we'd huddle and hover as he flung astonishingly amped-up fabrics from shoulder to
shoulder—draping and tucking, gazing hard into the three-way.
"What feels new to you, what looks fresh to you, what are you thinking of,
what do you like, how do you see it, what do you want to do?" Always "you."
Then he'd toss us *his trust*, and we'd be off.
Who *did* that?
In lockstep, we conjured up jolting themes, startling silhouettes, satiric wordplay . . .
a veritable Xanadu constructed from rules of our own making—which, by the way,
we broke every season.

It was a magic-carpet ride:
We championed croquet, we clicked castanets, we played with our
chopsticks.
We attended the hunt, we sailed with the navy, we waltzed through the
Outback.
We lunched at La Grenouille. We were stuck on Sonia.
We doted on all Seven of the Sisters.
We dreamed that cloaks became unicorns, coats begat coatlettes,
Shetlands attended balls, and farthingales time traveled.
We saw intarsias as canvases and pelts as mosaics.
We had pleats running riot.
We made colors spar, textures collide, prints clash, proportions buckle.
We sandblasted makeup, unleashed tresses, encouraged theatrics.
We nipped and cinched and padded and peplumed.
We dimpled.
We used tartan as a verb.
We worshipped the white shirt, revered the camel's-hair coat.
We dragged old-lady furs out of mothballs.
We fed steroids to tweeds.
We took liberties with Liberty.
We thought sweaters were gods.

We were . . . *never bored*.
And PE—more than anything—*enjoyed* himself. Life. Work. Everything. It showed.

He was drop-dead serious about *not* being serious. So everything Perry touched looked like
Perry alone—which was the very point of it for him, such was his demand for originality, his exacting eye.
Fearless contrasts were the backbone of his work; extremes made for brilliant parameters.
At once both iconoclast and traditionalist, his standards changed *the* standard.
The post–Perry Period is defined by the open doors he unlocked years before.
Hi-low is the lingua franca. Fashion is a universal entertainment.
Pigeonholes are relics of the past. American creativity is a global commodity.
Darling lit a fuse. We thought he might.

We spent just a decade side by side—howling with laughter, slaving like dogs,
skewering the pretentious, swearing like longshoremen, exploring the world,
sniffing out truffles, finishing one another's sentences (and sketches) . . .
relentlessly tossing off a *tsunami* of ideas with both precision and abandon.
We watched, we learned, we had the best teacher, we had a great friend.
Outrageous that there is no extant archive; simply a miracle that this book can
reveal once again what the fuss was all about—for indeed there was quite a fuss.
Darling would have *loved* it.
We do too.
We still miss him so very much.

<div align="center">

JED KRASCELLA AND PATRICIA PASTOR
NEW YORK, 2013

</div>

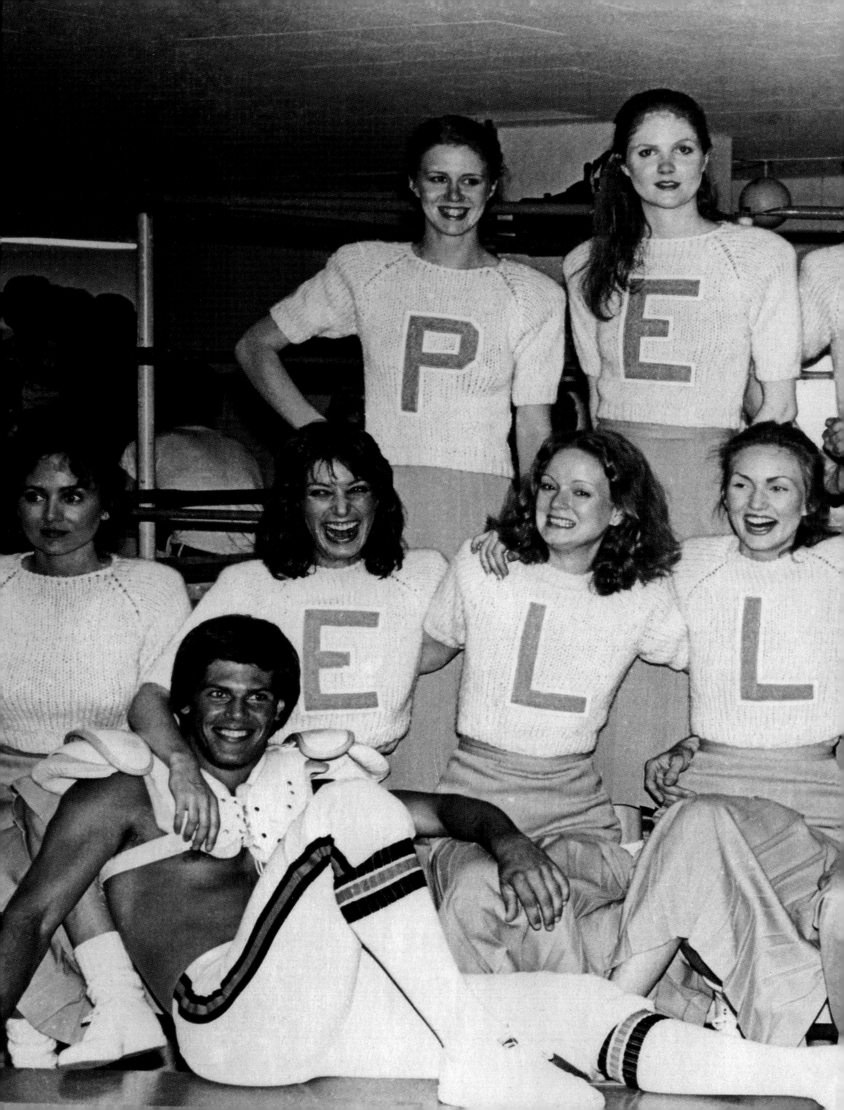

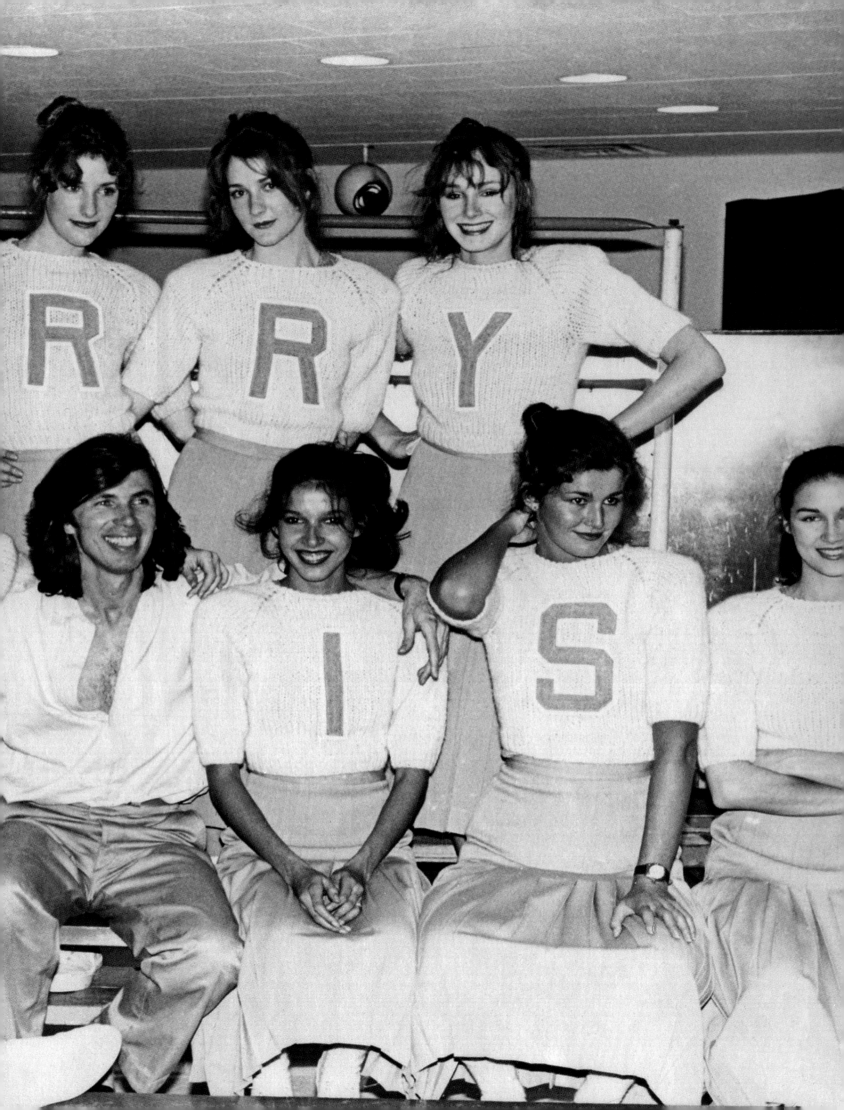

"Perry Ellis fashion represents, to me, an unhinged staple. He painted a mustache on the Norman Rockwell portrait of American dress. Those classic clothes were twisted into knots like a magician making dachshunds from balloons."
—Amy Spindler

ou need an invitation and, ideally, a shoehorn to squeeze into the showroom where designer Perry Ellis is about to unveil his Fall 1978 collection. Early buzz from *Women's Wear Daily* has sent fashion industry VIPs into high anticipatory mode, and seating is scarce. *Interview*'s Andy Warhol, concerned there isn't room for him on the bleachers, opines that everyone should send in their backside dimensions before the next show so that custom seating can be assured. But eventually they all pack in: Grace Mirabella, Polly Mellen and Jade Hobson from *Vogue*; John Fairchild, Michael Coady, Etta Froio, and Carolyn Gottfried from *WWD*; Carrie Donovan and Bernadine Morris from the *New York Times*; Marilyn Kirschner from *Harper's Bazaar*; Edie Locke, Nonnie Moore, and Sandy Horvitz from *Mademoiselle*; Jean Guilder from *Glamour*; and the executives and buyers from Bloomingdale's, Bendel, Saks, Neiman Marcus, among others—all of them jammed shoulder to shoulder on rows of bright orange stadium bleachers. Before them lies a long catwalk with a stretch of clean white paper down the middle, waiting for Perry Ellis to make his mark.

At the end of the runway is a goal post (see page 25), a large orange *P* at its center, in front of a large black screen. When Perry gives the signal, the lights are dimmed, a disco beat (this *is* the1970s) begins to throb, and a squad of wholesome Princeton cheerleaders in letter sweaters, pleated skirts, and pompoms appear then erupt into a rafters-shaking cheer. The real-life captain of the Princeton football team bursts through the screen in his orange and black Tiger football jersey and sprints down the length of the runway. Finally, the show begins with a gaggle of models skipping down the catwalk in giant-shouldered corduroy coats with chrysanthemum corsages over shrunken nubby wool sweaters and long, skinny corduroy skirts. Puffy Michelin Man–esque parkas top narrow pants. Proportion and shape are key—either big over skinny or short over long—with lots of little details like cropped boots, leggings layered with dyed-to-match socks, and flat-heeled Oxfords. And then come the best accessories ever: a few great-looking male models in tweed sweaters and easy, unconstructed jackets, almost identical to the ones the girls are wearing. Could this be a trend?

The mood and energy are that of a 1950s collegiate homecoming game, but the clothes are a game changer: Perry's collection is a study in new proportions, fabrics, and silhouettes that give his sportswear an undeniable chic. It's a style all his own: inventive and every inch of it American. The models are laughing, enjoying themselves, moving—and the clothes move with them. Their joy is contagious and the audience picks up the vibe. At the end, the models emerge, clad in sweaters spelling out P-E-R-R-Y E-L-L-I-S, and the crowd of editors and retailers cheer raucously as Perry himself, grinning, skips down the runway with his models to take a bow.

When the applause finally dies down, no one wants to leave. Perry has outdone himself. No one else in America is doing clothes like this. Perry knows it, and everyone who is there knows it. The designer, up to this moment merely a rising star, has begun his meteoric journey into the fashion stratosphere.

Previous pages: Perry's model cheerleaders and the real-life captain of the Princeton football team. Fall/ Winter 1978.

PERRY ELLIS

As if the brilliance of Perry's Fall 1978 show were not enough, Laurence C. Leeds, Jr. Chairman of Manhattan Industries, the conglomerate that owns Perry Ellis, underscores the success of Perry's Fall 1978 show, announcing that MI will be establishing a new division, to be known as Perry Ellis Sportswear, with Perry as president and designer.

One might have said that the planets seemed to have been perfectly aligned for Perry Ellis on that April day, but that would only begin to explain his warp-speed journey to the top. From the late 1960s, with its anti-establishment social upheaval, to the mid-1970s, much of American fashion was foundering between the last flutter of hippie fringe, the strictures of European style, and a plethora of wrinkle-free polyester. It was a perfect moment for young American designers with a fresh aesthetic to seize the stage. Ralph Lauren had launched his aspirational sportswear for both men and women with refined taste and an Anglo-American country-weekend style; Calvin Klein was achieving great popular success with his tailored European-inspired sportswear; and Perry Ellis, who once told *New York Times* writer John Duka that he "always made a determined effort to do something different,"[2] decided to do just that.

Rather than trying to emulate his peers, Perry set out to create a new, soft-tailored American sportswear idiom by working with traditional shapes, deconstructing them and making them younger, more spirited, and modern. His philosophy seemed to have been forged out of pragmatic American principles: he gravitated to ease, comfort, authenticity, and understatement. He worked in natural fabrics and textures like linen, hopsacking, cotton, and wool. As a purist, he often used drawstrings or hidden closures rather than buttons. He disliked makeup. There was just enough of an "antiestablishment" undercurrent to his work to create a kind of hip, cult-like appeal. And he was young, handsome, lanky, long-haired, and articulate. He spoke about clothes as though they were "old friends."[3] He avoided Studio 54. He wasn't interested in what anyone else was designing. He was very comfortable in his own skin. He was the right designer at the right time.

Princeton cheerleaders on the runway. Fall/ Winter 1978.

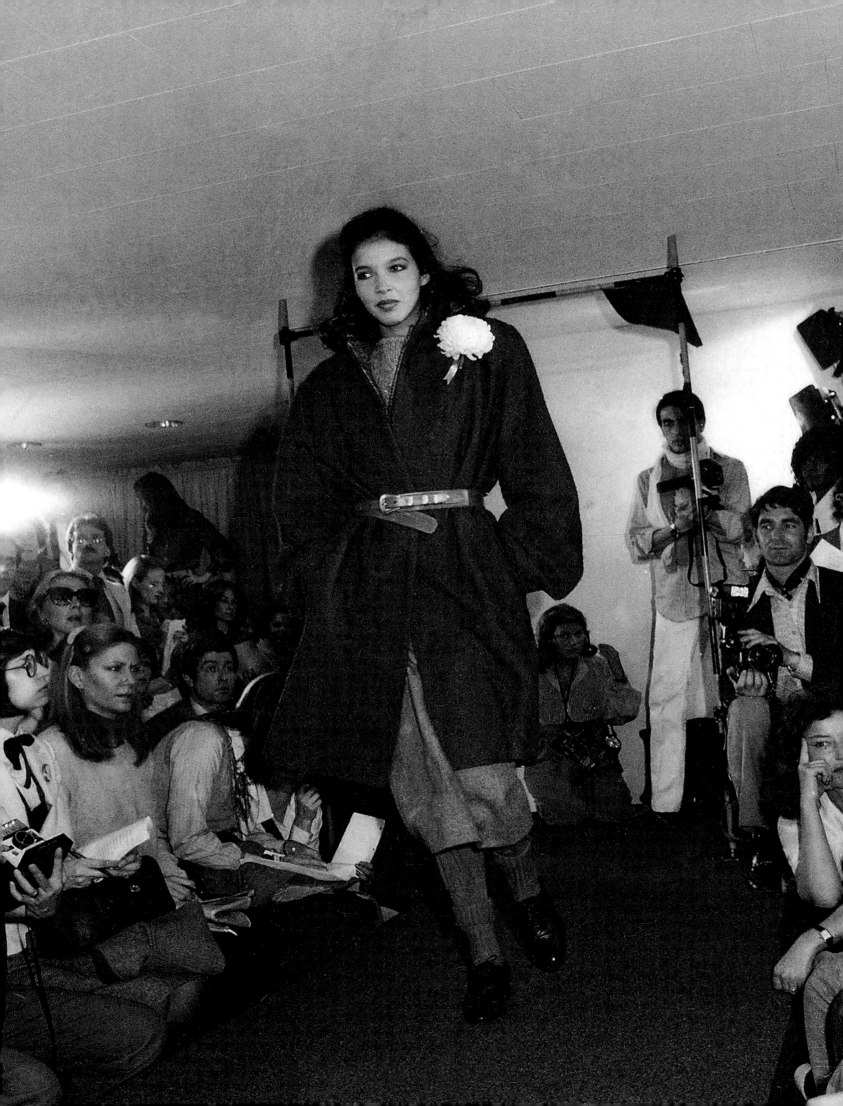

> "Since Perry didn't have a design background,
> he worked from a purer point of view. He wasn't
> encumbered by rules."
> — Patricia Pastor

There was little in Perry Ellis's early life that could have hinted at the notion of a spectacularly successful career in fashion—not a preternatural fascination with clothing or hours spent sketching at the kitchen table or afternoons watching Ginger and Fred in darkened movie theaters. Rather, Perry grew up light-years away from the noisy and intense spotlight of the New York fashion scene, in the southern coastal city of Portsmouth, Virginia—a part of the country where genealogy, history, and good manners are woven into the rhythms of everyday life.

Perry was an only child born, on March 3, 1940, into a close family, with a wide network of relatives nearby. The Ellises, his father's family, were native Virginians, while his mother's family, the Roundtrees, hailed from North Carolina. In that longtime tradition of the American South where family names are passed down to succeeding generations like good silver, the newborn boy was given the name Perry, after his maternal grandmother's family. His father owned a successful fuel company and his mother was a homemaker; they lived in Portsmouth in a house that belonged to his grandmother and later, in a neat

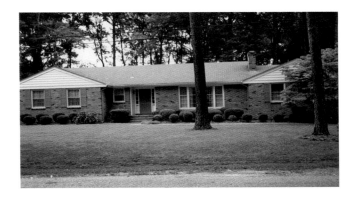

brick ranch house in the rural suburbs. Later in Perry's career, this ordinary background would be embellished by journalists who, impressed by his Virginia roots, endowed his circumstances with great wealth and lofty First Family of Virginia credentials. Perry didn't stop them; he knew who he was and let them write what they wanted to believe.

Above: Perry's childhood home in suburban Churchland, now incorporated in the city of Portsmouth, Virginia.

After graduating from high school, Perry enrolled at the College of William and Mary, graduating with a degree in business administration in 1961. So as not to be drafted into the military, Perry signed up for the U.S. Coast Guard Reserve, where the term was shorter and the duties less onerous. His tour of duty was unspectacular with one exception: he was chosen to join the Coast Guard's Ceremonial Honor Guard, which meant he was often called to duty at the White House when John Fitzgerald Kennedy was president, and his wife, Jacqueline, was First Lady of Fashion.

According to Perry's Coast Guard pal, Troy Swindell, "Most of our duties consisted of being there [at the White House] when the president was receiving heads of state. I can remember when Prime Minister Nehru of India came in and also the president of Finland, but that was probably only because we noticed Jackie was wearing the same brown outfit on both occasions. Perry and I were probably the only two people in Washington who realized she wore the same dress twice!"[4]

After he served his requisite stint in the Coast Guard, Perry enrolled in a graduate business program at New York University, where he earned an MBA in Retailing. Heading back to Virginia, he entered the executive training program in 1963 at Miller and Rhoads, an esteemed old carriage trade store in Richmond, where his clean-cut appearance, style, and sense of purpose served him well. After learning the ropes in various departments of the store, Perry became a buyer in women's junior sportswear—a relatively small and insignificant department. He was assigned to both the Villager and John Meyer of Norwich lines— two big, preppy labels in 1960s women's junior sportswear. Highly motivated and quick to learn, he was doubtless thinking he might someday become a senior merchandiser at Miller and Rhoads, but he was about to begin an education in fashion that would ultimately change the course and tenor of his life.

As one of a handful of people in retailing with a graduate business degree, Perry certainly had an advantage, but he also had a visceral instinct for merchandising coupled with an exceptional level of taste. Under Perry's sharp guidance, Miller and Rhoads did over two and a half million dollars worth of business with John Meyer in 1964—more than any other store in the country. Not only that, Perry's junior sportswear department had become the biggest money-maker at Miller and Rhoads.

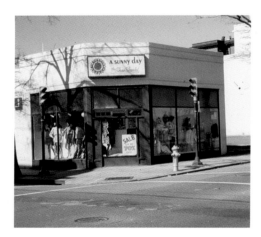

But it wasn't long before Perry became restless. Observing an empty space that had been a laundry near Virginia Commonwealth University, Perry spoke to Ephraim "Ed" Steinberg, the building's proprietor, and proposed the idea of opening a fashion boutique. He persuaded Ed to join him in the endeavor and then enlisted the help of Jerry Yospin, a young salesman for John Meyer, who had become a good friend. Each man contributed $3,000 to the project (Perry borrowed his share from his parents), and Perry came up with the shop's name: A Sunny Day. At first the shop was stocked with preppy pink and green collegiate classics. But in a sign of the changing times, Peter Pan–collared blouses and A-line skirts proved too conservative for A Sunny Day customers. With the help of Ed's daughter, Myra, a young dance student at the university, Perry filled the shop with sexier and edgier fashions like Betsey Johnson, fishnet stockings, and Doc Martens shoes. A Sunny Day became legendary: shoppers would line up on Saturdays, and when the four dressing rooms overflowed, the girls would try on new clothes on the floor

A Sunny Day, the hip young women's clothing boutique that Perry founded with his friends in Richmond in 1967. The boutique catered to the students at nearby VCU and local fashionistas, and thrived well into the 1990s.

of the shop itself, creating a new kind of "window dressing." A Sunny Day, founded in 1967, thrived well into the 1990s.

Ultimately, Perry decided Richmond was too small to contain his ambition and that, if he were to make it big in fashion, he would have to move to New York. He rang up John Meyer to ask him if he would consider giving him a job. Meyer, a big fan of Perry's, hired him readily; he, along with his wife, Arlene, who helped design for the company, believed Perry to be a crackerjack forecaster of what the public would want to buy in the future—a very valuable asset to a manufacturer.

Meyer himself had been trained as a textile engineer, and he took the time to school Perry in the world of fabric, "how to 'build' a plaid, as well as the different techniques utilized in printing fabric." He also taught him a wealth of information about knitwear and the technology of dyeing. The knowledge and mentoring Perry gleaned from his boss was to be of paramount importance to him when he designed his own collections, as both fabric and yarn became the genesis for all his work.[5]

As Perry told John Duka in an interview for the *New York Times* several years later, "I stayed there for seven years and merchandised their sportswear line, but more importantly, I learned about fabrics, pattern making, sketching, and designing. I ended up doing what fashion designers do, but at the time I didn't realize it."[6]

But by 1973, the market for "country club" clothing had shrunk and conservative clothes had lost their relevance. With Perry's friend and mentor suffering from cancer, the John Meyer company was sold. As Perry contemplated his next move, he received a call from the Vera Companies, offering him a position with its sportswear line.

Vera Sportswear had made its name designing silk scarves, but by the 1970s was known for its polyester double-knits—an unlikely choice for Perry, who doted on natural fabrics. But he adored Vera Neumann, a talented artist and collector who had founded her company in 1946 with the idea of screen printing her floral and abstract paintings onto practical items like linen placemats. In addition, capitalizing on the surplus of parachute silk available after World War II, she designed beautiful scarves, and, in turn, blouses made of the scarf silk.

In January 1974, Perry officially joined Vera Sportswear, which was owned and operated by Manhattan Industries, the large and venerable shirt manufacturer. Hired as a vice president and merchandise manager, selecting fabrics and colors and styles for the Vera line, he was also given the creative freedom to turn Vera's brilliant-colored silk-screen paintings into sportswear. One of the first things he did was to play with the proportions of Vera's flowers, reducing a print until it became a small overall design—or blowing up a flower so that only a fragment of the original was on the fabric. Then, as Vera herself was soon to retire, he was named "designer" of the line, replacing the namesake founder.

In the first of his collections under the Vera label, Perry returned to the natural fabrics like linen, cotton, and flannel that he had always loved and used at John Meyer, and a world removed from the polyester he had been working with recently. Working denim and French toweling into layered, uncomplicated shapes, he created a small group of clothes with considerable charm. The press was delighted with the clothes' simplicity and freshness and featured them prominently. Cognizant that Perry was creating something new and different, the president of the company, Frank Rockman, asked Perry to consider designing his own collection, also under the Portfolio label.

Perry initially responded to Rockman's suggestion by saying he wouldn't know how to design his own collection. Traditionally, a fashion designer is presumed to have the knowledge to create a garment from concept to the finished product, including sketching, draping the muslin on a mannequin, making the pattern, and sewing the finished garment. Since Perry had not formally studied fashion design in school (nor had other American designers like Ralph Lauren), he knew he was less than skilled in the art of dressmaking. But he possessed a deep comprehension of merchandising, a finely honed sense of proportion, and a reservoir of ideas—and he knew how to communicate them. What he needed to learn was how to express his ideas on paper and translate them into three dimensions, both of which he could do with the help of a technically trained staff.

Once he became enthusiastic about the possibilities of designing his own line and said yes to Rockman, Perry placed a call to the prestigious Parsons School of Design in New York City to find an assistant designer. The school sent him Patricia Pastor, a brilliant and stylish recent graduate who had had her heart set on working for Calvin Klein—in 1975, he was the hottest designer in town. Patricia recalls every detail of their first meeting:

"Having no idea what Perry looked like, I pictured this short, balding garmento-type. Instead, I found myself face-to-face with this great looking guy wearing a blue button-down shirt, khakis, and boat shoes." Perry vividly described the new line, verbally sketching out the future Portfolio: "It was made of linen, unconstructed drop-shouldered dresses, light airy tops over pants. I immediately saw that they were very simple things that I would want to wear myself. I instantly forgot about Calvin Klein. I decided I wanted to work for Perry very badly."[7]

The first show on which Perry and Patricia collaborated, for spring of 1977, was young and fresh, made up of natural washed linen, cotton, and hopsacking with charming details like deep pockets finished with the same stitching you'd find on bound buttonholes. The shapes were soft and free-floating, sometimes caught loosely with a drawstring to indicate a waist or create a slimmer shape over the hip. Since Perry Ellis was not exactly a well-known name at the time and this was his first show under the Portfolio label, it hadn't been easy to round up the important press. But somehow, together with Rea Lubar, his irrepressible PR maven, Perry had managed to fill the seats in the small showroom with the right people.

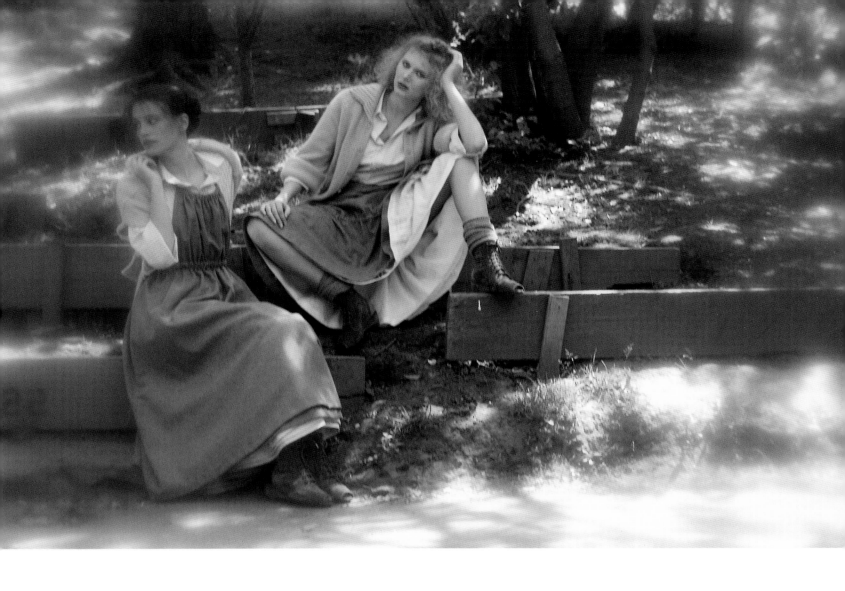

Cotton hopsacking jumper, skirt with linen petticoat, cotton-slubbed hand-knit sweaters, and open-toed canvas boots from a Hungarian store downtown. Spring/ Summer 1978.

Carolyn Gottfried, a junior sportswear editor at *Women's Wear Daily*, who had been assigned to Perry for the previous two years, helped land a cover story on him as one of several emerging designers on the day his first Portfolio show for spring took place in November 1976. She recalls how, "compared to the uptight sportswear that was being done in the mid-1970s, his clothes were a complete change and unlike anyone else's on Seventh Avenue. They were refreshing, easy shapes. The details were charming, the fabrics natural and uncomplicated. They were different in a wonderful, new way."[8]

Finally, Gottfried managed to introduce Perry to her boss, John Fairchild, chairman of Fairchild Publications (now a division of Condé Nast that still publishes *Women's Wear Daily*), and in her words, "Mr. Fairchild became as smitten with him, as we all were."[9] Gottfried, well aware of the weight that John Fairchild carried in the fashion industry, telephoned Perry and said "Perry, do you have a good lawyer? . . . You are about to become famous!" Gottfried didn't need to worry; Perry had just hired Mort Kaplan, the brilliant agent who would negotiate all terms and conditions for his many licenses. Kaplan, in turn, referred Perry to Stanley Lesser, one of the savviest lawyers on Seventh Avenue.

Dubbed the "Slouch Look," Perry's first fall collection for Portfolio debuted in April 1977, and featured layered, oversized clothes in colors that revolved around the natural and neutral earth tones that he customarily favored. Models wore skinny pants that dribbled around the ankles, or baggy, crumpled hobo pants, topped with wide-sleeved hooded jackets, tunic dresses, or coats gently shaped with drawstrings. Topping these off were long jackets and sweaters in a fresh and unpretentious mix of tweeds, corduroy, flannel, and Shetland wool. Perry blithely explained his philosophy to *Women's Wear Daily*: "It's all an attitude with my clothes. Some women can just wear them all day long anywhere."[10]

But while he was starting to get serious "ink" from the press and positive reactions from prestigious stores, there were still a number of important retailers who were not fully convinced that the innovative and quirky items they saw on the runway were going to sell in their stores. So in preparation for the spring collection, Perry went back to his merchandising "roots": he reasoned that for a collection to be more salable, stores needed to see more continuity—ideas that work one season then evolve into the next, such as signature items like a rounded jacket or skinny pants that buyers could build on, whether they were done in wool melton for winter or washed linen for summer. Instead of providing his audience with novelties for spring, he built on the concept of his successful "Slouch" collection of the previous season, retaining his signature shapes and details but slimming them down and lightening up the fabrics. He layered his clothes in light naturals like linen and cotton and hemp, and, to punch up his usual palette of soft neutrals, he added some deeper shades like burgundy as accents.[11]

When Perry Ellis's deal with Manhattan Industries was finally signed in August 1978, several months after it was mentioned to the press, his new company started from scratch in a loft at 148 West 37th Street, with only a cutting table and few chairs. Soon Perry and Patricia Pastor, his new design assistant, realized that they needed more help. They quickly settled on Jed Krascella, who was just about to graduate from Parsons. Tall and genial, he looked more like seventeen than his actual age of twenty-one. After a brief meeting, Perry emerged from the interview and whispered to Patricia, "I like him, but he seems quite serious." Patricia replied, barely able to contain herself, "Uh, Perry, did you notice he's wearing saddle shoes? I really don't think he could be *too* serious!" Jed was hired and turned out to be both seriously funny and seriously talented as an artist and designer. While Perry was incapable of telling a joke, he had a wicked sense of humor, and more than anything, he loved to laugh.

Perry's assistants complemented his talent and business acumen with their unique perspectives. Jed turned out to be both funny and talented as an artist and designer, wielding an encyclopedic knowledge of theater and fashion history. Patricia, who was passionate about vintage fashion, would often wear some of her smart thrift-shop finds to work: a jacket with an interesting sleeve

Backstage, Lynn Kohlman sports Perry's foxy jacket for Alixandre at the Fall/Winter 1978 show.

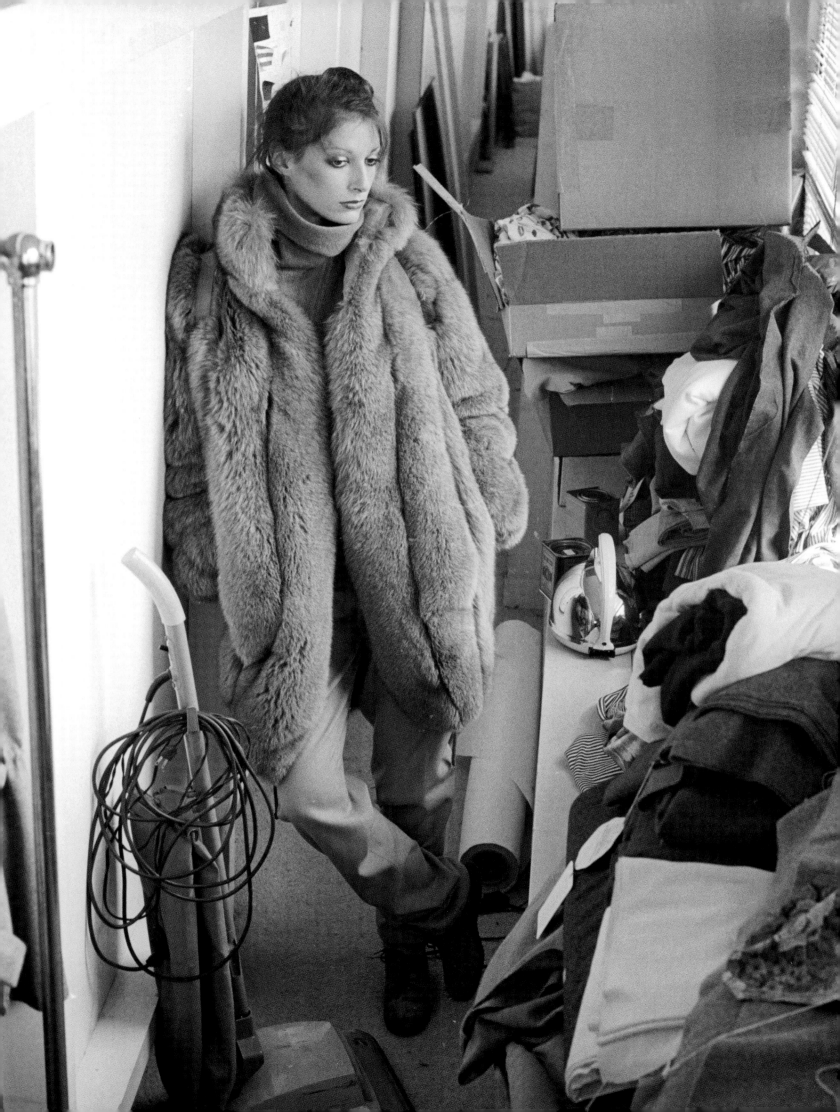

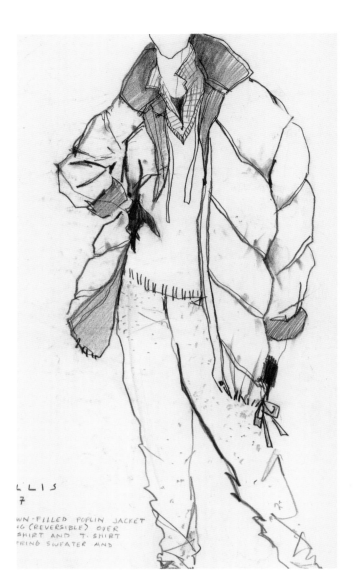

ELLIS
7
WN-FILLED POPLIN JACKET
·G (REVERSIBLE) OVER
SHIRT AND T-SHIRT
RING SWEATER AND

or a skirt with clever inverted pleats—elements that inspired the Ellis team to look at things differently. They might take apart the sleeve, analyzing it and learning from its construction, sometimes incorporating some aspects of it into their own designs. Perry loved the broad-shouldered, narrow-hipped silhouette and he wanted to approach it in a variety of ways. So he and his team would study the silhouette of a classic jacket and think, *How can we broaden the shoulder without adding a shoulder pad?* Then they would conjure up ideas: Maybe we could add a pleat to widen it. Or perhaps extend the shoulder of a ruffled blouse by adding another ruffle around the shoulder? Or similarly, in order to come up with a new version of a flat-hipped silhouette, they experimented with nipping in the skirt of a dress with double drawstrings—one at the waist, one five inches lower, to provide an easy, soft-tailored look instead of the traditional stitched-down pleats. They were constantly thinking outside the box, challenging themselves to find new ways to tweak traditional shapes.

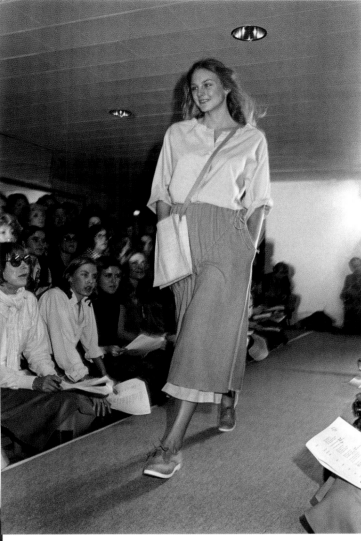

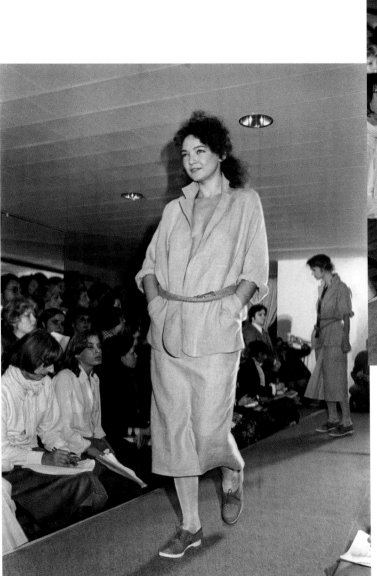

Perry's unforgettable Spring 1978 show (above and left) was a midsummer day's dream of a collection with fabrics of mostly linen and white cotton, detailed with faggoting and eyelet. For reasons no one but Perry could understand, he had his heart set on recreating the idea of a day at the beach, with his models strolling along the water's edge while the sea lapped at the hems of their pants and skirts and tunics. The problem was that Perry's boss, Frank Rockman, had issued a strict warning that under no circumstances was water to be allowed in the showroom. But somehow Perry got his way. The designer and his PR team managed to sneak in a child's wading pool. As each model emerged onto the stage, her clothes got progressively wetter. Finally, the last girl made her appearance completely soaked to theskin, having knocked over the pool, which, in turn, flooded the showroom floor. The press was utterly charmed, the buyers couldn't stop raving about the collection, and Rockman, forgetting for a moment about his sodden floor, couldn't resist intoning, "A star is born!"

Photographer Erica
Lennard's first job for
Perry was to photograph
this Bloomingdale's
advertisement that ran
in the *New York Times*.
Spring/ Summer 1978.

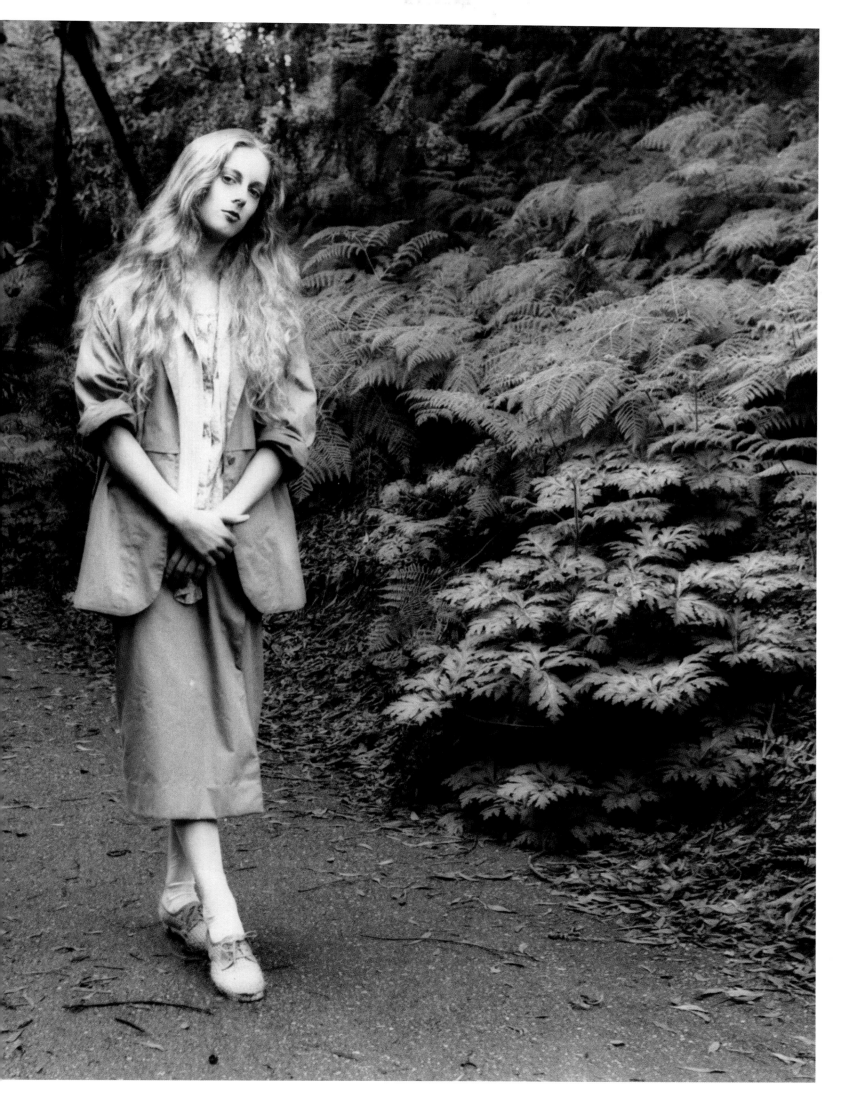

"I have always adored the ease of sportswear and Perry's clothes had it in spades. . . . I can remember how I felt wearing Perry's long, tweedy jackets with those shoulder dimples to Saratoga; there was nothing like them—such effortless elegance, not like sneakers and warm-ups, but terrific in a relaxed, American way."

—Grace Mirabella

erry and his team knew that the gigantic success of his Fall 1978 "Princeton cheerleader" show was going to be a tough act to follow, so his unerring instincts led him to design a low-key and lighthearted collection for the spring of 1979, keeping variations on the ideas of the fall show but allowing them to evolve into new shapes, fabrics, and colors. It was a pretty, witty show, and the tone was carefree and pitch-perfect Perry.

That show had no sooner been successfully presented in the old Portfolio showroom when Perry began searching for a larger showroom to accommodate his new label and its rapidly growing business. When he was shown a rubble-filled former bank space at 575 Seventh Avenue, the designer was immediately struck by its immense potential, with its Art Deco décor, lofty ceilings, floor-to-ceiling windows, massive chandeliers, and giant bank vault that had once belonged to Manufacturers Hanover Trust, which had vacated the address years before. To realize his showroom dream, Perry hired one of his closest friends, James Terrell, a talented partner in the architectural firm Hambrecht Terrell International, who began a long-term, two-stage renovation project. The result was a great palazzo-like room in gradations of beige, with pale sycamore panels, enormous marble columns, and magnificent mirrors. Very much in the grand European palazzo tradition, it was unlike anything ever seen on New York's somewhat gritty Seventh Avenue. However, the price of the renovation was commensurate with its grandeur: the costs were in such stratospheric numbers that the showroom became a major issue in the future battles—sometimes acrimonious—between Perry and Manhattan Industries.

The elegant, new Perry Ellis space was still a work in progress when the company began to move in part of its operation in January 1979. While he and his design team remained in their temporary quarters for a few more months, Perry desperately wanted to stage his Fall 1979 collection in May in the unfinished showroom. Art director Martha Voutas Donegan, who had been engaged to create the invitation for Perry's fall show, viewed the new space with the designer and recalls that "it was still pretty musty and dusty, and the floor-to-ceiling windows looked as though they hadn't been washed in decades." Perry just replied cheerfully, "It's going to be grand—we'll have stacks of moving

Opposite and Following Pages: Shot in the not-yet-finished Perry Ellis showroom in an old bank building. Spring/ Summer 1979. Photographs by Barbara Bordnick.

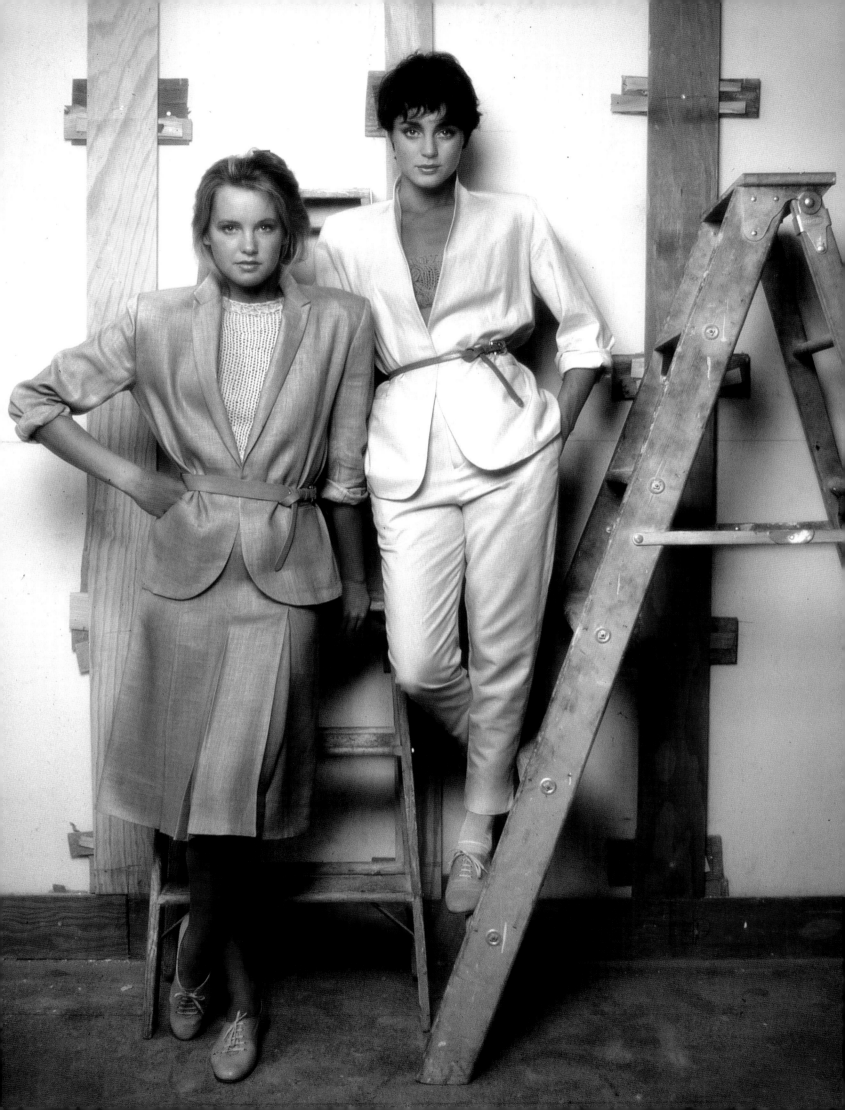

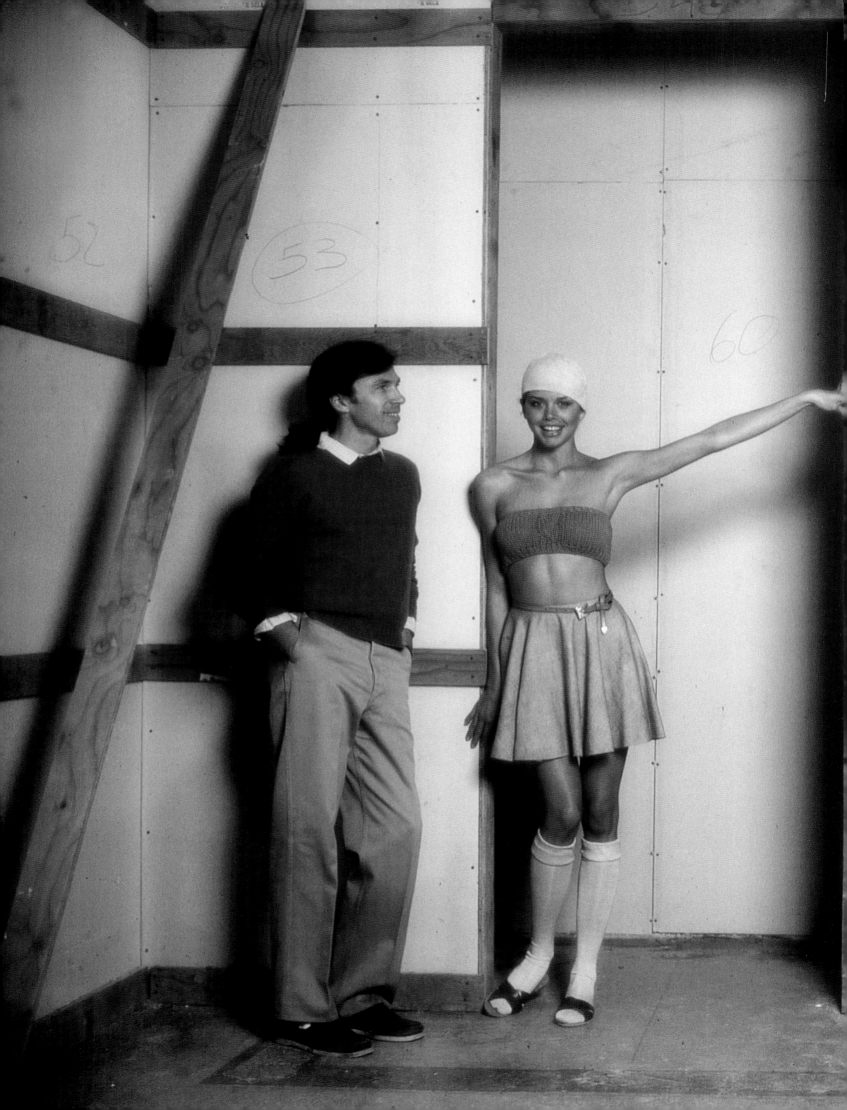

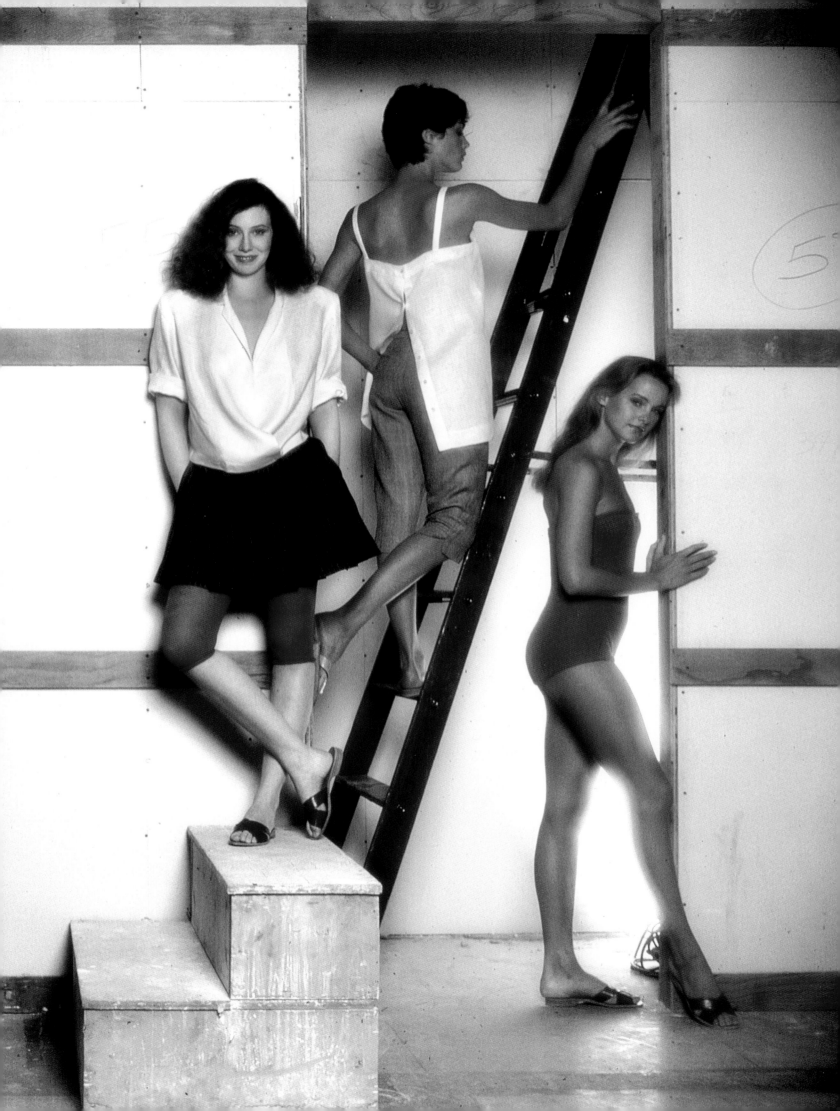

boxes around to show them we're in the process."[12] Martha was inspired to create a brown craft-paper-wrapper envelope, tucking inside a piece of cardboard packing material and the invitation to the Fall 1979 show, which began with the words, "Please join us in our new, unpacked home."

Martha was also commissioned to design the new Perry Ellis logo, which she was determined to differentiate from those of Ralph Lauren and Calvin Klein. She "eventually fell into the rhythm of the five letters of both his first and last names, spread them out on equidistant frets, then moved the frets to center with the letters,"[13] hand-setting the font, known as Folio, to give it a modern freshness that complemented his signature. As she had planned, it stood apart from the more traditional Ralph Lauren logo in the serif font Fenice and the well-known Avant Garde font that identified Calvin Klein. Perry was thrilled with his sleek, new corporate look and ultimately hired Martha to design all of his promotion, packaging, and advertising, as well as those of most of his licensees.

Perry Ellis's Fall 1979 show was the hottest ticket in town, as far as anyone whose business was fashion was concerned. Everyone wanted to see whether the designer, now that he had his own label, would take his clothes in a new direction, but they were even more anxious to see the fabulous showroom that Manhattan Industry's millions had created as a tribute to its bright young star. Crowding into the lobby of 575 Seventh Avenue, then filing up the charming late-nineteenth-century iron filigree staircase to the mezzanine, the fashion press and retailers could hear the elegant strains of classical music in the salon—a forerunner of what was to come. The brilliant cheerleader show of the previous Fall collection emanated a youthful collegiate exuberance, and Perry's collection for Fall 1979 featured a more grown-up girl, a sophisticated upperclassman, as it were, with a veneer of elegance that reflected her new surroundings and lots of new ideas. The show was a blockbuster: press and retailers alike were enthralled by the elegance and wit of the collection, commenting that while Perry's tailoring had become more refined, his clothes retained a softness, fluidity, and ease that made them young and hip.

Perry was consistently turning out progressively more sophisticated collections, which were celebrated by the press, both domestic and foreign, and

Perry's spectacular Ham-brecht showroom, designed by James Terrell, was both elegant and soothing. The entire palette was marble, polished English sycamore, clear mirror, gray glass, and stainless steel. Perry's shoe store in New York City used these materials but reversed them so that what was wood became mirror and mirror became wood, giving a fresh yet distinct look.

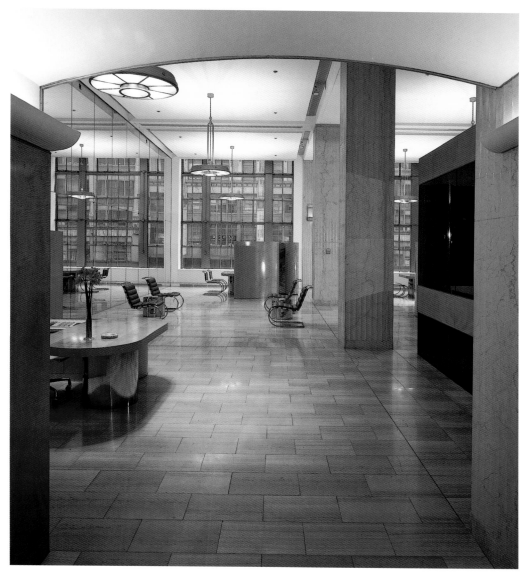

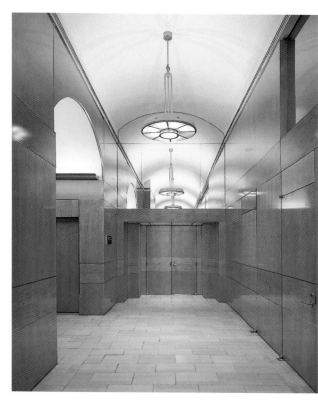

appreciated by a growing group of devoted customers. In the fall of 1979, when Perry was designing his collection for the following spring, he couldn't have known that Ronald Reagan and his fashionable wife Nancy would soon be moving into the White House, but he was right on the money when he anticipated that the 1980s was going to be a far dressier decade.

His sophisticated Spring 1980 collection was not only feminine and pretty, it also used gorgeous, luxurious tissue-weight linen and glazed silk organza—expensive fabrics that had rarely been used for sportswear before. The shapes were rounded but refined: feminine silhouettes in sophisticated but soft shades of seashell pink, pearl gray, tea rose, shy blue, and yellow, as well as some dark, rich-colored linens. There was a dressier quality to the clothes and a heightened sophistication. Perry was quoted as saying, "It's the most feminine collection I've ever done."[14] And no one took issue with that.

Perry Ellis had become the new American designer "phenom"; his Fall 1980 show was deluged by the tide of photographers, foreign press, celebrities, and fashion groupies jamming into the designer's showroom. Overcrowding and flashbulb-popping paparazzi were standard operating procedure for the big prêt à porter shows in Europe, but New York's Seventh Avenue shows had remained relatively civilized to date. Now there was no stopping Perry Ellis's rise to the top—and everyone wanted to be part of it. Actress Tatum O'Neal, a big Perry fan, showed up and explained that Farrah was heartbroken because she had strep throat and couldn't attend.[15] She was one of the few who didn't.

As Perry's career skyrocketed, so did his fame and fortune; inevitably, his life-style expanded as well. He had lived for a number of years in a charming townhouse on New York City's Upper West Side, which he shared with his former companion and longtime friend Robert McDonald. It was filled with a wonderful mash-up of family antiques, a four-poster bed and Biedermeier desk, comfortable lived-in upholstery, and a few gleaming contemporary pieces; in back, there was a lovely garden with a deck for entertaining. During summers, Perry had typically rented houses on Fire Island, but had recently found a small house to rent on the bay side of Water Island (a tiny, relaxed, and remote beach community on Fire Island), and he would soon purchase it, along with another house a short distance away on the ocean side. He had earned them: in five short years, he had gone from modest no-name merchandiser for a polyester clothing line to confident, big-time American sportwear designer whose name was on everyone's lips. For a man who loved his privacy, this was a serious adjustment. But most people who knew Perry felt that Perry stayed the same grounded, well-mannered guy he had always been, although perhaps just a tad more aware of his celebrity and the power that accompanied it.

Personally as well as professionally, 1980 was a particularly pivotal year for Perry; it was the year that he was introduced to Laughlin Barker, a handsome and dynamic lawyer who worked for Patterson, Belknap, Webb, and Tyler, a highly-respected white-shoe law firm in New York, and the man who was to become,

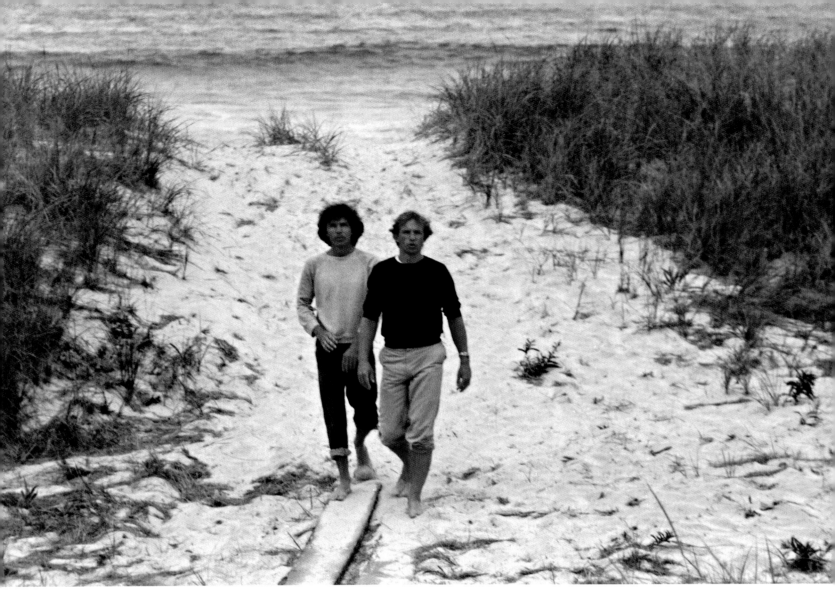

Perry and Laughlin Barker on the beach at Water Island during one of their first summers together. Circa 1982.

in Perry's words, "the love of my life."[16] No one was certain as to how or when Perry met Laughlin, but it was rumored that they were introduced by Patrick McCarthy, who was at the time a powerful editor at *Women's Wear Daily*. In any case, Laughlin and Perry were immediately attracted to one another, and, with Laughlin's fair-haired good looks, sharp intelligence, and refined sensibilities, Laughlin seemed not only a perfect partner for Perry but also an ideal fit in terms of the "larger" life and wider circles Perry was cultivating.

"It's My Turn," sung by the supremely sultry Diana Ross, was heard over the speakers as fashion-industry types, photographers, celebrities, and friends filed into Perry Ellis's Spring 1981 show. The song might have been an anthem for the designer, whose moment had definitely arrived: Perry was truly at the top of his game, with a range of soft, rounded silhouettes and, once again, a strong emphasis on proportions. The show was a display of Perry's ease and versatility, reminding some buyers and editors of the late Claire McCardell, one of the pioneers of American women's sportswear in the 1930s and '40s, who was celebrated for a kind of whimsical softness in her clothes along with practicality and a wonderful sense of humor. No wonder Bendel's Geraldine Stutz, thrilled with this exceptional Spring 1981 collection, was quoted as saying: "I think he [Perry Ellis] is becoming our contemporary Claire McCardell. His signature is that strong"[17]

But henceforth, no matter how many raves his collections garnered from other worldwide press, *Women's Wear Daily*, even when reviewing his collection positively, would always seem to throw in a few well-placed barbs and sometimes insert what seemed like gratuitous personal criticisms into reviews. Perry was said to have taken it all with a grain of salt, assuring one of his employees, "Darling, when they stop talking about you, that's when you worry."[18]

The brilliant show that Perry mounted for his Fall 1981 collection was his grandest—both literally and figuratively—and his most adventurous to date: a virtual Baedeker guide to sophisticated interpretations of romantic clothes from faraway places. The theme of the brilliantly staged show was "The Hunt," and, in addition to longbows and arrows, there were influences ranging from English hunters, Russian Cossacks, and Irish countryfolk to Bohemian gypsies and Berber tribespeople. But beneath the layers of gorgeous skirts and overskirts and dizzyingly colorful fabrics were some great-looking, soft-tailored modern clothes with scores of options.

The day after his April 21 presentation, *New York Times* fashion editor Bernadine Morris wrote a stunning review, elevating Perry's status to that of a handful of fashion greats: "Perry Ellis has reached that admirable stage in a designer's career where one doesn't need a score card to tell the player. It's not merely a question of turning out best sellers that are recognizably his. . . . It is a bit more than that. It is establishing a style that is his own. Chanel accomplished this decades ago. In this country, Claire McCardell's relaxed casual clothes set the mold for sportswear. And now, operating within that American tradition, Mr. Ellis is carrying the feeling for easy dressing even further."[19]

Both Perry's Spring 1981 and Fall 1981 women's collections garnered Coty Awards, placing him in the Coty Hall of Fame. In June of 1981, the Council of Fashion Designers of America announced the first CFDA Awards, and Perry was nominated for "Designer of the Year."

Perry had finally been elevated to the level of fashion royalty, up there along with Ralph Lauren and Calvin Klein, although his numbers didn't begin to approach those of the two more established powerhouses. Further, he was expanding his horizons: he was invited to Tokyo to launch his much-awaited Perry Ellis collection for Renown, his important Japanese sub-licensee, which was considered an enormous coup. With both his 1981 Spring and Fall shows enthusiastically received, Perry was ready to expand and launch a menswear line. Soon it, too, would begin to win its own accolades, including the first Coty ever given for men's fashion.

PERRY ELLIS

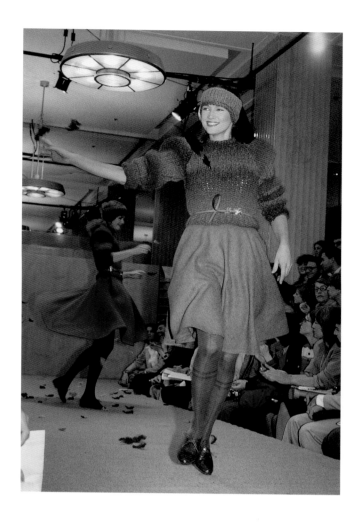
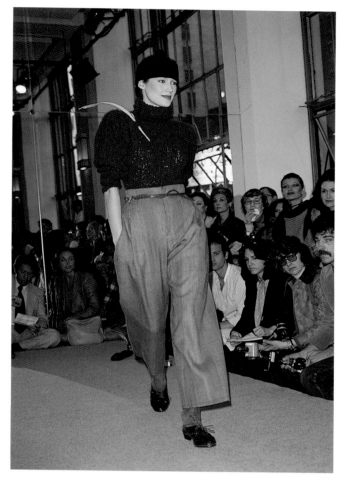
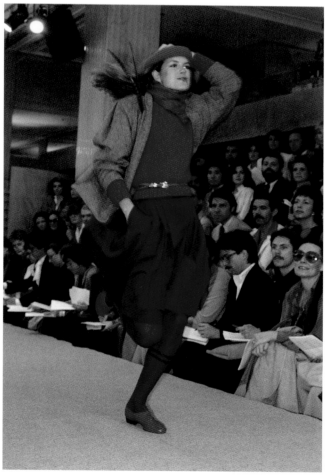
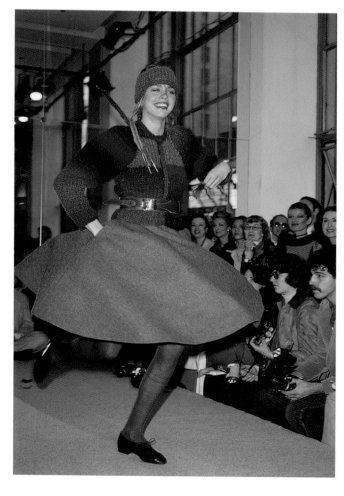

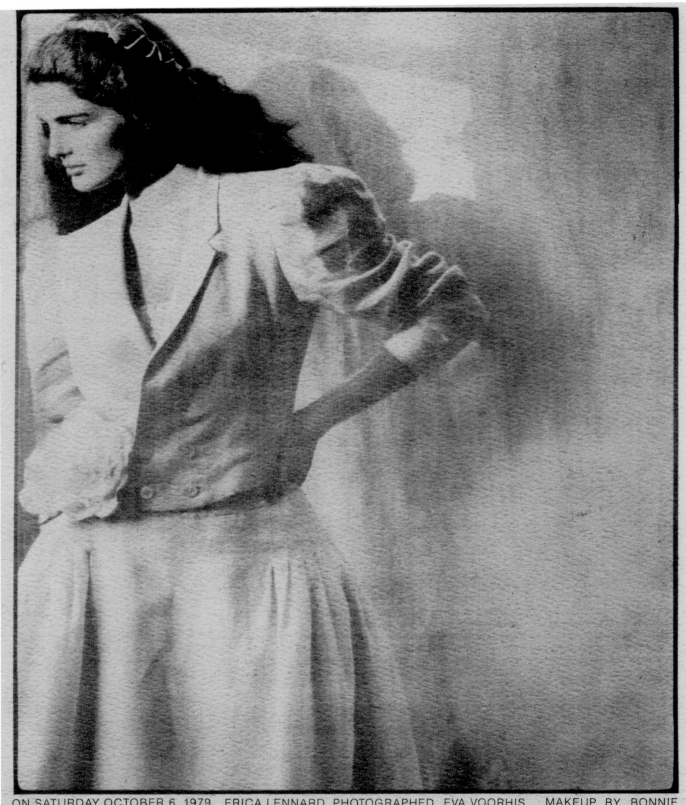

ON SATURDAY OCTOBER 6, 1979, ERICA LENNARD PHOTOGRAPHED EVA VOORHIS. MAKEUP BY BONNIE MALLER, HAIR BY ALAIN OF CINANDRE, ROSE BY JEAN-CHARLES BROSSEAU AND CLOTHES BY PERRY ELLIS

S P R I N G 1 9 8 0

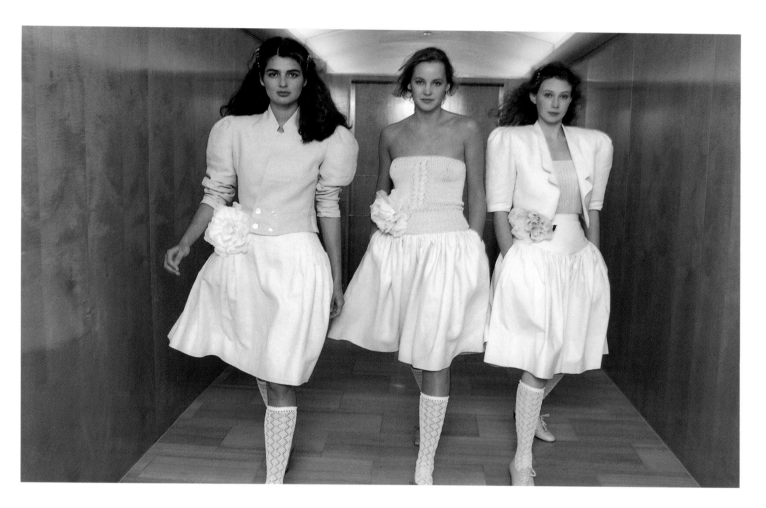

Opposite: The invitation to the Spring/ Summer 1980 show featuring Erica Lennard's photograph of Eva Voorhis in the collection's pastel linen jacket and farthingale skirt.

Above: Perry's pretty pastel jackets and skirts, hand-knit bustiers, and crocheted white socks paired with delicate, small-heeled Oxfords from Spring/ Summer 1980, perhaps his most feminine collection ever.

Following pages, left: Sheared mink coat with capelet attached. Mohair cap. Fall/ Winter 1980.

Following pages, right: Initial mood and silhouette from the Fall/ Winter 1980 collection of a grand fur cloak in the classic fully let-out technique. Details show the unusual treatment of the small and fine pelts at the neck becoming much wider at the hem. Sketch by Jed Krascella.

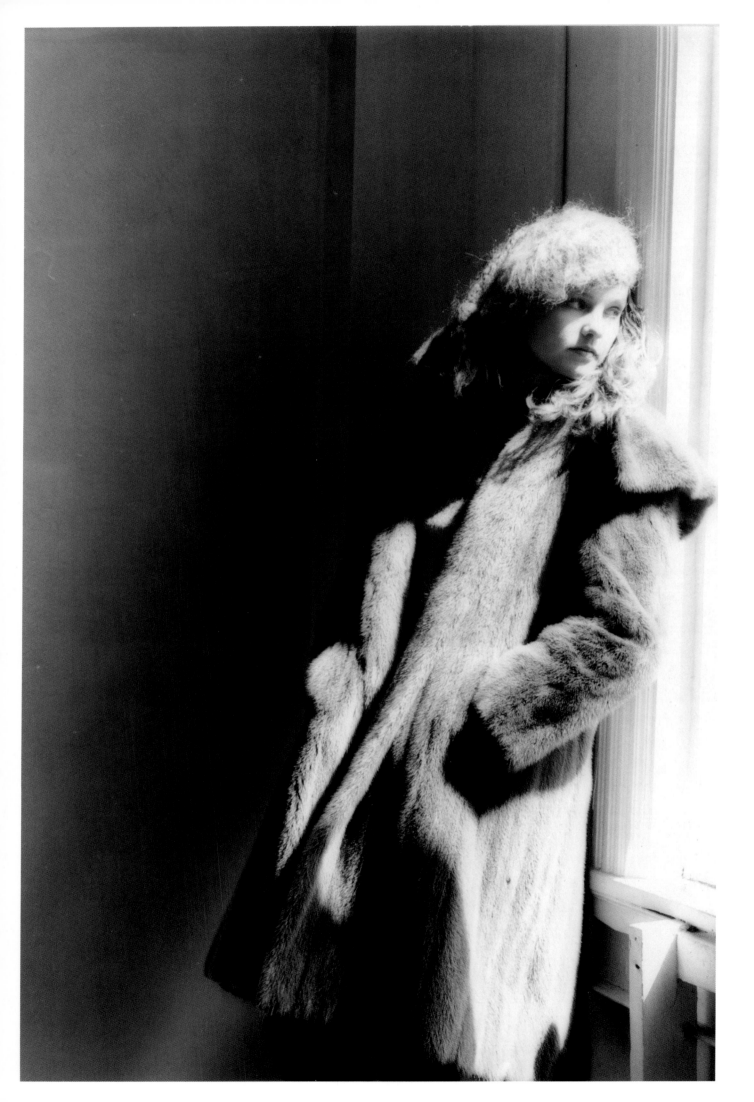

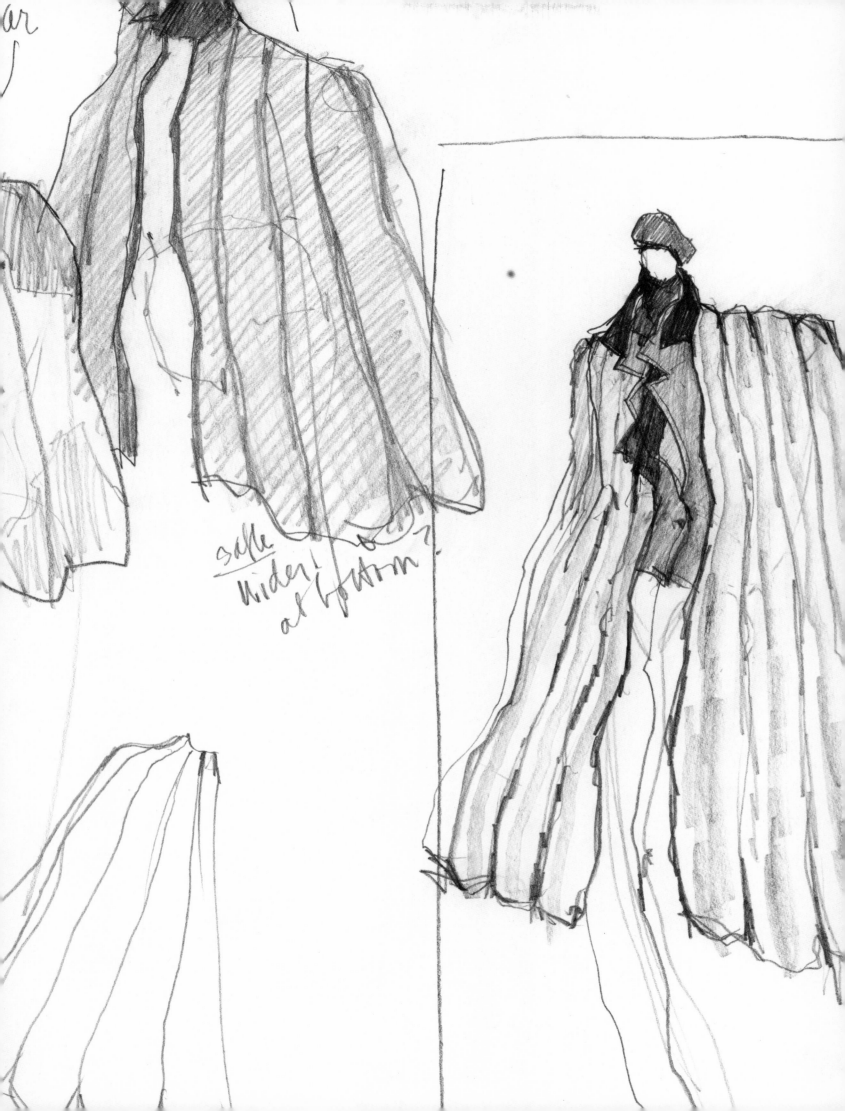

ar

salle
wider
at bottom?

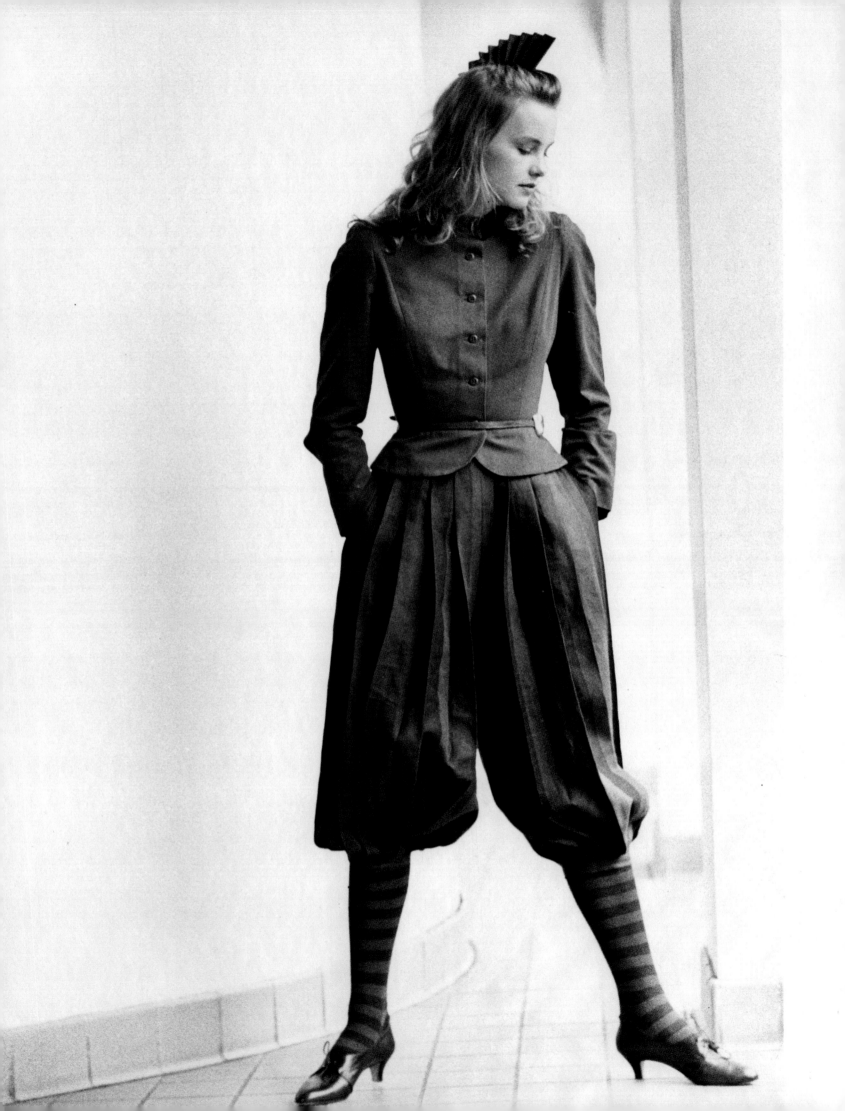

November 7-14, 1980 $1.50 a copy

Now:American Fashion

W

Perry Ellis' khakis in Times Square

W photo by DUSTIN PITTMAN

Above and opposite:
Spring/ Summer 1981.

Following pages:
Fall/ Winter 1981.
Sketch (left) by
Jed Krascella.

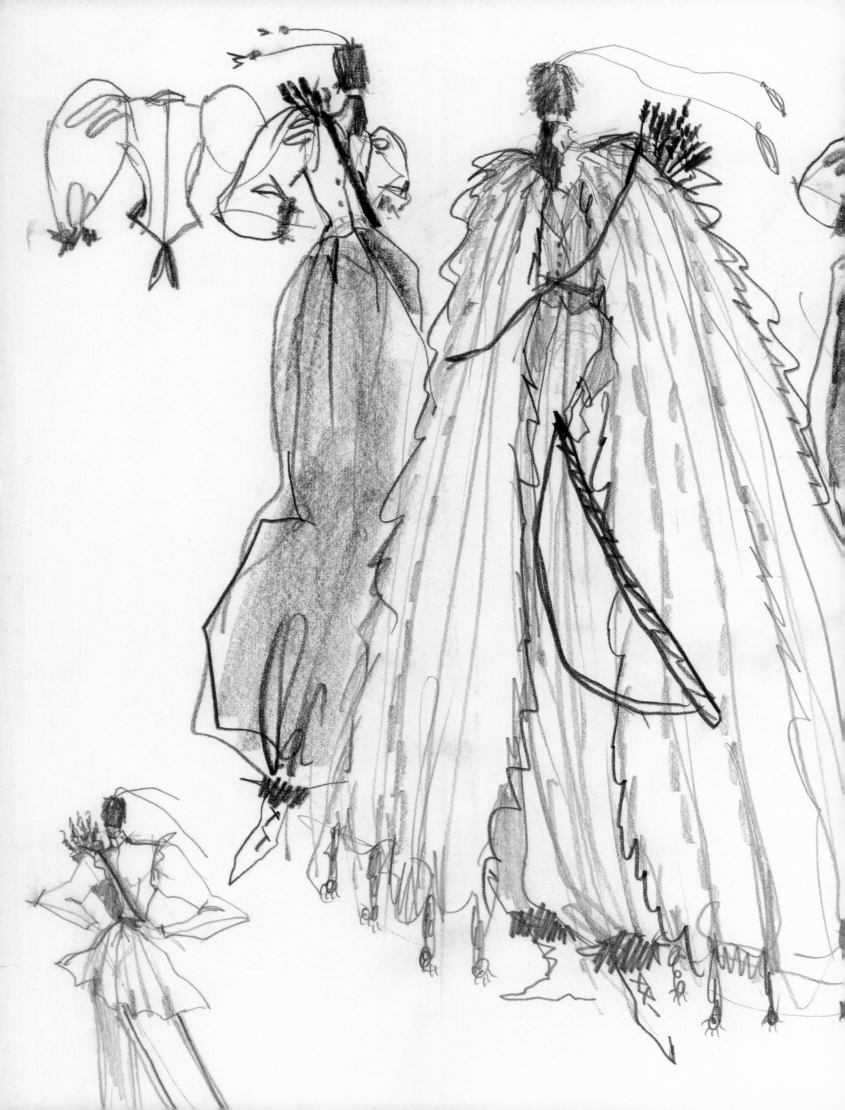

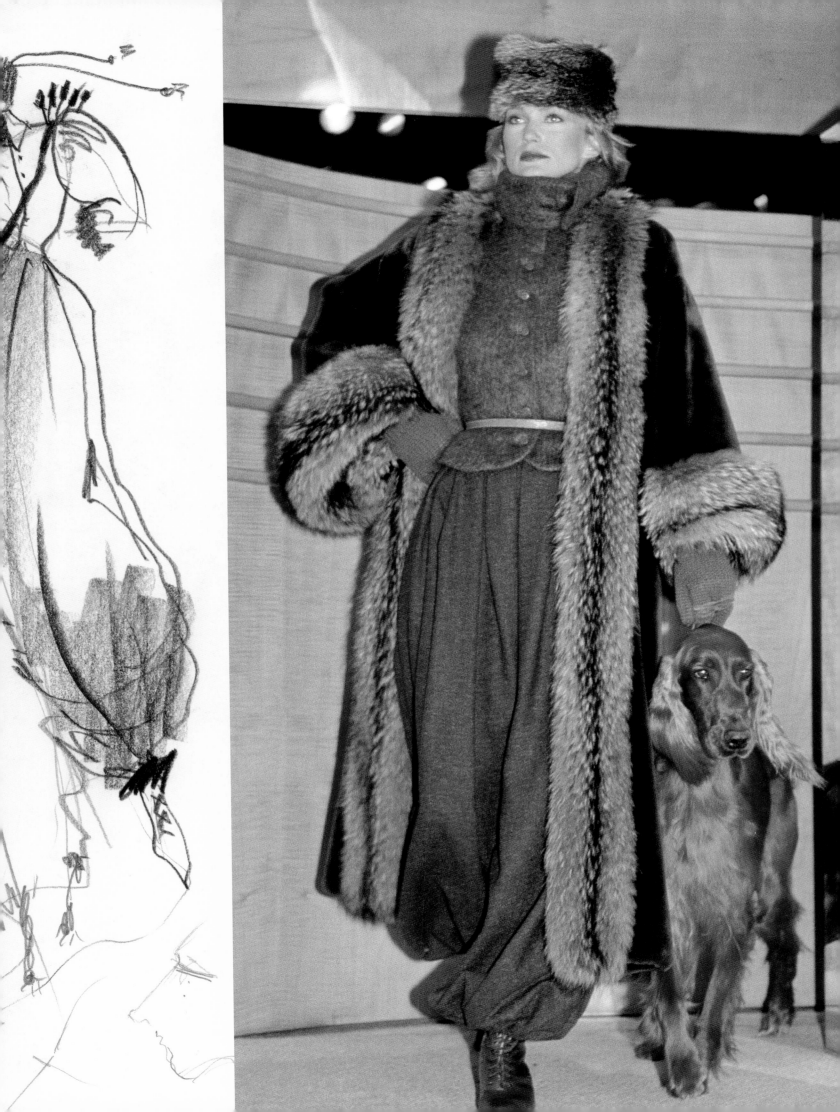

"The wonderful thing about [Perry's] clothes is their free
spirit. They have no time, no place."

–Koko Hashim

"[Perry] was a genius with color and fabric, and his sense
of proportion was unique and unrivaled. His clothes were
never about overt sexiness. He never objectified women;
there was restraint and respect of women, with a
dose of fun. It was like the coolest Marian the Librarian
you would ever want to know."

—Holly Adam

n early December of 1981, the Japanese government, Japanese textile
and trade associations, Japanese newspapers, and *Women's Wear
Daily* chose the "International Best Five" designers in the world to take
part in a fashion extravaganza. Perry Ellis shared this distinguished honor
with the august company of Karl Lagerfeld of France, Giorgio Armani
of Italy, Zandra Rhodes of Great Britain, and Hanae Mori of Japan. For
Perry, the illness and death of his father, which he kept private from the
media, overshadowed this prestigious event, but the distinction gave him
a new global recognition that he heretofore had not possessed.

One of the reasons that Fall 1981 was such a standout collection was Perry's
use of fabrics, particularly the way he put together a covey of game bird prints

Below: In December of
1980, Perry was selected
(along with Giorgio Armani
of Italy, Karl Lagerfeld of
France, Zandra Rhodes of
England, and Hanae Mori
of Japan) to participate in
the elite "Best Five" fashion
event in Tokyo, elevating
the young sportswear
designer to the top of the
fashion firmament just five
short years after design-
ing his first collection for
Vera Sportswear. From left
to right: Model Tree Allen,
Perry, and Patricia Pastor.
Tokyo, 1980.

Opposite: Etro patchwork
of paisley and foulard
patterns. Fall/ Winter 1981.

in different colors from Etro. Perry Ellis's Spring 1982 collection was considered by many to be some of the designer's purest and most elemental work. Opening with Vangelis's haunting theme from the Academy Award–winning British film *Chariots of Fire*, it was also one of his most beautiful and romantic collections ever. The press was unanimously appreciative of its beauty and originality, and *Women's Wear Daily* reported that Bloomingdale's highly-regarded fashion director, Kal Ruttenstein, raved about it, calling it "the most important statement to be made on both sides of the Atlantic."[20]

With the vast changes that were occurring in his business, the Perry Ellis physical premises were in need of expansion again: the number of Perry's employees had grown exponentially from five to seventy-five, menswear and accessories licenses had been added, and a major renovation and reorganization was required. Manhattan Industries took a lease on the third floor of the building, adding another thirty thousand feet. A reception room and offices for menswear and public relations were to be placed on the mezzanine level, while design, fabrics, and sample studios, plus corporate offices, would be moving up to the second and third floors. Perry worked with James Terrell, creating beautiful light-filled spaces—and sparing no expense.

While Perry Ellis Sportswear was growing at an astronomical rate, its parent, Manhattan Industries, was concerned about its excessive spending. Citing that Perry had supposedly spent $800,000 on sample fabrics that year alone, they were concerned about both operating expenses and the projected cost of new construction on their offices. As it turned out, the addition would cost them at least $3.5 million ($140 per square foot: a staggering figure for office space in 1982), and the rumor was that it was Perry's preoccupation with the project and micromanagement of every minute detail that helped drive the price sky-high. The company was trying to figure out new ways to rein in Perry.

Perry's Fall 1982 show opened with the upbeat sounds of "Dreamgirls," the title song from the soon-to-debut Broadway musical, based on the lives of the legendary 1960s girl group The Supremes. Among the fortunate five hundred or so fans who managed to squeeze in were models Lauren Hutton and Cheryl Tiegs, actress Anne Baxter, Tina Chow, Andy Warhol, and redheaded French designer Sonia Rykiel, who pronounced Perry's clothes, "*Si jeune, si originale.*"

Although reviews for the 1982 collection were mixed, for the first time, retailers did not respond well to the collection, calling it impractical and unsalable, and there were rumors in *Women's Wear Daily* that part of the line had been pulled back for revisions after the show. The rumor was denied, but the fact remained that the collection did not sell well. The company was already undergoing some serious growing pains as their business plan had been woefully inadequate for the amount of growth that had taken place, leaving them overextended. Perry Ellis Sportswear, Inc., was also facing the looming costs of expanding its showroom, and now the company was having to deal with

PERRY ELLIS

Perry's pink and white mile-wide striped double-breasted blazers over a striped pleated skirt with white stockings and v-throated pumps from the iconic "Chariots of Fire" collection. Spring/ Summer 1982.

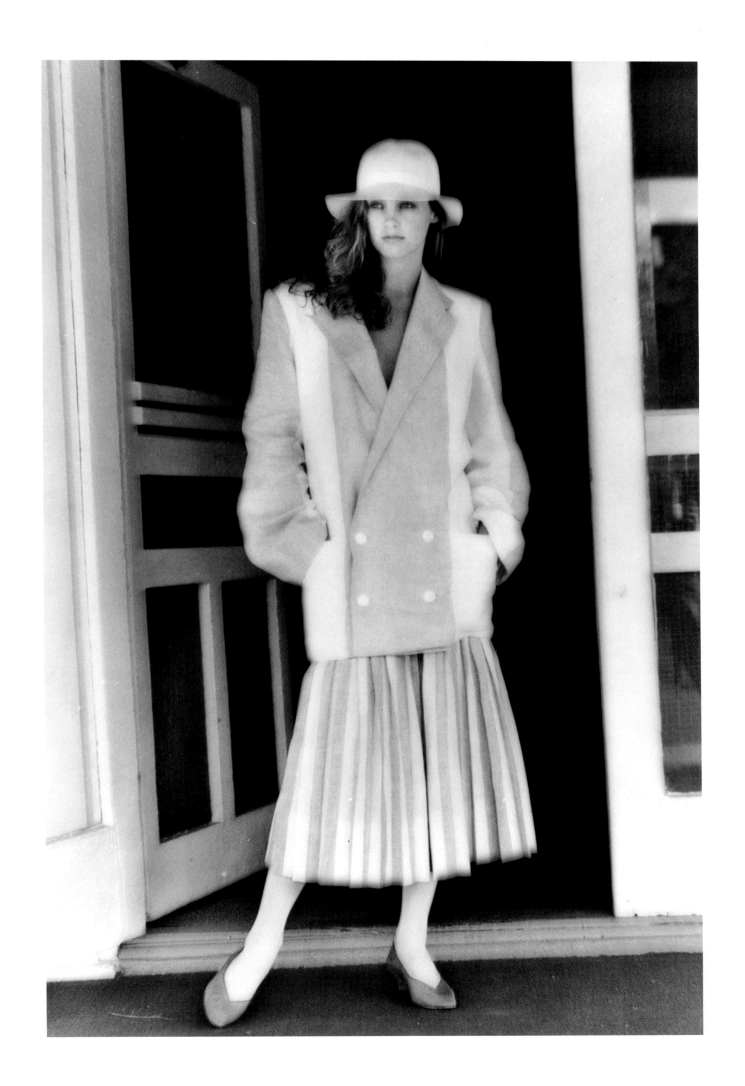

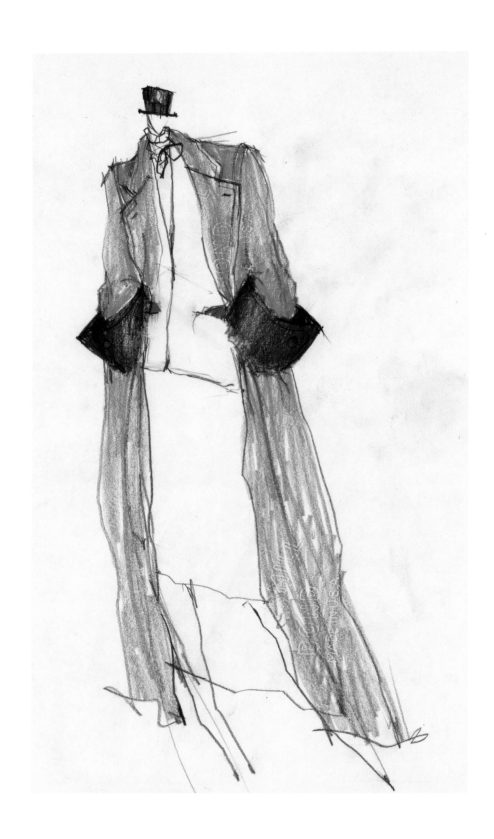

Above and opposite:
Fall/ Winter 1982. Sketch
by Jed Krascella.

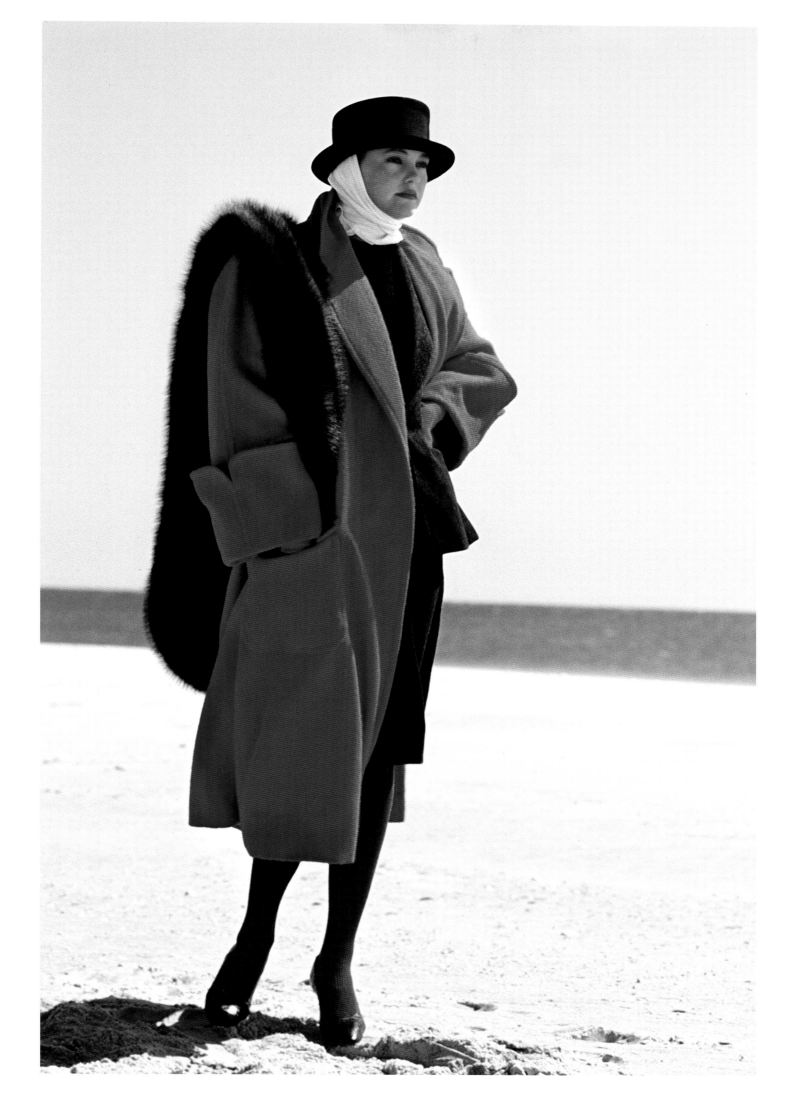

losses from an unsuccessful fall collection. The situation was grim, but Perry never let on that anything was amiss, carrying on with such apparent confidence and cool that very few people, even in an incestuous industry, knew how truly serious the situation was. This Teflon-like mentality—the ability to let criticism or bad news bounce off—was a classic Perry coping mechanism, one that he would rely on again and again as time went on.

Despite the recent financial problems in his business, Perry's status as a star in America's fashion firmament remained as bright as ever. The designer, whose favorite motto was "Never enough!" decided to expand his horizons beyond the United States and realized he needed some expert guidance. Fortunately for him, he didn't have to look far. His companion, Laughlin Barker, a lawyer with both international legal and business experience, had frequently counseled Perry on a number of complicated international issues. Significantly for Perry, Laughlin was also the person he trusted most in the world. The designer persuaded Laughlin to give up his job at the law firm Patterson, Belknap, Webb, and Tyler to sign on as chairman of Perry Ellis International.

Laughlin assumed his new role at the end of June 1982, shortly after the fall collection show that had "bombed" financially. It couldn't have been at a more propitious time. Within three years, by taking the reins and further developing the licensing arm of the business, Laughlin took Perry Ellis International from sixteen licensees, earning about $60 million wholesale, to twenty-three licensees, with a revenue five times that.[21] And there was something else: according to Ed Jones, having Laughlin at his side seemed to impart more confidence to Perry, making him a stronger, more assertive designer.

In November, with a gorgeous aria sung by Wilhelmenia Wiggins-Fernandez from the soundtrack of the film *Diva* as the opening for his Spring 1983 "España" collection, Perry sent out a series of graceful feminine silhouettes with high-rise nipped-in waists, fuller-than-full skirts, and rounded toreador pants, in fabulous Italian linens from Solbiati and Etro, in red, yellow, black, and white.

In April, he showed his finely-tailored Fall 1983 Winter Nautical collection, highlighting yet another new proportion: slim waists under short-cropped, fly-away jackets, balanced with full, bias-cut skirts or even bell bottoms. A delighted audience included actresses like Susan Sarandon, Sigourney Weaver, Mariel

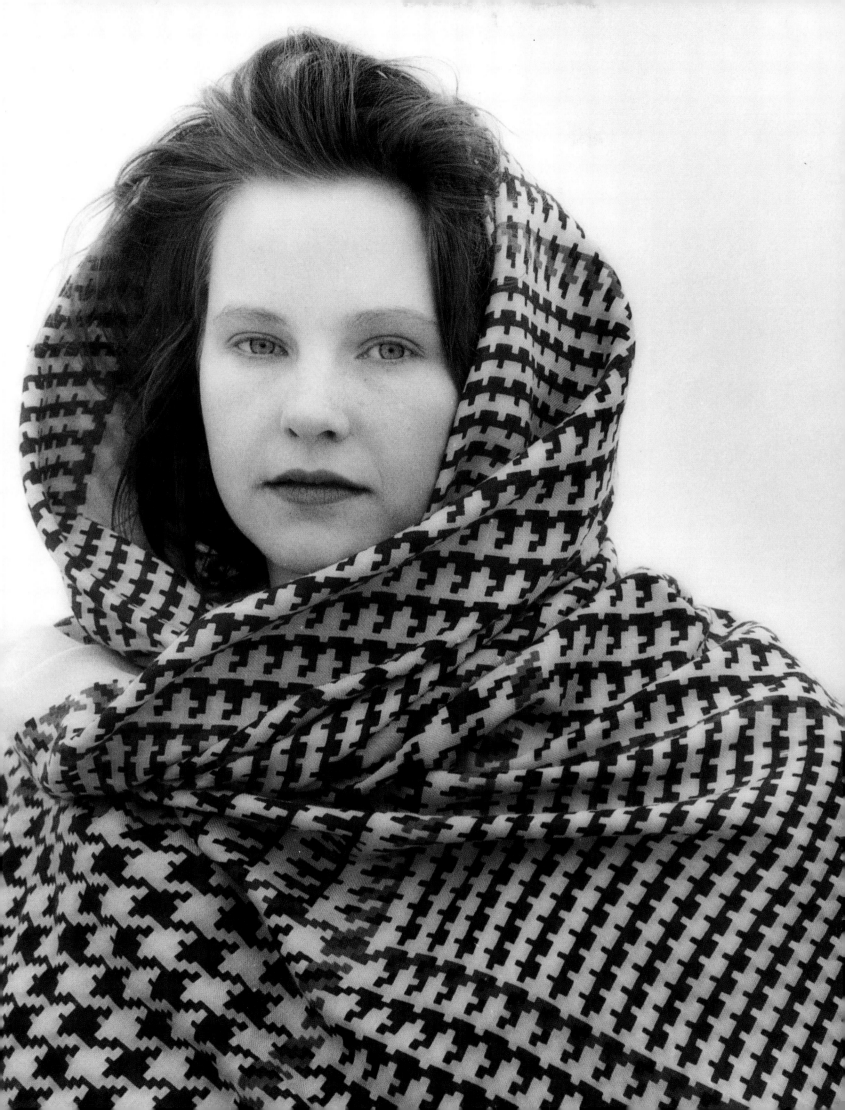

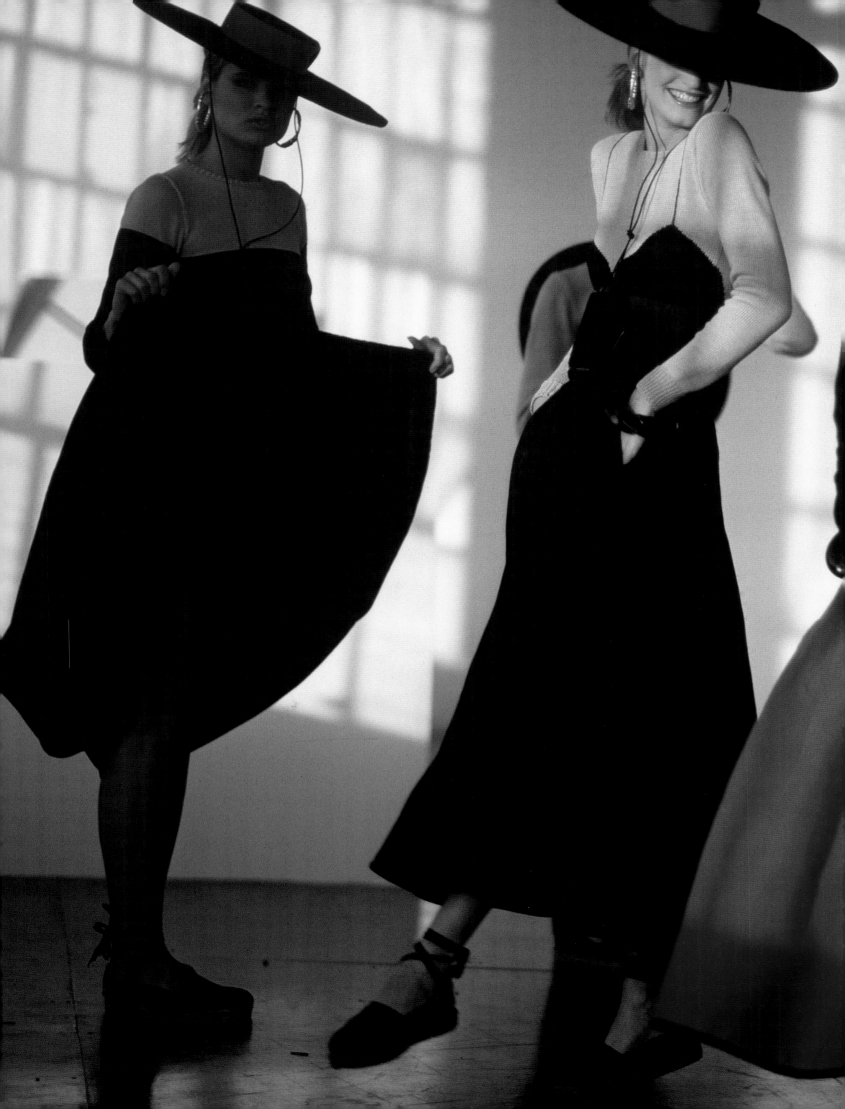

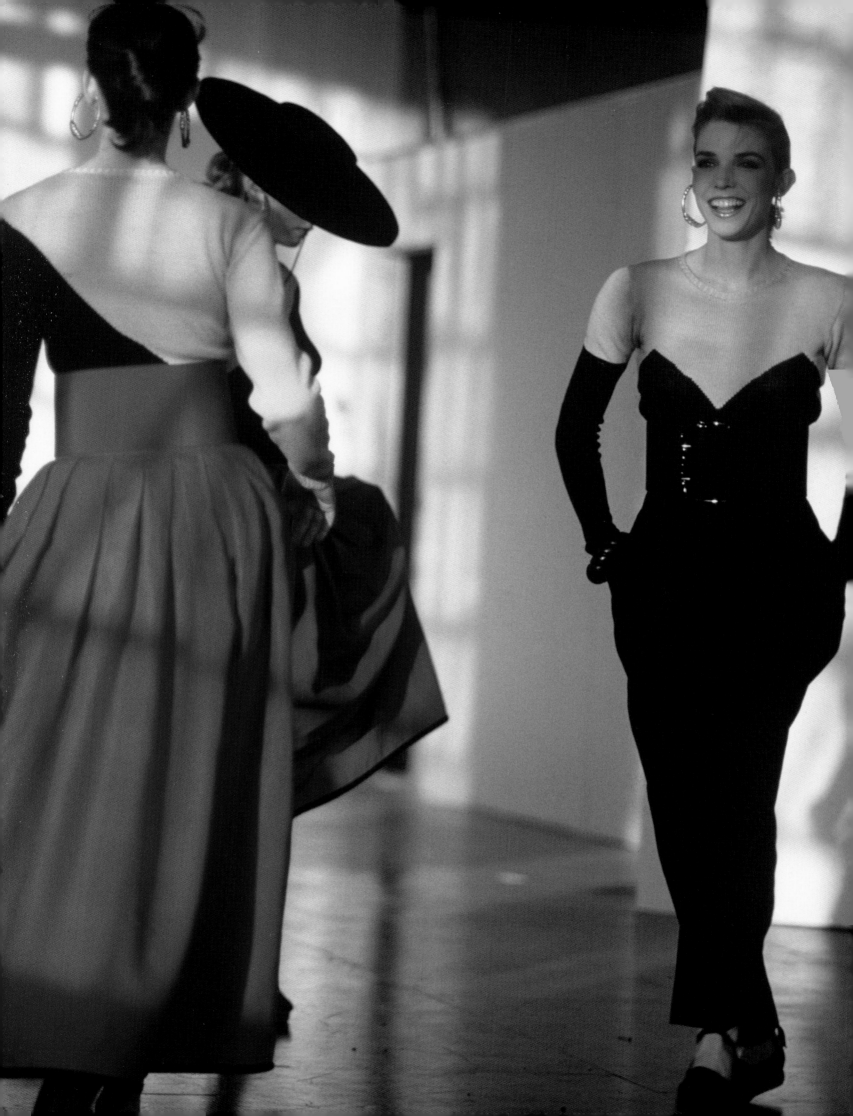

Hemingway, and Isabella Rossellini; and given his increasingly popular mens-wear, a roster of jocks showed up to cheer: professional hockey players Barry Beck, Ron Greschner, and a couple of their teammates. This time *Women's Wear Daily* conferred four stars upon the designer for his work, and called it "his best, most well-rounded collection ever and the most original looking of the season."[22] His two women's collections and men's collection earned two more Coty Awards; earlier in the year he had earned a CFDA Award for his men's wear, as well as the Cutty Sark Men's Fashion Award for Most Outstanding U.S. Designer. No other American fashion designer had ever garnered so many awards in a single year.

Previous pages: From Perry's "España" collection, a fiesta of black, white, yellow, and red high-waisted, cinched, full-skirted shapes, and exquisite flat-brimmed hats designed by Patricia Underwood. Spring/ Summer 1983. Photograph by Arthur Elgort.

Opposite: Fall/ Winter 1983.

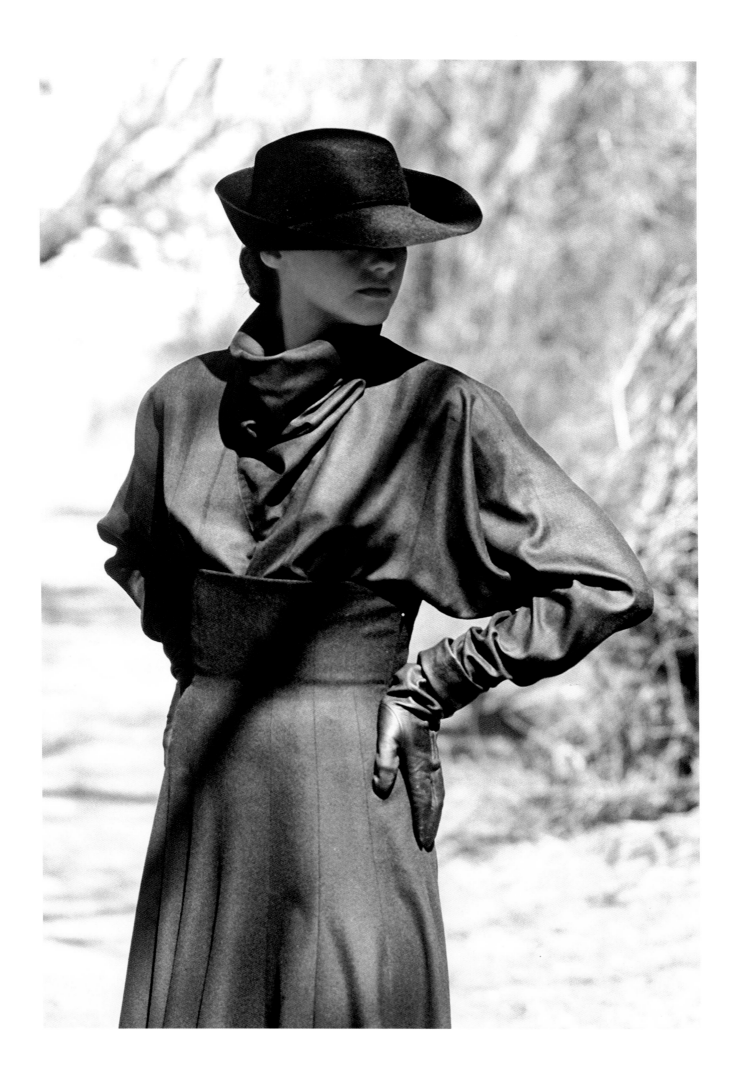

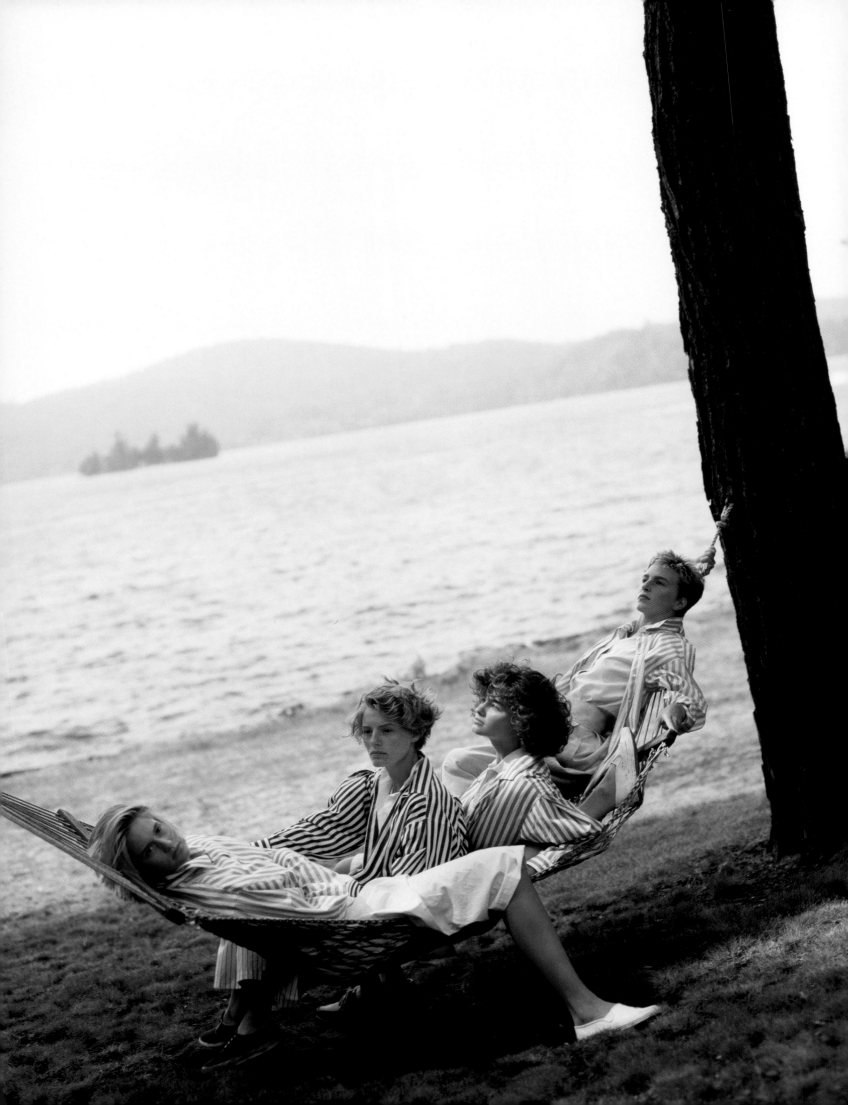

"I think Perry captured something about America: what we love about ourselves and what people love about us. He drew upon the natural and organic, knew what was real about clothes, and seemed to always represent our core values. There was a youthful quality to his designs: they weren't necessarily big on sex appeal, but they were feminine without being sweet."

—Holly Brubach

Meanwhile, there were some major changes afoot at Perry Ellis. Erwin Isman had stepped down as president and was replaced by Ed Jones, who had been heading menswear and now became president and chief executive officer of the newly consolidated men's and women's apparel operations. Ed felt that, strategically, it was important that the new men's collection should debut as a "couture" operation (with expensive fabrics, tailoring, and high prices) in keeping with the Perry Ellis women's collection, even though it would initially lose money. To counter the initial money loss, he planned to introduce two lesser-priced men's and women's lines under the Portfolio label, which would cover the lower-end of the market. Manhattan Industries' Larry Leeds picked up the option to produce those two lines and also expressed his desire to produce a line of more casual clothes under Perry's label. As they were trying to work out timetables for the launching of these new collections, a once-in-a-lifetime opportunity presented itself, a veritable "offer you can't refuse." It would take some months before all the details were worked out, but it was so big that when it was announced in January 17, 1984, it made the front page of the *New York Times* financial section.

Perry had been contacted by Levi Strauss & Company, the jeans giant who had for a long time resisted the idea of putting a designer label on its clothes, only to change its mind. With the announcement of its licensing deal with Perry Ellis, Levi's was joining the growing ranks of retailers and manufacturers who realized they could help broaden their market by affixing someone else's name to the back pocket of their product. It sounded like a match made in Seventh (Avenue) Heaven: the youthful, exciting designer and the people who actually invented the original blue jeans. Perry would be designing a new line of active sportswear, including designer jeans, for one of the best-known manufacturing companies in America. "We have never done anything like this before," said Robert Haas, executive vice president and chief operating officer of Levi's, and the great-great-grandnephew of the founder, Levi Strauss, explaining that the deal was unusual in the retail world because all the garments will carry both the Levi and Perry Ellis names. Haas added, "It's one of the few examples where the manufacturer's name will be given equal prominence to the designer's name."[23]

Presenting casual sports clothing, the Perry Ellis America 1984 collection, in collaboration with Levi Strauss. Photograph by Bruce Weber.

According to the pact, Perry was given control of design, advertising, and distribution; for Levi's part, it enabled them to expand and upgrade a line of its sportswear and reduce its reliance on jeans and work clothes. The deal was also to include the creation of a separate company called Perry Ellis America to design active sportswear for men, women, and children. Laughlin, a champion negotiator, had hit the ball out of the park.

In September, the opening of the new 8,000-square-foot showroom on the twenty-first floor of 575 Seventh Avenue took place. At the last minute, Perry, the perfectionist, took issue with the concrete floor of the terrace where the party took place, so he hauled in truckloads of pricey sod to supply the grassy setting he felt his casual clothes required. The walls had been hung with Bruce Weber's gorgeous photographs of healthy girls and guys in their Perry Ellis America shirts, jeans, and sweaters, hanging out in idyllic lakeside settings. The clothes incorporated some of Perry's signature details: dimpled shoulders, giant stripes, khakis, unique proportions. But there was a big problem: this was "designer" sportswear, bearing designer price tags. It was all way too expensive for the mass-market customer the clothes were meant to reach.

The Perry Ellis America collaboration with Levi Strauss & Company, which should have been the licensing deal to end all licensing deals, was more bust than blockbuster, never living up to its huge potential, partly because the line was vastly overpriced, and partly because Perry insisted on limiting distribution to the three hundred stores where he already had accounts—not by any means a big enough base to launch to the mass-market.

In their haste to proceed with their new licensing strategies, Perry and Laughlin had made a critical error in judgment, simultaneously saturating the market with three distinctly different price levels of Perry Ellis merchandise for men and women: Collection, Portfolio, and Perry Ellis America. Needless to say, it was hard enough for the consumer to comprehend two vastly different prices for what appeared to be the same designer shirt, let alone three. Jones revealed later that he was certain all of the Perry Ellis collections would have succeeded individually if Perry and Laughlin had been more patient and spaced out the launches over a longer period of time.

While the relationship between Perry and Manhattan Industries continued to be fractious, Laughlin was busy developing a brilliant new licensing agreement between Perry Ellis International and Visions Stern, a Paris-based perfume company, for the rights to Perry Ellis fragrances and cosmetics for men and women. This was a huge deal both for Perry and for Manhattan Industries, as cosmetics and fragrances easily have the potential to earn large profits for designers whose names are on their product, even if the design companies are losing money on their fashion collections. The deal came at a propitious time and helped smooth over the contentiousness between Perry Ellis and his parent company.

Below: Perry Ellis's eponymous original fragrances launched in 1985 by Parfums Stern offered a leathery, smoky scent for men, and a floral, woodsy scent for women. The perfumes were both packaged in handsome bottles resembling mini-flasks. Photograph by Sheila Metzner.

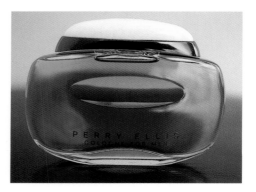

PERRY ELLIS

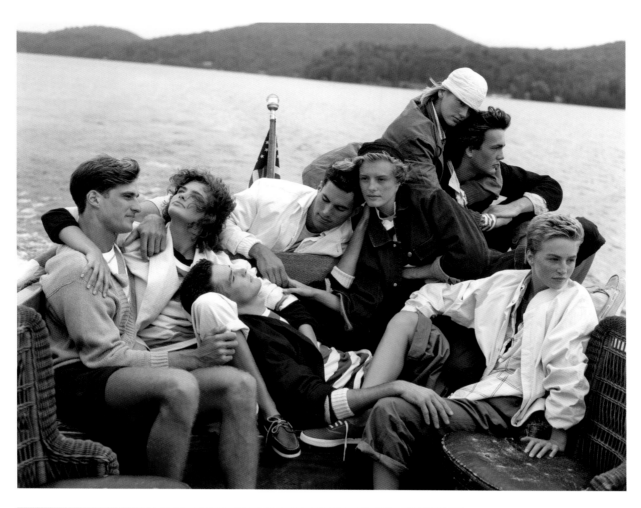
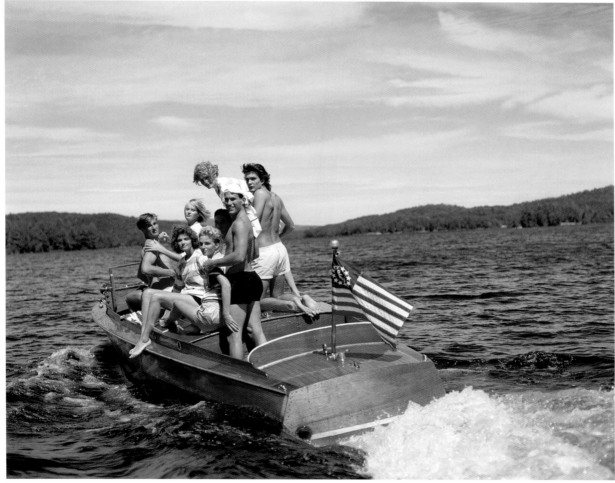

Perry continued to create beautiful, sophisticated clothes, work on growing his business, mentor his students at the Parsons School of Design, and devote time to charitable pursuits. When summer arrived, he and Laughlin spent most of their time at their house on Water Island while Perry's design staff traveled back and forth from New York to Water Island on Perry's Cessna 206 khaki-striped seaplane (with khaki interior), in order to meet with him during the week. Perry had informed everyone that he and Laughlin were staying out there because their new townhouse was still under construction, but there was another, more serious reason: Laughlin had been suffering from a series of health problems and needed lots of rest.

Back in town after a peaceful summer, Perry started working on his Spring 1984 collection. The designer had fallen under the spell of the Australian Outback's wide open spaces and sunburned earth colors, which inspired a palette that ranged from desert sand to deep terra cotta. After all the earth tones, Perry turned the second part of the show into a sailing regatta with lots of nautical and nice navy and white stripes and dots. The enthusiastic audience was peppered with the usual actresses, plus newcomer Terri Garr, not-so-new but fun Carol Channing, and Ron and Doria Reagan, who had met Perry when he designed their clothes for President Reagan's inaugural.

Perry had always seemed concerned with leaving a legacy. It turned out that he and Barbara Gallagher, a singularly lovely lady whom he had met in the late 1960s through his friend Robert McDonald, had each talked over the years about how much they wanted to have a child. Barbara had been very involved in her career as a producer and screenwriter in New York City and Los Angeles, and as she approached forty the issue of having a child became more urgent. Perry and Barbara were revisiting the topic one night as they had dinner at Michael Chow's when Perry asked, "How about it?" They agreed to have artificial insemination performed in February 1984.

Perry was buoyed up by his impending fatherhood and poured all his energy into the two shows he presented for Fall 1984: the first, in March for the new Portfolio line, which garnered positive reviews; and the second, for his women's and men's designer collection on May 3. Vangelis's sweeping soundtrack from the 1983 movie *Antarctica* was the introduction to the collection, an homage to the brilliant Russian-French abstract artist, Sonia Delaunay, whose Art Deco paintings Perry admired. The show was a work of art in itself, demonstrating extraordinary design creativity and craftsmanship, and the audience loved it. The lone negative review of the show came from *Women's Wear Daily,* which gratuitously criticized almost everything in the collection from its "dowdy" shapes to its "wan" colors, ending it with the zinger that one retailer found it "old-fashioned" looking, "like a bunch of old refugees getting off the boat."[24] As was his custom, however, Perry let the nasty review roll off his back, saying about the show, "Darling, I loved it. I did it for me, not for them."[25] But, in fact, he was deeply disappointed for his team, who had expended so much talent

Navy and white regatta stripes from the "Australia" collection. Spring/ Summer 1984. Photograph by Roxanne Lowit.

and effort in creating the Delaunay collection; he sat down and wrote notes to each of them, assuring them that he was incredibly proud of them and that it had been his favorite collection ever—and, in fact, the collection went on to earn Perry his eighth Coty Award that year.

As summer neared, Perry had made plans to spend the entire summer with Laughlin at Water Island, so he insisted that his staff shuttle back and forth most days to meet with him and keep him abreast of the day-to-day business. There were few weekend guests and little entertaining. By this time, Laughlin had become ill with what was believed at the time to be shingles (but was actually the early signs of AIDS), so their business was conducted indoors.

The return to the city in the fall energized Perry: his new Perry Ellis America collection was debuting early in September and he and his team were already hard at work on their Spring 1985 show. Perry was definitely in a California state of mind. His baby was due to be born in Los Angeles in the middle of November 1984, likely inspiring his choice of a Hollywood theme for his Spring 1985 collection, which was scheduled at about the same time.

Ten days after Perry's show, on November 16, 1984, Tyler Alexandra Gallagher Ellis, a blonde, blue-eyed baby girl was born, with proud dad Perry present at the delivery. It was a joyous experience for both parents, and even his employees remarked that fatherhood had made Perry a different person: so much happier, friendlier, and more open. He couldn't stop talking about his child.

As positive a year as 1984 had been for Perry, it ended with some unhappy news when Ed Jones, who had been an exceptionally resourceful CEO of Perry Ellis International, announced that he was leaving to start a business of his own. He had accomplished exactly what he had envisioned: growing the collections as well as the Portfolio divisions, and creating, from the ground up, a first-rate, well-organized structure for all of them. But Perry was out of the office more than ever, flying back and forth to California to visit Tyler and spending time with Laughlin, who was undergoing chemotherapy for Kaposi's sarcoma, one of the manifestations of AIDS. By the beginning of 1985, Laughlin was in the hospital more often than not. As Perry and Laughlin's absences from the office grew more frequent, it was clear that Perry's first priority was his commitment to "being there" for Laughlin. To Perry, maintaining his and Laughlin's privacy took precedence over everything, even his business.

Perry *did* devote a lot of time during this period to the Council of Fashion Designers of America, of which he had been elected president in April of 1984. The organization had been founded in 1963 as a nonprofit to support and promote fashion design as a branch of American art and culture. Under the direction of designer Bill Blass in 1981, they had initiated an awards program to compete with the Cotys. When Perry was elected, he galvanized the loosely knit Seventh Avenue design establishment to forge closer relationships in order to help carry

74

PERRY ELLIS

out their good work. It was the first time that the organization had a young president who could envision the extraordinary potential that the CFDA possessed.

Perry revolutionized the CFDA, taking charge of every element of its annual event and turning it into a much bigger deal. He transformed what had been a low-key luncheon event into a glamorous, Oscar-worthy evening, raising ticket prices, changing the venue to the elegant white-marbled Astor Hall at the New York Public Library, and hiring the chicest caterer in town. He added some hip new award categories for non-designers who had contributed significantly to the world of fashion, like photographer Bruce Weber and former *Vogue* editor-in-chief, Diana Vreeland, who had just penned her autobiography, entitled *D.V.* The following year, Perry was reelected president for a second year and made up his mind that they would snare actress Katharine Hepburn to honor her with

a Lifetime Achievement Award as an inspiration, especially because she popularized the notion of women wearing pants. Perry and Robert Raymond, the CFDA's executive director, pleaded, cajoled, and sent flowers and notes to her and still got a "no." After one last note, she finally invited Raymond to meet with her at her Turtle Bay house, where they looked at her old photos and chatted, and somehow he charmed the ultra-reclusive Hepburn into appearing at the event to accept an award. Hepburn's appearance at the CFDA ceremony would be an enormous coup for the CFDA and a priceless fashion moment.

But the job was not all about glamour. In the two years that Perry served as president, he changed the tenor of the CFDA, promoting inclusivity, increasing membership, and recruiting new designers, particularly women. Hat designer Patricia Underwood was thrilled when Perry asked her to join the board of the organization: "It made me finally feel that I was accepted in the design community," she said.[26] Esteemed designer Stan Herman had been reeling off into businesses other than Seventh Avenue when Perry invited him to become a board member. Herman recalls, "That one call simply elevated my status among my peers."[27] (Eventually Herman did such a good job on the board, he himself was elected as CFDA president and remained at the helm for sixteen years.)

The year leading up to the 1985 awards ceremony, which would be held in January of 1986, was the toughest of Perry's life. He had spent most of his time caring for his beloved companion, Laughlin, who was terribly ill, and Perry himself was not well at all—he also had contracted AIDS, which was a closely guarded secret from even his closest friends. But the energy that he devoted to the preparations for the CFDA evening, his attention to the minutest detail, buoyed him and, according to Raymond as he later reflected on that difficult time, kept him alive for an extra year. (In fact, despite his serious illness, the CFDA thought so highly of Perry that shortly before he died, they reelected him him president for a third term, in recognition of his contributions.)

Perry's romantic Fall 1985 collection had a rich Renaissance theme, with Titian-inspired colors, poetic shapes, and an emphasis on short lengths. His soft side-draped, single-buttoned jersey jacket over slim pants was totally modern, while it simultaneously conjured up the look of a medieval page. Unfortunately, the show was not terribly well-received by the retailers or the press. Laughlin who had not been seen for months appeared backstage at the show, and it was clear from his appearance that he couldn't continue to work much longer.

Perry began to spend less and less time in the office, and suppliers and licensees were becoming justifiably nervous as to whether the business would continue. He did remain involved with the forthcoming collection, however, and had Patricia and Jed bring the items they were working on to his house, so they could look at them together. Perry spent most of his waking hours with Laughlin, making certain that he received the best possible care. Christine Barker, one of Laughlin's sisters, a young actress who was living in New York, also stayed at the house and played a supportive role.

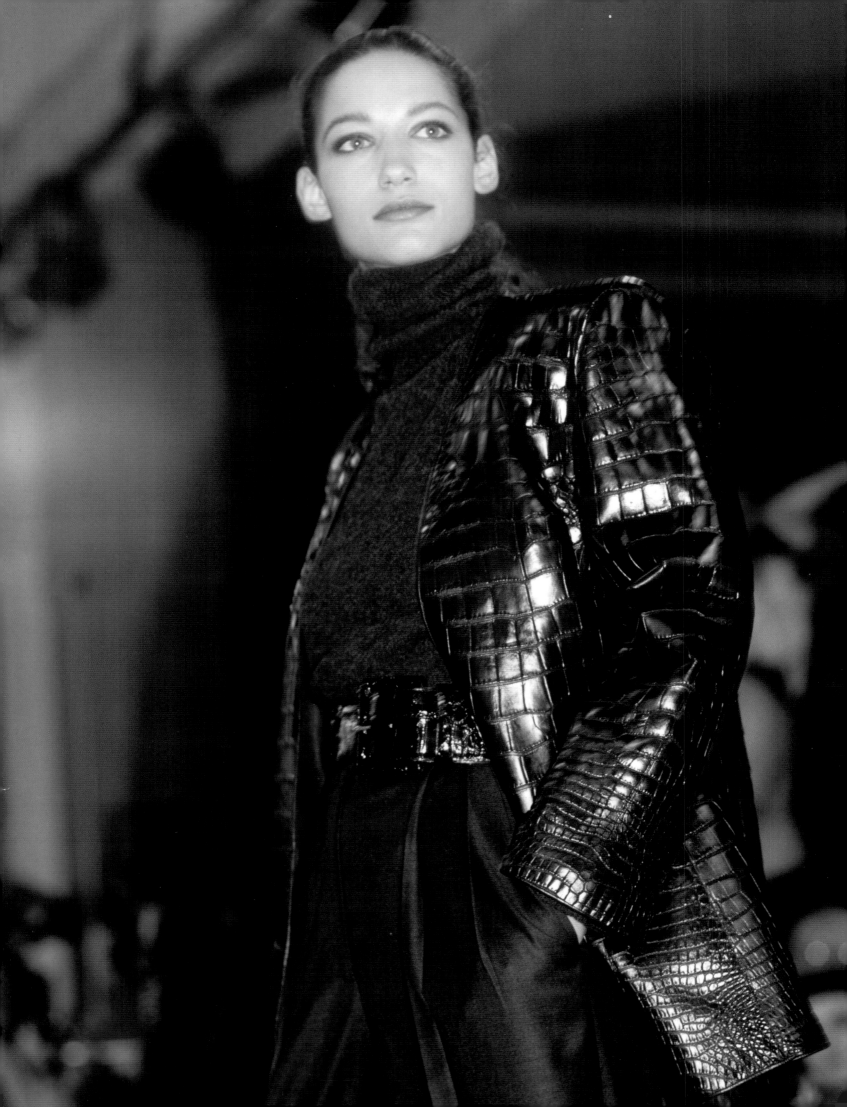

Throughout all this, there was the collection to be completed and a Spring 1986 show to be mounted for November. It seemed logical, since Perry was spending most of his time in his new townhouse, that he would be inspired by its exquisite interiors. He had amassed a superb collection of Chinese export and Wedgewood porcelain and it was these that inspired him to design an Oriental-themed collection, in shades of china blue, emerald, rose, and indigo in addition to black and white.

When Perry walked the runway with model Elle McPherson to take a bow after the show, the audience was stunned to see a gaunt, pale, middle-aged-looking man with thinning gray hair, wearing horn-rimmed glasses and an oversized red sweater as if to disguise himself. The designer, who had always looked years younger than he was, had lost a lot of weight and aged frightfully in the last six months, and people finally realized that there was something really wrong with Perry, too.

Laughlin was brought home for the Christmas holidays and died on January 2 (the official, stated cause was lung cancer). A memorial service was held for him at the New York Public Library on January 10, and while a chair was held for Perry, he was so grief-stricken that he was unable to bring himself to attend.

Several weeks following Laughlin's death, on January 19, 1986, Perry made a herculean effort to perform his duties as master of ceremonies at the 1985 awards ceremony for the CFDA, at the New York Public Library. His friend, Robert McDonald, helped him up to the podium, and as he started to speak, the audience of his peers burst into thunderous applause, cheering and shouting. Acknowledging the ovation, he went on to say, "My name is Perry Ellis and I'm resident of the Council of Fashion Designers, and I'm delighted to be here tonight." Then, gathering himself, he continued, "I can't tell you how much it means."

Designer Calvin Klein presented the award to Katharine Hepburn, and Perry, appearing somewhat disoriented, continued emceeing, but somewhat shakily, as McDonald helped him on and off the stage. It was a painful evening for everyone, most of all Perry, who was distressed that people had seen him in his weakened condition, as he had so carefully tried to mask his illness from everyone.

There was a brief period when he appeared to be feeling much better, during which Perry looked healthier and even traveled and gave interviews. He and Robert McDonald flew out to Los Angeles to spend a couple of weeks with Barbara Gallagher and the baby, Tyler, and Perry managed to gain twelve pounds and a tan. It is believed that he was in a state of remission. Returning to New York, he certainly looked much better and actually did an interview with *Women's Wear Daily* entitled "Perry Looks Ahead" where he expressed an exceedingly optimistic view of the future for his company. *WWD*, perhaps with an understanding of his state of health, was gracious enough to use an

Matte black collarless crocodile sports jacket over a charcoal cashmere turtleneck, complete with crocodile belt and cropped charcoal worsted pants. Fall/ Winter 1986.

old photograph of him to accompany the piece. The remission was not to last, however, and he became very sick again.

Nevertheless, with the help of McDonald and Raymond, he bravely willed himself to show up at the American Foundation for AIDS Research benefit at the Javits Center in April. Astonishingly, it was the first time that the fashion industry, which had lost a disproportionate number of its own to AIDS during the previous four years, had acknowledged the problem as a group. Even so, a number of designers had declined to participate until Calvin Klein agreed to offer his support. Calvin arrived at the amfAR event with a beaming Elizabeth Taylor, who was the foundation's national spokesperson and angel, guaranteeing the vast amount of press coverage they needed to create more awareness of the disease.

Dressed in black tie, with his beloved camel coat draped over his thin shoulders, Perry was supported on either side by McDonald and Raymond, who were literally holding him up. Very few people approached him. As Raymond recalls, "It was incredibly sad. He was very sick and everyone ignored him. Almost no one came up and spoke, as people were so afraid of the sickness and so uninformed about how it was communicated."[28] Perry's close friends felt that by showing up that night, he was making a statement. He was too private a person to have made an announcement or even to have shared the news with his staff, so this was the way he acknowledged that he was suffering from the very disease they had all gathered to fight: it was an heroic gesture.

As frail as he was, Perry somehow managed to push himself to appear at his office for a few hours each week to help oversee the new fall collection, "He was driving everybody crazy again," said Patricia Pastor, his first assistant, fondly.[29] To everyone's surprise, he decided to show up for the show itself, arriving via the freight elevator so none of the press would see him. He sat on a stool backstage and watched the whole thing via a two-way mirror.

The Fall 1986 show, known as "The Pale Fall," was textbook Perry; it was one of the most winning collections he and his team had ever produced. Starting with the upbeat notes of George Gershwin's "'S Wonderful," it encompassed all the elements anyone could want from Perry: the lean and clean lines, the tongue-in-cheek attitude, the luxurious fabrics, and his perfectly proportioned shapes.

At show's end, all the models came out on stage, clapping and waving, and Perry came out, too, but instead of skipping down the runway, as had been his custom, he could not walk unaided and had to be supported by Patricia Pastor and Jed Krascella, his two devoted assistants. The audience, seeing him, was shocked and after a moment, stood up as one and applauded, with tears coursing down their cheeks. "There was a real surge of emotion," said Perry's menswear designer Brian Bubb, "and Perry just wanted to move toward it, to grab it. We had to pull him back because he couldn't make it. Finally we had to tell him, 'Okay, Perry, okay. It's time to go.'"[30]

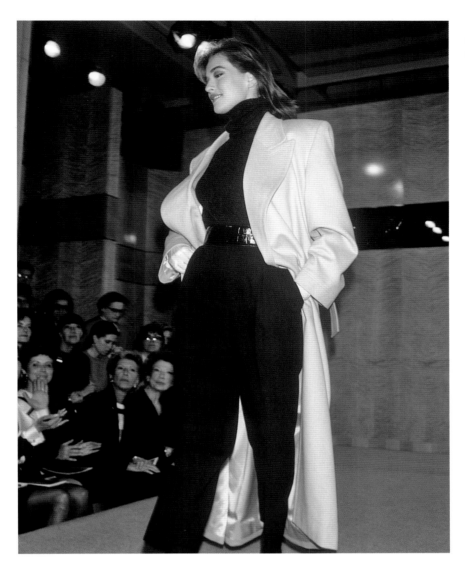

Perry's beautifully man-
nered, pale-pink cashmere
ankle-grazing coat for his
"Seven Sisters" collection.
Fall/ Winter 1986.

Perry went home immediately thereafter, picked up his clothes, and was taken
to New York Hospital. He fell into a coma two weeks later and died eight days
after that on May 30. The cause of death was listed as viral encephalitis. He
was forty-six years old.

Viral encephalitis is a virus that a healthy person can fend off under normal con-
ditions. Perry died of AIDS, which destroys the immune system of the body,
leaving it completely vulnerable. AIDS research pioneer and Founding Chairman
of amFAR, Dr. Mathilde Krim recalled: "The treatment of people with AIDS by
the public in the 1980s was cruel. Of course, nowadays, we can diminish the
effect of the disease through new drug therapies, but in those early days, you
had to fight both the physical disease and the public's perception that it was
an immoral disease. It is difficult, however, to place moral judgement on the
people who ostracized those with AIDS because there was such rampant fear
prevalent then." [31] Today, thanks to D. Krim and many, many others, AIDS is not
necessarily a death sentence. If Perry had contracted the disease just a few
years later, he might well have continued to design, no doubt still "looking at
things differently."

Patricia Pastor assumed the lead at Perry Ellis, and having been mentored by Perry for ten years, she made the transition seamlessly, explaining that "we learned a lot from Perry—that's why I'm not afraid to carry on without him." Jed Krascella took a few months off to devote to studying drama at Oxford, but as promised, returned in the fall to help plan the Spring 1987 collection. They both felt they owed it to Perry, whose spirit always hovered "like a guardian angel."[32]

By the time the 1986 CFDA Awards ceremony took place in January 1987, Perry had been dead for six months and a new award had been established in his honor. The Perry Ellis Award for New Fashion Talent was bestowed upon twenty-five-year-old designer Marc Jacobs, his former "mentee" at Parsons. Three years later, Jacobs was to become head designer of Perry Ellis.

Perry and his daughter, Tyler Alexandra Gallagher Ellis, 1985.

PERRY'S WORLD

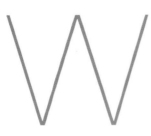hat he wanted in his life, it seemed, was to create a Perry-sphere where everyone was committed to him and his vision of a life devoted to perfect, understated taste. Surrounding himself with talented and attractive people, he had the ability to "turn employees into loyal friends and friends into loyal employees,"[1] thereby providing himself with a strong support system and a network of impenetrable privacy.

Perry was both insightful and opportunistic: he could zoom in on the essence of someone to determine what they had to offer. If a person was talented, hard-working, and loyal, he was willing to give them any opportunity. There was a charismatic quality to Perry: a compelling blend of gentlemanly charm, bright, intelligent eyes, and a soft, low, Virginia-inflected voice that attracted men and women alike.

James Terrell, who was studying architecture at Yale when Perry had first met him, was a partner at an architectural firm in New York when Perry engaged his services. High-spirited and handsome, James renovated both of Perry's town-houses and the impressive Seventh Avenue showroom that helped create the prototypical Perry image—modern and polished, luxurious in scale and materials, and beautifully nuanced. James was Perry's best friend, period. The two of them had a deep friendship based on a certain sense of taste, appreciation for the finer things in life, a respect for great design in all arenas, and a passion for living a wonderful, full life.

There were two women whose personalities and personal style captured Perry's attention. Lynn Kohlman, who started modeling for Perry in 1978, was one of them. She became part of Perry's "family," joining him for quiet dinners at home, weekends on Water Island, even traveling with him and Laughlin on their first trip to Russia. Tina Chow was Perry's other favorite. She was an icon of her time to so many in the fashion world, but her relationship with Perry went much deeper. Mr. Chow was a favorite restaurant of Perry's, and Tina was its perfect hostess. Both she and Perry had the gift of making those they were with feel as if they were the only people in the world that mattered. Their ability to captivate people set them apart from others.

Carrie Donovan (or "La Donovan" as she was fondly known in Perry's office), the influential and rather grand fashion editor of the *New York Times Magazine*,

was also part of Perry's inner circle. Perry adored and respected Donovan, and they would frequently see each other in New York or at his house on Water Island, where she might spend a week or so during the summer. Donovan loved Perry's irrepressible sense of humor and style and appreciated his hospitality; a strong believer in his talent, she was an astute adviser and perfect sounding board for the designer, supporting his talent with pages of gorgeous color fashion spreads in the *Times* Sunday magazines and the seasonal *Fashions of the Times.*

Another journalist member of Perry's posse was Pamela Altman Brown, an editor at *Daily News Record* (Fairchild Publications' men's equivalent of *Women's Wear Daily*), who first bonded with Perry in 1976 when she met him on the beach at Menemsha Pond in Martha's Vineyard. Altman (whom Perry nicknamed "Prunella") recalled, "We were all long-haired hippies, sharing a joint, eating lobster and enjoying a beautiful sunset together. We both knew some of the same people in the fashion business, some of whom Perry eventually hired, like Ed Jones, Ernesto Aguirre, and David Rosensweig. That all helped to forge a relationship, but beyond that, I sensed a kindred spirit in Perry."[2]

Perry worked closely with Patricia Ashley at John Meyer of Norwich, and they remained good friends afterwards. He always credited her with teaching him about the beauty of khaki, beige, and the "spectrum" of all neutrals. Throughout the late 1970s and early 1980s, Perry, James Terrell, and Patricia Ashley would go to Europe to attend Interstoff and then vacation together.

William Smith was an old friend of Perry's from Virginia. He would visit with Perry from time to time, bringing him glorious antique rugs that he had selected for Perry's home. When Perry and Laughlin bought the house on West 70th Street, William was the overseer for all work that was done, and he lived in the front bedroom on the ground floor. He was also one of the few people that Perry would trust in matters like antiques, home, and giant projects—and this is saying something, as we know how demanding Perry was.

After Perry met Laughlin, he got to know Laughlin's family, especially his sister, Christine Barker, then a sparkling young actress, who became a good friend and frequent guest. Perry was very fond of her, saying she was like a young Gwen Verdon. She was in *Chorus Line* playing Cassie at the time.

Perry not only cultivated meaningful personal relationships but professional ones, as well. Bobbi Queen, Perry's editor at *WWD* at the time, recalls, "I think for Perry, friends were a combination of genuine affection and no benefits. In terms of business, I would say he made wise and considered choices."[3] He was exceedingly generous and knew how to cater to the press, spending hours entertaining and hosting fashion editors, even gifting them with clothes from his collections. Once, when Bernadine Morris, fashion editor of the *New York Times*, wrote a lukewarm review of his collection, he sent her flowers along with a note of apology for "disappointing" her.[4]

Perry shared his life with James Terrell (left, circa 1979), and James made Perry's homes his oases. Although their individual tastes could not have been more different (Perry had a classic sense of style, while James was all twentieth-century modern), James was the perfect person to design Perry's surroundings, from the antique-filled duplex in the brownstone on the West Side and the showroom and offices on Seventh Avenue, to his final home, a four-story townhouse where the entire back of the building was enclosed in glass to house the stairway and make a home for Perry's collection of orchids. They shared each other's success and were there for each other through thick and thin. But most important, James made Perry laugh like no one else. To be with the two of them was to share in the pure joy of life lived to its absolute fullest.

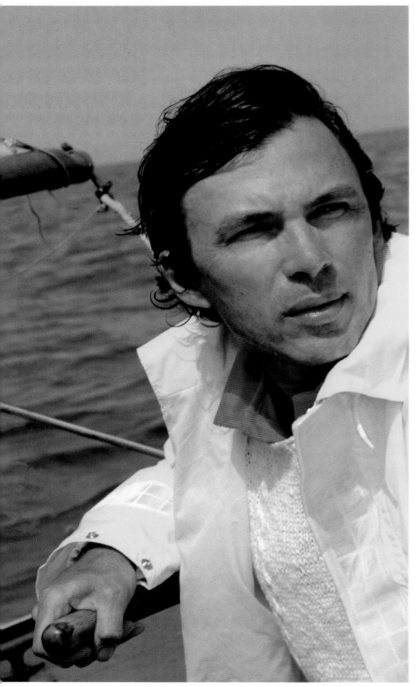

Perry (left); his seaplane and boat at the end of the dock. Water Island, New York, 1983.

Perry and pals at Water Island: Left to right, Joe D'Urso, Edward Caracci, Chester Weinberg, and Perry. Circa 1978.

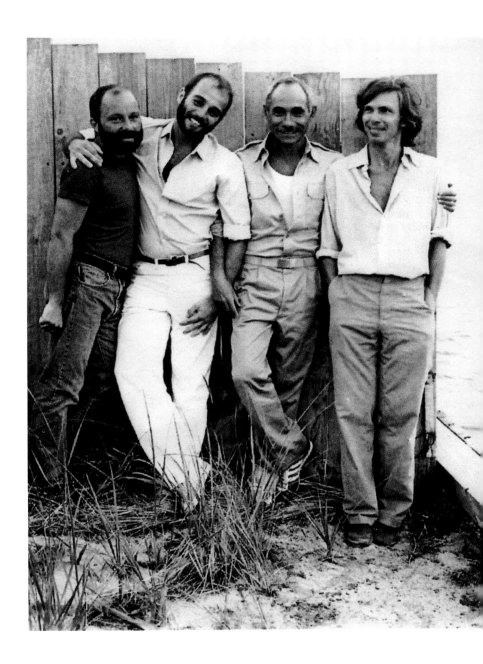

Perry's most loyal friend was Robert McDonald (left), a tall Scottish Canadian with blond good looks, who was working in television when he and Perry met at Expo 67 in Montreal. Soon thereafter, he moved to New York to share a rented townhouse with Perry at 57 West 69th Street, which the designer ultimately purchased. They lived there as companions for at least six years and continued, as platonic friends, to share the house for several years after that. It was McDonald who introduced Perry to his lovely friend, Barbara Gallagher, who was later to become the mother of Perry's daughter, Tyler. And toward the end, when Laughlin Barker, Perry's beloved companion and president of Perry Ellis International, became very ill, it was the loyal "McD" again who took charge of the business at Perry's request, knowing little about the company other than that his friend was desperate for his help.

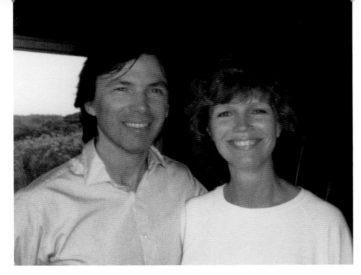

Above: Perry and Barbara
Gallagher (his dear friend
and mother of their daugh-
ter, Tyler), 1984.

Right: the splendid isolation
of Perry's Water Island
house, with views of the
bay and the ocean.

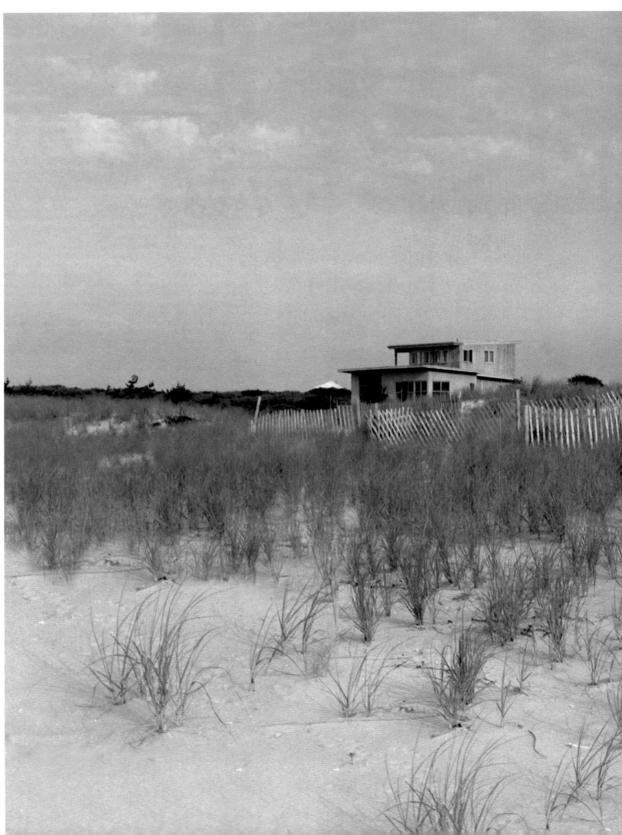

Perry's friendship with Tina Chow (left) rose out of a deep, mutual respect. Tina never wore Perry's clothing, as she was much more of a Chanel or vintage couture woman, and Perry respected her unique sense of style. Before each of Perry's runway shows, Tina would pick a day and call Perry in the morning to say she would be sending over lunch. At midday, a large basket would arrive filled with all of his favorites from her restaurant, Beijing duck, gambei, crispy beef, dumplings, and more, and he would happily devour all before going back to hours of work. Photograph by Roxanne Lowit.

Perry's Cessna 206 seaplane with customized khaki stripe. Water Island, New York, 1983.

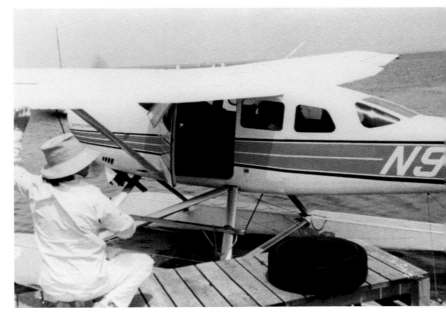

President and Mrs. Ronald Reagan celebrate Christmas at the White House with son, Ron, and daughter-in-law, Doria, both wearing Perry Ellis, 1983.

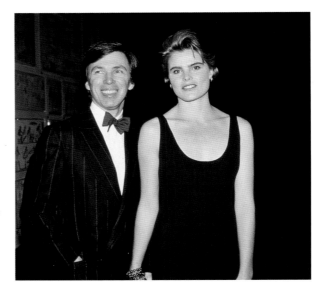

Perry and his friend, actress Mariel Hemingway, at The Metropolitan Museum's Costume Institute Ball in 1983. Photograph by Roxanne Lowit.

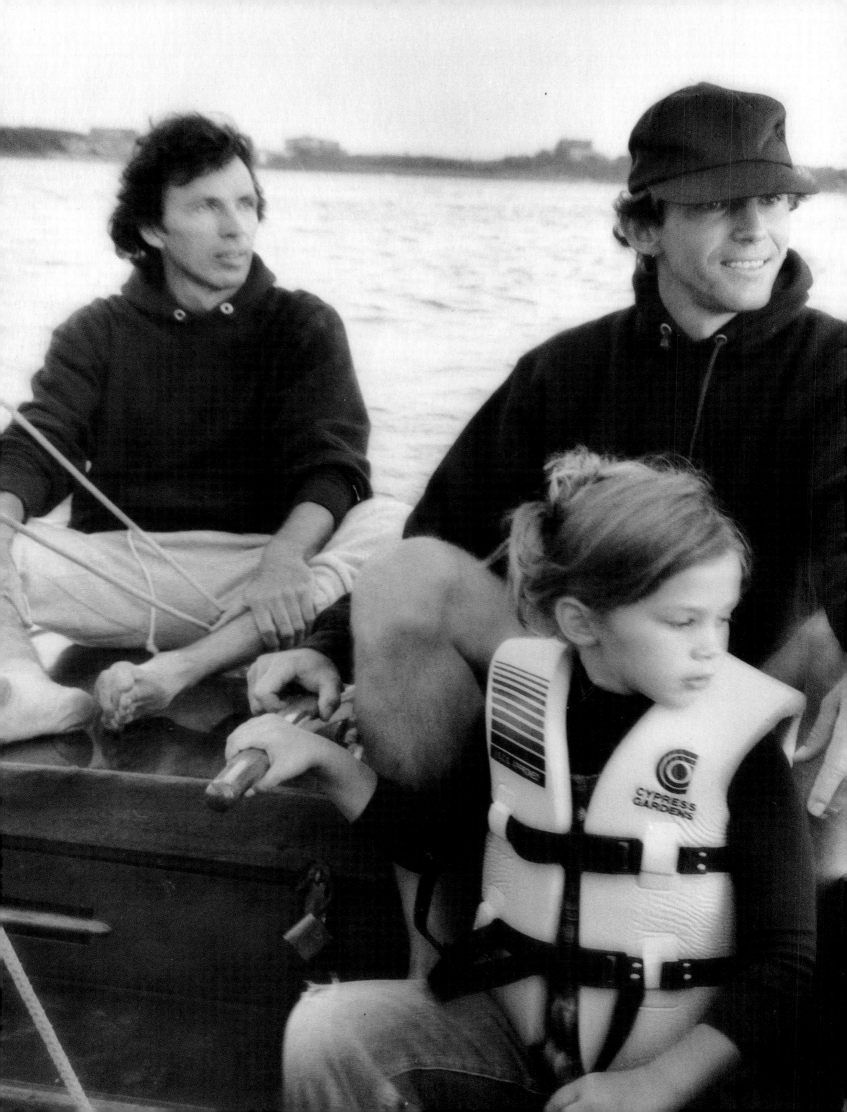

According to one of his oldest friends, Perry was a born "schmoozer," powerfully persuasive, but in a charming, southern-gentlemanly way. His handwritten notes to friends, editors, assistants—anyone who was meaningful to him—were legendary.

––––––––––

"Being with Perry and my dad [Laughlin] was wonderful: they really doted on me, and I loved spending time with them both and going out to Water Island. My birthday is in July and for my tenth birthday, Perry decided to organize a birthday party at the beach for me. They invited everyone on Water Island that had a kid to this party but then Perry, ever the foodie, served steamed artichokes and some kind of fish as the party meal. Hardly the usual fare of a ten-year-old's birthday party!

I remember one day in Water Island when I was photographed in a coat from Perry's girls' collection for an advertisement. I really liked the coat, but I was very annoyed when I was told not to smile for the picture. Perry had had a lunch set up on the beach for the crew doing the shoot and just as I was about to reach for something, my father said, "Sorry, Kate, no lunch for you today—you're modeling." I didn't know if he was joking or not.

The thing I liked best was that during those idyllic summers, my dad and Perry both treated me in some ways like a small adult.

Perry had a brown and white Brittany spaniel named Josh. I loved that dog. I had a black and white springer spaniel named Gibby. The only communication I had from Perry after my dad died was in the form of a very sweet letter he sent me, which I still have. It was framed as though Josh had written it to Gibby, saying that while he [Josh] hated Perry's stinky feet, he licked them anyway. But most of all, he missed Gibby.

— KATE (BARKER) ROMM

––––––––––

When I first started working for Perry, he generously invited me to join him for weekends at the house he rented in the Pines on Fire Island. It was a lovely home that was completely fenced in, and once we arrived we rarely left until Tea Dance on Sunday afternoon. Time was spent relaxing by the pool, sunning, playing backgammon, and reading. James [Terrell] would cook wonderful meals (soft-shell crabs were a favorite), and occasionally a friend or two would join us for dinner. When he purchased the little "Bay house" (as it was called) on Water Island, it was generally the three of us on weekends, as there were only two bedrooms. Water Island itself was very quiet—no scene there. In the late afternoon, Perry loved to take a walk along the beach with his Brittany spaniel, Lily, and James's Doberman, Guinevere. As always, James would cook, and my job was to set the table while Perry had cleanup duty; he ended each evening washing the dishes. We would usually turn in early, as Perry was an early

Perry, Laughlin Barker, and Laughlin's daughter, Kate Barker, heading out for a sail in the bay. Water Island, New York, 1981.

riser and loved to lounge around in the morning on the deck drinking tea in the blue-and-white printed cotton kimono he'd pinched from the Hotel Okura on one of our trips to Japan.

Later, when he was able to purchase the adjacent "Ocean house," the "Bay house" was used for guests. Carrie Donovan, Tina Chow, and assorted friends would stay there, and "family" would stay with Perry. By this time (around 1980), Laughlin had become part of his life and time away from work involved more entertaining. He now employed someone to cook and clean, but the comfort of staying at his home never changed. He would spend extended time there, and Jed and I would be flown out on his seaplane with bags of work that we would spread out on the deck. He was a generous host and knew when to set the work aside to allow us to enjoy with him the solitude the beach had to offer.

As for parties, most were get-togethers with dear friends. After dinner in his home at Christmas, he would present Jed and me with our gifts, sitting in front of the fire in the parlor. New Year's Eve in his home included never-ending champagne and caviar. He was the perfect host, making you feel totally comfortable in his home, sharing all he loved with you. This special quality was shown to all when he became president of the CFDA. The first event he hosted was in the New York Public Library, where he served chicken potpie and promised all they would be home in time to watch "Masterpiece Theatre" later that night. He knew all the rules of good entertaining but, more importantly (as in his design), he knew how to bend or even break them to create unique experiences for the people around him.

By far the most important thing in his life was the birth of his daughter, Tyler. Perry always spoke of wanting to have a child. He would teasingly ask the model Tree to have his baby, as he loved her red hair so! When Tyler was born, Perry was a natural at fatherhood. He would walk around the design room with her on his shoulder with a cloth diaper to protect his Oxford shirt from her drool. During fittings, he would cross his long legs and place her in the crook of his knee where she would lay or sleep as the work went on. His desire to have a child was honest and real, and when she arrived it was a dream come true for him.

Perry truly believed his mantra, "Fashion is low on my list of priorities—first comes love, then family and friends," and he lived his life true to that. Being with a loved one and good friends and then his real family, sharing laughter and great food, surrounded by the people and things he loved was what he lived for.

Losing Perry was hard for me—he was my mentor and friend and I owe him so much for the person I am today. In that dark time, the one truth I knew more than anything was that he lived a special life completely true to himself, enjoying every day to its fullest. Although it was not long enough for those of us lucky to be a part of it, I'm sure he would say he had no regrets.

— PATRICIA PASTOR

Perry was just enormous fun to be with. He had such a unique sense of "the event"—turning the most mundane of circumstances into something more than memorable. He had a warm, devoted circle of friends who must have felt the same way as I did. I felt at home with him as soon as I met him. Perry loved laughing. We all had such a similar, shared sense of humor—I could set him off with a couple of well-placed words. And I was not alone here, many did! Especially James [Terrell] . . . my God, he could make Perry laugh.

Perry simply loved mad behavior—in manner and speech and style and dress—and he encouraged it in all of us. I can't tell you how many times he told me to "give a performance!" at one dinner or another. This was, at the end of the day, our way of relieving tension. We would pause anything for a laugh . . . and then resume. This laughter was our drug, and it showed in the work.

He really was a marvelous host. As soon as you crossed the threshold of one of his houses, he was just really gracious—turned the work stuff right off and went into high-host gear. The total Southern-gentleman-at-home come to life, he was the real thing. Perry loved having a small group over. The champagne was served to you in his ancient Napoleonic flutes, the pasta was tossed with caviar or white truffles or some such extravagance, the china was his beloved white Wedgwood, the linens were perfectly starched and plain white, the flowers were fragrant and profuse, the serving pieces were from his collection of Chinese export porcelain and English Derby (which he loved). And all this with us dressed in the most casual stuff . . . an unusual juxtaposition, in retrospect.

The show parties were great. In the early years they were always at his home for a select few—not a big, noisy press party by any stretch of the imagination, ten to twelve people at most . . . friends, Patricia, me. Quite intimate but so much laughter, such fun. We would watch the unedited videotape of the show together, eat, drink.

We had dinners together, every night in those early years. Perry always paid. Always. Even when you weren't there, he'd phone ahead and pick up the bill, often sending champagne. A few times I was taking friends or family out for a celebration and was just gobsmacked when I was not allowed to pay the bill.

I remember dinners at his house when his mother cooked us Southern food—marvelous, perfection—his Brittany spaniels by our feet. Later on, I remember a few cocktail parties thrown by Perry and Laughlin for Christmas, with bartenders and a full complement of caterers, but always this simplicity under huge quality and larger gestures, but so casual against all the eighteenth-century furniture.

On Water Island, Perry was just so relaxed—he loved the beach. We would always go to the bay side for a cocktail at sunset, and we would all watch it together.

—JED KRASCELLA

Design Process

"It's a team effort." —Perry Ellis

Perry Ellis always acknowledged that his design process was a collaborative one, the result of his working side by side with a hand-picked team of his own, originating ideas and experimenting, refining, and translating them into wondrously imaginative clothes.

With an exacting eye for talent, Perry hired his two principal assistants straight out of Parsons School of Design: first Patricia Pastor, with whom he built the early foundation of his business and, two years later, when things started to take off, Jed Krascella. Gifted designers and problem solvers with an infinite capacity for work, both were about twenty-two when they met Perry and neither of them had ever held a design job before (or, for that matter, a real job of any kind).

Yet, within a short period of time, the team developed such a harmonious working relationship that they were able to practically intuit one another's thoughts. George Malkemus, president of Manolo Blahnik USA, who produced Manolo shoes for a number of Perry's shows, recalls, "I had never seen anything like the way Perry, Patricia, and Jed worked together. It was as though they communicated by osmosis."[1] When Perry began his acceptance speeches for his eight Coty Awards and four Council of Fashion Designers of America Awards, he never once failed to begin with the plural: "We are honored to receive . . . " or "My assistants, Patricia Pastor and Jed Krascella, and I . . ." As time went on, he would even insist that Patricia and Jed take bows with him at the end of a show—a gesture that was unheard of at the time.

From the beginning, Perry had a vision of a working environment that was open to new ideas. Fittingly, his showroom space was set up as an open plan, with the team sitting at a long table, shoulder to shoulder, allowing a constant exchange and natural cross-pollination of ideas. Later, when they expanded their space and their staff at 575 Seventh Avenue, Perry, Patricia, and Jed had separate offices but still worked out in an open, communal space. Each designer had a huge mobile bulletin board on which work-in-progress would be pinned up so anyone walking by could take it in: everyone was part of the free flow of ideas. Perry was also a wonderful catalyst, urging his assistants to buy reference books and to travel, sending them anywhere just "to look around" and see with "clear and curious eyes" and bring back ideas.[2] Yet while Perry would always solicit his assistants' opinions, he reserved the right to make all final decisions.

Perry himself was particularly adept at visualizing ideas, selecting sample fabrics, and determining which fabrics would be bought and how they would be

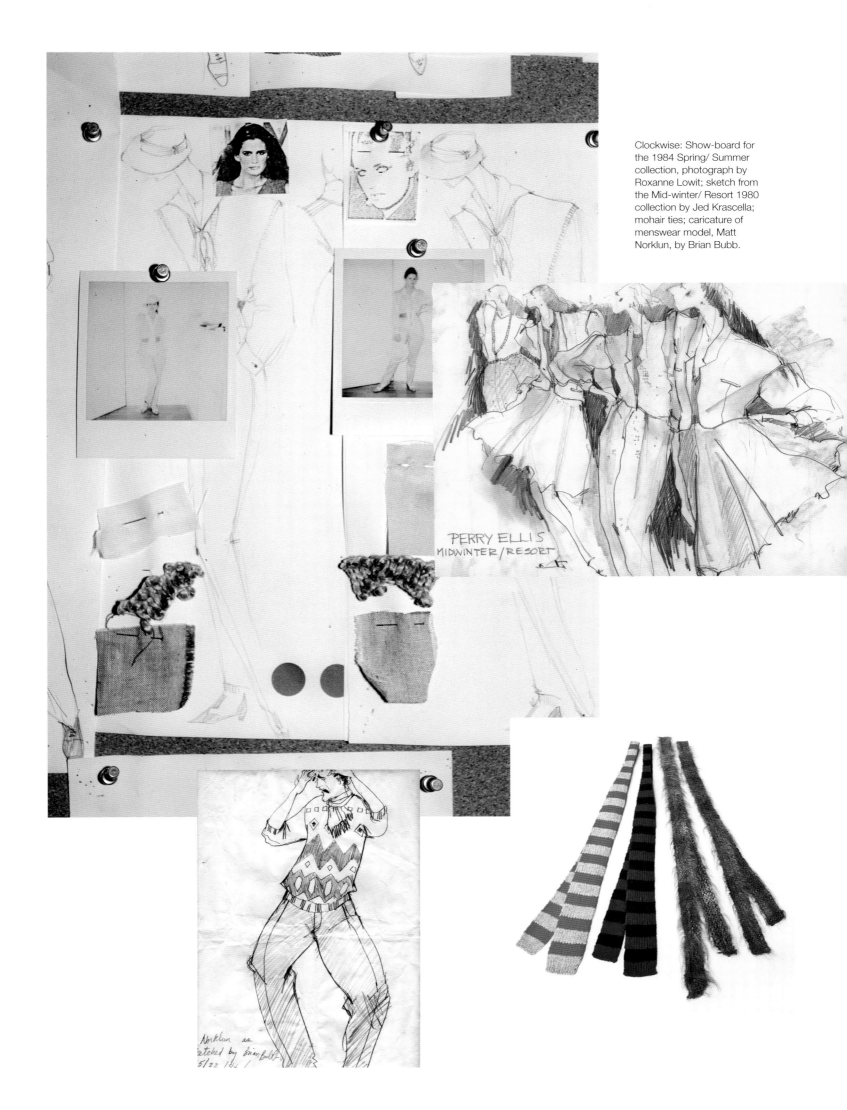

Clockwise: Show-board for the 1984 Spring/ Summer collection, photograph by Roxanne Lowit; sketch from the Mid-winter/ Resort 1980 collection by Jed Krascella; mohair ties; caricature of menswear model, Matt Norklun, by Brian Bubb.

PERRY ELLIS
MIDWINTER/RESORT

purposed. He would sometimes spend hours in front of the mirror, draped in fabrics, wrapping them around his body, and visualizing the way they could be used. At times, his assistants would join him, swathing themselves in the luxurious linens and wools, sticking feathers in the fabric, and letting their imaginations fly.

The team knew a lot about designing, but not a great deal about the processes that were required to produce a collection. In the end, this collective lack of knowledge served them well, motivating them to devise their own modus operandi as they went along. Because they didn't know the rules, they had no preconceived notions about how something should—or shouldn't—be done. Everything was possible!

In an interview with John Duka of the *New York Times,* in early 1982, Perry attempted to describe his team's design process:

"I start with the fabric; it is the inspiration. We select it four months before our show at places like the Interstoff Show in Frankfurt. Then we experiment with it when it arrives. It's a team effort. . . . We work off a backbone of ideas and designs that we have been kicking around. Then two months before our show, after I've digested the previous collection and I know what's selling, we sit and talk. We discuss what was successful the season before, we philosophize, we joke. It's an emotional process. We ask ourselves what we *feel is* interesting. Then we all sketch; we play with proportions. Out of that come four or five shapes, and then we narrow it down to two."[3]

Everything in the collection was presented as a totality: jacket, sweater, skirt, hat, belt, legwear, shoes—the entire look. Only when the whole outfit was together would they construct a pattern and develop more ideas. The fittings were done in muslin, but Perry was not interested in seeing anything until it was done in the real fabric that would be used for the garment—an expensive way of working that has now become cost prohibitive. Once something was approved by Perry, Jed would get the nod to do the final sketch. Jed always drew the same chic, attenuated mannequin whom Perry had, for some reason, dubbed "Dogface." Dogface became part of their team, and Perry would speak of her as though she were a real model: "What if we give Dogface long gloves with this? Don't you think Dogface should have a hat here?"[4] Together the team would attend all fittings for prototypes and looks, and all fittings for production. During the process, the chief of the sample room would show Perry every style on the mannequin to elicit his input. Perry *insisted* on seeing everything.

Finally, Perry, Patricia, and Jed would create "looks" and special "showpieces." They would design the order of the show and put it up on the boards. Then they would begin to pick it apart: outfit by outfit, group by group, item by item. Perry would be very specific: "I really need some gray flannel here. Go find it!" Or "We have only fashion pants—we need some basic pants here." He never forgot his training as a merchandiser: it equipped him with the knowledge to build a collection the way few designers did. He and his team literally worked from the business side on out.

Each of the assistants brought special talents and interests to the team: Patricia, for example, contributed her passion for vintage fashion, often wearing some of her finds to the office: a jacket with an interesting sleeve, a skirt with a clever inverted pleat—elements that they would dissect and sometimes use in the context of a collection they were working on. Having grown up in Connecticut, Jed brought his vast knowledge of preppy Americana, as well as fashion and theater history. He was a walking repository of design references. When Perry, with his insatiable desire to try something different, wanted to improve on the shape of his big-shouldered jackets, Jed would be the one to suggest that they examine the fashions of Adrian, a Hollywood designer of the 1930s and '40s, whose extended but graceful shoulders in his clothing were particularly well engineered.

The team was relentless in challenging themselves to find new ways to transform shapes. They would study a classic blazer and think, "How can we broaden the shoulder without adding a shoulder pad? Maybe we could drop the shoulder and add a reverse pleat? Or maybe we could extend the width of the shoulder on a blouse by adding a ruffle at the shoulder seam?" They would sketch a dozen different ways to play with drawstrings: one to nip in the waist of a dress; another, five inches lower, to create narrowness at the hip; a third to lift the hem of a skirt. Everything was explored.

Patricia and Jed were very adept at sketching, but Perry drew very little. At one point, however, he decided he wanted to learn to sketch and he called the esteemed *Women's Wear Daily* fashion illustrator, Kenneth Paul Block, to ask him if he might be willing to teach him. Block attempted to refer him to other teachers, but Perry persisted, so he graciously offered to give him a few lessons at Perry's townhouse. Block found Perry to be an eager student who was quick to grasp the major concepts of volume and line and space. The illustrator added, "It was clear he really meant to learn. . . . The only thing he resisted was homework."[5]

Perry was about sixteen years older than his assistants—old enough to be a leader, mentor, and "big brother," but still hip enough to relate to them. The relationship worked brilliantly: Perry brought to the party a great deal of knowledge, ideas, encouragement, generosity, and good judgment, which he happily shared with his team; Patricia and Jed brought their youth, energy, relentless intellectual curiosity, humor, and extraordinary design skills to help Perry realize his vision.

Nearly thirty years after their partnership with Perry ended, Jed and Patricia discussed the benefits of working in a collaborative way. "I think," said Jed, "if you're designing alone, you go straight ahead. If you're working with others, you take a more roundabout trip: the creative process may be longer and more complicated, but ultimately, having developed via different sensibilities, the result is more successful."[6]

Fabrics, Textures, Prints

"Perry's great gift . . . was his horrifying elitism and snobbery about fabric. He loved fabric and would insist on using only the best."
—Isaac Mizrahi

Perry's fascination with fabric can be traced back to his early years. In a 1979 *Vogue* interview with Holly Brubach, when the designer was reminiscing about his early childhood in Virginia, he alluded to the cool and comfortable fabric that he wore: "Among my most vivid memories was how absolutely wonderful it was being dressed in clean cotton and linen pants and shirt, how all of that felt in the summer. . . ."[1] During his years as a buyer he had begun to learn about quality fabrics and later, under the tutelage of his boss, John Meyer, who had been schooled as a textile engineer, he gained firsthand experience by going to mills and learning techniques used in dyeing and printing.

Fabric was the genesis of Perry's design process. Looking at fabric and touching it—the coolly elegant linens, the nubby Irish tweeds, the richly patterned Italian wools—was almost a religious experience for him. He would reverently pick up a sample of fine Braghenti linen or Etro silk or wool, running his fingers along it, feeling its weight, getting a sense of how it might hang or gather, billow or drape. Counter to the way that designers traditionally worked—starting with an idea or sketch and then moving on to the fabric—with Perry, "nothing was really designed until the fabric came in," remembered Carol Lawler, who worked in Perry's merchandising department. "Especially in the women's sportswear, with, say, the plaids, the size of the plaid would determine the actual silhouette of the garment. That's backwards from the way everybody else works, but it was wonderful because the fabrics became such an intrinsic part of the garment. It meant that the garment was conceived as a whole."[2]

As Perry's designs grew in sophistication, so did the fabrics he used, although he remained true to the natural materials that he'd always doted upon. A self-described fabric snob, Perry insisted upon dealing almost exclusively with the finest, established European fabric houses, appreciative of the beauty and workmanship that went into their products. At first, Perry would shop fabric fairs; as time went on, he and his team developed close relationships with the manufacturers, many of them in Italy, who invited them to meet and work with their fabric designers, ultimately allowing them to design some of their own fabrics on site at the mills—an extraordinary privilege granted to few.

Gravitating toward the concepts of "oversized" and "overstatement," he created strong, bold, often outrageous designs, silhouettes, and proportions—and

"The Hunt" collection's collarless coat in berry, mustard, and brown awning stripe; billowing pants in wool twill; and short belted jacket. Fall/ Winter 1981. Sketch by Jed Krascella.

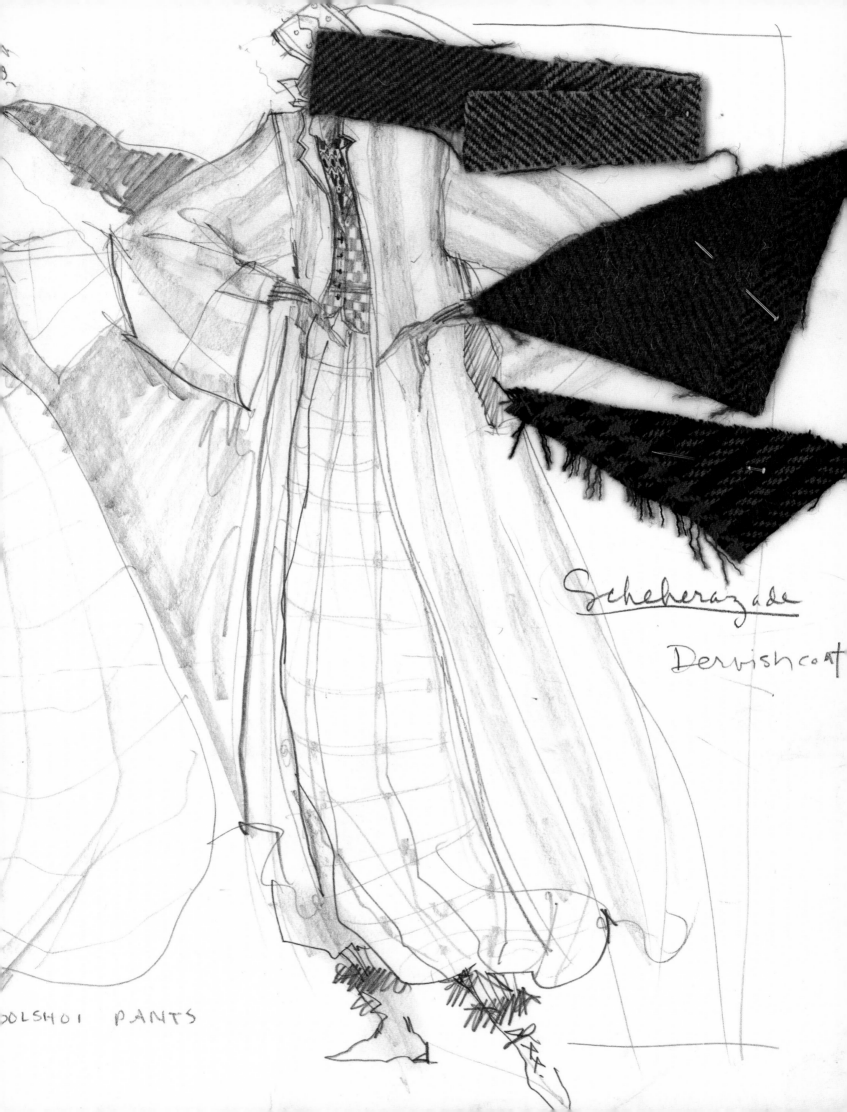

Scheherazade
Dervishcoat

BOLSHOI PANTS

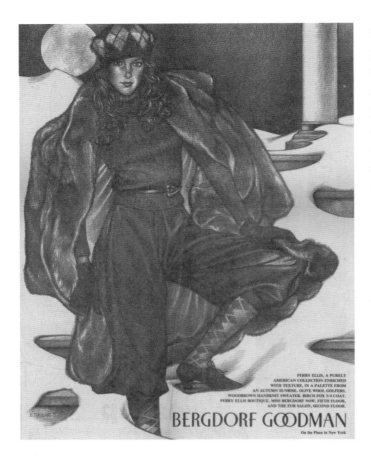

PERRY ELLIS, A PURELY
AMERICAN COLLECTION ENRICHED
WITH TEXTURE, IN A PALETTE FROM
AN AUTUMN SUNRISE. OLIVE WOOL GOLFERS.
WOODBROWN HANDKNIT SWEATER. BIRCH FOX 3/4 COAT.
PERRY ELLIS BOUTIQUE, MISS BERGDORF NOW, FIFTH FLOOR,
AND THE FUR SALON, SECOND FLOOR.

BERGDORF GOODMAN

On the Plaza in New York

the fabrics he chose always com-
plemented his choices. In his first
formal collection, Fall 1978, one
of Perry's biggest hits was an ele-
phant-gray overcoat: long, with
giant shoulder pads, made of thick,
wide-wale, upholstery-weight cor-
duroy, and looking for all the world
like a coat on steroids.

Perry was known for giving a
"twist" to the traditional, and never
more so than in his tweaking and
mixing of Irish tweeds. Working
with the McNutt Mills in Ireland's
County Donegal, he created new
combinations of tweed, season
after season. Not only did the col-
ors differ—from salt-and-pepper
river tweeds one season to multi-
colored rainbow tweeds the next—
but the weights of the fabric also
varied from light to heavy-duty. A
Perry Ellis look could easily be composed of a chill-proof McNutt tweed coat in
upholstery-weight wool, over a medium-weight tweed suit and a chunky tweed
turtleneck sweater, hand-knitted with McNutt's tweed-flecked yarn.

While he appreciated a wealth of different textures in his fabrics—soft, nubby,
brushed, smooth, linen-like, or lofty—Perry had never been keen on prints. He
did use a series of Liberty prints in one spring collection and he had always
loved plaids, but everyone knew Perry was not a "print" man. Then one day,
while shopping for fabric at Etro in Milan, Perry discovered a duck-printed wool
challis that he liked. Judy Beste, his savvy merchandising manager, was with
him, writing the sample book, when suddenly Perry started to toss one duck
print after another onto her lap, then some quail prints, then more duck prints,
until they were piled up almost to her shoulders. Patricia and Jed were sitting
there marveling, trying to fathom what he was up to. They finally did when Perry
pulled the fabrics all together into what was, in Beste's opinion, one of the best
collections Perry had ever done for fall: "That's why I say fabric gave him inspi-
ration. He saw something in that print that none of us saw, and then to com-
bine the prints the way he did—the blues, the reds, the greens—that was what
made him so special. Even Mr. Etro, who came in and saw the collection, was
overwhelmed. He told us he thought it was the best creative use of his fabric
that he could ever have dreamt of."[3]

Left: The *New York Times*
ran this Bergorf Goodman
advertisement of Perry's
Fall/ Winter 1981 medley:
birch fox three-quarters
coat over a wood brown
hand-knit turtleneck and
olive wool golfers. Illustra-
tion by George Stavrinos.

Opposite: Perry's marvel-
ous mismatches of ducks
and pheasants with flowers
and paisley prints in a
full-sleeved Cossack shirt,
swirling skirt over skirt. Fall/
Winter 1981. Photograph
by Rico Puhlmann.

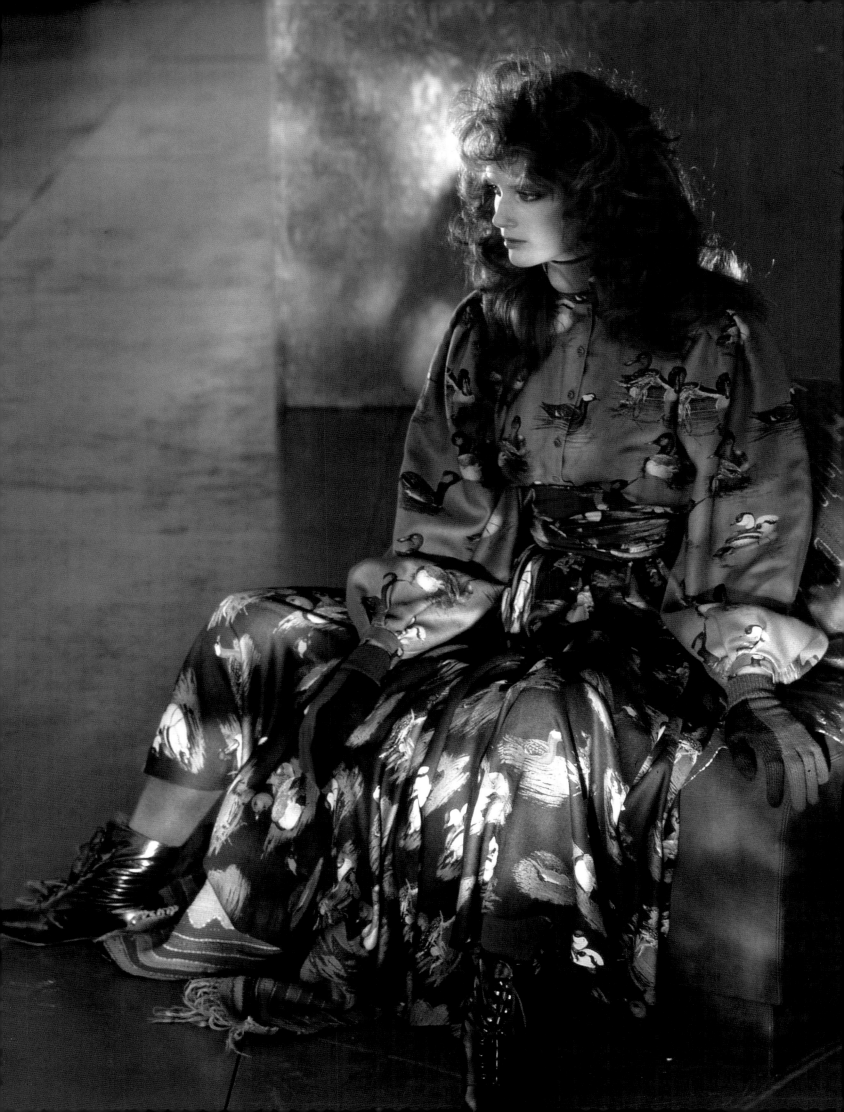

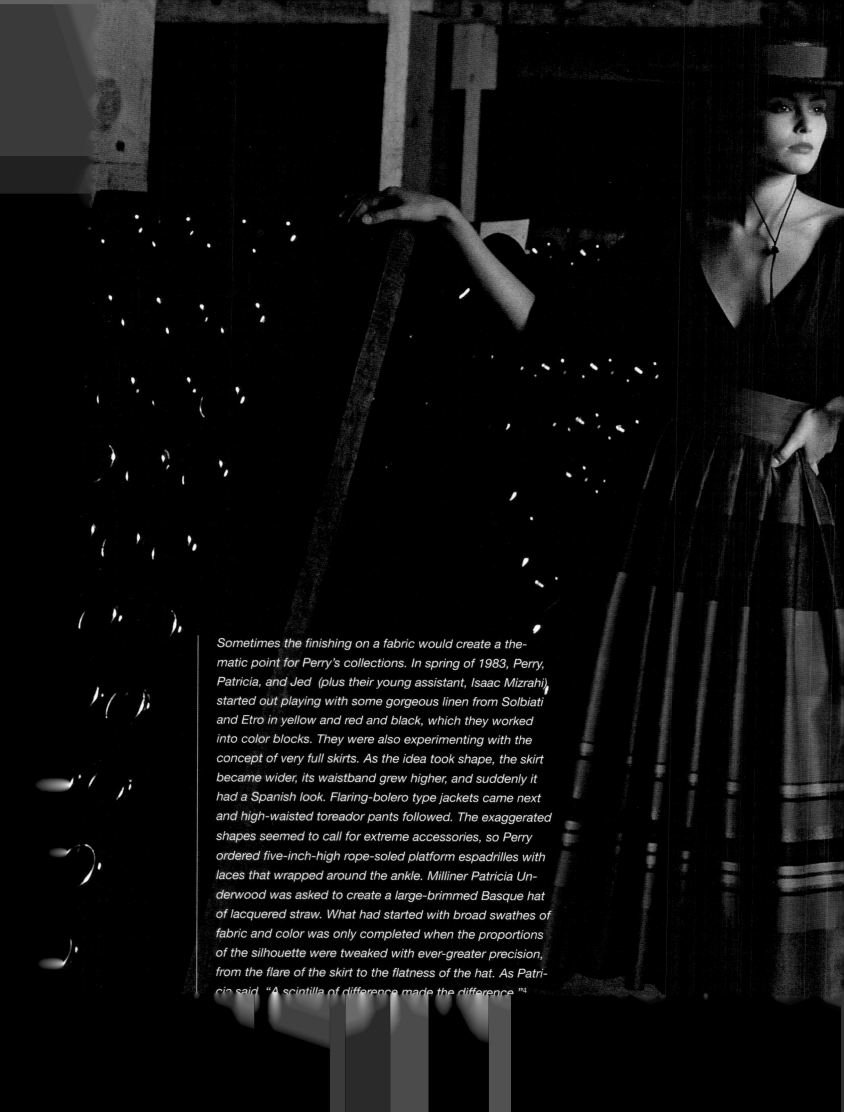

Sometimes the finishing on a fabric would create a thematic point for Perry's collections. In spring of 1983, Perry, Patricia, and Jed (plus their young assistant, Isaac Mizrahi) started out playing with some gorgeous linen from Solbiati and Etro in yellow and red and black, which they worked into color blocks. They were also experimenting with the concept of very full skirts. As the idea took shape, the skirt became wider, its waistband grew higher, and suddenly it had a Spanish look. Flaring-bolero type jackets came next and high-waisted toreador pants followed. The exaggerated shapes seemed to call for extreme accessories, so Perry ordered five-inch-high rope-soled platform espadrilles with laces that wrapped around the ankle. Milliner Patricia Underwood was asked to create a large-brimmed Basque hat of lacquered straw. What had started with broad swathes of fabric and color was only completed when the proportions of the silhouette were tweaked with ever-greater precision, from the flare of the skirt to the flatness of the hat. As Patricia said, "A scintilla of difference made the difference."[4]

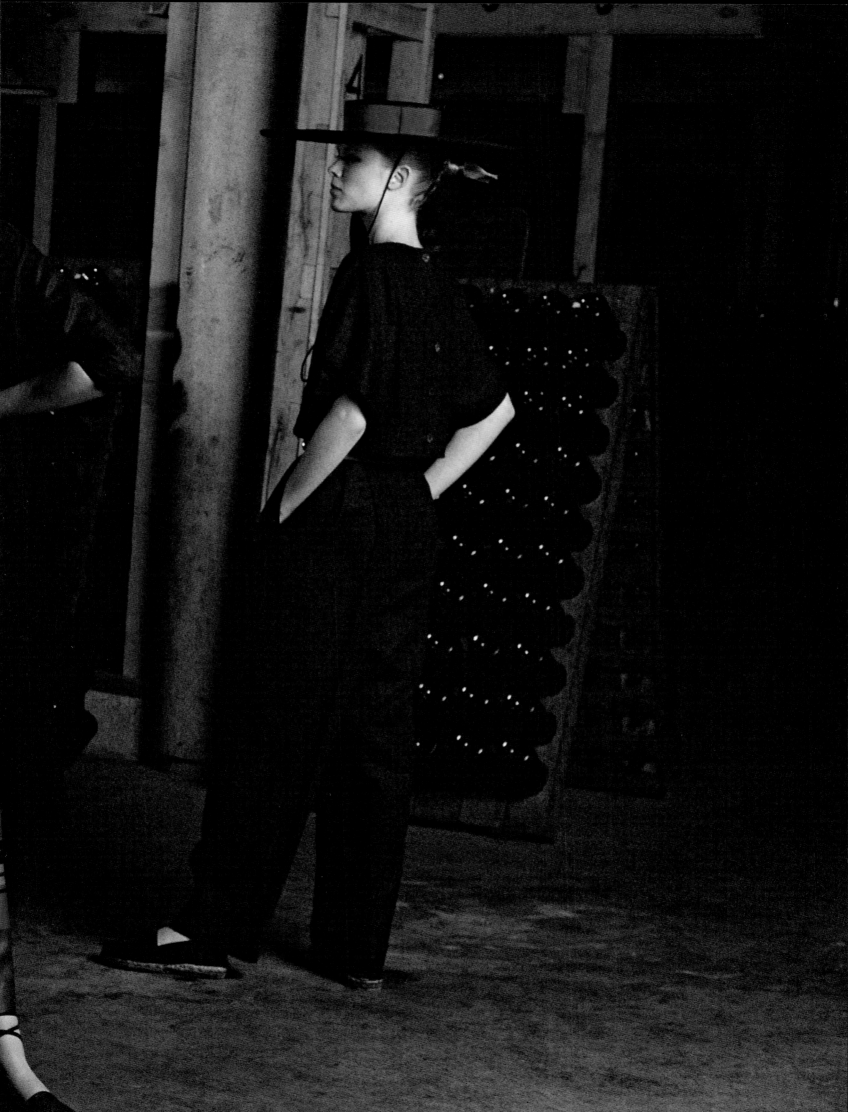

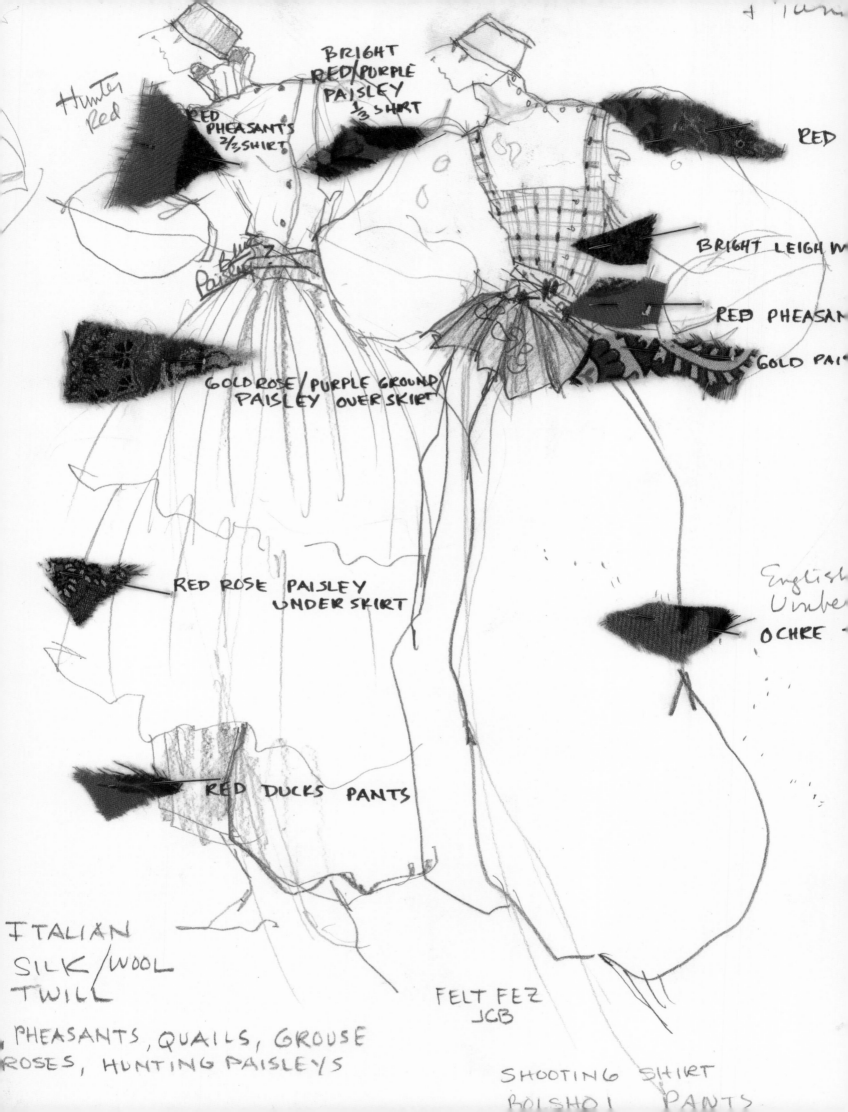

Hunter Red

BRIGHT
RED/PURPLE
PAISLEY
⅓ SHIRT

RED
PHEASANTS
⅔ SHIRT

RED

BRIGHT LEIGH W

RED PHEASAN

GOLD PAIS

GOLD ROSE / PURPLE GROUND
PAISLEY OVER SKIRT

RED ROSE PAISLEY
UNDER SKIRT

English
Umbe
OCHRE

RED DUCKS PANTS

ITALIAN
SILK/WOOL
TWILL

PHEASANTS, QUAILS, GROUSE
ROSES, HUNTING PAISLEYS

FELT FEZ
JCB

SHOOTING SHIRT
BOLSHOI PANTS

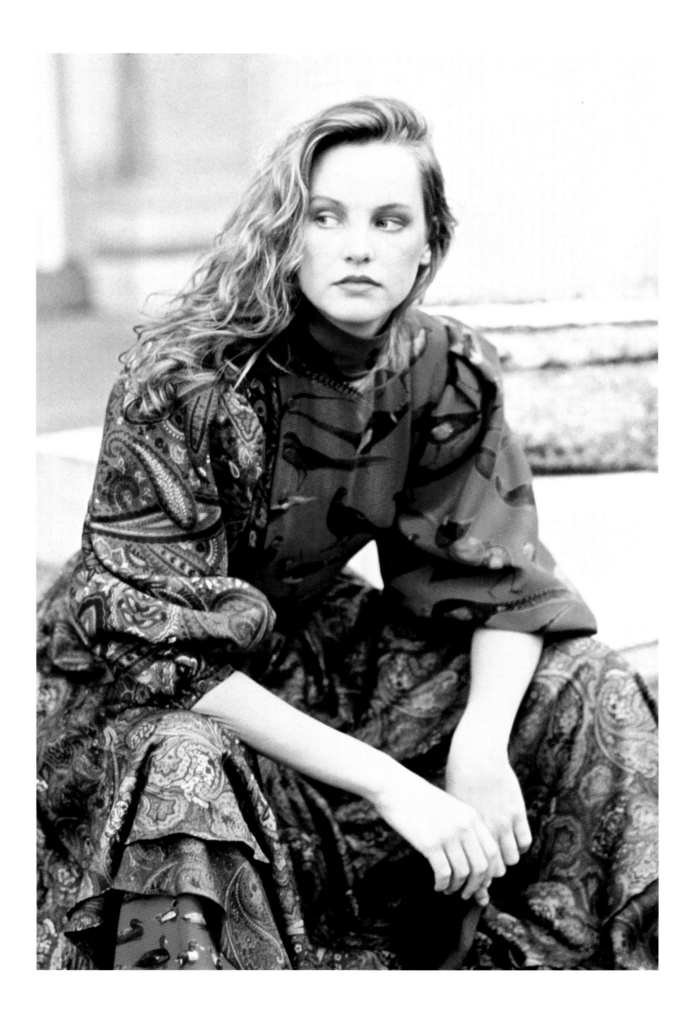

Above and opposite:
Fall/ Winter 1981. Sketch by
Jed Krascella.

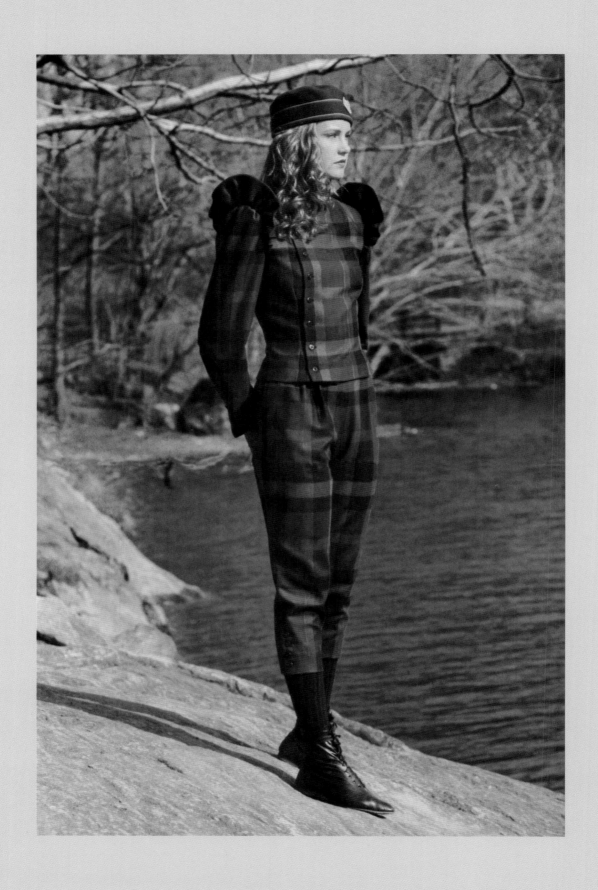

Above and opposite:
Fall/ Winter 1981.

Following pages, left:
Sketch by Patricia Pastor

Oatmeal

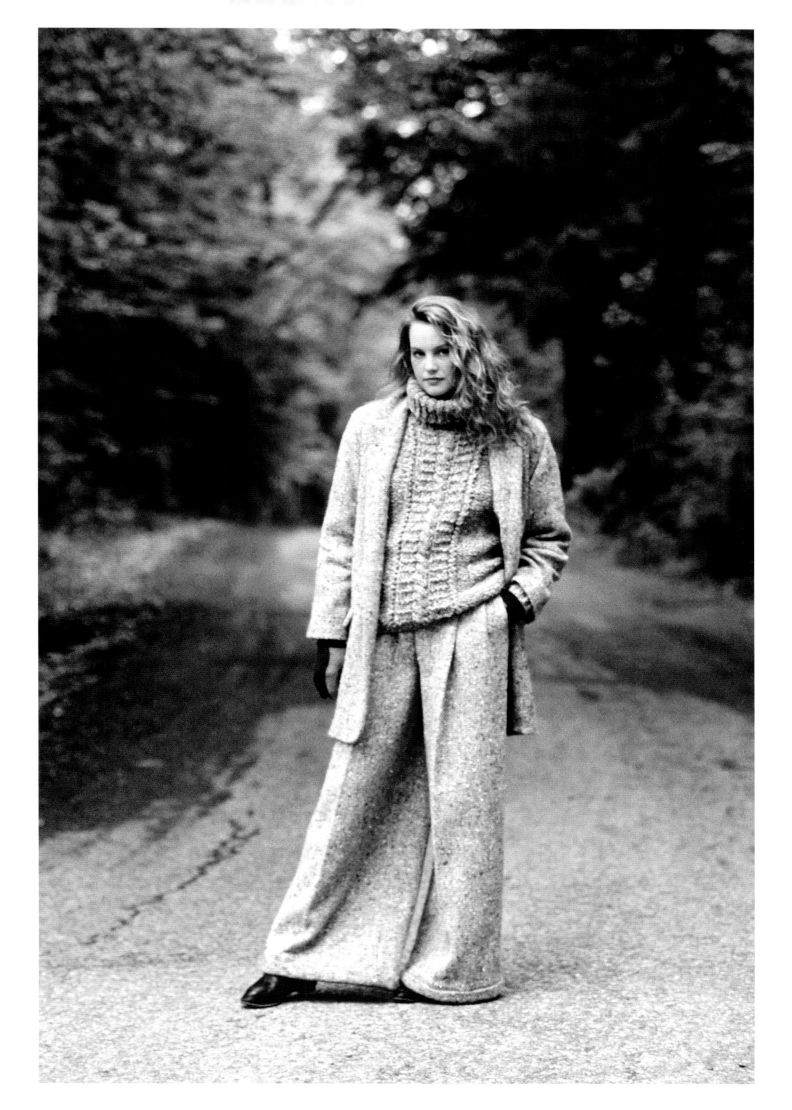

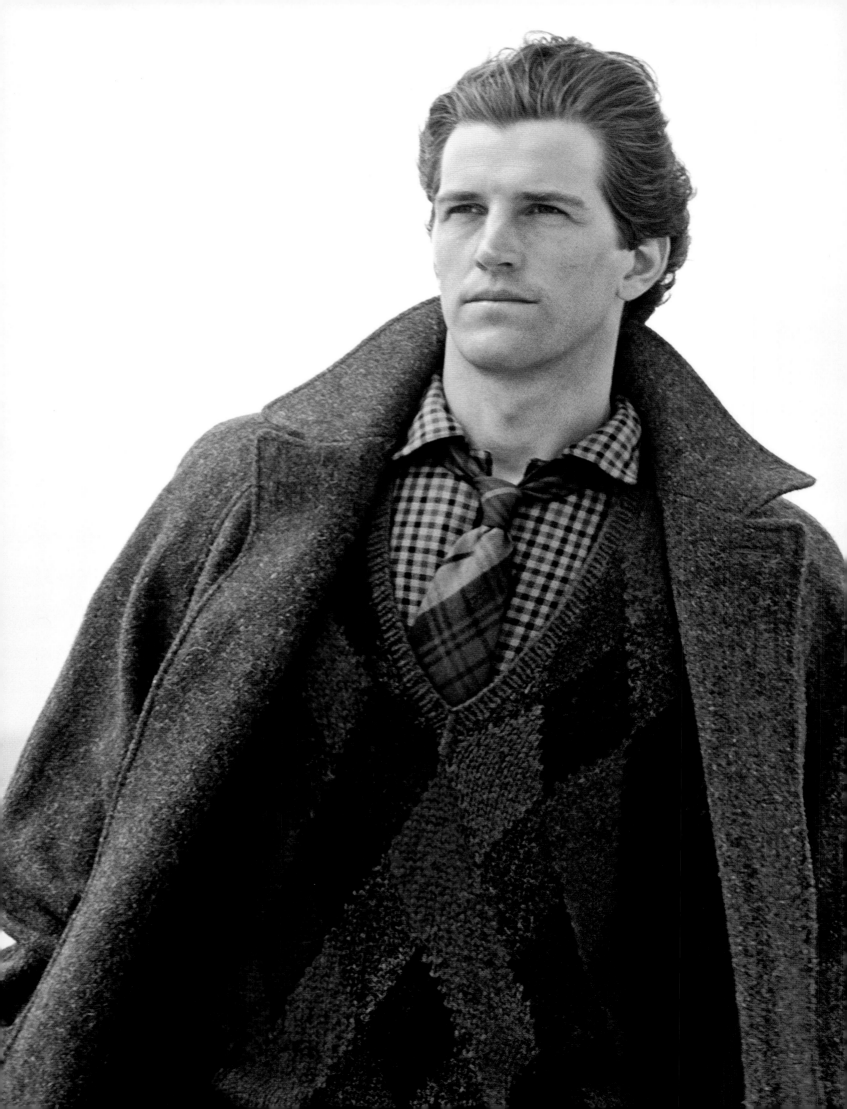

A New Take on Menswear

"I'm taking the same approach [to men's clothing]
that's worked for me in my women's wear.
The clothes cross all the points of my personal lifestyle.
They're to wear in the city or the country,
to work, or to go out."
—Perry Ellis

Perry had been flirting with the idea of menswear since his first show, when he had designed a few items for a handful of male models and used the men like handsome accessories for his women's wear collections, but the clothes had never been produced. Then, in the fall of 1980, the soft tailored jackets, hand-knit sweaters, and coats for men that he showed on the runway—relaxed, oversized, and beautifully colored—brought a cool, new sensibility to American menswear. Perry had timed it all brilliantly, waiting until his name had earned credibility in women's fashion before he committed himself to introducing a line for men. As Bendel's president, Geraldine Stutz, presciently commented, "There's nothing like Perry . . . his men's clothes are androgynous, neither masculine nor feminine, in the mood of the way Perry himself dresses."[1] Several months later, Bendel's, New York's chicest women's store and way ahead of the game, opened the first Perry Ellis for Men shop in the country.

These were clothes for a somewhat adventurous man, a little rebellious and with a secure fashion identity. As with his women's line, there were no buttons on his sport jackets because he avowed that he never buttoned his own jackets. But while some of the fabrics in the menswear line were identical to the women's, Perry spent time developing special colors that had never been used commercially in menswear before: earth tones in mustard and clay, spice shades from cinnamon to paprika, plus a glorious sunset purple.

Up until the showing of his Fall 1980 collection, Perry and Jed had been designing a very small group of menswear; once they signed a licensing agreement with Manhattan Industries, Perry's parent company, they began to

expand. In July 1981, Perry hired one of the most respected men in the menswear industry, Ed Jones, a take-charge, cowboy-boot-wearing Texan, to join the company as president of his menswear division. Within a short space of time, the division added fresh new talent: designer Brian Bubb and head of men's merchandising, Karen Golden Oronte—both friends of Jed—designer Richard Haines, and vice president of men's sales, David Rosensweig.

Perry had instinctively anticipated the return to classics in menswear in the late 1970s, even before Giorgio Armani had. But unlike the Italian designer's broad-shouldered, highly constructed suits, Perry's jackets were wide in the shoulder yet soft tailored, a look that many American men preferred. His pants were made with a looser fit and a button fly, and his woven shirts had been given a new relaxed shape—roomier, with more stitches per inch, more luxurious fabrics, and real pearl buttons. And his sweaters—the slouchy, hand-knits in richly colored cottons and wools—were unlike anything that had ever been done before for men. Even his polo shirt was singular; double the weight of a usual pique knit, and with a relaxed, dimpled dropped shoulder, it didn't need a logo to say it was Perry Ellis.

Perry and his design team made classic clothes more dramatic, layering shapes and extreme textures one over the other. Imported fabrics, with deep and strong or subtle and natural colors, were combined in fresh, innovative ways. And there were the perennial Perry Ellis quirky details: back pockets on a coat, dimple-sleeved shirts with no cuffs, sophisticated yet hip linings in the jackets.

The success of the menswear line showcased the genius of Perry and his menswear team. While being trailblazers, they never went too far: the line was pure class, only slightly subverted. Rebellion had never seemed so attractive.

114

PERRY ELLIS

Saks Fifth Avenue advertisement for Perry Ellis menswear that appeared in the *New York Times*; L. Greif and Brothers was Perry Ellis's Menswear licensee for tailored clothing, including men's suits, sport jackets, and dress trousers.

On these pages: The weather coat: longer, fuller than ever before from a collection; and in the palest of tones. And handknit raglan sweaters, cabled crewnecks, wide wale cords, classic houndstooth sportcoats, bold plaid jackets. And basics, too: blue oxford cloth button-downs, and Perry's new spread-collared shirtings. Multicolored speckled sportcoats and trousers and heather flannels. So, here you see it: tradition, and innovation. For a collection that's all at once relaxed, yet classic... classic, yet modern...

Here, Now! at Saks Fifth Avenue

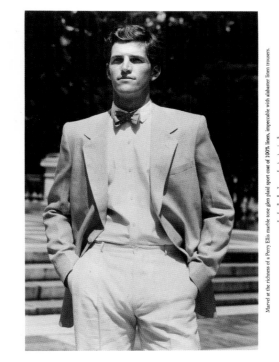

Marvel at the richness of a Perry Ellis marble tone glen plaid sport coat of 100% linen, impeccable with alabaster linen trousers.

PERRY ELLIS

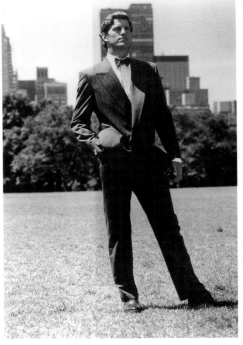

A Perry Ellis signature: the two button double breasted suit; the undarted, ventless jacket has besom pockets and the fabric is an equally unique multi-shadow stripe in navy of 100% cotton.

PERRY ELLIS

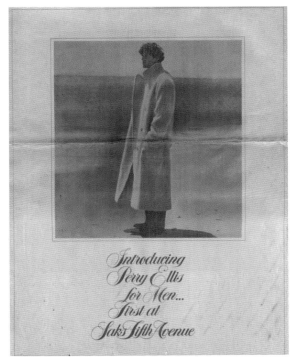

Introducing Perry Ellis for Men... First at Saks Fifth Avenue

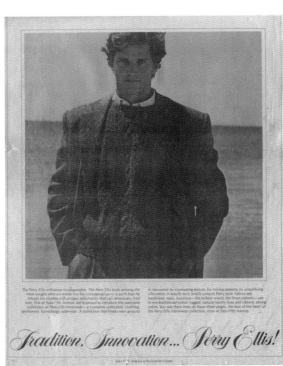

The Perry Ellis influence is incomparable. The Perry Ellis style among the most sought after anywhere. For his conceptual savvy is such that he infuses his clothes with an easy informality that's all American. And now, first at Saks Fifth Avenue, we're proud to introduce the expansive collection of Perry Ellis menswear — a complete collection: clothing, sportswear, furnishings, outerwear. A collection that breaks new ground in menswear by contrasting texture, by mixing patterns, by simplifying silhouettes in totally, by a totally unique Perry style. Fabrics are traditional, even luxurious — the richest wools, the finest cottons — yet in non-traditional colors: rugged, natural earthy hues and vibrant, strong colors. You see them here, on these three pages, the best of the heart of the Perry Ellis menswear collection, now at Saks Fifth Avenue.

Tradition. Innovation... Perry Ellis!

The Perry Ellis navy blazer, styled his way for casual comfort of 100% wool, coupled with cream linen trousers.

PERRY ELLIS

115

PERRY ELLIS

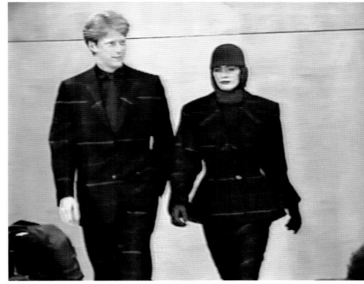

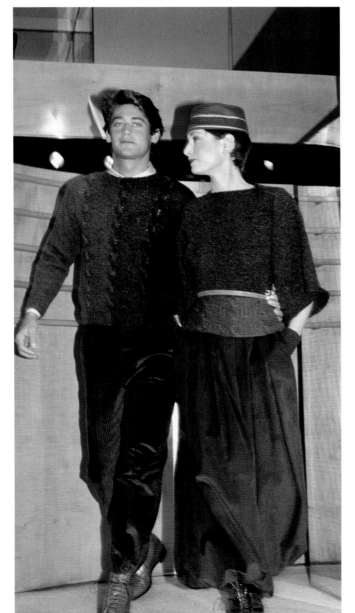

Perry Ellis was among the first to blur the lines between menswear and women's wear with great success. His classic looks—from pleated trousers with white silk shirts, deeply hued hand-knit V-neck sweaters, and bow ties, to single cable knits and handsome black cashmere coats—worked brilliantly on both.

Opposite and left: Photographs by Roxanne Lowit.

Above: Top and bottom, right: video stills from the runway. Fall/ Winter 1982.

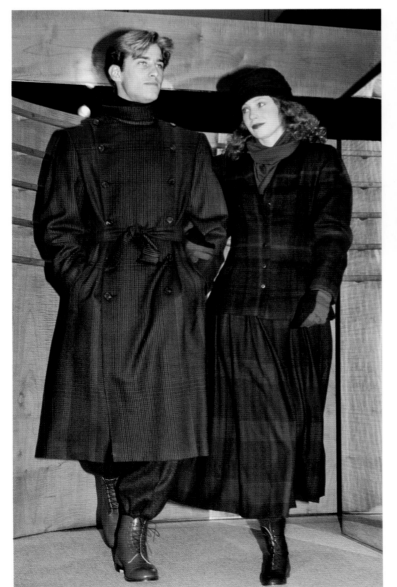

Perry pioneered the use of deep color and unusual fabrics for men, including fuzzy textures, giant-scale plaids, and startling color combinations such as mustard and paprika jackets with royal blue pants.

Left and opposite: Photographs by Roxanne Lowit.

Right: Video stills from the runway. Top, Fall/ Winter 1981; Bottom, Fall/ Winter 1982.

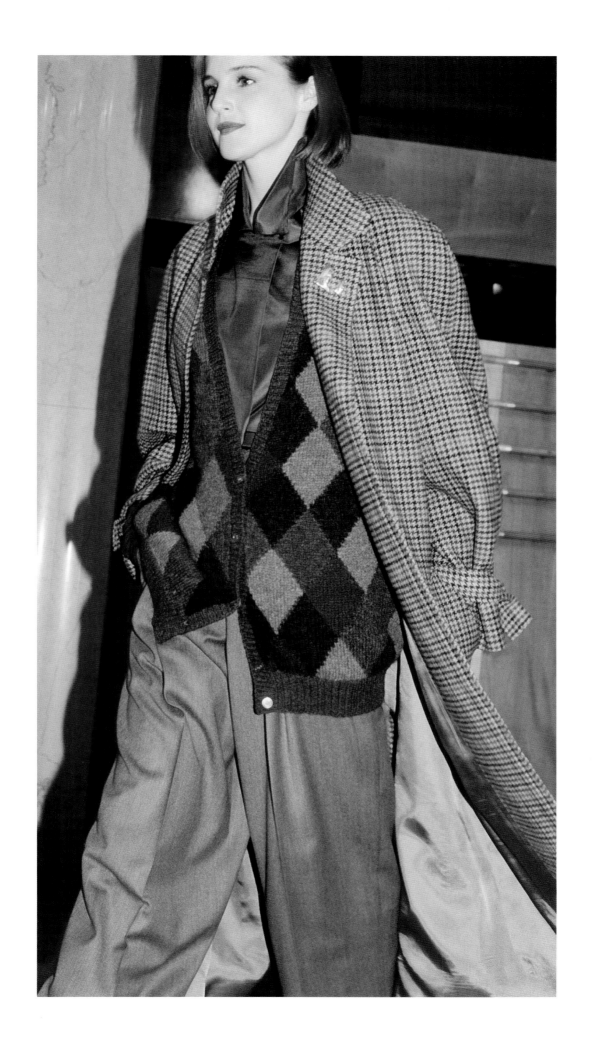

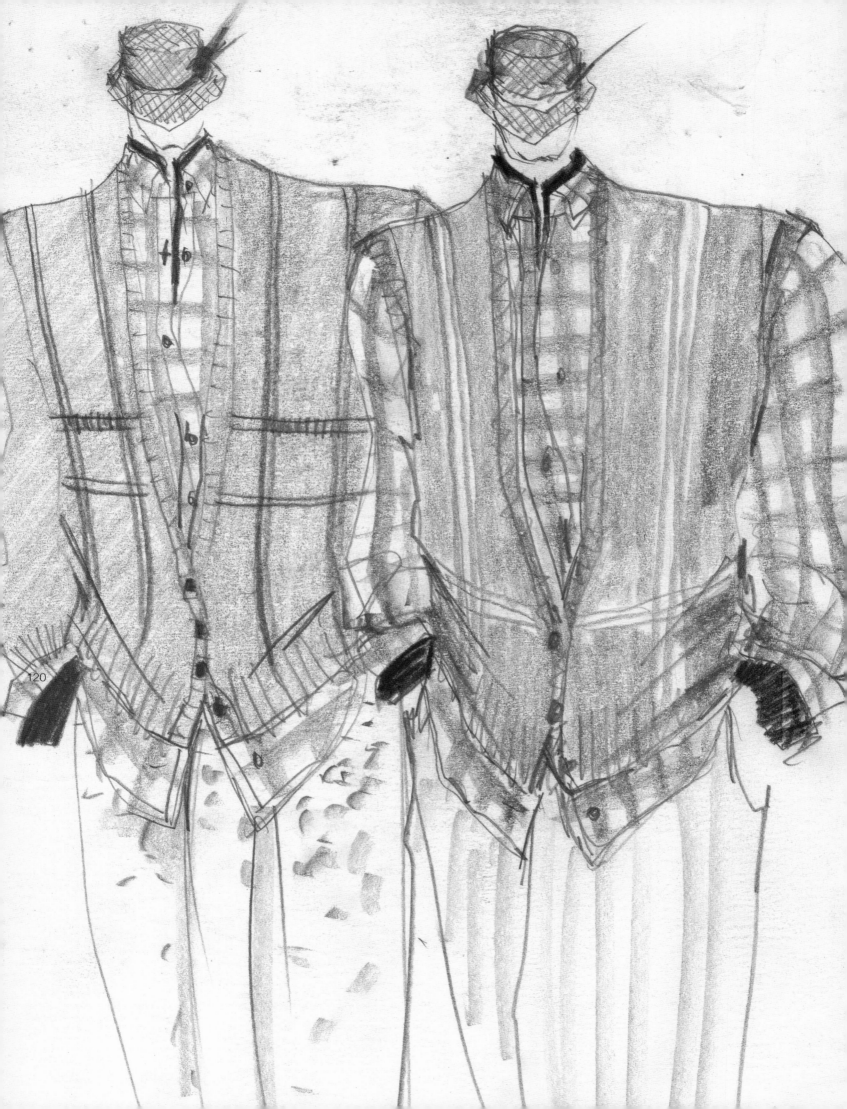

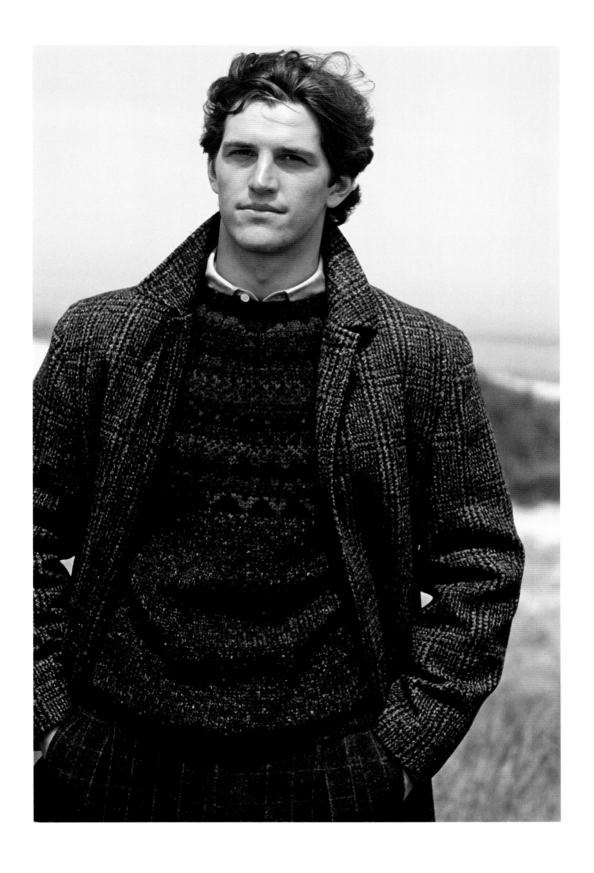

Opposite: "Textures" sketch
by Jed Krascella.

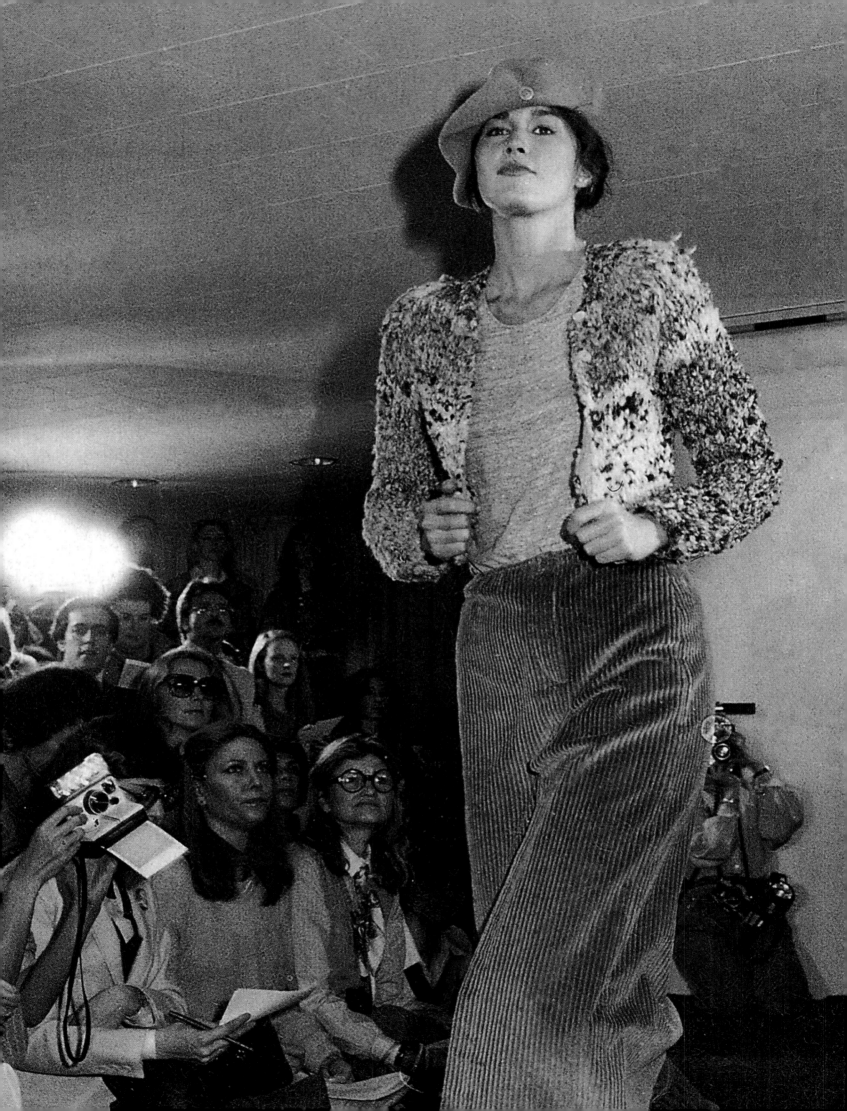

There's a Lot of Love in a Hand-Knit Sweater

"A Perry Ellis sweater does not resemble
a sweater by anyone else."

–Bernadine Morris

Among the fresh and often witty American sportswear looks that Perry Ellis created, none would become as coveted as that of his innovative hand-knit sweaters. In the late 1970s, Perry almost single-handedly resurrected a moribund knitting business in America by designing original and technically advanced hand-knits, created on big knitting needles to give them character and texture and modernized with a slew of new ideas.

The casual, relaxed look of sweaters had always interested Perry. Determined to start his own sweater initiative, Perry canvassed the market and was dissatisfied with the flat, "artificial"-looking knits he saw. His love for all things natural drove him to want to create his own hand-knit sweaters to ensure the raw, chunky textures that he preferred. And there was his personal, organic perspective as well: "There is a lot of love in a hand-knit sweater that a machine can't fake," the designer once observed.[1]

Hand-knit sweaters—labor-intensive and more expensive than machine-made sweaters—were virtually nonexistent in the American sportswear industry in the late 1970s, and producing them in bulk was unheard of. Perry was at first unsure how to go about it. Patricia Pastor, his first assistant, remembers that he actually recommended that she try the Manhattan Yellow Pages. After thumbing through "yarn shop" and "knitting," she found, sure enough, a woman named Belle Meyers, who owned a yarn emporium on the Upper West Side in New York City and could, they found, provide both yarn and nimble fingers. Belle Meyer located some natural Colombian wool full of dirt, sticks, and burrs, with bits of corral fencing still in it. Perry and Patricia adored it, laughingly dubbing it "sheep-shit wool," but it couldn't have been more authentic and perfect for the Perry Ellis hand-knit aesthetic: the yarn had actually been spun right in the fields where the sheep had been shorn. From a team of local women who knitted the first sweaters, Belle ended up employing a whole neighborhood of knitters working out of her cavernous apartment above the yarn shop, each knitting different parts of a sweater: sleeves, backs, fronts, and cuffs.

Perry's chunky shoulder-padded cardigan sweater made of undyed wool, spun in the fields right next to the sheep who produced it. Fall/ Winter 1978.

Of course, Perry was not interested in simply re-creating the standard sweater. His hand-knits were classic examples of his talent for tweaking the traditional. For example, cable stitches had long been a classic sweater pattern, often with the same-sized cables distributed evenly on the body and, occasionally, on the

123

sleeves of the sweater. Perry set out to create a new cable model: a single, thick cable, running down the center front of a chunky crew-neck sweater—a minimalist touch that somehow made a sweater look cool, modern, and equally good on women and men.

Perry also made use of the cable in a functional way. In designing a sweater with sections of different-colored yarns, he would work in a cable to serve as a boundary where the yarns changed color. He pioneered the notion of a "dimpled" shoulder, a kind of pucker created with an inverted pleat that softly extended the shoulder line and gave the sweater a softer, slouchier look. Employed on shirts and jackets and even his fur coats, this became a subtle but recognizable Perry Ellis signature.

One season, when they were working with some beautiful plaid fabrics, Jed Krascella was inspired to create tartan sweaters. In Scotland, Jed met with various experts and finally spoke to someone at Pringle of Scotland, one of the most respected knit-

The Metropolitan Museum of Art

Fifth Avenue at 82nd Street, New York, N.Y. 10028 212-TR 9-5500

October 14, 1983

Dear Perry,

I adore my grey and white striped sweater of such beautiful cashmere. It's very, very hot and I am saving it for the colder weather which we are sure to have after this wonderfully hot summer.

My best wishes to you.

Signed in Mrs. Vreeland's absence—
P. Lennox Secretary

Diana Vreeland

Perry Ellis
575 Seventh Avenue
New York 10018

wear companies. Jed explained his mission and the fellow told him flatly, "It can't be done." So Jed asked if they had a piece of graph paper and showed him how it *could* be done. Ultimately the Perry Ellis team had their own sweaters created by hand, as working with human knitters turned out to be easier than dealing with machines. The prevailing attitude at Perry Ellis was always, "There is no such thing as 'it can't be done.'"

Perry's knitted sweaters soon became a signature look and, eventually, serious collector items. He was one of the first to experiment with beautifully muted mohair yarn, in strié patterns or subtle mélanges of soft, earthy tones. He was also a big fan of bold graphic patterns on sweaters. His early work at Vera designing silk scarves had schooled him in the value of the "blown-up" image, and he experimented with oversized dots and stripes as well as giant-sized giraffe and zebra patterns, starting a trend that continues today. One season, he turned his hand to oversized playing cards—giant versions of the Queen of Hearts and Jack of Spades, like a page out of *Alice in Wonderland* come to life.

While the hand-knit sweaters were widely acclaimed, they were unaffordable for many, and Perry would receive sacks of letters from consumers request-ing home-knitting instruction and sources for yarn, so they could replicate his sweaters at a lower cost. Perry had licensed his name to Vogue Patterns, but in 1982, he also decided to embark on creating his own home-knitting kits,

signing a license with Burren International to create packages that included yarn, knitting needles, and instructions and tips, along with any trimmings, a hangtag, and a Perry Ellis label—all for a fraction of what it would cost to buy a sweater at retail. Perry, always the romantic, at first chose to equip his knitting kits with handsome wooden knitting needles because he thought they were beautiful and he loved

the soft "clicking" sounds they made as the sweater progressed. Unfortunately, the heavy wooden needles often poked through the clear plastic packaging of the kits, so they had to be replaced by the more functional plastic variety. The knit-kit business was never a serious money-maker, and after a couple of seasons it was folded, but it was a wonderful gift to home knitters and a goodwill ambassador for Perry Ellis around the world.

Ultimately, due to the huge demand, Perry was forced to farm out the majority of his knitting to larger shops, both in the United States and abroad. Perry hired a knitwear director, Monique Recant, who became his source for first samples. She would be given detailed design sketches, yarns, and trim, and, together with Perry and his team, she worked out each prototype design for both women's and men's sweaters.

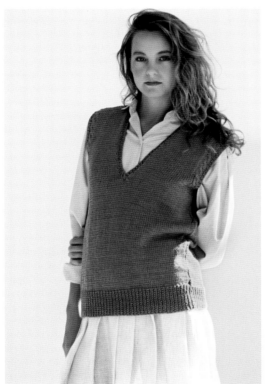

When Perry later decided to expand into luxurious cashmere knits, he and his team intended to push creative and technical boundaries. Designing the extraordinarily intricate cashmeres based on the abstract art of Sonia Delaunay for his Fall 1984 collection was certainly one of their greatest challenges, and they had a steep learning curve ahead of them. Undaunted, the team worked out their own method to graph and map out, in full scale and great detail, exactly what they required. The resulting intricate and colorful Delaunay-inspired sweaters were themselves works of art—as innovative and masterful, in their way, as Delaunay's original masterpieces.

Above: Perry's sweater license with Vogue Batterick Patterns; Below, left, hand-knit sweater vest made from his kit; Bottom, Perry's "knit kit," consisting of yarn, needles, instructions, and a prized Perry Ellis label.

125

PERRY ELLIS

Following pages: Nothing telegraphs the Perry Ellis message as quickly as his hand-knit crewneck sweater with a single fat cable running down the middle of its front, another Perry-ism that works equally well on women and men. Spring/ Summer 1981.

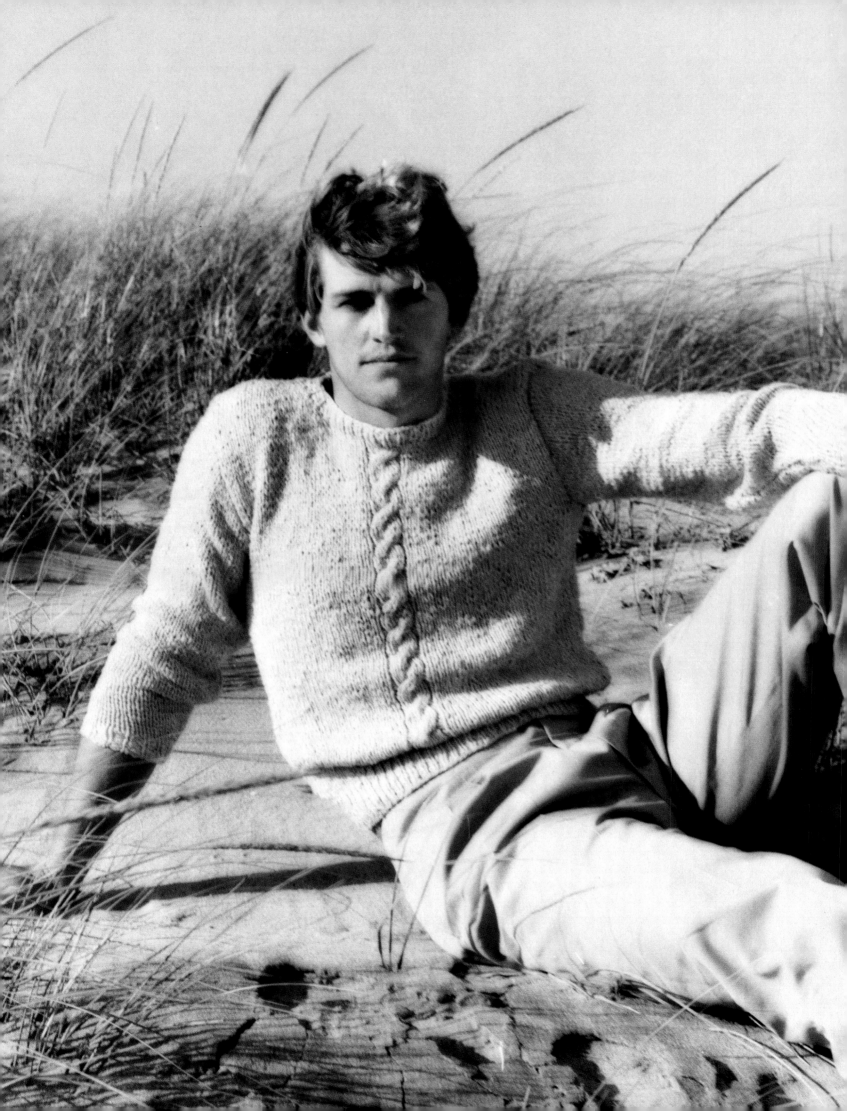

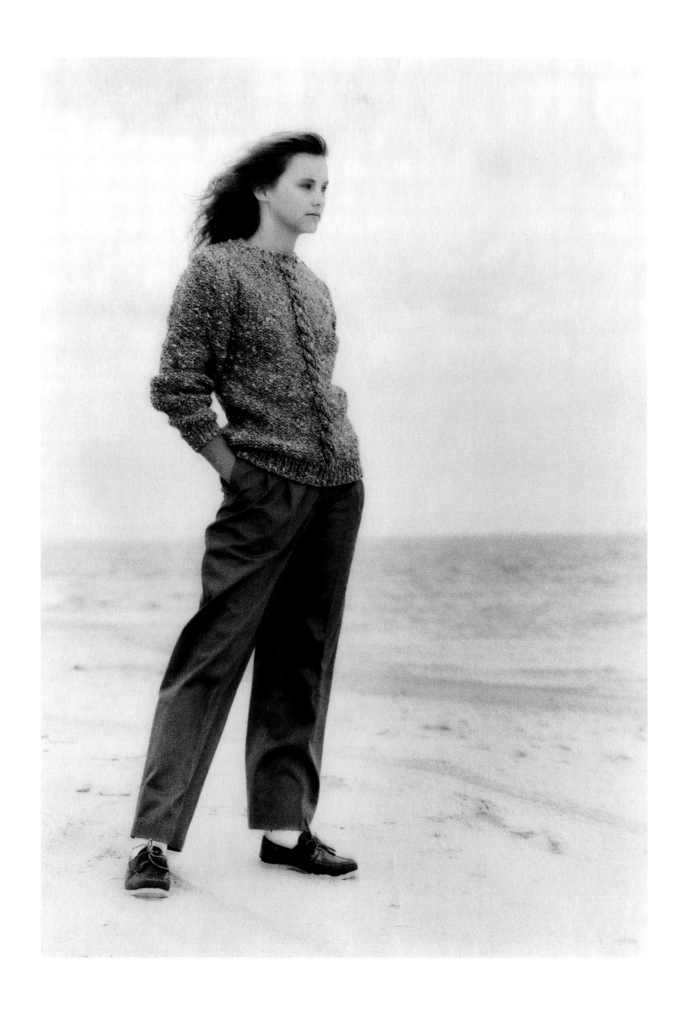

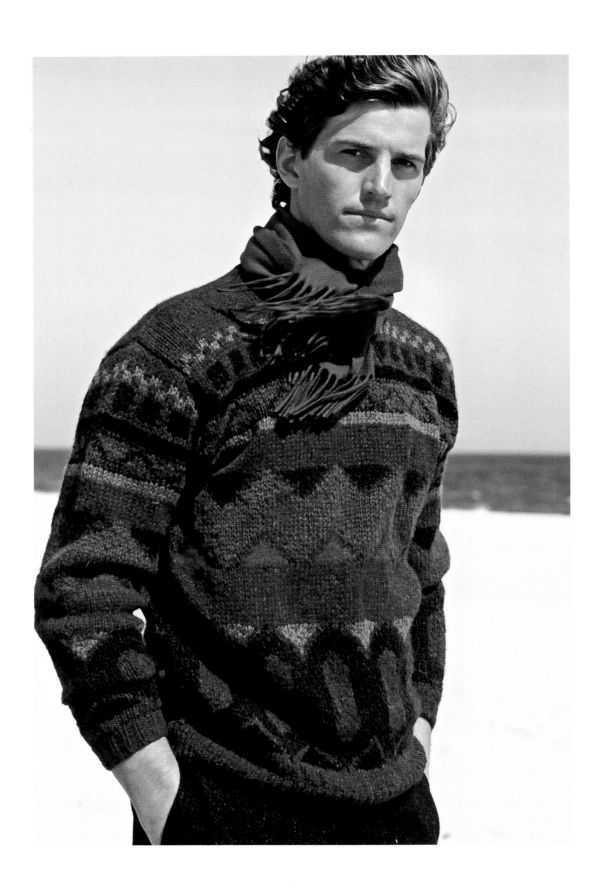

Above and opposite:
Perry's dazzling hand-knit
sweaters are works of art,
inspired by the Russian-
French Art Deco painter and
designer, Sonia Delaunay.
Fall/ Winter 1984.

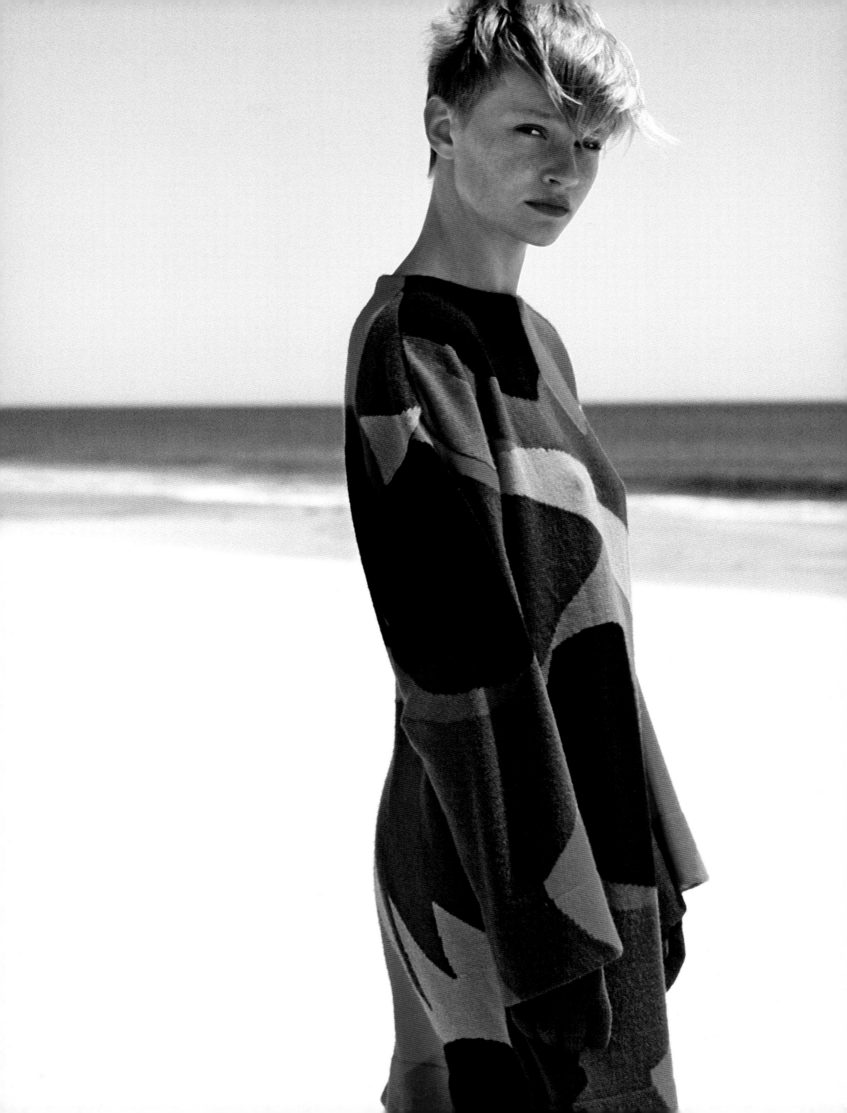

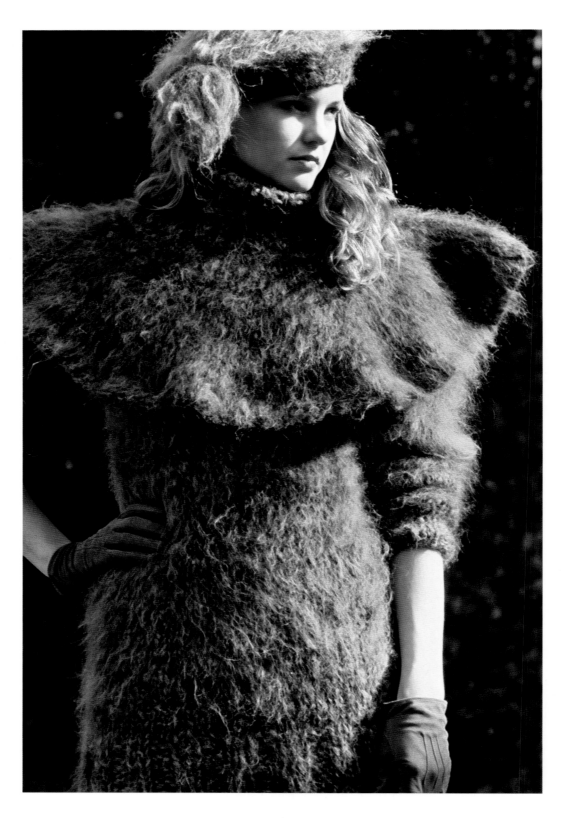

Above: Ombré-capeleted
sweaterdress from the
"Capelets" collection. Fall/
Winter 1980.

Opposite: Perry's multicolored
McNutt Donegal tweed and
pumpkin-ribbed long sweater
over a matching mid-calf
skirt with deep ribbed hem.
Fall/ Winter 1982.

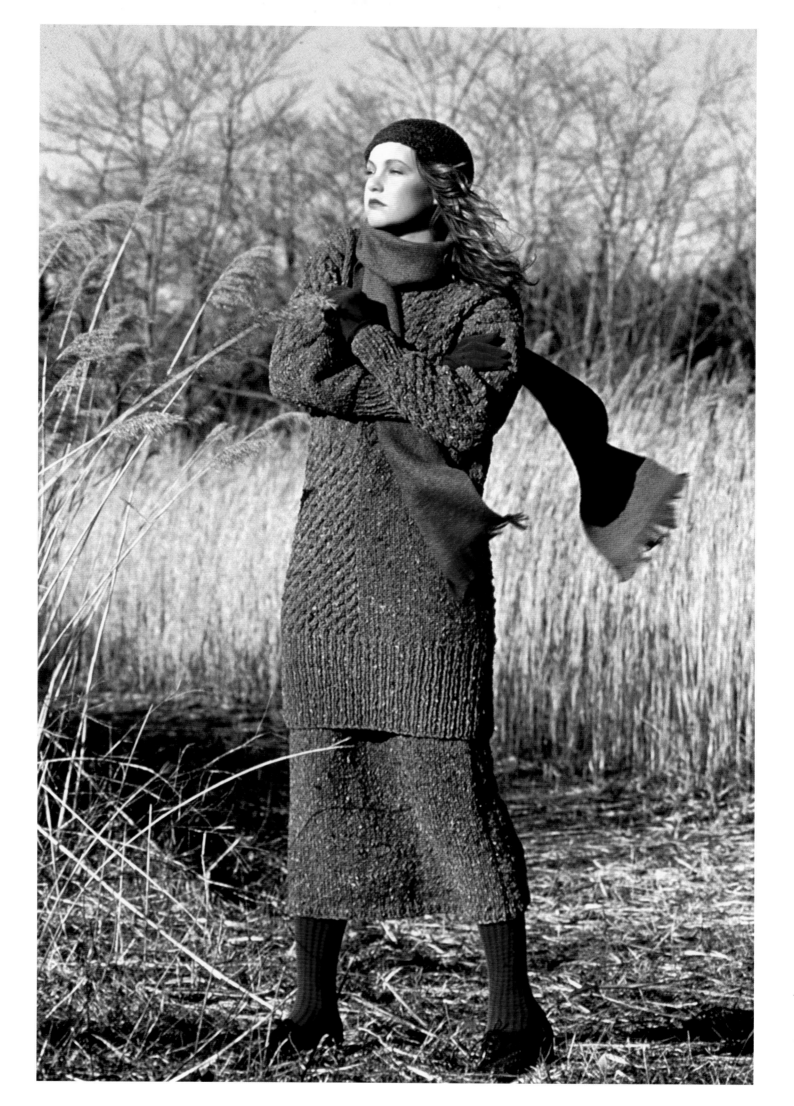

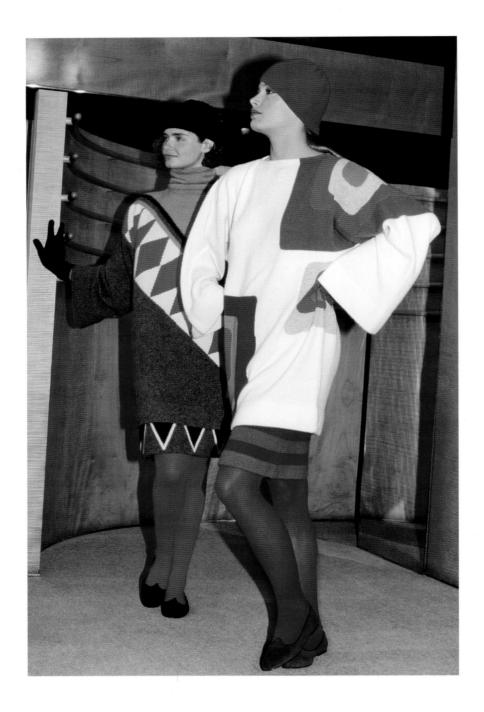

Above, Perry's Sonia
Delaunay-inspired cash-
mere tunics; Opposite,
bold black and white zebra-
striped twin-set: hand-knit
Shetland short sweater coat
over matching crewneck
and dotted ascot. Fall/
Winter 1984. Photographs
by Roxanne Lowit.

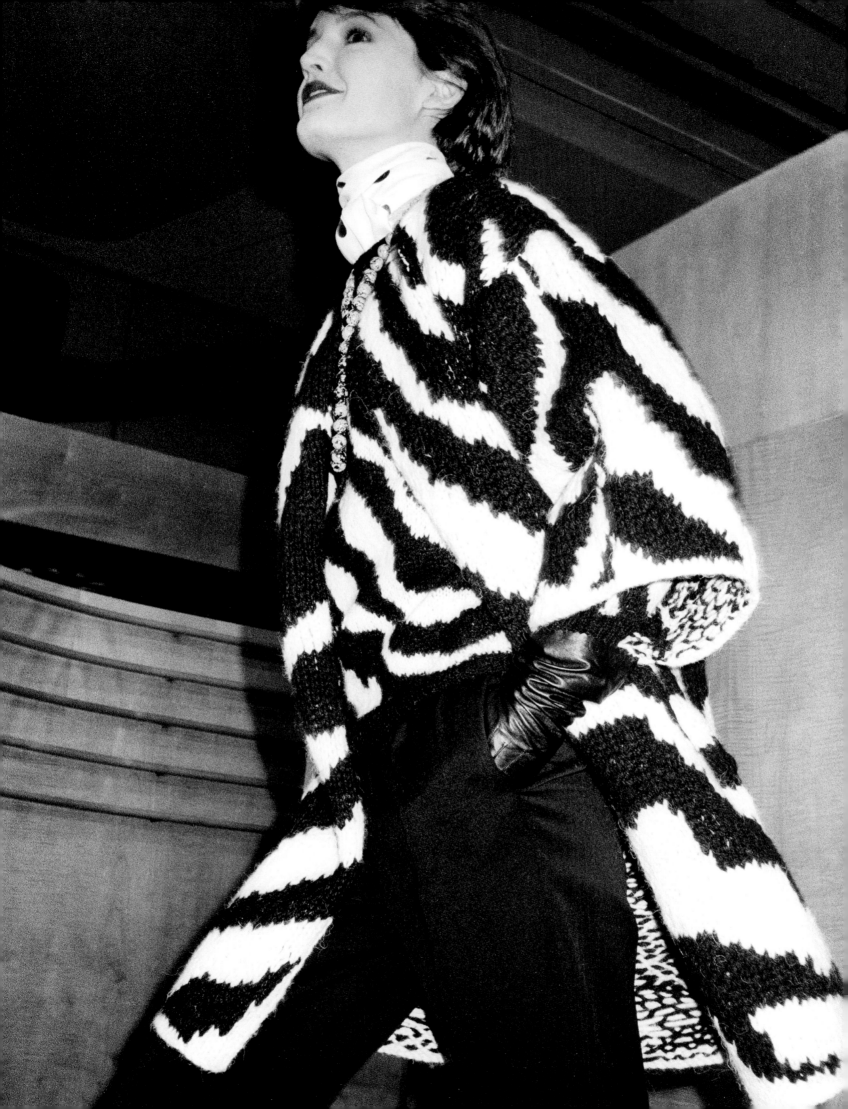

Perry's Wedding Belles

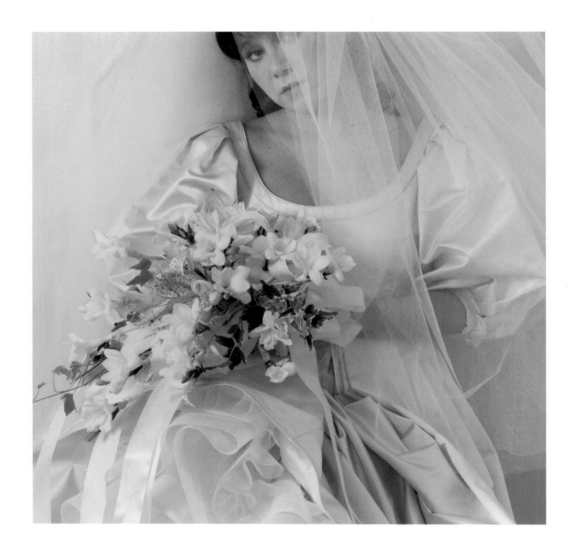

Food and travel writer Elise Meyer (daughter of Perry's former boss and mentor, John Meyer) married Henry Feuerstein in Perry Ellis's Renaissance-inspired ivory duchesse satin dress with puffed sleeves and a deep-scooped neck. Photograph by Sandi Fellman.

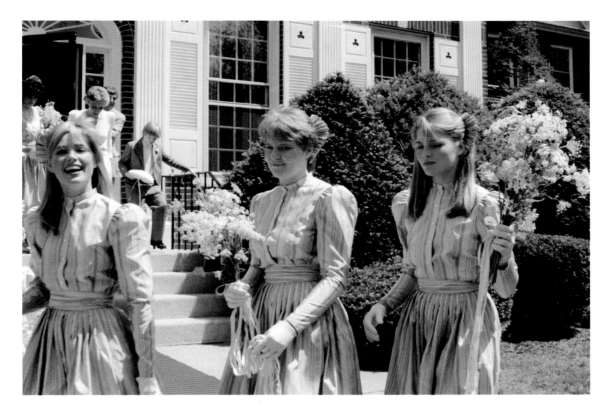

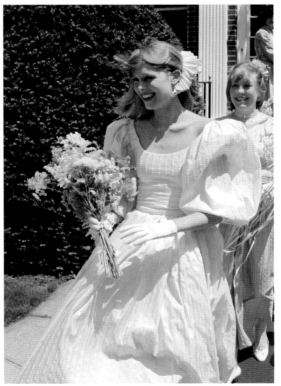

Cover girl Nancy Donahue
married model Jeff Aquilon
in Perry's ivory French
taffeta-jacquard dress. Her
model bridesmaids, includ-
ing Kelly Emberg and Kim
Alexis, wore ribbon-striped
taffeta. Photographs by
Peter Schlesinger.

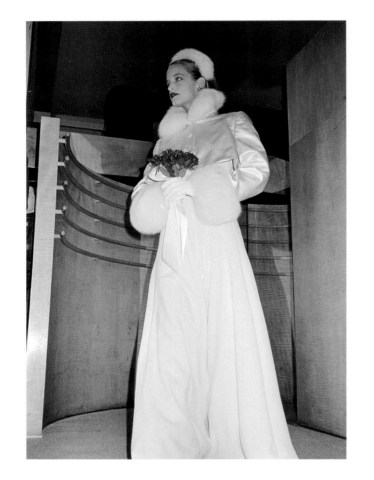

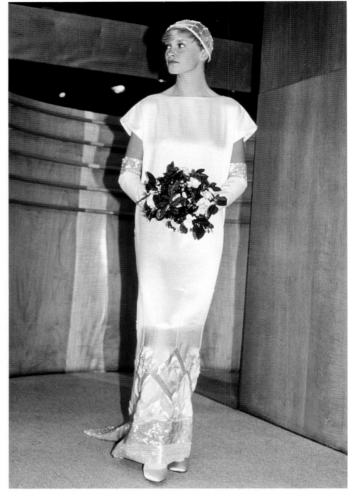

136

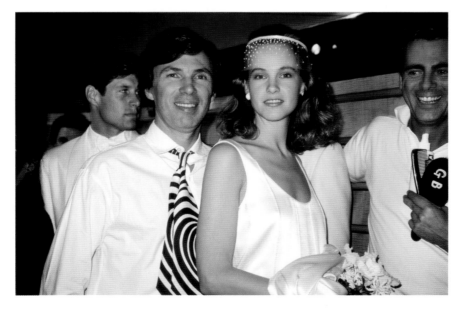

Runway brides: Top left, Bonnie Berman in off-white satin jacket with white fox-collar and cuffs over gored dress in Fall 1983; Top right, Lenita Oderfelt in a silk-satin beaded dress with a graphic Sonia Delaunay-inspired hem; Bottom, Lise Ryall in charmeuse, Spring 1984. Photographs by Roxanne Lowit.

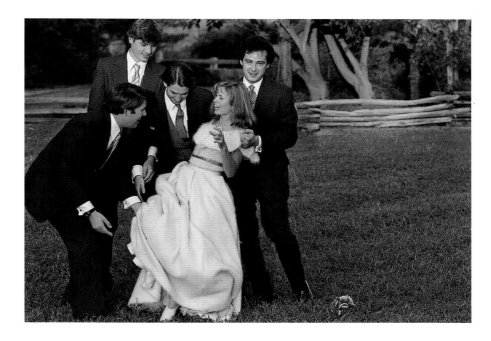

Top and center, When Liza Carter married John Norton at their family home in Virginia, Perry lent them a bridal gown and six dresses fresh off the runway from his Fall 1980 show for her bridesmaid sisters: ivory mohair skirt and hand-knit scoop necked sweater for the bride and similar deep-hued sweaters and skirts for her sisters. Photographs by Andrea Alberts; Bottom, Nancy Donahue and her bridesmaids. Photograph by Harry King.

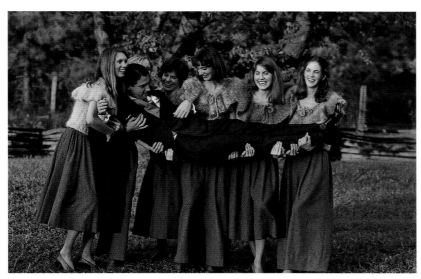

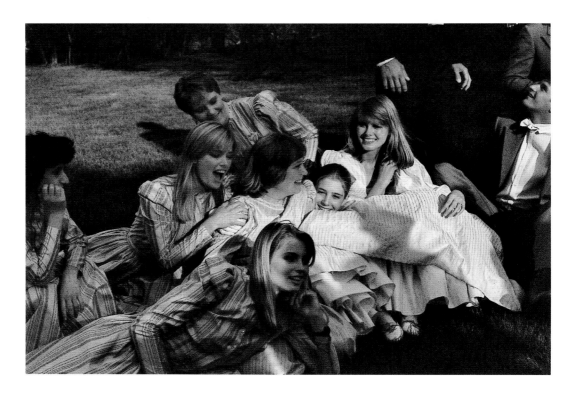

Perry Ellis International
Licensees

"At one point, I think everyone in America
was wearing a Perry Ellis coat."
—Gerald Solomon

It is doubtful that anyone could have foreseen just how valuable the freedom to license his name would be for Perry. In the eight years after his contract was signed, as the designer made the rapid transition from virtual unknown to renowned, Perry Ellis International acquired twenty-three licensees, which enabled Perry to reach into new markets, broadening his appeal.

Along with Manhattan Industries' Perry Ellis Sportswear and Vera's Perry Ellis Scarves, he branched out with shearlings (Sawyer of Napa) and furs (Alixandre Furs). To increase the market for his highly desirable sweaters, he signed deals with both Batterick Patterns and Burren International, so that home knitters could have access to his patterns and yarns and create their own sweaters at a lower price. He also developed a number of accessory collections: hosiery and socks (Trimfit Hosiery), shoes (Michael G. Abrams Shoes), sunglasses (Colors In Optics), and handbags (Holiday Fair), as well as girlswear (Lolly Togs) and menswear (Manhattan Industries and Greif and Company), and men's footwear (Church's) and underwear (Jockey International).

Within a couple of years, Perry had signed with Yagi Tsusho, a Japanese licensee, to produce women's clothes and, several years later, a men's line. Perry Ellis expanded to fragrance (Parfums Stern, later Parlux) and watches (Asia Commericial), and partnered Perry Ellis America with Levi Strauss and Company and Perry Ellis Home with Martex. While designers' licensing deals sometimes allow the licensee to have control of the product, in Perry's case, he and Mort Kaplan, who represented Perry Ellis with exclusive licensing agency rights, took great pains to ensure that Perry would have personal approval of everything his name was to be placed on.

One of his most successful partnerships was with Gerald Solomon, the owner and manufacturer of Fairbrooke Coats. Perry's own low-stance, double-breasted reefer with patch pockets, scaled down slightly for women, would be a winner, Solomon predicted, and he was right. "We sold over 150,000 pieces of that style alone," Solomon says. "At one point, I think everyone in America was wearing a Perry Ellis coat. When I'd check my own coat at a restaurant, I'd always look around the coat room, and virtually every coat in there was one of ours."[1]

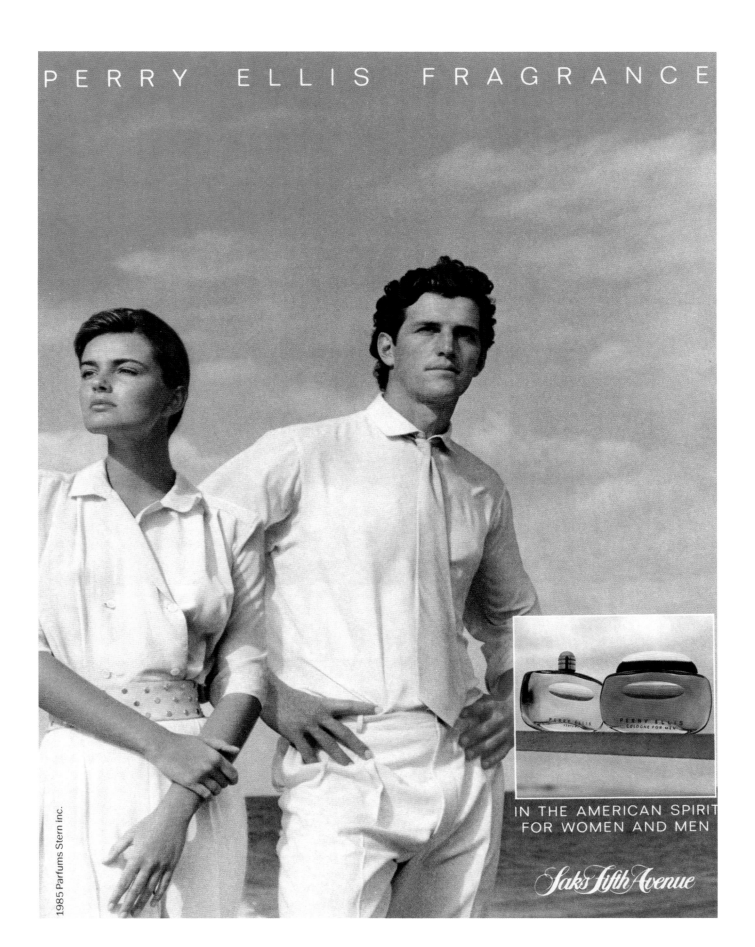

PERRY ELLIS FRAGRANCE

IN THE AMERICAN SPIRIT
FOR WOMEN AND MEN

Saks Fifth Avenue

1985 Parfums Stern inc.

Several years later, Fairbrooke added a line of Perry Ellis Men's coats, known for their distinctive silhouettes: broad shoulders, low-placed pockets, and a swashbuckling, ultra-long length. Ultimately the line was expanded to include rainwear, fur-trimmed coats, and jackets, all developed in conjunction with Perry's design teams.

Certainly, one of the classic stories about Perry and his licensees was recounted by Mort Kaplan. Mort had put together a licensing deal for Perry with Martex, for bedding and bath.

"When we had our first design meeting after the signing, the Martex executives asked Perry what kind of sheets he liked to sleep on," Mort remembers. "He immediately replied that he liked only pure white linen sheets and that when he traveled, he brought those white linen sheets with him. You could have heard a pin drop."[2] But Perry, perhaps sensing their trepidation about the possibility of a designer line of nothing but solid white sheets, created a hit collection consisting of zebra and leopard prints, which helped ignite the passion for animal prints that still thrives today. Bob Berger, resident star designer at Martex, said at the time that Perry was "the most talented bedding designer."[3]

Perry Ellis Licensees:

Womenswear:
Perry Elllis Sportswear -
 Manhattan Industries
Perry Ellis Scarves - Vera
Perry Ellis Hosiery and Socks -
 Trimfit Hoisery
Perry Ellis Shoes - Michael G.
 Abrams Shoes
Perry Ellis Shearlings - Sawyer of Napa
Perry Ellis Patterns - Vogue Batterick
 Patterns
Perry Ellis Furs - Alixandre Furs
Perry Ellis Handknit Kits - Burren
 International
Perry Ellis Girlswear - Lolly Togs
Perry Ellis Japan - Yagi Tsusho
Perry Ellis Sunglasses - Colors In
 Optics
Perry Ellis Coats - Fairbrooke Coats
Perry Ellis Handbags - Holiday Fair

Menswear :
Perry Ellis Men's Sportswear -
 Manhattan Industries
Perry Ellis Tailored Clothing -
 Greif and Company
Perry Ellis Footwear - Church's
Perry Ellis Underwear - Jockey
 International

Women's and Men's :
Perry Ellis Fragrance - Parfums Stern
 (later Parlux)
Perry Ellis America - Levi Strauss and
 Company
Perry Ellis Watches - Asia Commercial

Home Furnishings :
Perry Ellis Home - Martex

PERRY ELLIS SOCKS

PERRY ELLIS COATS

PERRY ELLIS SHOES

PERRY ELLIS SHOES

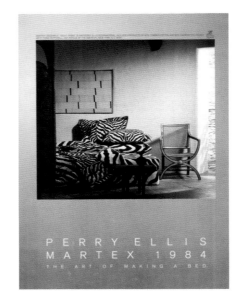

PERRY ELLIS
MARTEX 1984
THE ART OF MAKING A BED

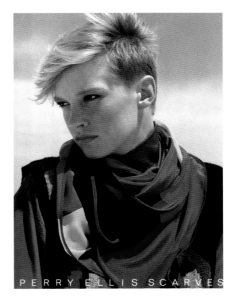

PERRY ELLIS SCARVES

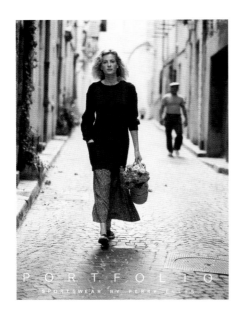

PORTFOLIO
SPORTSWEAR BY PERRY ELLIS

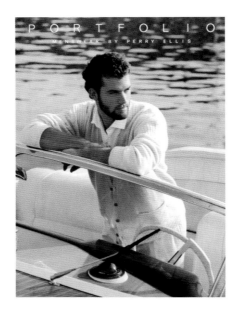

PORTFOLIO
MENSWEAR BY PERRY ELLIS

PORTFOLIO

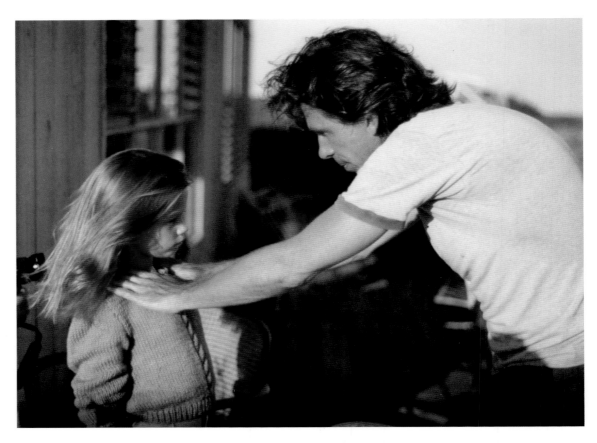

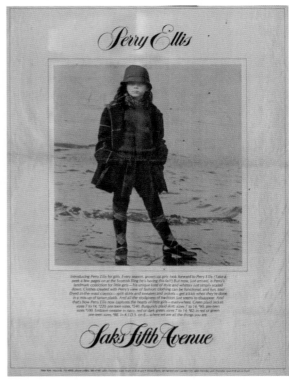

Within three years, by taking the reins and further developing the licensing arm of the business, Laughlin took Perry Ellis International from sixteen licensees, earning about sixty million dollars whole- sale, to twenty-three licensees, with a revenue five times that.[4] And according to Ed Jones, having Laughlin at his side seemed to give Perry even more confidence, making him a stronger and more assertive designer.[5]

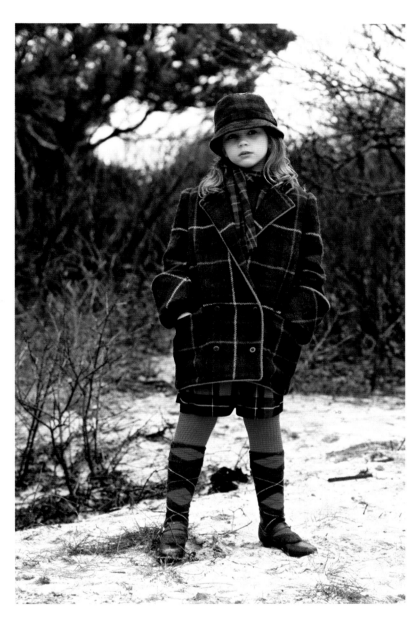
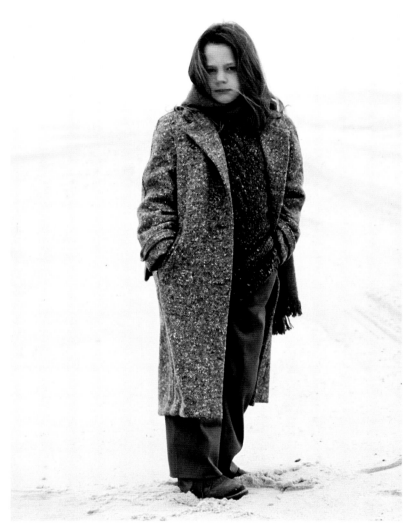

Kate Barker, daughter
of Perry's companion,
Laughlin Barker, was the
model for Perry's girls' line,
first licensed to Lolly Togs
and later to Manhattan
Industries. Classic Perry in
its attitude, the girls' clothes
were diminutive versions
of the designer's iconic
looks, including single cable
sweaters, tweeds and cor-
duroys, argyles, and plaids.

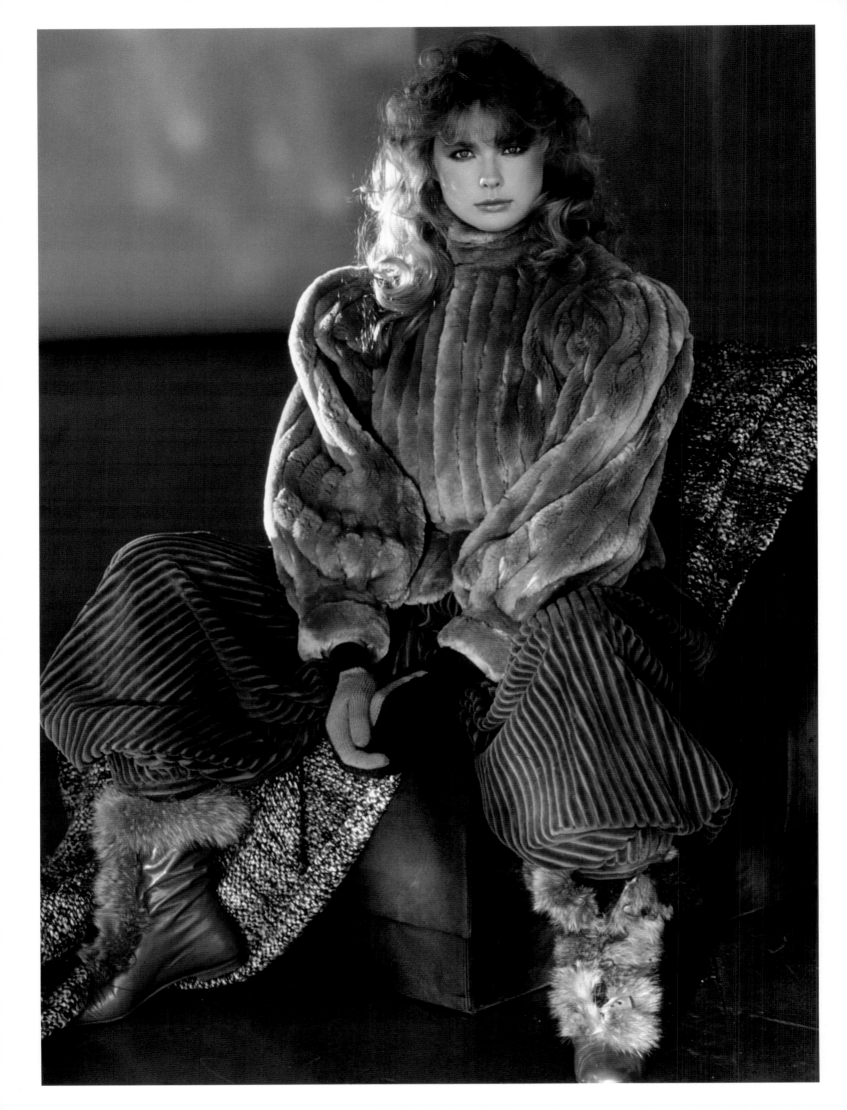

Perry's Irreverent Furs

Perry Ellis inked a deal with his first licensee, Furs by Alixandre, in 1978, when he was just making a name for himself, and it turned out to be one of the most fortuitous and successful alliances he could have forged. Alixandre, founded by Samuel Schulman in 1923, was one of New York's oldest and most prestigious furriers and had years of experience working with designers such as St. Laurent, Givenchy, Valentino, and Oscar de la Renta. Perry, on the other hand, had never before worked with furs, but he brought a young, irreverent attitude to the mix, insisting that he wanted to treat fur coats as though they were cloth. And that is really what he did.

Perry's first designs for Alixandre were casual, oversized, slouchy shapes. Each coat was sold with a matching Barry Kieselstein-Cord jeweled belt. According to Larry Schulman, "Perry's colors were unique: olive, taupe, heathery gray—a difficult feat for the dyers—and earth tones. No one else was doing that. He was really into textures and used a ribbed beaver that had the effect of wide-wale corduroy." Schulman had sheared a beaver pelt as an experiment and showed it to Perry, who instantly loved its lightweight texture. And that was the beginning of a whole new genre of fur. It wasn't long, Schulman says, before "we began to shear not only beaver but mink and sable, which gave a whole new subtlety to the fur."[1]

Perry's assistant Jed recalls that "the furs were an integral part of Perry's propensity for theatrical *wow*! . . . Our furs always got applause and were a highlight of each collection in which they were featured." And the Schulmans made excellent partners, says Jed: "We asked for some unusual things over the years . . . It was incredible that they had the vision to embrace this younger, more spirited look—it was clearly not in their past, nor in their comfort zone, but they so supportive and willing to explore ideas."[2]

Perry and his team asked for and received a variety of furs, from squirrel and skunk to Persian lamb and gray and beige spilt-skin chinchilla; from Russian and Canadian sable to marten and fisher. Alixandre provided dyed mink, fox, and beaver and sheared mink and "mosaic" sheared beavers—in patterns like Fair Isle, yoked, pinstriped, ribbed, tartan, Delaunay—all of which were an "engineering nightmare," recalls Jed with a laugh. Alixandre furs made their way onto the runway in showstopping, over-the-top Perry Ellis pieces like an ankle-length fox cloak, white mink bustier, sheared mink circle skirt, broadtail suit, pink chevroned fox coat, attached capelets, and countless fur trims for woven pieces and cashmere sweaters.

"We did love our fur!" Jed says. "Some of my fondest memories at Perry Ellis were of creating the furs—the excitement of seeing my ratty little sketch transformed into his larger-than-life, gorgeous, luxurious piece. It was magic!"[3]

Ribbed khaki sheared beaver jacket with nipped waist and small peplum and enormous dimpled sleeves, with olive wide-wale corduroy pants and fox trimmed lace-up boots. Fall/ Winter 1981. Photograph by Rico Puhlmann.

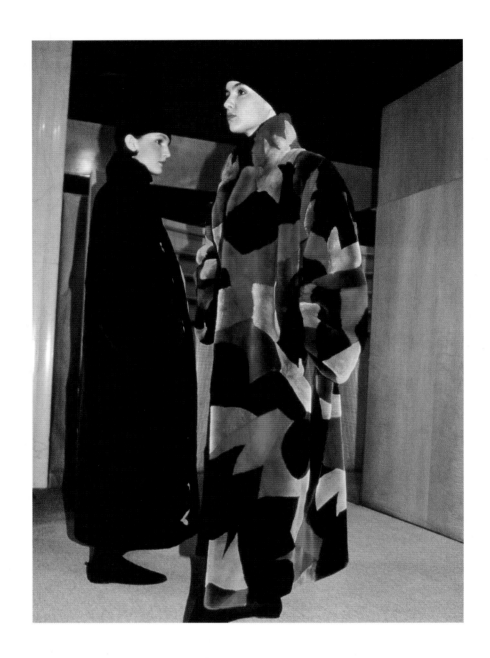

Perry also experimented with what were referred to as "old lady" furs—like Persian lamb—which he shaped into fitted little peplumed jackets, taking them from grandmotherly to just plain grand.

One of the great coups that Perry and Alixandre created as a team were the Sonia Delaunay furs in the Fall 1984 collection, based loosely on the Russian-French artist's Art Deco paintings. Larry Schulman recalls, "There were enormous challenges in trying to replicate art on fur: first, building the pattern; second, cutting the fur; third, sewing the fur pieces together. Because of the intricate nature of the Delaunay designs, like concentric circles and other geometrics, it was almost impossible to re-create them. But we prevailed. The results were amazing and we actually sold a large number of hugely artistic, labor-intensive designs."[4] Photograph by Roxanne Lowit.

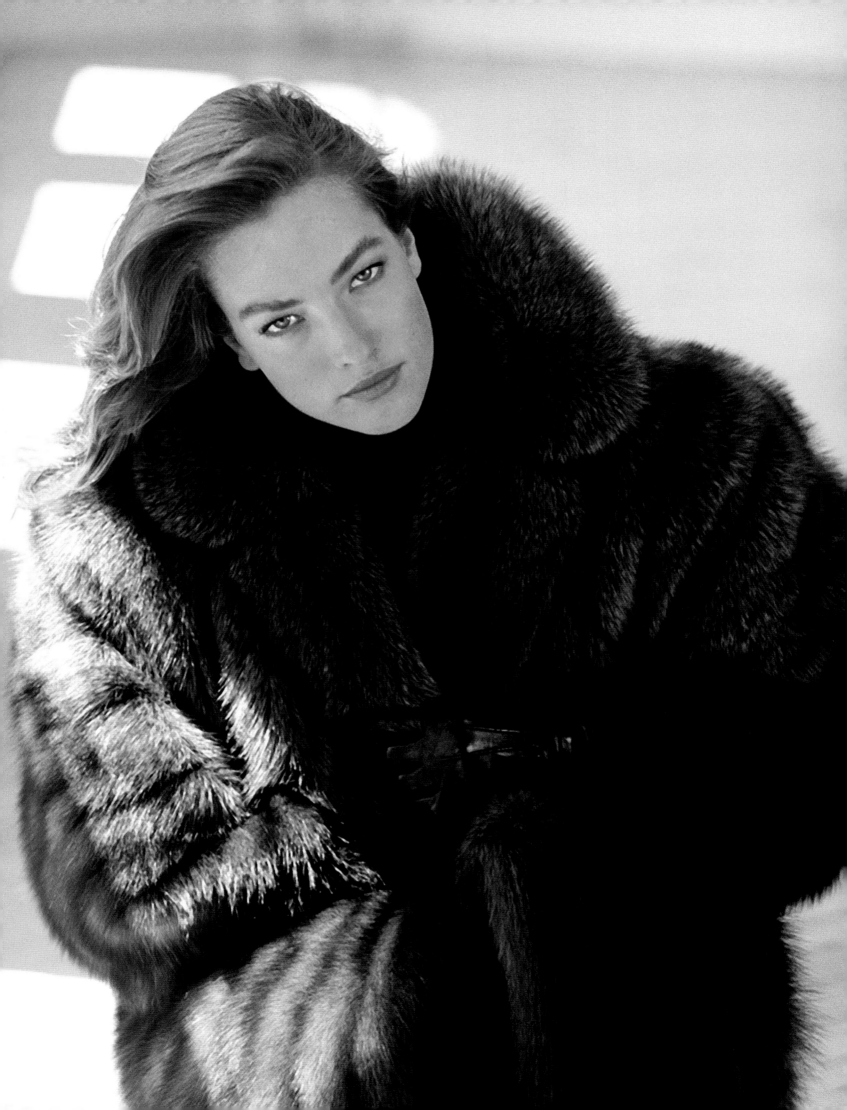

With a Little Help from
his Friends…

"Perry was the first designer who had me make custom
shoes for his shows. He was a genius, and I loved
working with him. I remember making a pair of tartan
Chelsea boots for him that were divine. I always found his
shows so uplifting, so fresh and full of beautiful blonde
girls and handsome men."
— Manolo Blahnik

While Perry's designs were always known for their clean lines, unusual col-
ors, and their textures and proportions, they were also appreciated for their
"attitude"—a kind of effortless, slightly offbeat elegance. Some of that atti-
tude stemmed from the right (often witty) accessory, whether a knitted cap or
a coachman's top hat, pale feminine saddle shoes, or a slender leather belt
latched with a sculpted gold buckle. There were four uniquely talented acces-
sory designers in Europe and America with whom Ellis collaborated, whose
accessories not only anchored and embellished a look but also created a "fin-
ish" to the proportion and silhouette Perry was after.

MANOLO BLAHNIK
When Patricia Pastor wore a pair of yellow suede Manolo Blahnik flats to
work one day, Perry almost flipped. When she explained that Manolo had just
opened a shop on Madison Avenue, Perry wanted to see it right away. Vis-
iting the new shop, they learned that Manolo Blahnik himself and his original
shop were in London, and as they were headed there shortly, they set up an
appointment to meet with him. Of course, they both fell in love with Manolo
and his shoes, particularly Patricia, who was swooning over his pink peau de
soie pumps with a Louis heel. That evening, when they met Manolo for dinner,
he presented her with the pink pumps! A wonderful working relationship devel-
oped: Patricia would tell him that they needed "an Oxford or a boot or pump
and show him sketches of the collection in progress, after which he would
design several things, send a sample with leather colors, and we'd place the
order from that. Or sometimes we'd have a specific idea—fur-trimmed boots

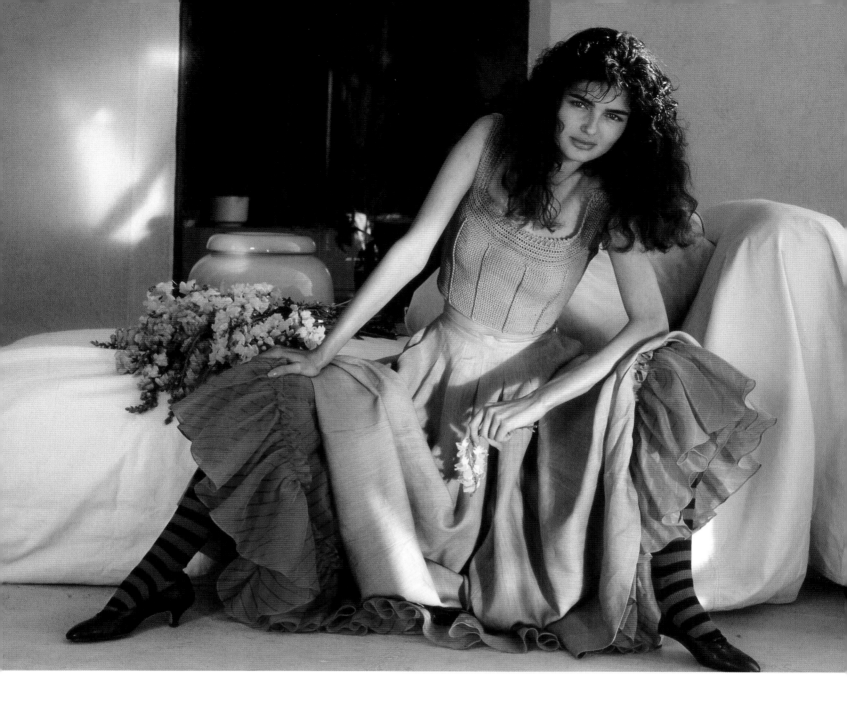

with horn toggles, for example—and he would create those, only make them better than we ever dreamed."[1]

One season they ordered some super-elegant high-heeled alligator pumps (which were almost unheard of at the time) for the show and at the last minute were told that the shoes were stuck in customs and would not be in New York in time. Perry, who did not know the meaning of the word "no," took matters into his own hands by flying George Malkemus, owner of the New York shop, to Paris to pick up the shoes, stash them in his luggage on a flight back to New York, and bring them to the showroom. Malkemus arrived after the show had started but delivered the shoes backstage, and Patricia and Jed frantically tossed them to the models who had only seconds to put them on before they headed out on the runway. Manolo Blahnik shoes brought elegance to Perry's sportswear and Perry, in turn, brought casual sportswear to Manolo, which changed his approach to shoes. Perry was the first designer to collaborate on shows with Manolo, bringing the shoe designer to the attention of press all over the country.

Perry's petticoats paired with Manolo Blahnik's playful grey calfskin pumps with romantic touches like a little bit of lacing and the slight "Louis" shape of the heel. Spring/ Summer 1981. Photograph by Rico Puhlmann.

JEAN-CHARLES BROSSEAU

Perry and Patricia were introduced to French knitwear designer Jean-Charles Brosseau at his charming shop in Paris on the Place des Victoires. They fell in love with his irresistible hand-knitted caps, gloves, and stockings and set up a working relationship. Patricia would often find vintage hats and wear them to the office to see how the shapes worked with the collection they were currently designing. After they decided upon something they liked, she would meet with Brosseau in Paris to see if he had anything similar. Often, he had the perfect thing: Patricia remembers a pair of tights striped under the knee (like athletic socks) that looked as though they had been custom-made for their twirling circle skirts. Brosseau found Perry to be very charming, and the team was invited to have dinner with him and his wife at home when they were in Paris. He also introduced them to exquisite out-of-the way knitting shops where they sourced some fabulous yarns—especially the exceptional multicolored mohair that they used for their Fall 1980 sweater collection. They worked with Brosseau for all of the early collections.

PATRICIA UNDERWOOD

Patricia Underwood, known as "La Underwood" in Perry's design office, was only one of two people given such an honorific, so highly was she regarded within the group. (The other person was Carrie "La Donovan," fashion editor of the *New York Times Magazine*). Patricia Pastor had been wearing one of "La Underwood's" porkpie hats and Perry wanted to meet the women who had created it. Perry's team and "La Underwood" really clicked. They loved her wonderful eye, great spirit, and sense of fun, while Patricia loved that Perry invited her to fittings, including her in the design process. Initially, she designed a few straw hats, then she began to work with them regularly, creating wonderful hat concepts from their sketches. After she made the block, she would bring in hat samples for them to examine and try on. Jed, a very tall guy with a perfect size seven head, became Perry's favorite hat model. Jed thought it was "a hoot" at first, but after a couple of years, it occurred to him that for some reason, Perry really *did* need to look at the hats on him. Underwood's wonderful brimmed hats were used throughout the "Chariots of Fire" collection in Spring 1982; the famous Basque

flat straw hat that succeeded after many "trying" tries was used in the "España" collection. Other hats having their star turns were the crushed fez toque, the coachman's top hat for the "Dreamgirls" collection, and the beautifully colored suede cloche hats for the Sonia Delaunay show of Fall 1984. "La Underwood" admired the way they did everything, commenting, "It was wonderful working with Perry Ellis; everything was true to a logic."[2]

BARRY KIESELSTEIN-CORD

Two very savvy editors, Jade Hobson of *Vogue*, and Eve Orton, then at *Harper's Bazaar*, had both suggested to Perry that he might want to meet Barry Kieselstein-Cord, a young sculptor and jeweler who was designing belts and other accessories with exotic skins and leather, using gold or silver buckles that he sculpted. Then, starting in 1979, BKC designed belts for Perry, season after season. Based on the fabrics and sketches he was given, his own sketched-out ideas soon took the form of a wax mold of what the sculptured buckle would look like. They were elegant forms—a duck, an anchor, a ruffled heart, a graceful wing—and for many, they became cherished collector items. The gorgeous belts had great cachet, and naturally Perry wanted to show the belts with his clothes during the shows and for photographic shoots. But because of their value, Barry had to substitute brass and plate for the precious metals, and even then they had to watch everyone like hawks to make sure a belt didn't walk off in someone's bag. (The belts were so expensive that BKC always had a gun in his own office and on his person when he brought the belts to Perry's showroom.) When Perry first designed furs for Alixandre, many of them were sold with Kieselstein-Cord's jewel-like belts—if you wanted the coat, you had to pony up for the belt. It was a wonderful and enduring association for both sides: the accessories perfectly complemented the clothes, and BKC and Perry respected each other immensely. "To this day," Barry says, "Perry is the finest person I ever met in the fashion business."[3]

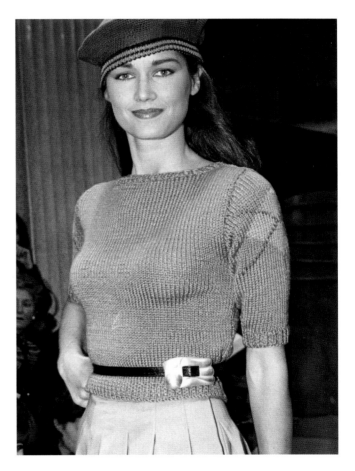

"Length just never matters—it's understanding proportions and looking in the mirror to see what works."
–Perry Ellis

"Perry would sit on the cutting room table as I draped a jacket on the form. He would tell me precisely how he wanted a collar or where a pocket needed to be placed exactly. He had this ridiculously important eye that knew exactly what it wanted. He couldn't look at anyone's sketches but Jed's. We worked ridiculously long hours. . . . Who could work 100 hours a week? We did. We did it because we were always motivated and happy. Perry was always so generous with his attention to us."
–Nick Gjovic

"Often, people would attach the word 'quirky' to Perry's clothes because they were different. I hate that word because it belittles that which is original or new—or just plain good. Perry's clothes were often labeled quirky until six months later when everyone was wearing and/or copying them."
–Isaac Mizrahi

"Perry had this remarkable sense of proportion. He knew if something was too broad or too long, if it was too wide or too short. Often we fit something three or four times. He would take something and craft it until it was exactly what he had envisioned. But nothing was ever extreme— it had to be believable and often the changes were very subtle. He had this unerring eye that could discern that minutest difference."
–Jennifer Houser

"Perry loved the precision of perfection, and he expressed that in his clothes. You know that I am a WASP, and Perry's clothes were very WASPy but never boring. They were very boarding school, very well brought up. He gave a certain weight to flimsy. I still wear some of his sweaters when I am golfing."
–Polly Mellen

"Perry was always so supportive. And I always think of him. You can never *not* miss him."
–Patricia Underwood

COLLECTIONS

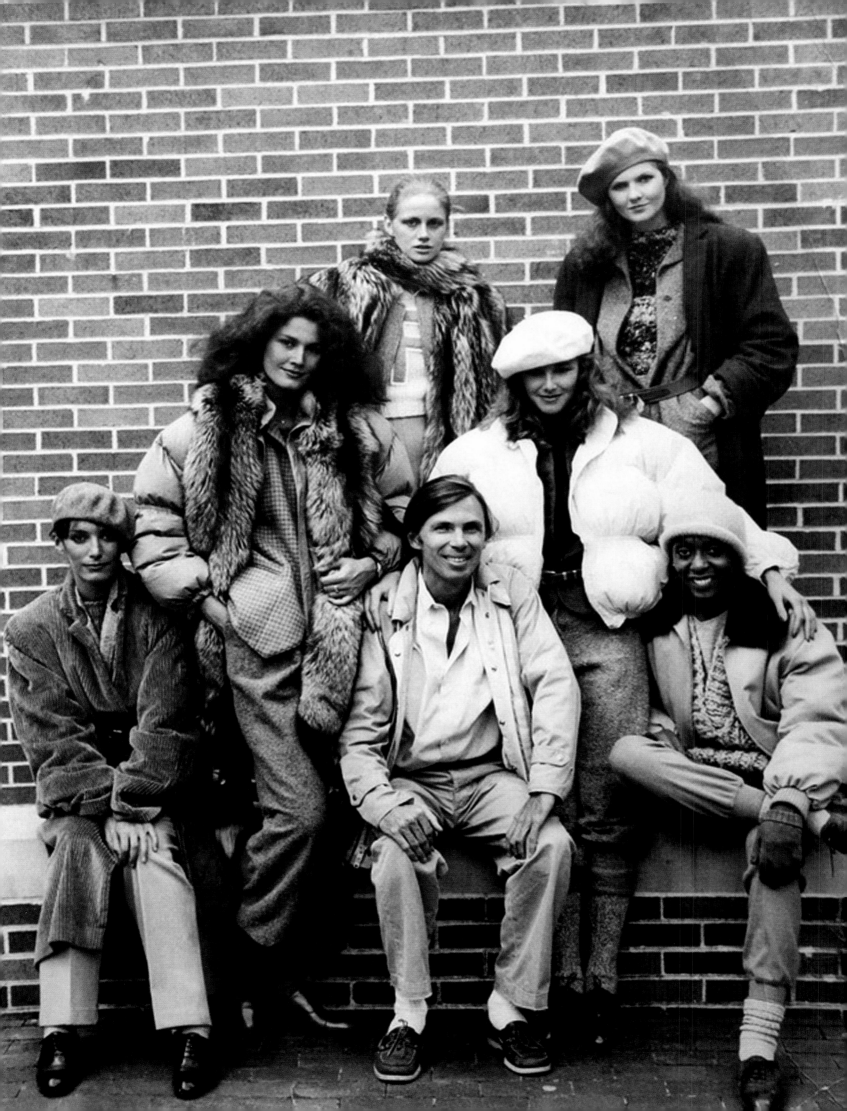

FALL/ WINTER 1978

The Perry Ellis approach to fashion was "to look at the familiar differently"[1] and his Fall 1978 collection, the first major show for Portfolio, was an extraordinary case in point. Using real-life cheerleaders from Princeton University and their football team's star quarterback, he set the backdrop for a parade of 1950s-collegiate-inspired clothes. But the familiar, nostalgic look was utterly transformed by proportions adding a bold, modern sophistication to the classic shapes and textures providing richness and depth. A new silhouette was introduced, in both overstated and understated ways, one wide at the shoulder and tapering to the hip.

Perry juxtaposed proportion and shape in big over skinny and short over long silhouettes. He put together unconstructed layers from a wide range of luxurious textures: plush wide-wale corduroy, chunky tweeds, hand-knits of unwashed Irish sheep's wool, soft mohair, Shetland wool, gabardine, flannels, checks, and adventurous new looks for fur, such as velvety sheared beaver, with thick ribs that gave it the casual nonchalance of cloth.

Stacks upon stacks of shoulder pads on steroids raised the profile of the whole look, from a shoulder-padded coat to a shoulder-padded jacket to a shoulder-padded "little" sweater, barely grazing the waist, together creating a strong silhouette that was broad at the top and narrow at the bottom. There were slim pants and stitched-down pleated skirts and on the legs even more texture: wool tights or long johns with rolled-down knee socks, dyed to match the dusty hues of the clothes—rose quartz, olive, slate blue, and mustard. And grounding everything were short cowboy boots or smart, flat-heeled, lace-up Oxfords.

The collection's short-over-long proportion was exemplified in what Perry referred to as his exaggerated "superhuman, surreal lifesaver"[2]: his short, bold-shouldered "Michelin Man" quilted poplin parka in battleship gray over skinny pants. The same proportion, subtler, was seen in a soft wool melton blouson jacket, with a rounded collar and outside merrow-stitched seams in hardy Irish tweed, over a slim silky tweed skirt. And one of the best moments? The quilted puffed jacket with a silver fox boa tossed over it—pure tongue-in-cheek Perry.

The spirit of the collection was completely American and unlike anything anyone else was doing. A huge step for Perry, it was enough of a sensation to make the European fashion community finally sit up and take a serious look at what American designers were doing.

Perry and models. Fall/ Winter 1978. Photograph by Judy Gurovitz.

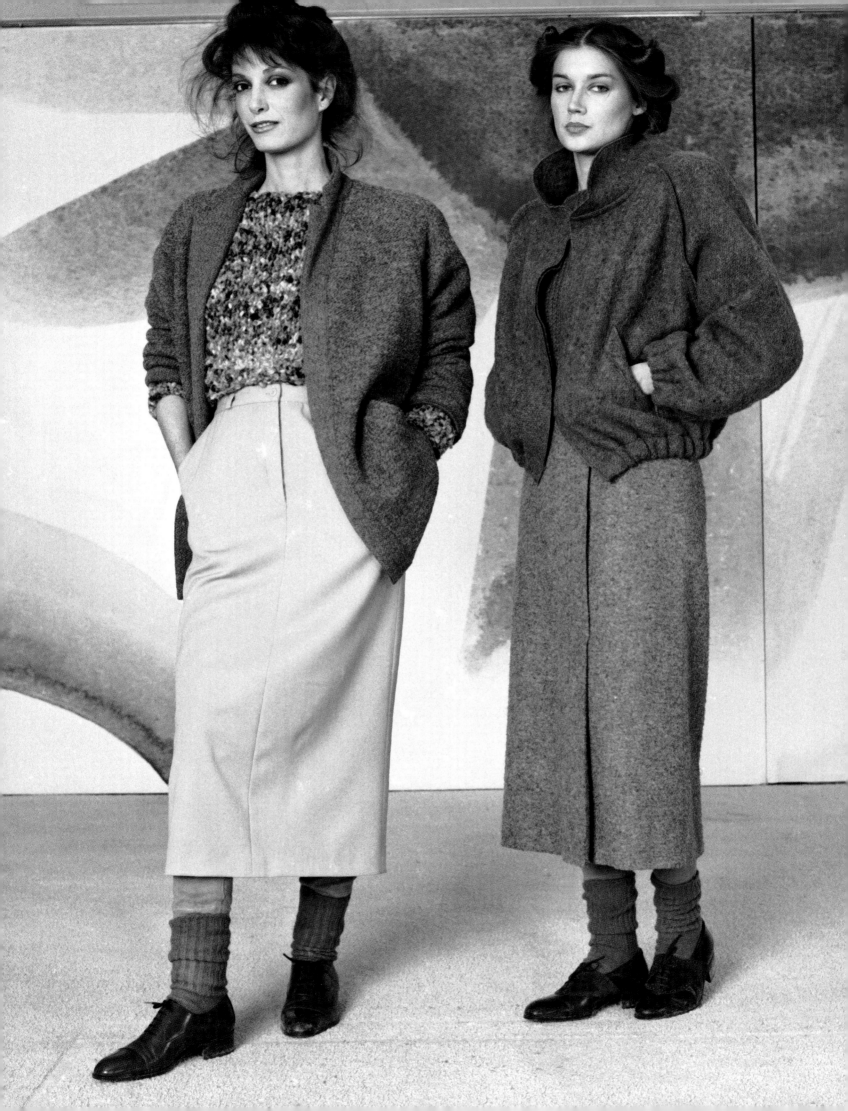

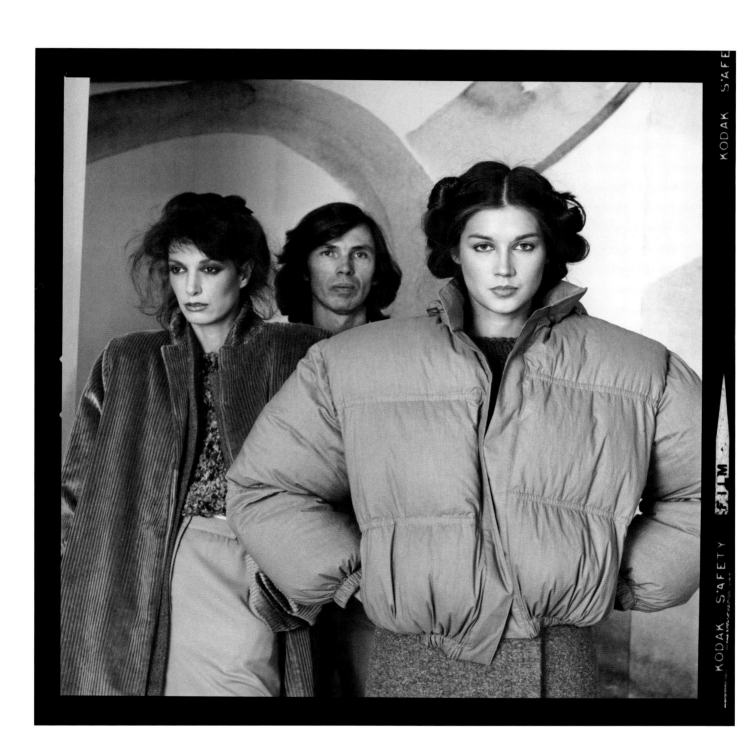

Perry's proportion of the
season—big over skinny.
Fall/ Winter 1978. Photo-
graphs by Harry Benson.

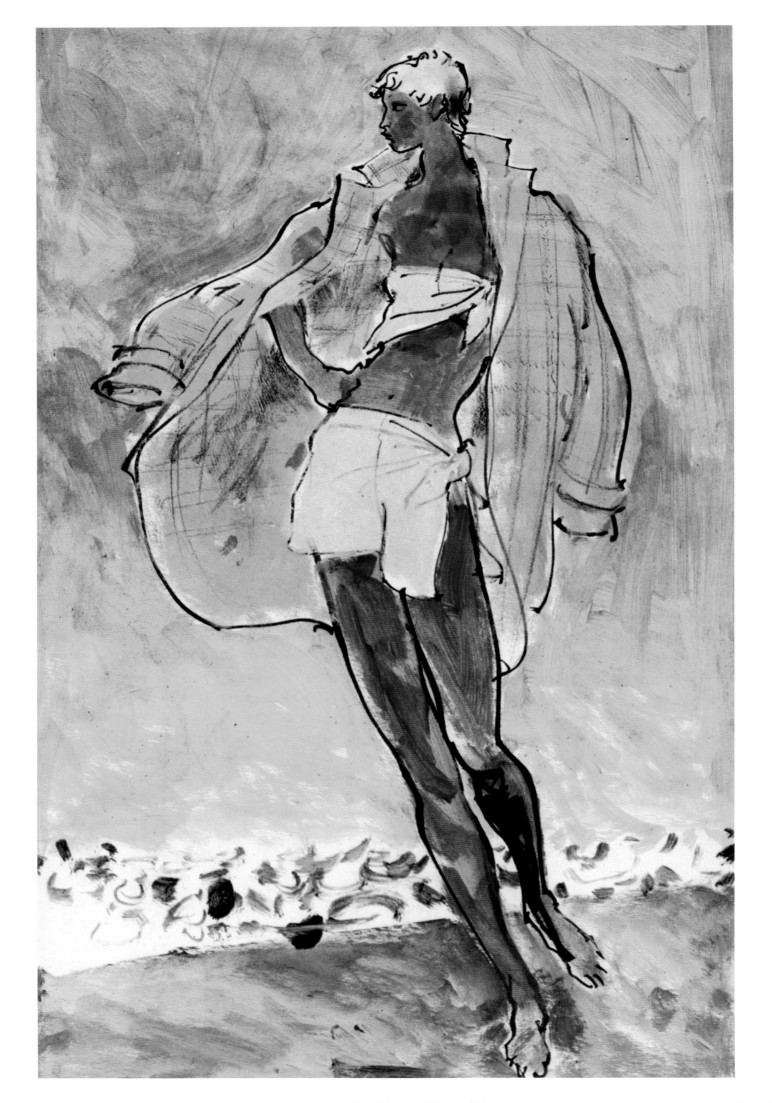

Perry decided to take a lighthearted approach to his Spring 1979 "Pink Champagne" collection, creating variations on ideas from the past season, allowing them to evolve into new shapes, fabrics, and colors. He kept the same broad-on-top, narrow-on-the-bottom proportions, but used lighter-weight silks, linens, and cottons in a fresh palette of rose quartz, carbon, taupe, blue, and silver—and worked in solids or beautifully-colored stripes and plaids. The layering of textures continued, with the addition of some light, warm-weather shapes: double-breasted linen jackets, little vests, skinny to the knee pants, and box-pleated mini skirts, which were shown over pale, footless tights. (Perry, the consummate perfectionist, could never find tights in the colors that he preferred, so Patricia Pastor individually hand-dyed some white tights in her bathtub to achieve the perfect summer rose.) Other accessories included crocheted socks, tams and caps, simple slides, and flat Oxfords.

Life magazine, in an April 1979 feature on Perry, the up-and-coming designer, previewed some of his bests-of-show: a short, waist-cropped, double-breasted white linen jacket, over a miniskirt and and footless tights rolled up to the knee with simple slides; a hip-length silk camisole that float open to the back over skinny silk toreador pants; and Perry's beguiling "swimsweaters"—a playful take on turn-of-the-twentieth-century bathing suits, handknitted of cotton yarn with drawstring detail at the top.

Perry had always harbored an antipathy toward pantsuits (to him, they seemed too stiff and serious), so he created his own take on them in a softer, re-proportioned way: short cropped jackets with cropped pants or short split-skirts; and a longer, big shouldered shirt-jacket with rolled up sleeves, over slim pants. There were also soft-tailored skirt suits in pinstripes and plaids and feminine hand-knitted bustiers and bandeaux tops to be worn with or without a jacket.

With a wink to the couture tradition, Perry finished each show with a traditional bride-look. Model-sisters, Janice and Debby Dickinson, along with Sunny Redmond appeared as bridesmaids pretty in pink, quaffing pink champagne, each bearing a single beribboned amaryllis lily with the bulbs and roots attached. The girls pranced down the runway, gliding into deep "splits" at the end, followed by Tree Allen, the strawberry-blonde bride in a short pink linen dress, singing the Barbra Streisand lyrics from the movie "Funny Girl": "I am the beautiful reflection of my love's affection . . . a beautiful, beautiful, beautiful bride!"

Spring/ Summer 1979.
Sketch by Kenneth Paul
Block.

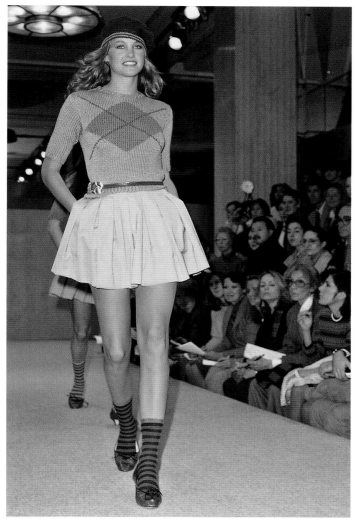
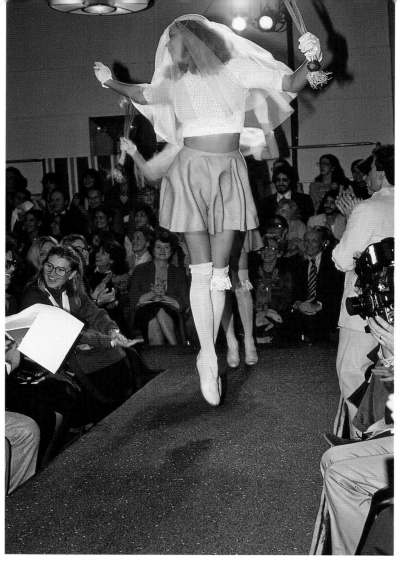

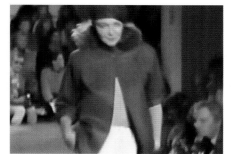

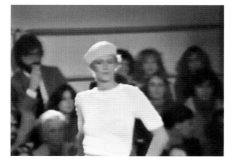

Video stills from the runway.
Spring/ Summer 1979.
Sketch (detail) by Jed
Krascella.

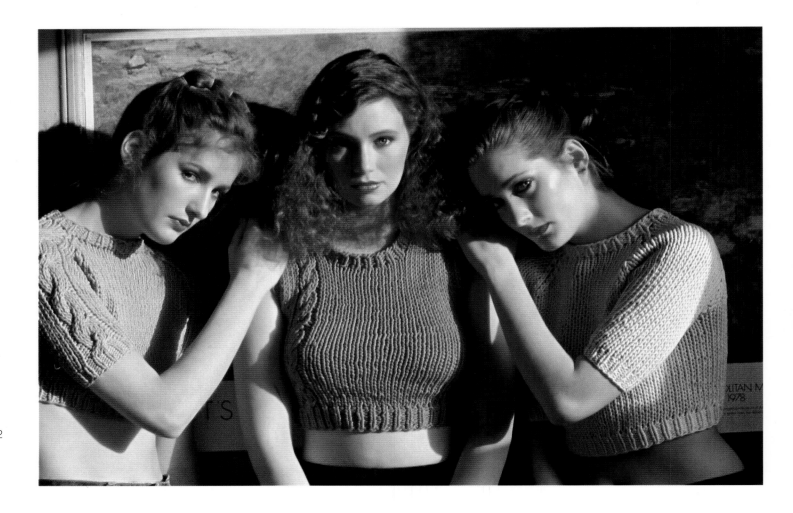

Perry's sexy midriff-baring hand-knit sweaters. Spring/ Summer 1979.

Opposite: Perry makes the cover of *W* with his bold-shouldered linen jackets over slim or pleated skirt and little hand-knits sweaters. Spring/ Summer 1979. Photograph by Ulli Rose.

Following pages: Perry's dressed down sportswear in dressed-up linens and silks. Spring/ Summer 1979.

One dollar

Happy American Fashion

W

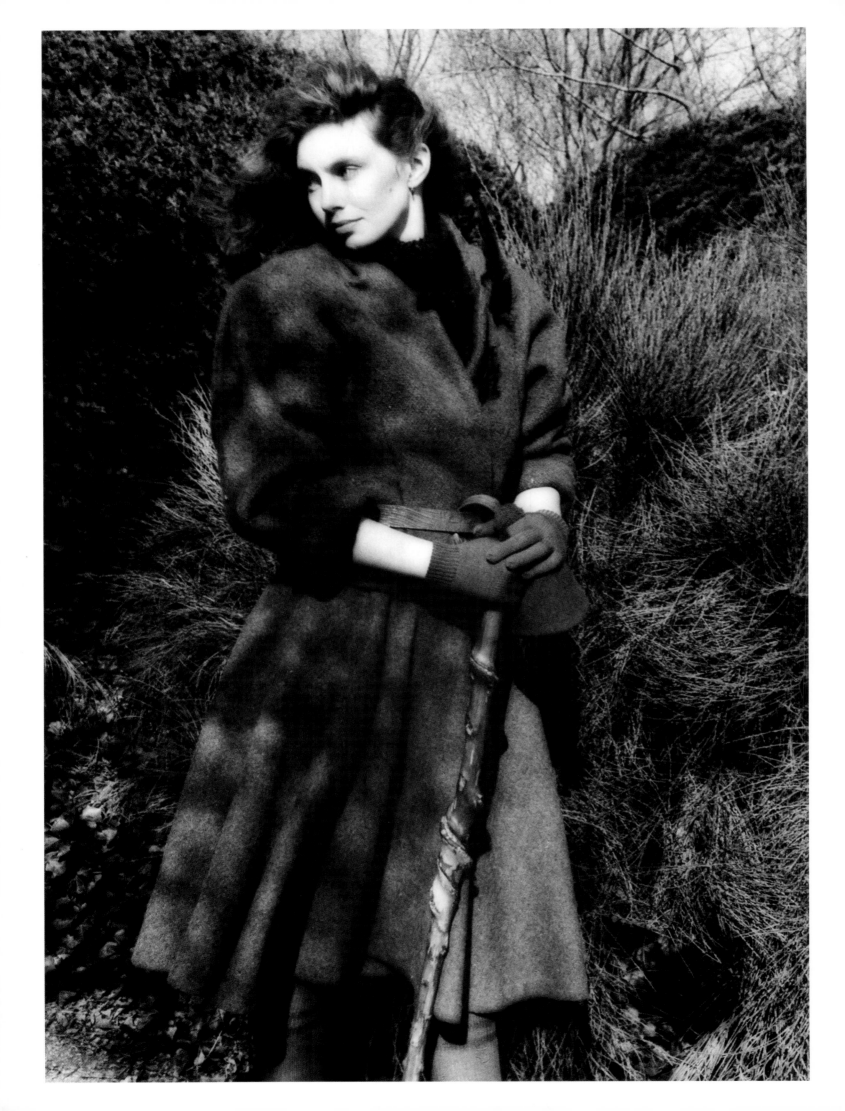

FALL/ WINTER 1979

If the brilliant Fall 1978 "Princeton Cheerleader" collection was about youthful collegiate exuberance, then Perry's new Fall 1979 collection featured a more grown-up girl, a sophisticated upper-classman, as it were, with a veneer of elegance that reflected her new surroundings. Fresh proportions prevailed—many of them rounded—short swinging circle skirts topped with big-sleeved, broad-shouldered sweaters or short shaped jackets and lots of high-waisted, full-legged pants that taper at the ankle. The show also debuted Perry's first plunge into pure color, in bold and unusual combinations: rich tones of teal, purple, and fuchsia, with some black and grays, various shades of pink used together, and a rainbow of multicolored Irish Riverton tweeds.

Fall/ Winter 1979 also featured Perry's new "dimple sleeve"—a kind of "pucker" created by a forward-facing pleat extending the width of the shoulder; it would soon become a treasured Perry Ellis trademark. The dimple was used at the shoulder of jackets, coats, sweaters, and shirts; it was also placed at the hip of his high-waisted "Hollywood" pant to create fullness before it tapered and buttoned at the ankle. The circle skirts, also pleated at the hip, had movement and swung gracefully around the knees. Another of Perry's favorite proportions— long over short—appeared in lean, hip-length sweaters pulled down over short pleated skirts. This mix of lengths and proportions reiterated Perry's sentiment that fashion should be fun; he favored options over rules. Perry also introduced his signature hand-knit single-cable sweater. A minimalist's version of the classic, it featured just one large cable down the front center (rather than in rows). The sweater was an instant hit, quickly becoming an identifiable Perry hallmark.

To accessorize the show, Perry called upon the inventive jeweler Barry Kieselstein-Cord, to design belts with his gorgeous handmade gold and silver buckles; he also worked with the French accessories designer Jean Charles Brousseau who created hand-knit gloves, scarves, and hats for a number of Perry's shows, and for this one: knitted berets, caps, and scarves. In addition, Perry unearthed a flock of whimsical pheasant feathers—floating around the runway, on sweaters, and tucked into jacket pockets and caps. Turning the traditional fur into young, sassy nearly floor-length oversized coats, Perry also showed, for the second season, his wonderfully irreverent way with furs for Alixandre, with whom he had begun to design the previous fall.

Perry continues to design broad shouldered silhouettes, and this season they become rounder. Fall/ Winter 1979.

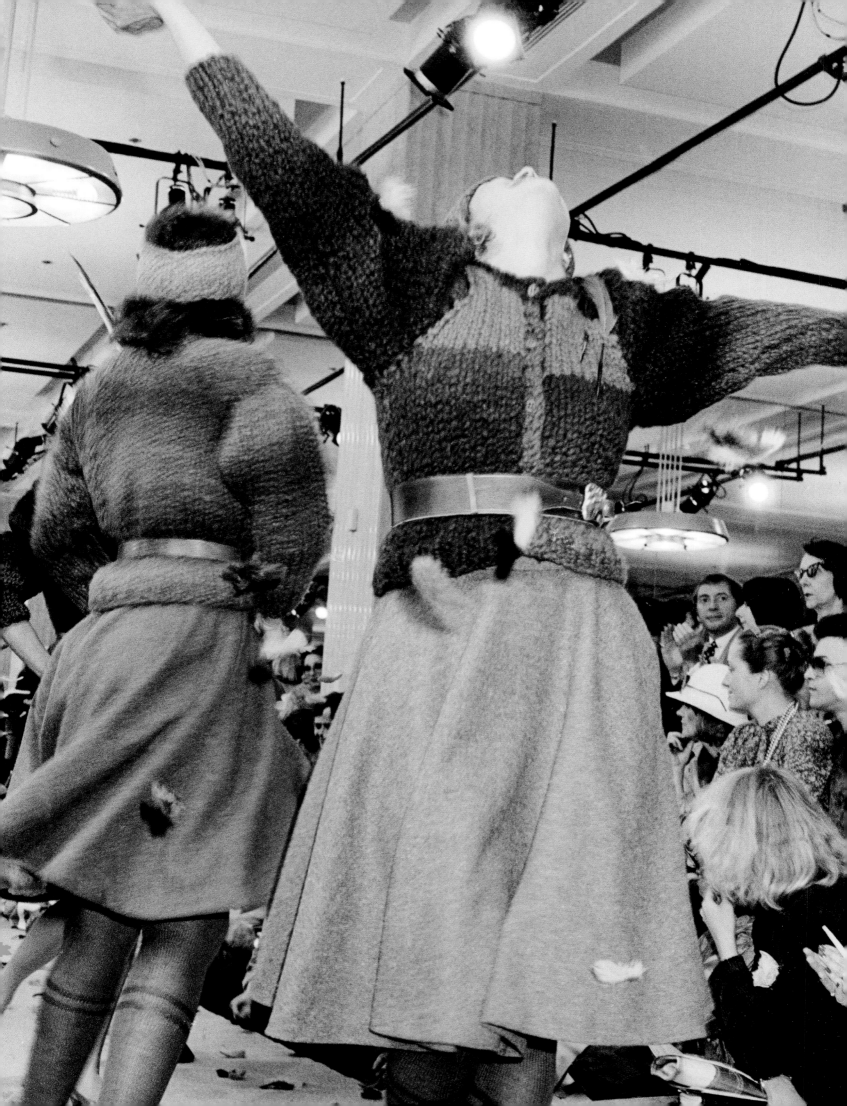

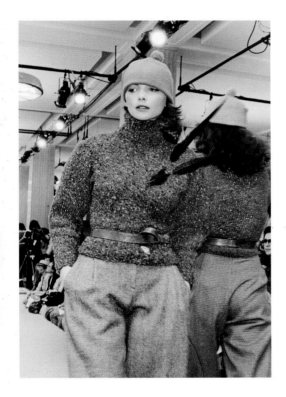 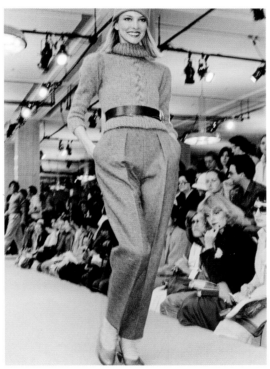 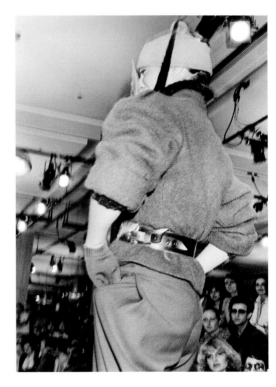

Opposite, Perry shows his
first dimple-sleeved sweat-
ers in chunky hand-spun
multicolor heathered yarn
that move from rich red into
deep pink, to blue, ochre,
olive, and khaki—all in one
sweater; Left, single cable
front heathered Donegal
tweed sweater; Center,
cable front dimple sleeved
Scottish Shetland hand-
knit; Right, tweed short
jacket over Donegal tweed
hand-knit, side-dimpled,
pleated pants. Runway, Fall/
Winter 1979. Photographs
by Roxanne Lowit.

Following pages: Left,
heathered, brushed McNutt
tweed jacket in sienna and
teal over hand-knit turtle-
neck sweater in bark-brown
Donegal tweed, paired with
heathered tweed circle skirt
in fuchsia and lizard belt
by Barry Kieselstein-Cord;
Right, matching look on
model in a different color
combination. Fall/ Winter
1979. Gouache drawing by
Jed Krascella.

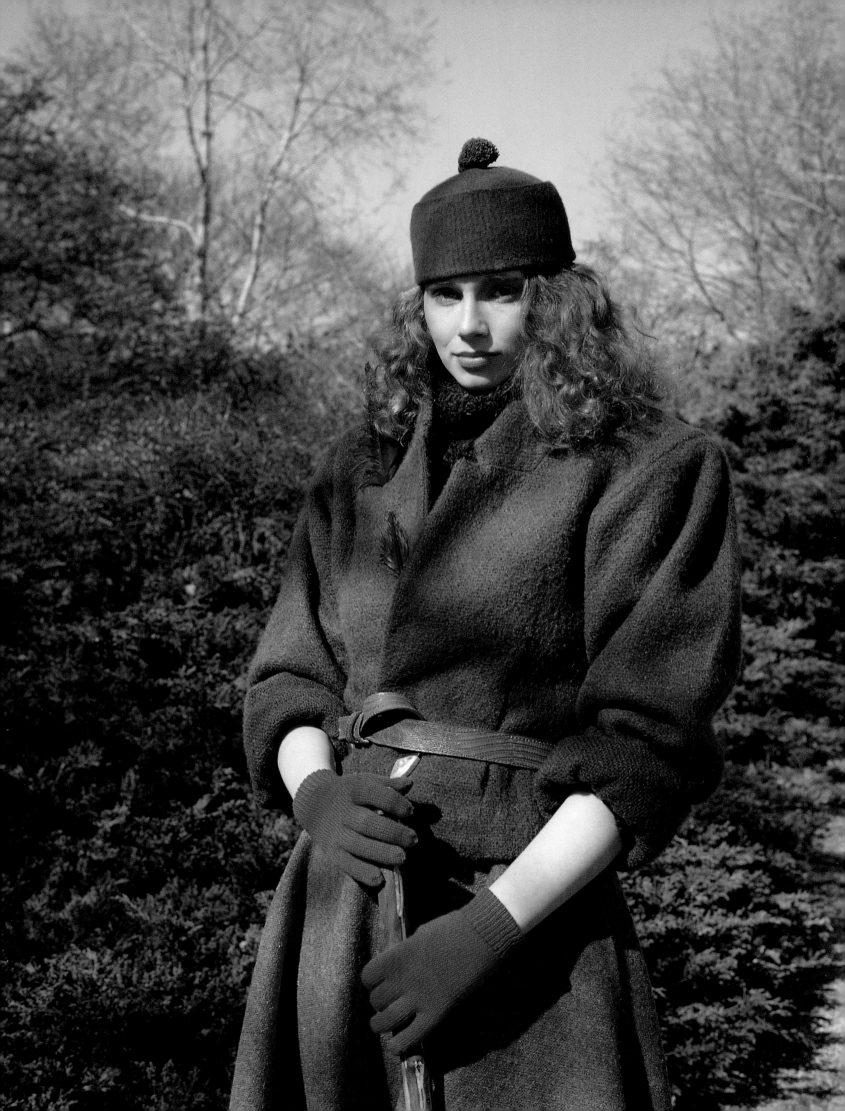

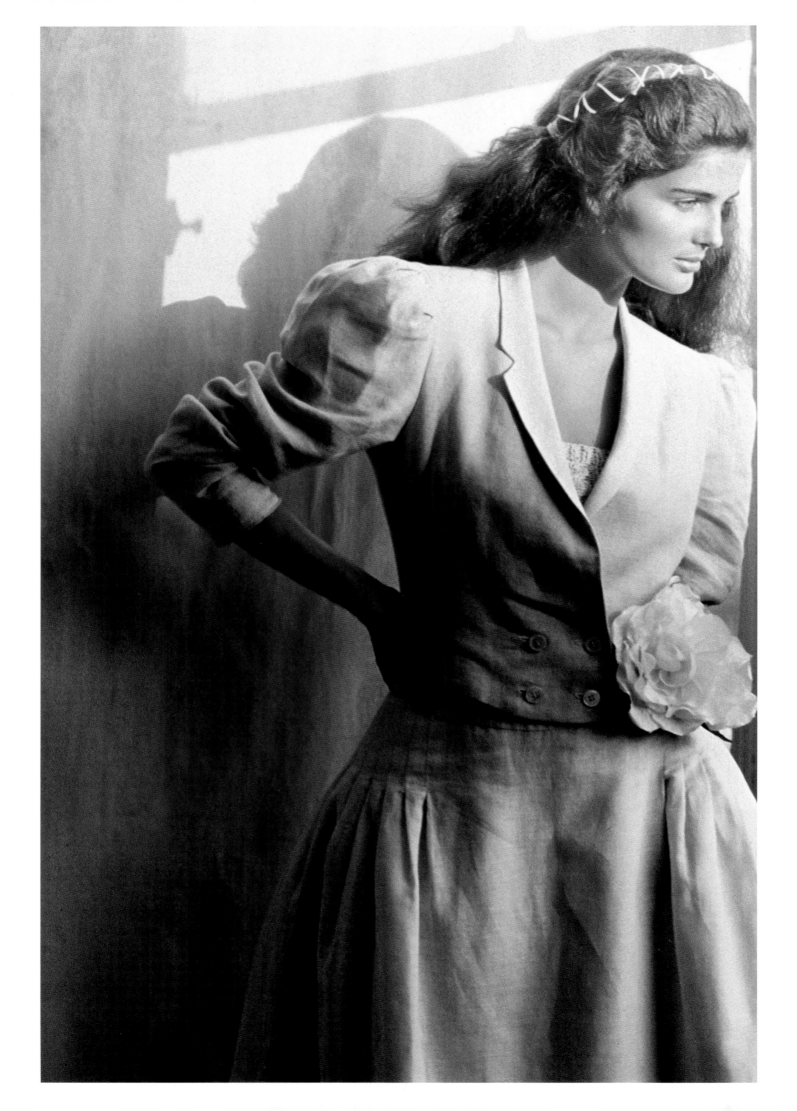

SPRING/ SUMMER 1980

Perry's Spring 1980 shapes for his "Farthingales" collection were rounded but refined: feminine silhouettes in sophisticated yet soft shades of seashell pink, pearl gray, tea rose, shy blue, and yellow—as well as dark and rich colored linens. Perry's jackets were still broad-shouldered, but the shoulders were rounded and cleverly extended via stiff, little pieces of organza; they were shown with small curved "petal lapels" or no lapels at all and were often cropped and close to the body—or longer in front and shorter in back.

The jackets topped yoked skirts that fit tightly over the hip, then belled out (thanks to the apron of organza inserted underneath) into a rounded, more voluminous shape. These skirt shapers were inspired by the Elizabethan "farthingale"—a boned sort of mini-petticoat—that, by rounding out the width at the hip, made the waist seem as tiny as Scarlett O'Hara's. (There were some dubious comments made by critics who wondered how many women in the U.S. really wanted to emphasize the width of their hips, but ultimately the charm of the look won them over.)

There were longer jackets, too, that hiked up over the hips revealing mini-skirts and shorts, or cropped pants. Perry's signature hand-dyed and hand-spun silk knits were used not only on single-cabled cardigans, but also on strapless tube-tops that buttoned up the back. White pointelle socks and pale beige Oxfords with a subtle heel completed the pretty, "girly" looks. There was a sense of chasteness and innocence in the collection, but also a kind of dressiness that Perry had never shown before, as he ramped up for a notably dressier decade.

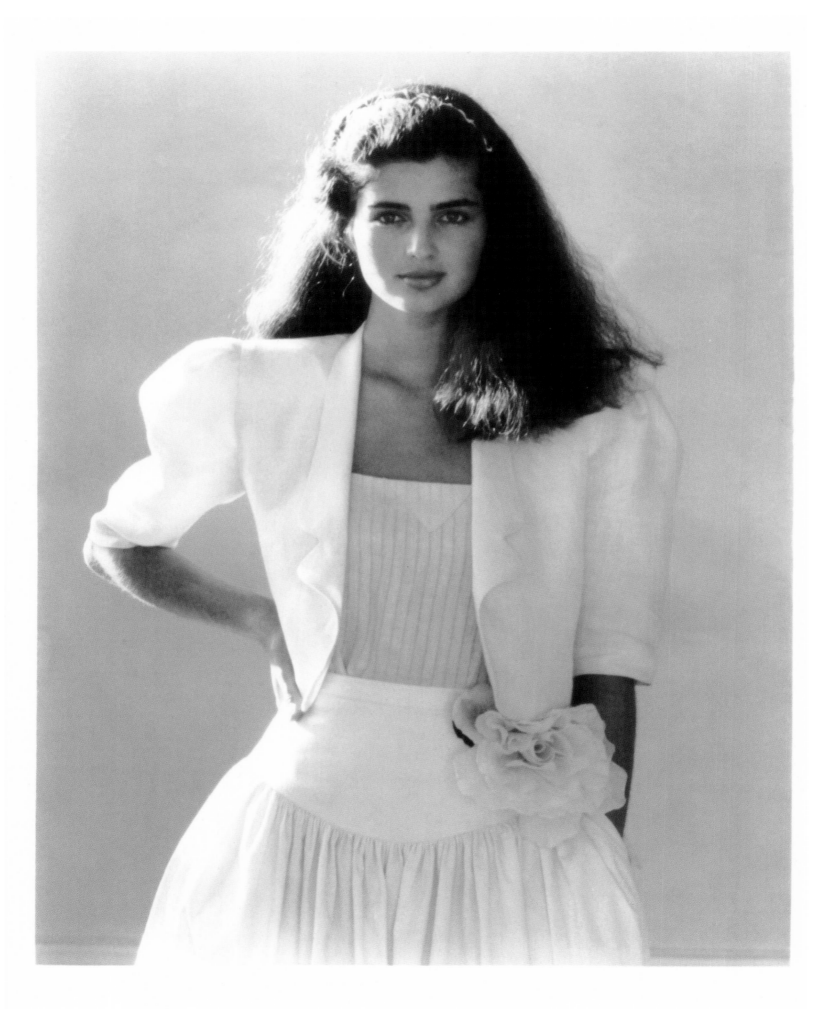

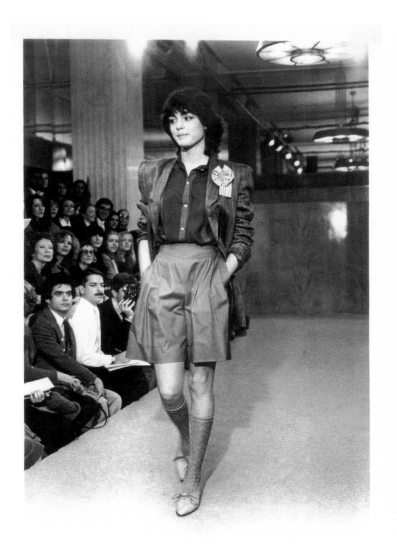

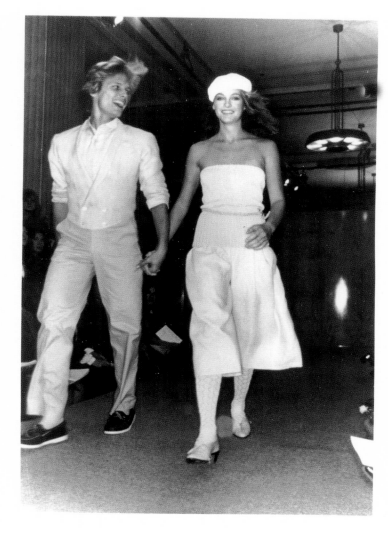

Opposite: Short and
structured pastel Italian
linen jacket with extended
shoulders, over a hand-
knitted bustier and farthingale
skirt. Skirt is pleated with
organza inserts so it falls
away from the body. Silk
organza rose at the waist.
Spring/ Summer 1980.

Above: Images from
the runway. Spring/
Summer 1980.

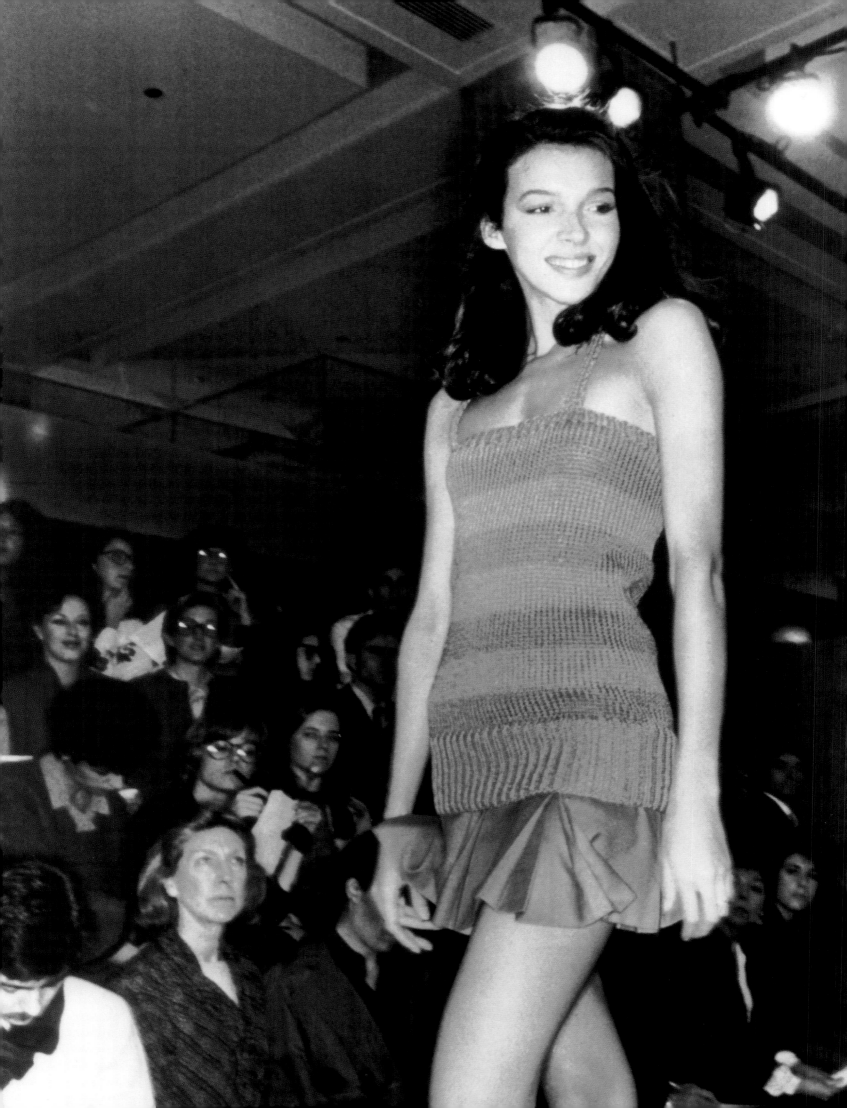

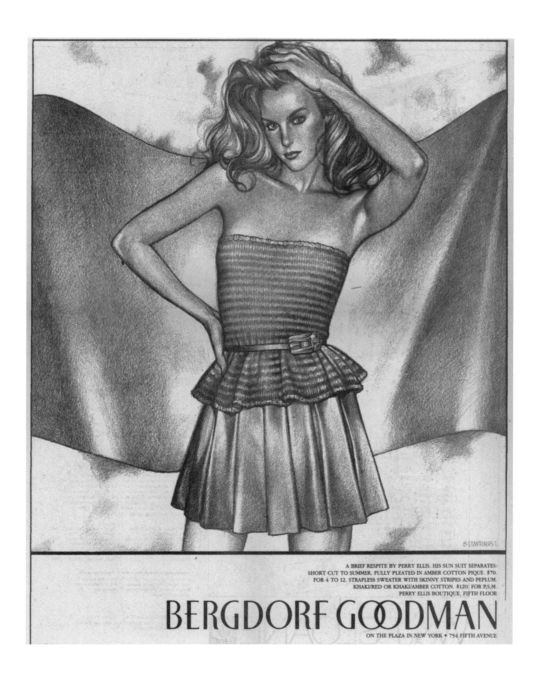

A BRIEF RESPITE BY PERRY ELLIS. HIS SUN SUIT SEPARATES:
SHORT CUT TO SUMMER, FULLY PLEATED IN AMBER COTTON PIQUE. $70.
FOR 4 TO 12. STRAPLESS SWEATER WITH SKINNY STRIPES AND PEPLUM.
KHAKI/RED OR KHAKI/AMBER COTTON. $120. FOR P.S.M.
PERRY ELLIS BOUTIQUE, FIFTH FLOOR

BERGDORF GOODMAN

ON THE PLAZA IN NEW YORK • 754 FIFTH AVENUE

Opposite: Long lean striped
skinny-strapped sweater
over short pleated skirt.
Spring/ Summer 1980.

Above: Illustration by
George Stavrinos.

Video stills from the runway.
Spring/ Summer 1980.

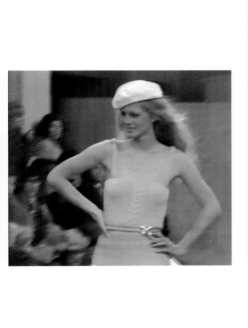
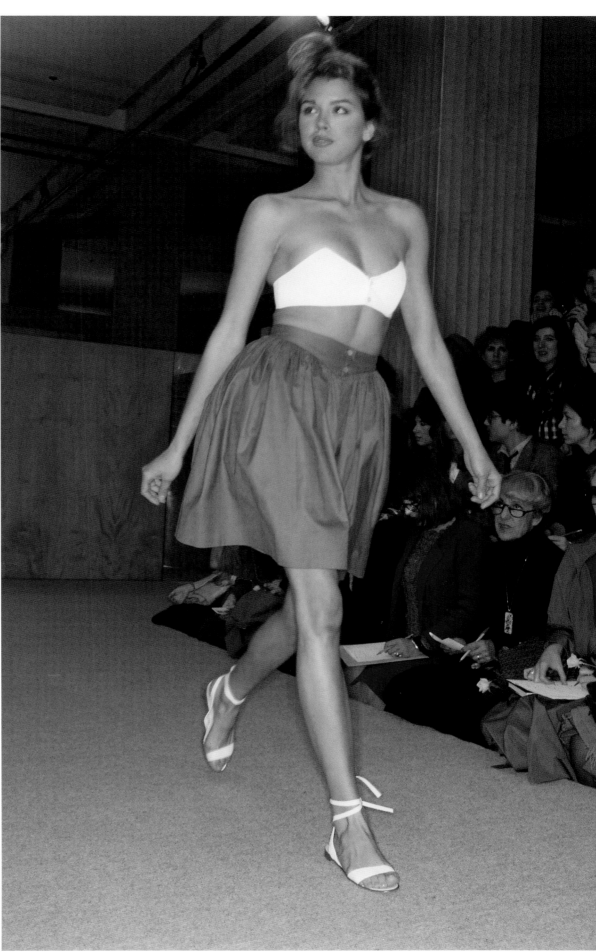

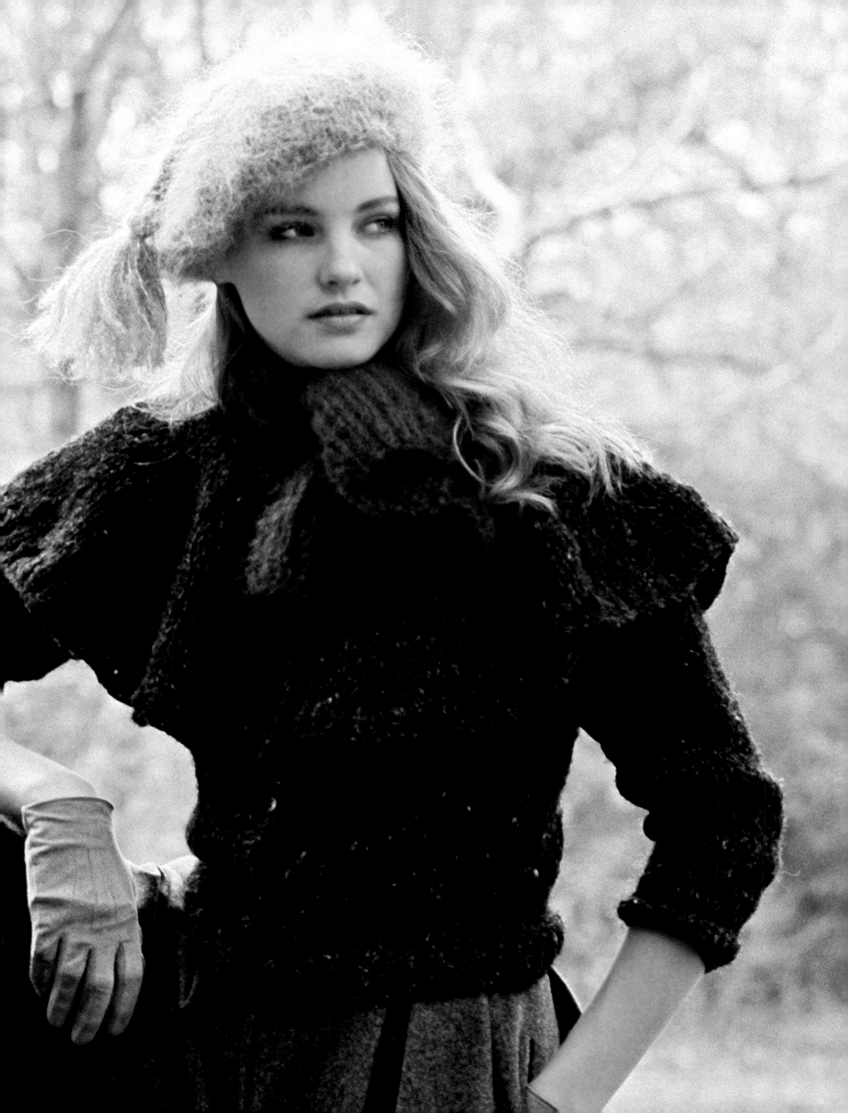

FALL/ WINTER 1980

As he had done in his previous spring collection, Perry continued to experiment with layers and rounded shapes, with a group of beautifully rendered wool suits, which *WWD* had charmingly christened "skating suits": jackets with capelets and peplums paired with full, back-swinging skirts. They were young and spirited, full of movement, yet at once polished—a conceit that the designer pulled off like no one else. Once Perry had a great shape in mind, he loved to reiterate it in different textures: ingeniously, he applied the capelet idea to his coats, jackets, and shirts—and especially to his hand-knits, a group of lush mohair sweaters, many of them done in a specially-spun ombre mohair from France, so soft that it needed to be brushed like a kitten. Fall 1980 introduced long and skinny pullovers with full capelets and short cardigans with capelets, layered up with mohair scarves.

For Perry, the more mohair, the merrier, so he worked with woven mohair fabric, fashioning a round-shouldered, big-sleeved cropped jacket in vibrant orange-red and pink plaided mohair over a pleated, tartan skirt. He used matching McNutt tweeds for sweaters and skirts in a variety of proportions—long over short, long over long. In a variation on a classic, Perry used a single argyle pattern, blowing it up so that it covered the entire front of a tweedy hand-knit crewneck, then paired it with short divided skirts and baggy pants. The feminine collegiate look carried right down to the knee socks and feminine Oxfords with small heels. Other accessories included mohair scarves, berets, and charming "unicorn" caps (their tops complete with a knitted "horn") by French accessories designer Jean Charles Brosseau.

In a departure from his soft-sweater look, Perry also showed a perfect gray flannel suit for women—a plausible outfit for the workplace but done with cropped, wide pants that introduced a little softness and wit. (In fact, the suit was a harbinger of the influence that menswear looks would have on women's clothing for the next few years.) His furs for Alixandre were sometimes given the capelet treatment, too: a sheared mink capeleted coat and a long shearling cloak, among others. Perry also showed for the first time, a full men's collection, gearing it toward the adventurous man and featuring a number of design elements like collarless jackets and baggy trousers that had been nicked from the women's collection.

Opposite: With an ever-keen eye on details, Perry's graceful cardigan with attached capelet in charcoal-gray and multi-flecked Donegal tweed is complemented with gray pearl buttons with a tasseled beret (hand-knitted in brushed mohair) and gray suede gloves. Fall/ Winter 1980.

Following pages, left: *WWD* called this look the "skating suit"—a waist-nipped, fuchsia jacket with capelet in French melton wool over a matching back-pleated circle skirt. Following pages, right: *W* featured this vibrant ensemble on the cover of their issue entitled "Look American" (May, 1980). Accompanying the photo was this precise description: "Perry Ellis—short, young, vibrant."

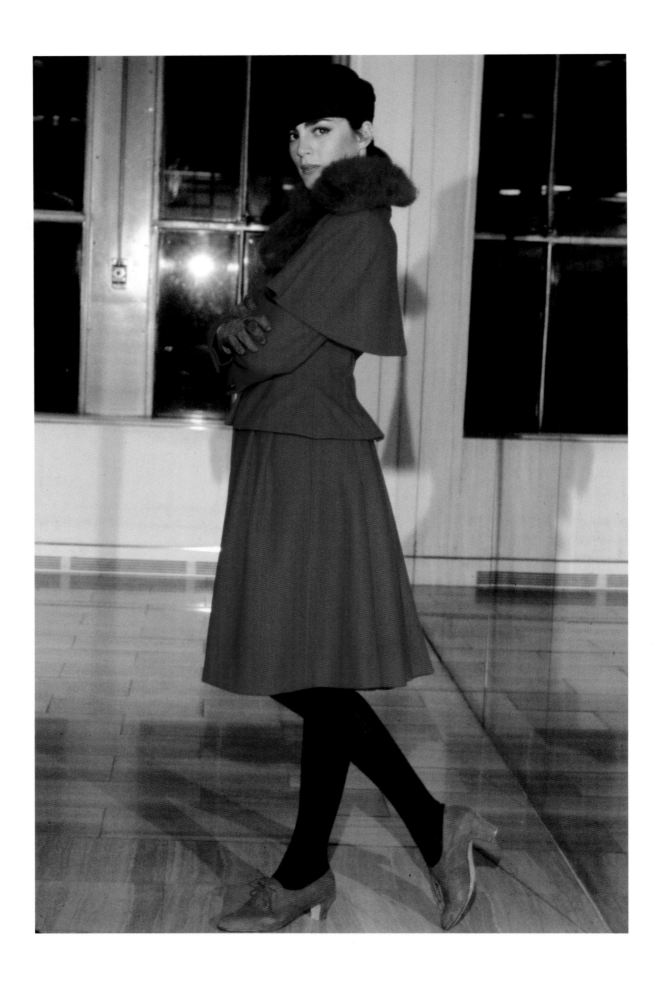

PERRY ELLIS

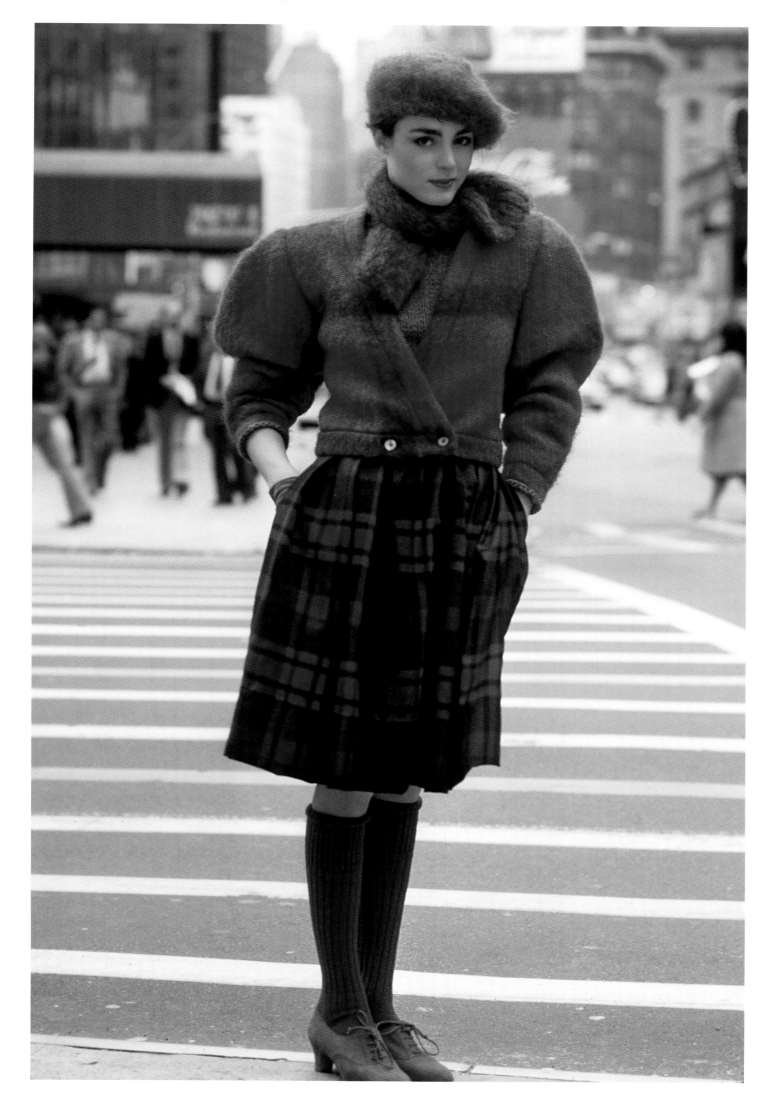

PERRY ELLIS

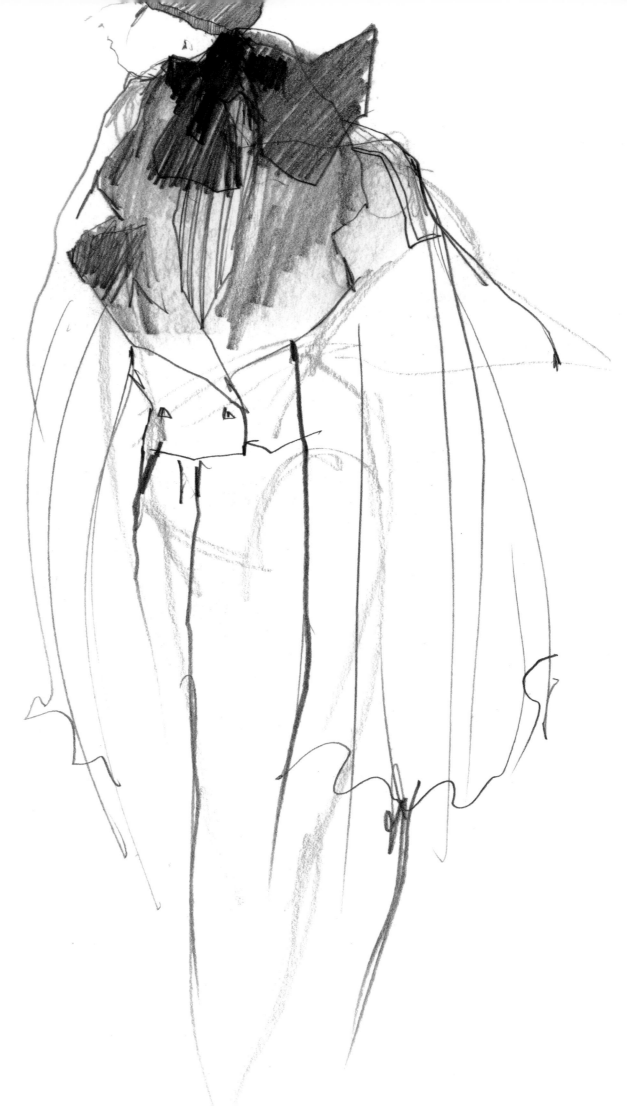

Inverness cape over
hand-knit turtleneck and
cropped wide-leg plaided
pants (opposite), a creation
inspired by the exploratory
cloak sketch (above) by Jed
Krascella.

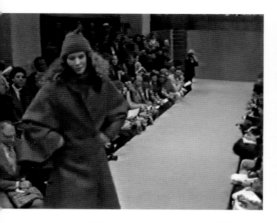

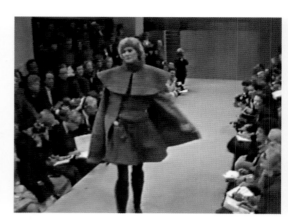

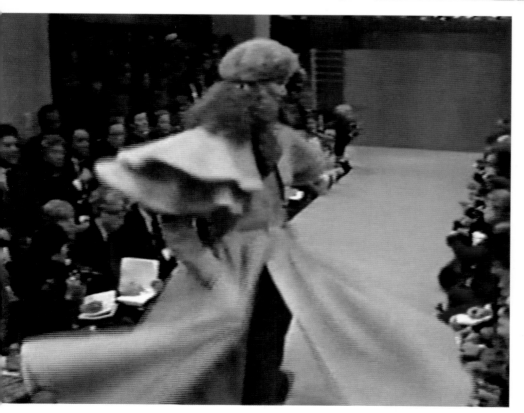
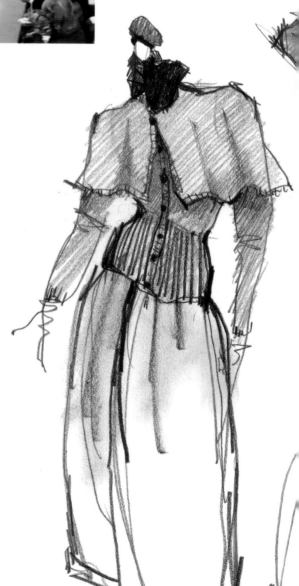

Video stills from the runway.
Fall/ Winter 1980.

Sketch by Jed Krascella.

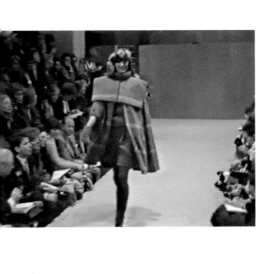

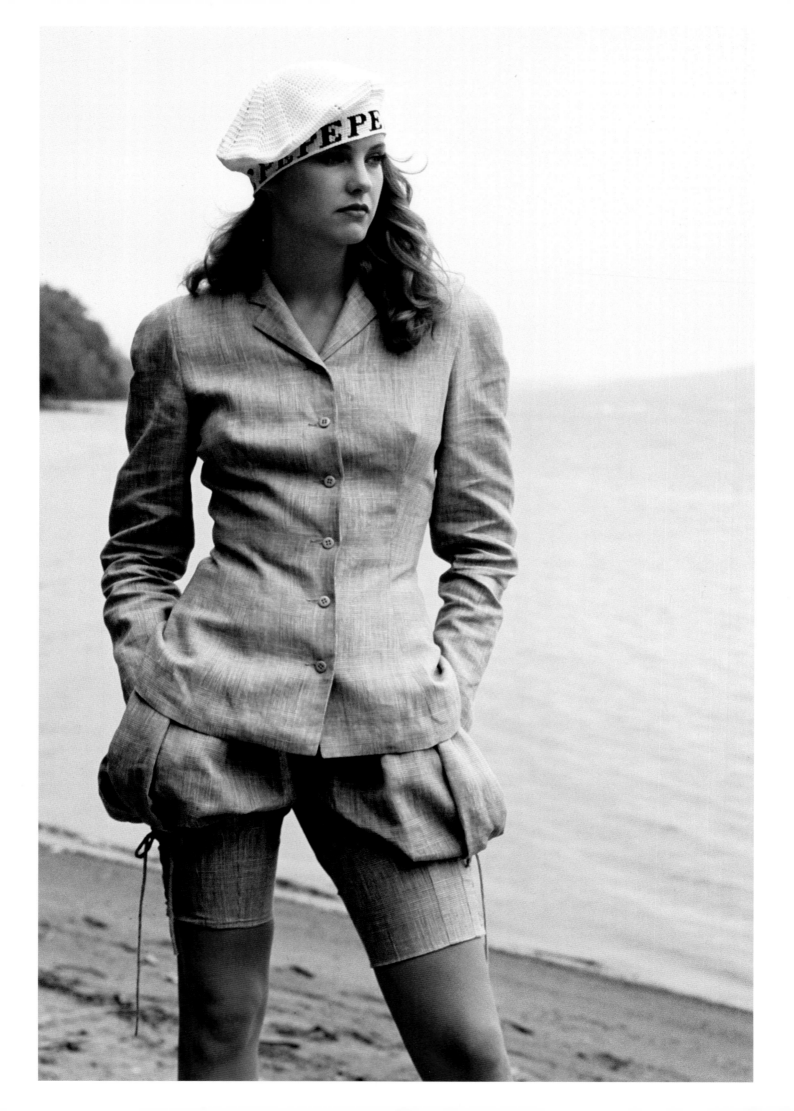

SPRING/ SUMMER 1981

"It's My Turn," sung by the supremely sultry Diana Ross, was heard over the speakers as fashion industry types, photographers, celebrities, and friends filed into Perry Ellis's Spring 1981 "Liberty of London" show. The song might have been an anthem for the designer whose moment had definitely arrived: Perry was truly at the top of his game, with a range of soft, rounded silhouettes—and again, a strong emphasis on proportion, which brought a new level of sophistication to his clothes.

The designer had lunched with John Fairchild, *WWD*'s publisher, several months before his show and had been giving him a verbal preview of what his new collection would look like. While he was discussing his fabrics—the bold striped cottons, delicate Liberty prints, and argyle knits, Fairchild evidently said to Perry, "Why don't you do a khaki collection?" Perry immediately took to the idea and incorporated some khaki pieces into the line: not the heavy duty, military-strength cloth, but a fine khaki cotton faille that was both dressy and casual at the same time. He experimented with a variety of jacket shapes, from long to fitted and waist-grazing to tailored with a pleated peplum. One beautifully fitted jacket was inspired by the Swiss Guards uniform. The jackets topped pants in every imaginable shape—short bloomers, culottes, billowing golf pants and cropped-at-the-ankle pants—and there were full skirts with petticoats, as well. Feminine new tops showed up, under jackets or on their own like camisoles, laced up corselets, belted sleeveless tunics called "tabards," as well as long wide-striped cotton croquet sweaters, which were pulled over skinny shorts. Again, his men's collection featured a number of the same fabrics and some similar silhouettes to those in the women's collection.

A gift from Jean-Charles Brosseau, the Perry Ellis banded beret is the only item that ever bore Perry's initials.

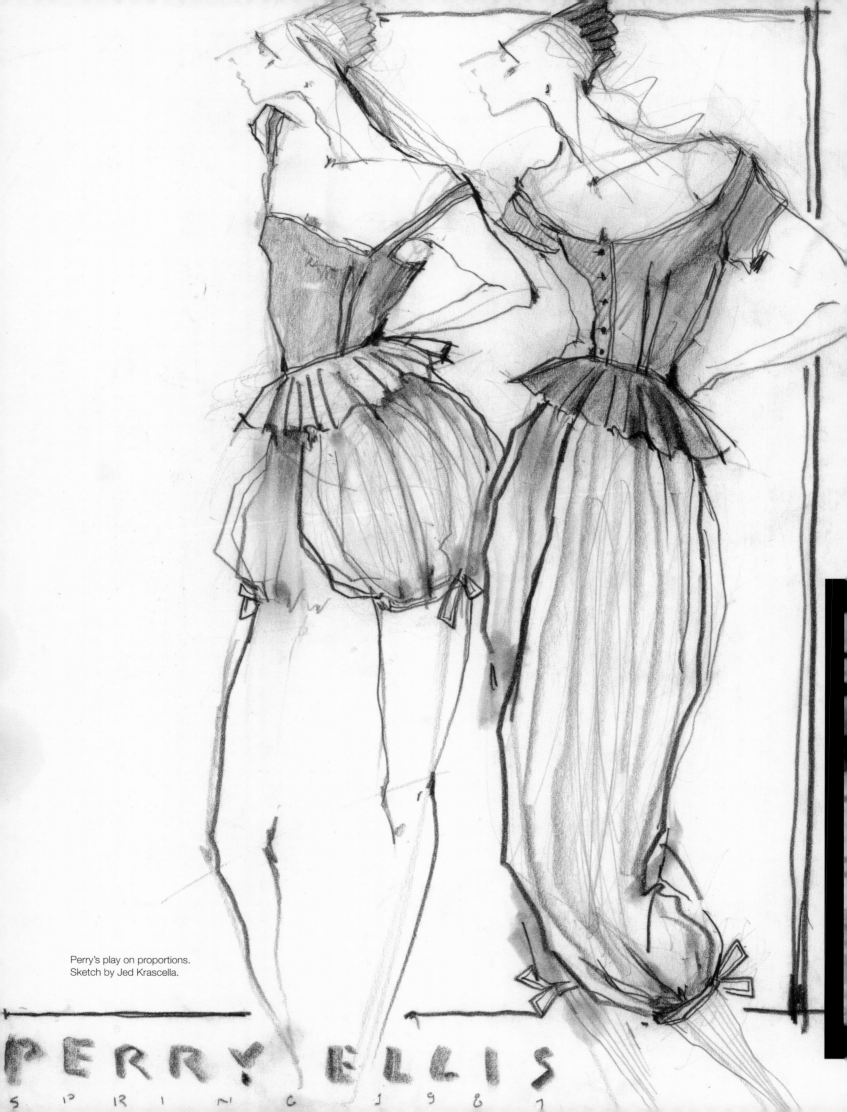

Perry's play on proportions.
Sketch by Jed Krascella.

PERRY ELLIS
S P R I N G 1 9 8 1

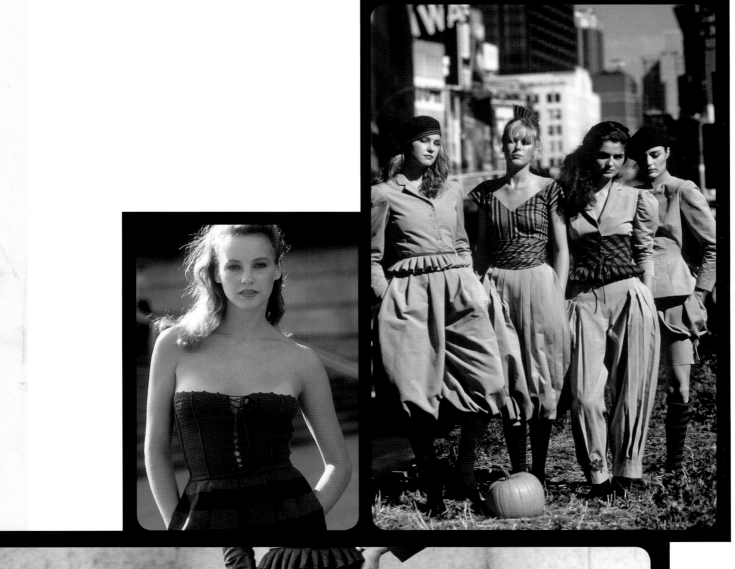

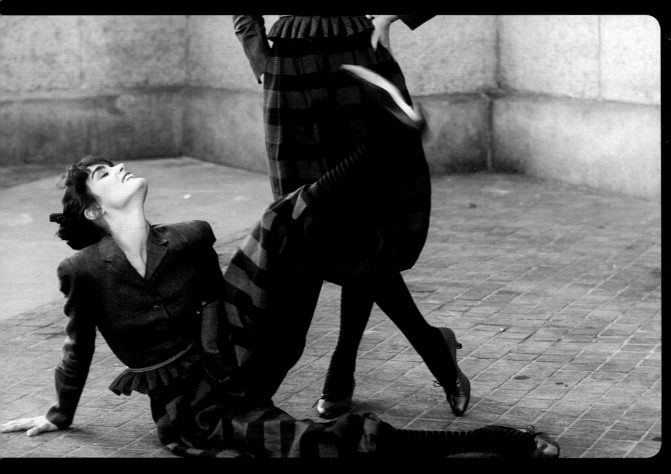

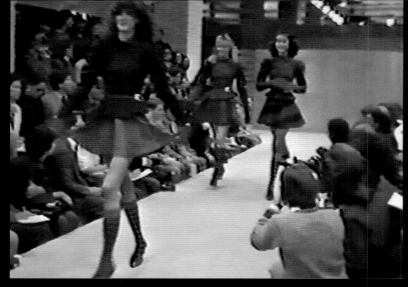

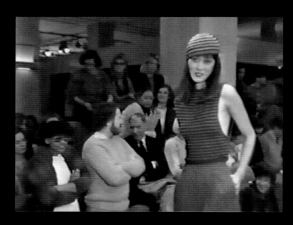
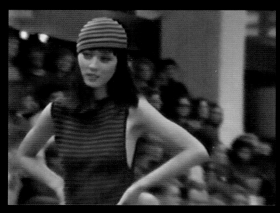

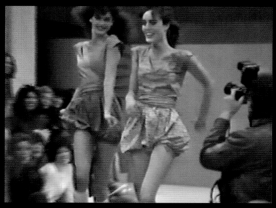
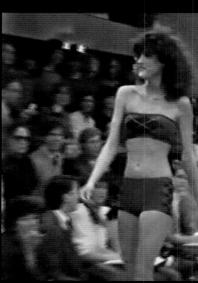

Video stills from the runway.
Spring/ Summer 1981.

Left: Lauren Hutton (left) and
TK (right).

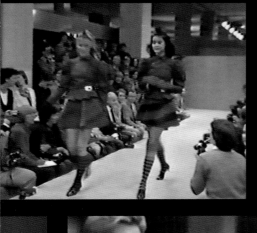
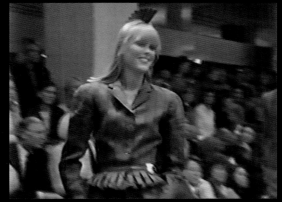
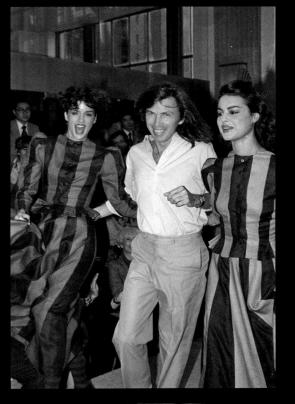

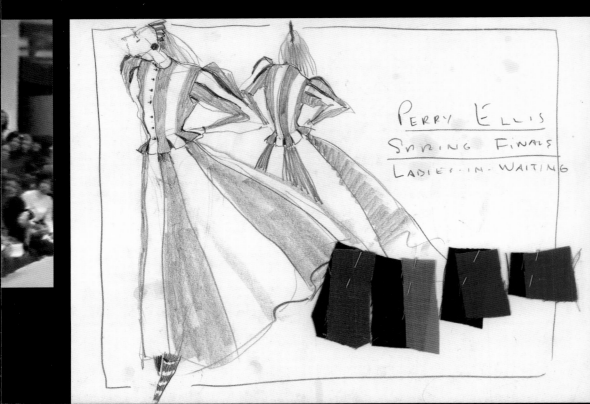

PERRY ELLIS
SPRING FINALS
LADIES-IN-WAITING

194

Above: Striped blazer
in fine Italian Etro fabric
over V-neck sweater with
pleated khakis. Spring/
Summer 1981.

Opposite: Jacket with
peplum over striped and
pleated pantaloons,
inspired by the Swiss
Guard uniform. Spring/
Summer 1981.

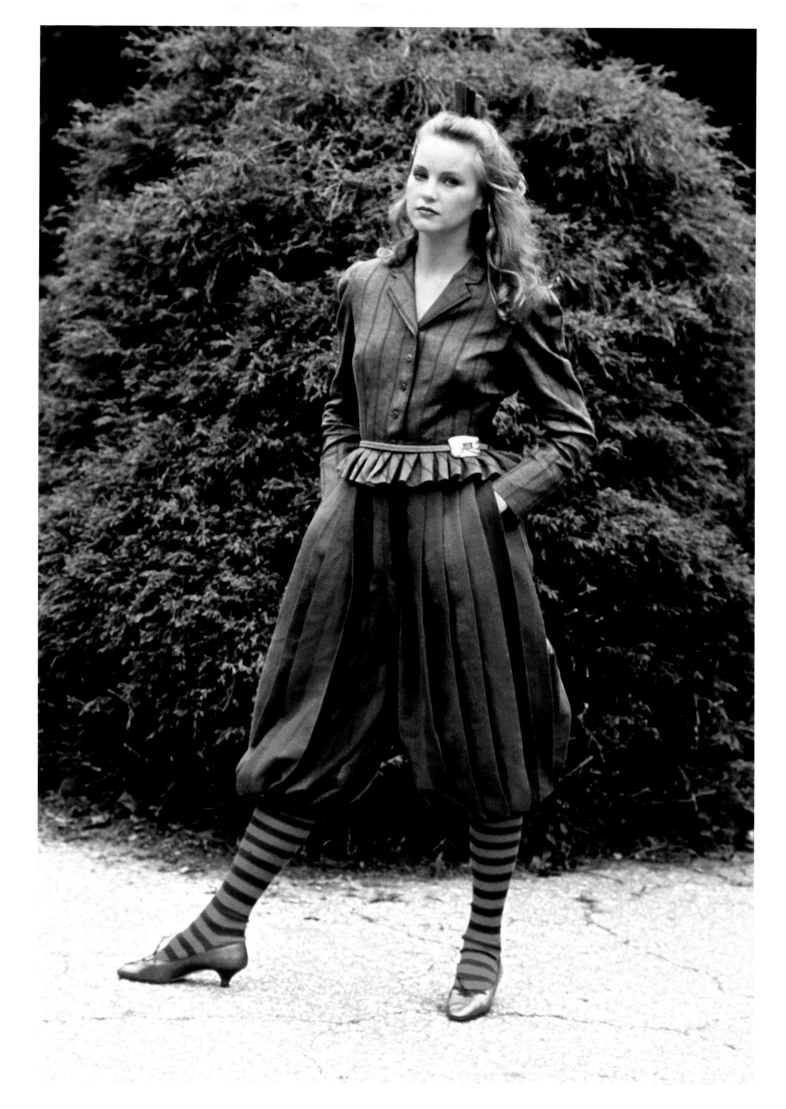

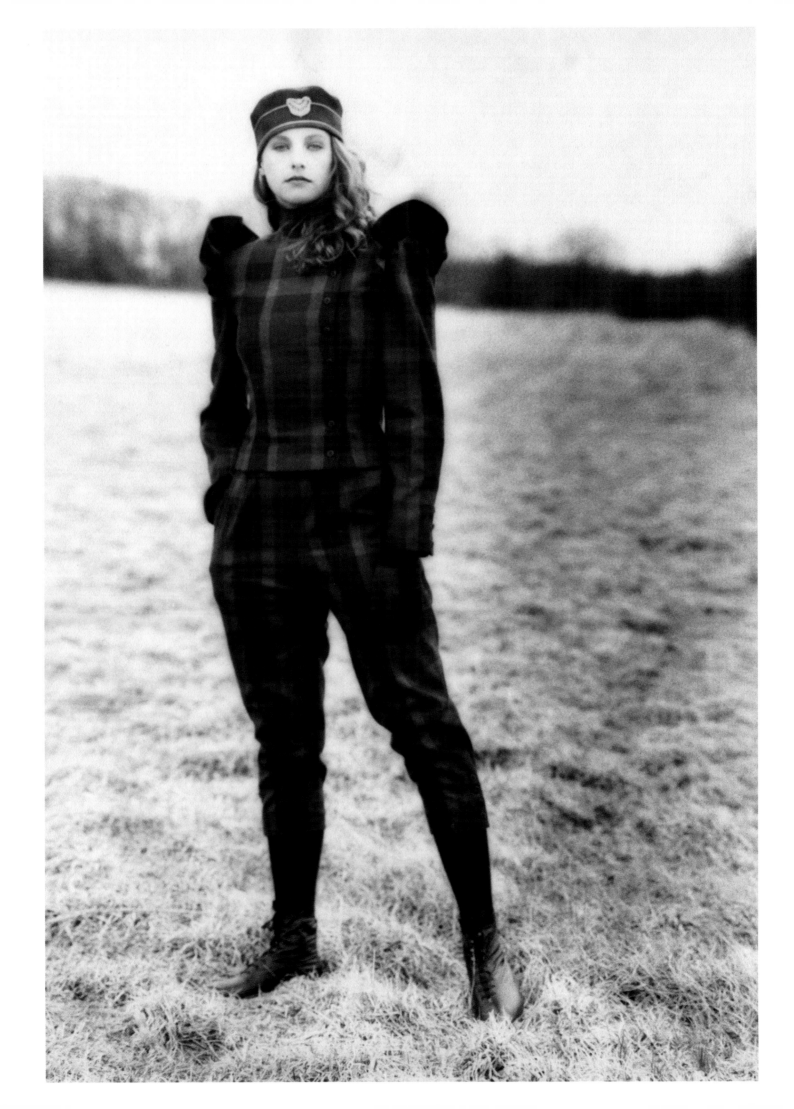

FALL/ WINTER 1981

Perry continued his study of volume and texture with "The Hunt," a collection of lush, rounded, and romantic clothes that at first evoked far away, folkloric places, but they also had a soft modern appeal. His hand-knitted tweed sweaters extended at the shoulder by knitted ruffles; while other knits were treated to cables and graceful kimono-like sleeves. Trousers were rounded and draped, or tight–waisted and ballooned into harem-like pants, but in a decidedly "un-harem-like" fine wool. Skirts were voluminous too, sometimes worn two at a time, over a pair of ballooning pants or "golfers" as Perry liked to call them. There were oversized, McNutt Irish woven tweed blazers worn with matching knitted tweed sweaters and full ankle-grazing skirts.

He carried over some shapes from the previous season, like his spring "corselette," but for fall he transformed it into a plaided vest and he continued to feature peplums on his jackets to accentuated the waist. Perry's furs for Alixandre were big on volume—and laden with luxury—lots of big-as-a blanket coats in cross fox, raccoon, and red fox with a matching Cossack toque. His accessories for "The Hunt" were carefully chosen: marvelous knitted Aran hats that resembled toques; eyelet boots, and Kieselstein-Cord's beautifully wrought silver and gold belt-buckles, this time in the shape of a duck. The highlights for men included wide-striped jackets in bold colors and Perry's own favorite low-belted camel hair coats.

For the first time, Perry really proved himself a Prince of Prints, in this case Etro's charming wool challis game birds—a covey of ducks, mallards, and pheasants which he combined with swirling paisleys and roses in bright green, tomato red, purple and navy—riots of color that were marvelous to behold. His fabulously theatrical finale featured a fairytale "Queen of the Hunt" cloaked in white fur, who brought the house down.

The day after his April 21 presentation, *New York Times* fashion editor, Bernadine Morris had touted his distinctive eye for subtle color mixes and his love for fine fabrics, but also added: "It is Perry's informal manner—a kind of studied carelessness—with which he treats these fabrics, along with his sense of romance and whimsy that sets him apart from anyone else."[4]

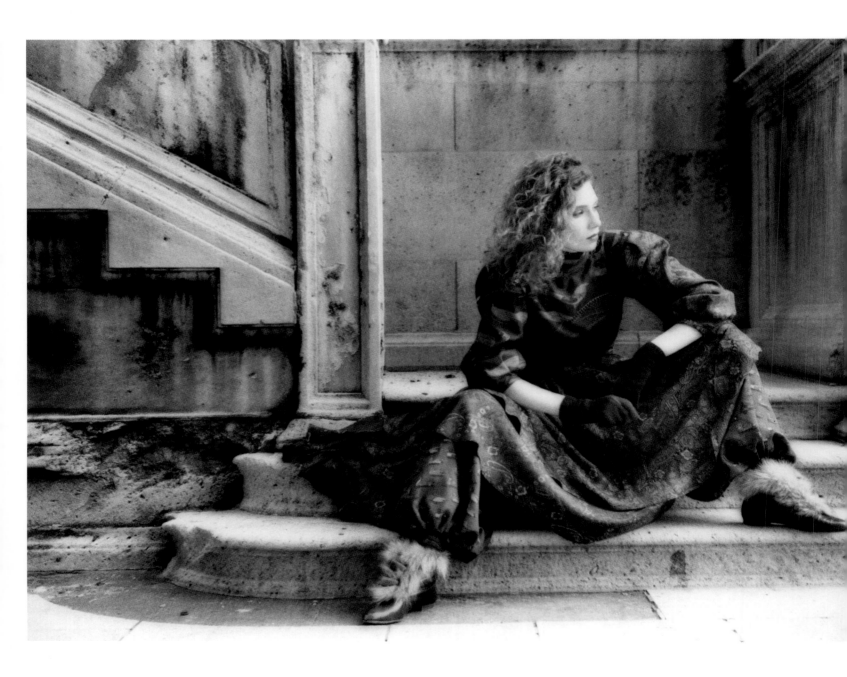

Above: Cossack shirt and
skirt in game prints and
paisleys. Fall/ Winter 1981.

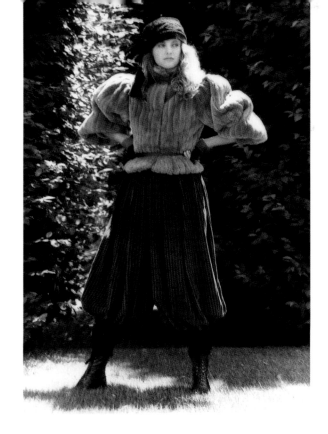

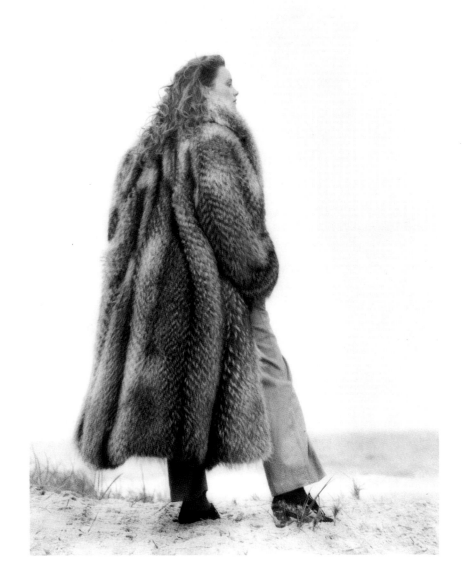

Top: Sheared beaver fur, ribbed like corduroy over full bloomers. Fall/ Winter 1981.

Right: Sweeping Finn raccoon coat. Fall/ Winter 1981.

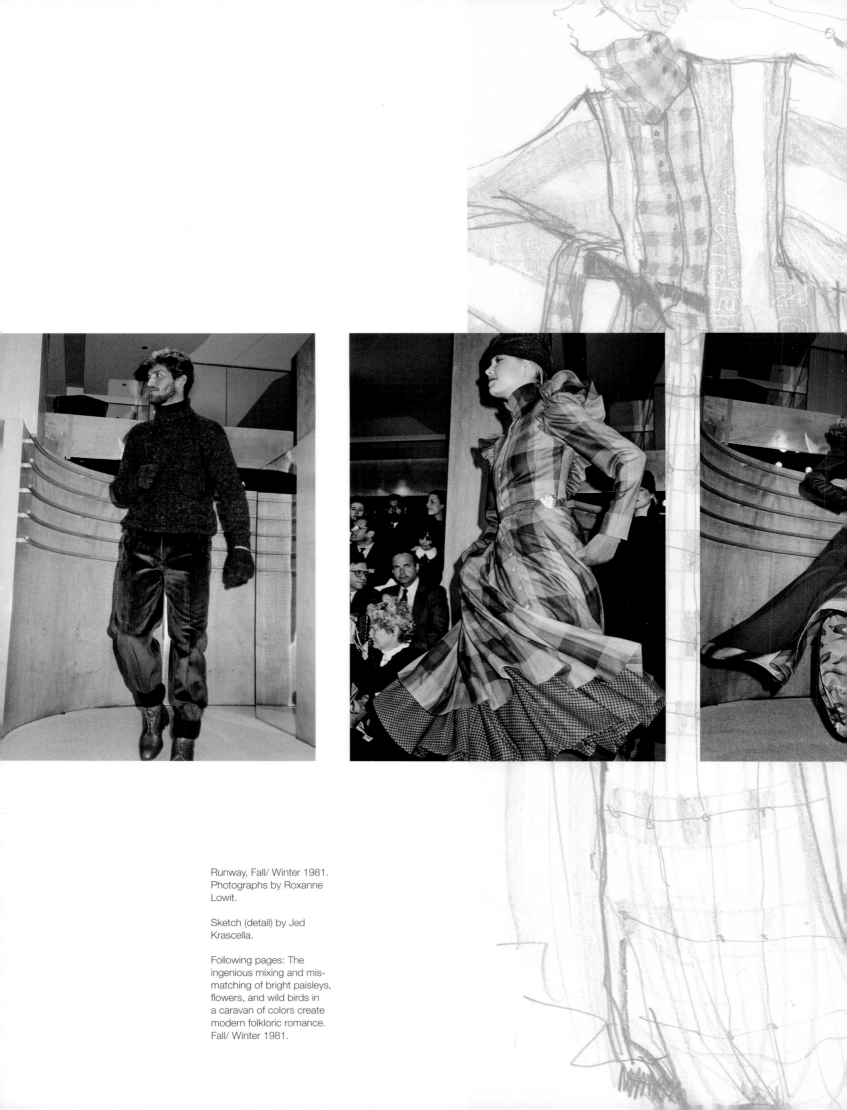

Runway, Fall/ Winter 1981.
Photographs by Roxanne
Lowit.

Sketch (detail) by Jed
Krascella.

Following pages: The
ingenious mixing and mis-
matching of bright paisleys,
flowers, and wild birds in
a caravan of colors create
modern folkloric romance.
Fall/ Winter 1981.

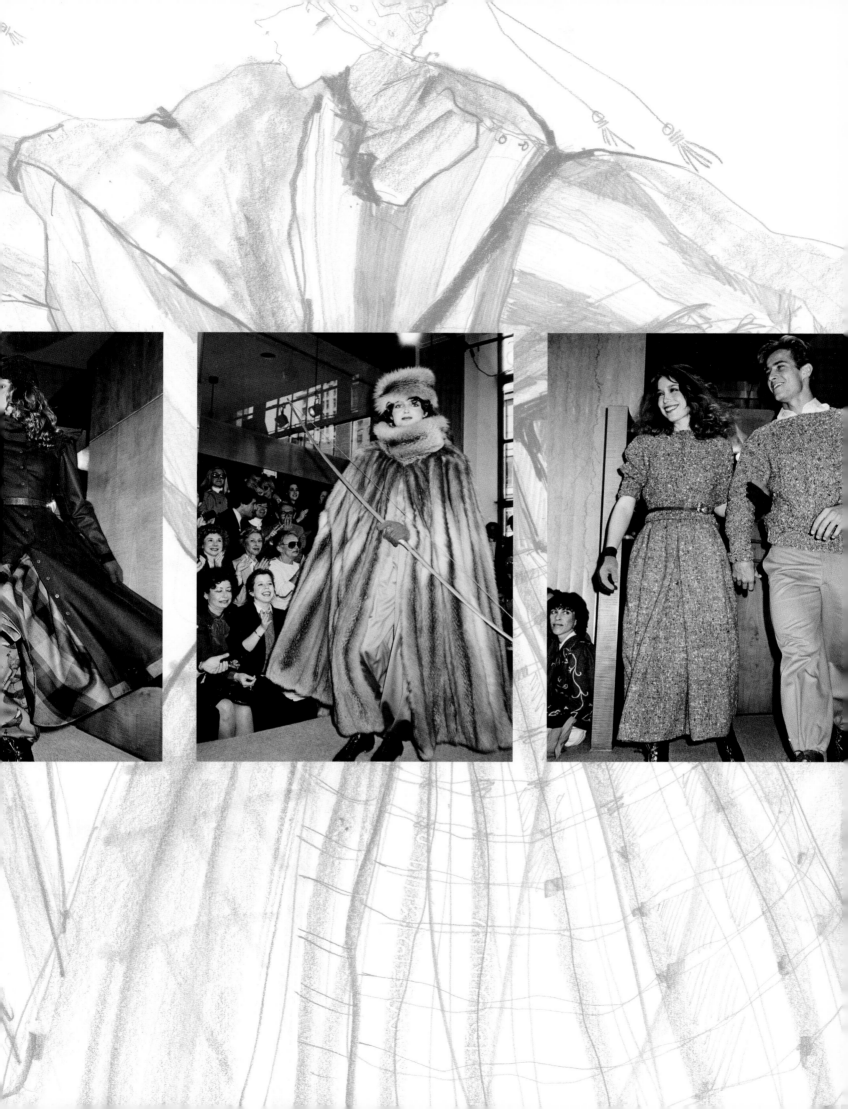

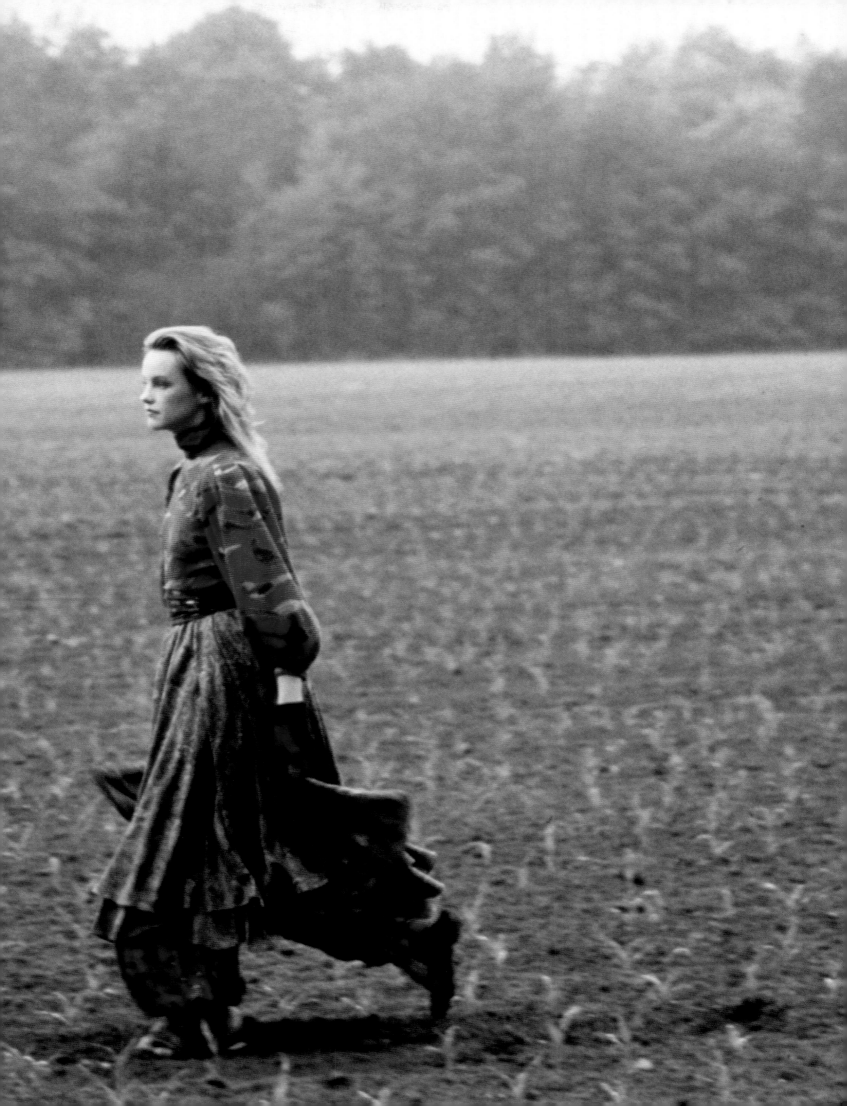

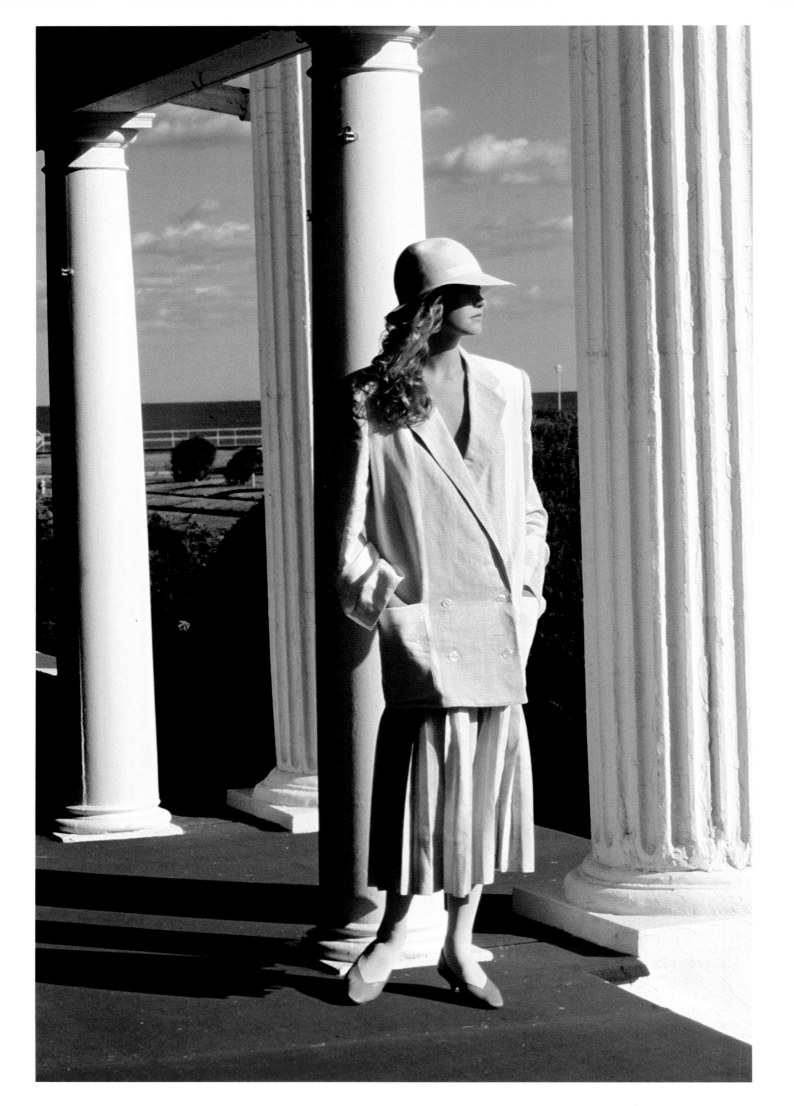

SPRING/ SUMMER 1982

In one of his most romantic and memorable collections, "Chariots of Fire," Perry explored oversized menswear jacket shapes, using a trove of luxurious Italian linens from Braghenti to create a slouchy broad-shouldered silhouette with a dropped waist, deep pockets, and extra-long sleeves that dusted the fingertips. These perfectly proportioned, more-than-hip-length jackets were buttoned low over long pleated skirts and generous trousers in swaths of fabric—so long and wide that they spilled over the heels and insteps of a model's shoes. And what cloth: the linen had the widest-ever stripes, some of them measuring almost a foot in width, in combinations of pale grays, creams, pinks, and blues, alternating with white. He did crisp regimental stripes as well, sometimes mixing different stripe–widths in the same manner he mixed patterns.

The fabric truly dictated the shape of the clothes: jackets were cut extra-long to emphasize the broad-striped fabric, and the placement of the stripes in the skirt determined the width of the pleats.

There were also pleated tunics, belted low; soft, sporty Swiss cotton knits in playful baggy pants and long narrow skirts topped with long, V-necked or oversized cowl-necked sweaters worn with long, white pleated skirts. Perry paired them with white tights and pumps or argyle socks and sandals, floppy brimmed hats, and the occasional croquet mallet to lend a leisurely "weekend at the country house" appeal. He experimented with layers and shorter skirts as well, but the long lean look prevailed, and in fact, would continue to prevail in future seasons. His menswear this season, followed suit, with low-buttoned striped or solid linen jackets and linen trousers with the same slouchy ease, worn with white bucks.

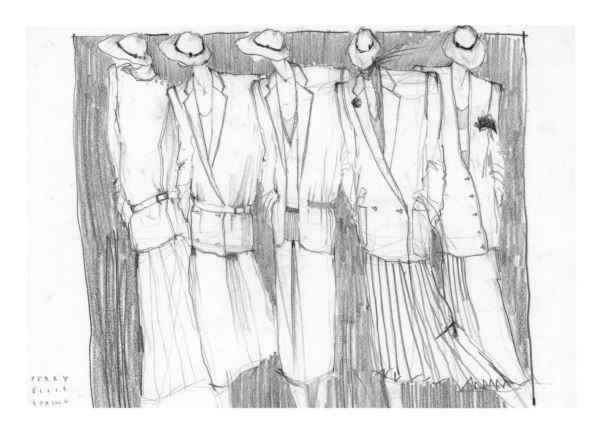

Above: Sketches for the
Spring/ Summer 1982
"Chariots of Fire" collection
by Jed Krascella.

Opposite: Oversized,
12-inch-wide stripes on
long sweaters and pleated
linen skirts. Spring/
Summer 1982.

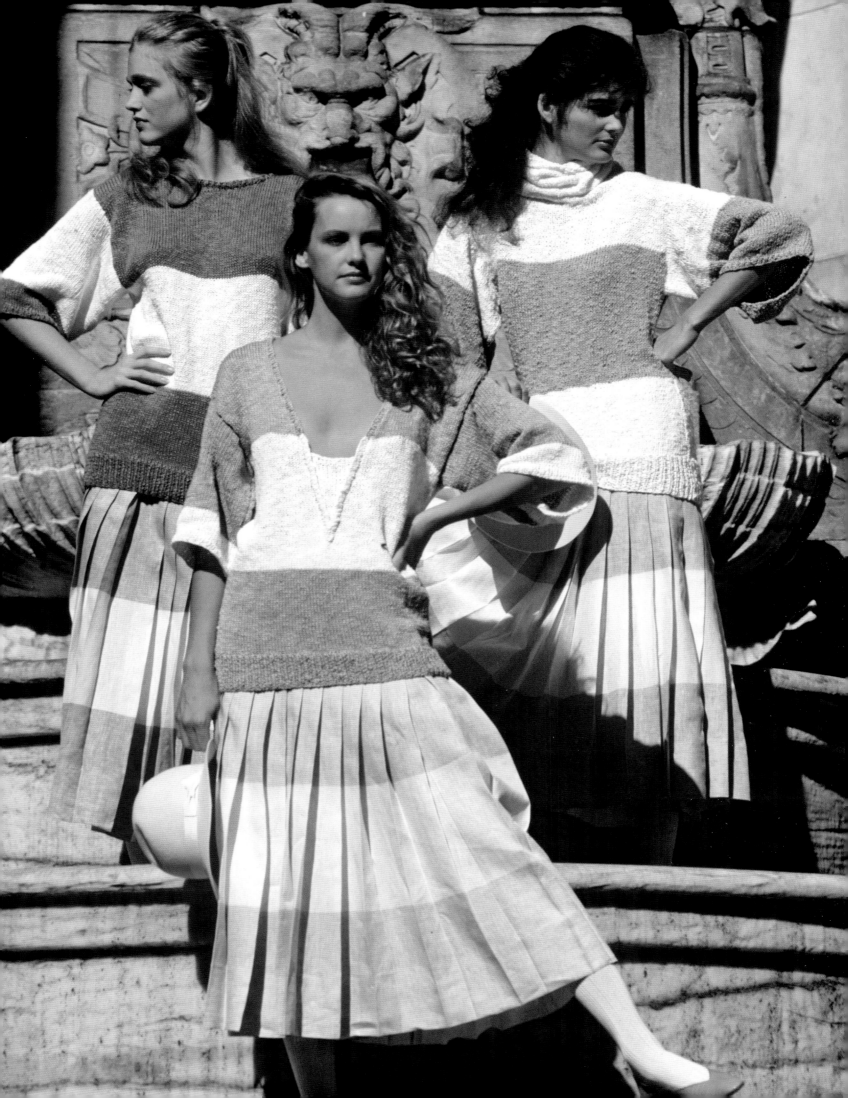

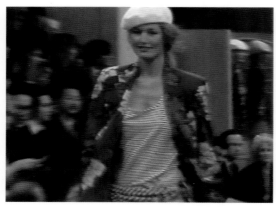

Above: Video stills from the
runway. Spring/ Summer
1982.

Opposite: Sketch (detail) by
Jed Krascella.

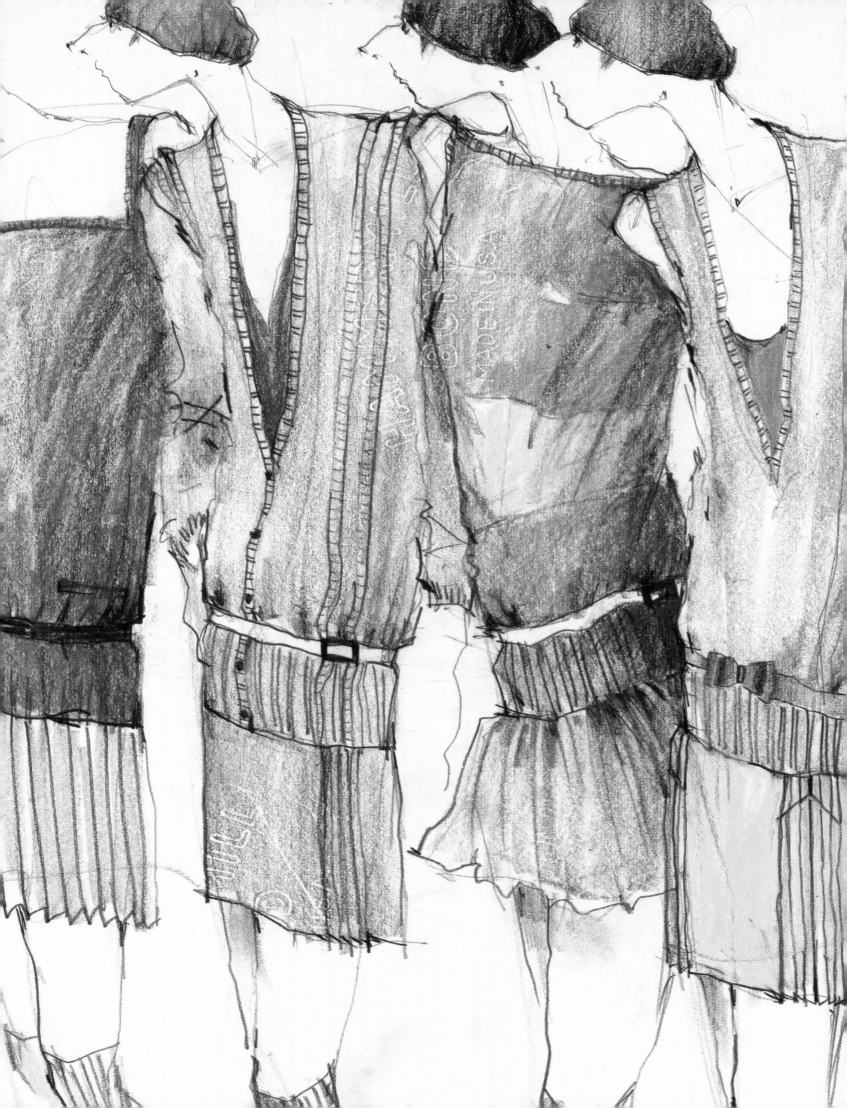

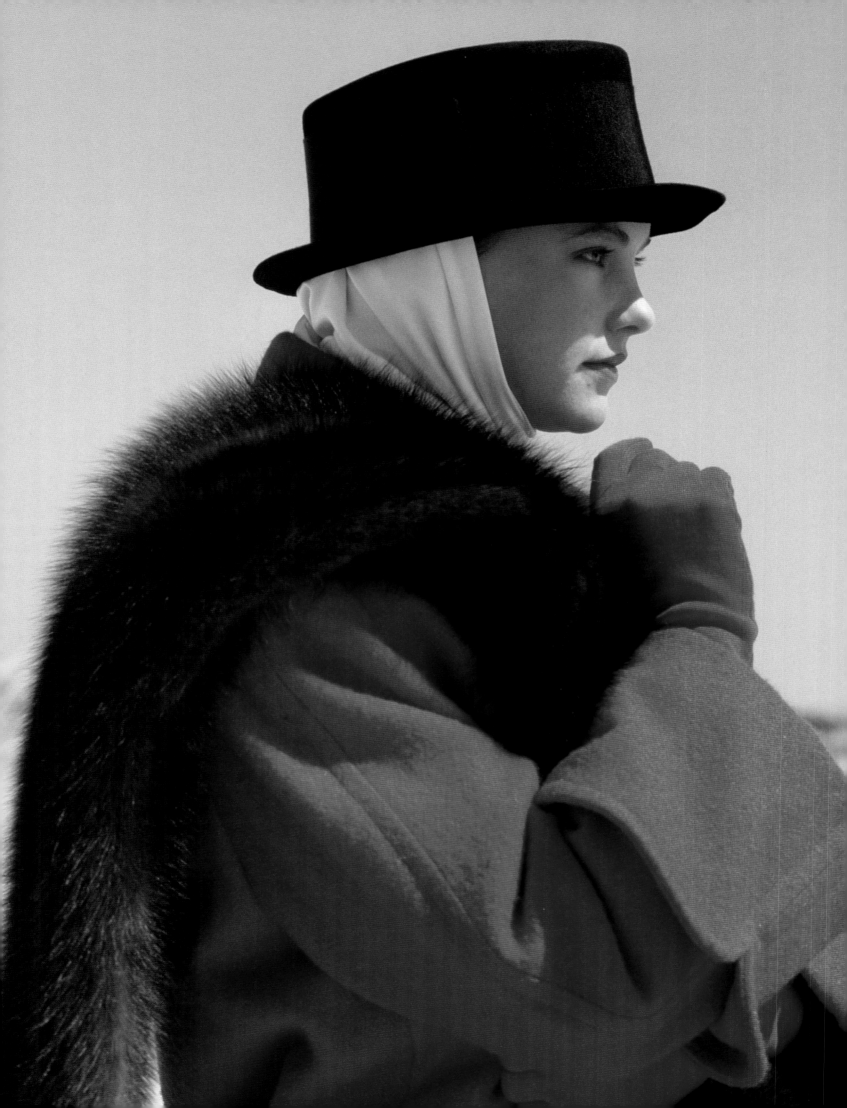

FALL/ WINTER 1982

Given the new, dressier mood of the '80s, Perry led off with a giant leap in tailoring with his "Dreamgirls" collection—experimenting with a more "grown-up" silhouette that featured exaggerated nipped-in peplum suits with tight below-the-knee pencil skirts. It was meant to be an homage to the so-called "ladies who lunch," the reed-thin New York socialites who would dress to "the nines" and nibble delicately at restaurants like New York City's La Grenouille. But some of the press and many of the buyers thought Perry had gone too far, too tight, too dressy—neglecting his signature sportswear looks *and* his customer. Still, there *were* some wonderful ideas: coats, jackets and sweaters were all on the voluminous and long side, although trousers were often cropped. And for the first time ever, in a nod to dressing up, Perry showed high heels with pants. There were McNutt tweed jackets over flaring, ankle-grazing skirts, sweaters in mohair and Shetland wool, and one made up of different left-over yarns they dubbed the "rags" sweater. Scottish Highland tartans were a hit, including a tartan coat with bias-cut sleeves, as were red and black checkerboard sweaters with wide black cuffs—worn in a tongue-in-cheek fashion—with white gloves and black cashmere skirts or trousers. Perry's ultra-glamorous coats included a camel hair back-belted number with white mink cuffs, black fox with white fox cuffs and a madly-plaided Black Watch tartan sheared beaver coat over a matching Black Watch flannel suit. Some of the coats sported long stoles that Perry tucked in under the back belt in a nonchalant way. And there were other dressy accessories: crocodile pumps and top hats worn over soignée white silk scarves. For evening, Perry showed strapless black Shetland sweater dresses, silk cravat blouses, and velvet trousers or long velvet skirts. The *piece de resistance* was worn by Perry's model-muse Lise Ryall, a fitted mink bustier, puckered at the waist and plunged in back, over a duchesse satin skirt. The menswear was also on the dressed-up side, in luxuriant velvets and cashmeres and suave colors and textures.

Following pages: Perry's sophisticated new silhouette for the Fall/ Winter 1982 collection: wide shoulders and jacket nipped at the waist with exaggerated peplum over a super-slim skirt. Sketch (left) by Jed Krascella.

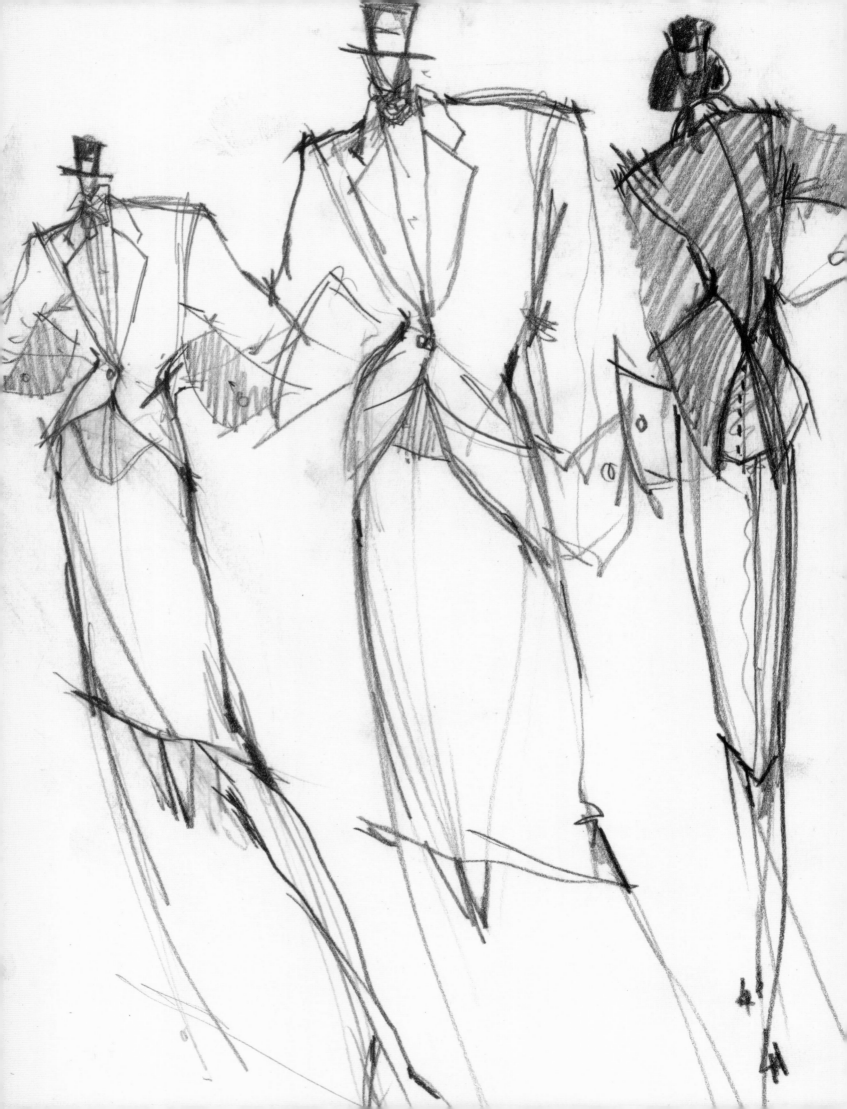

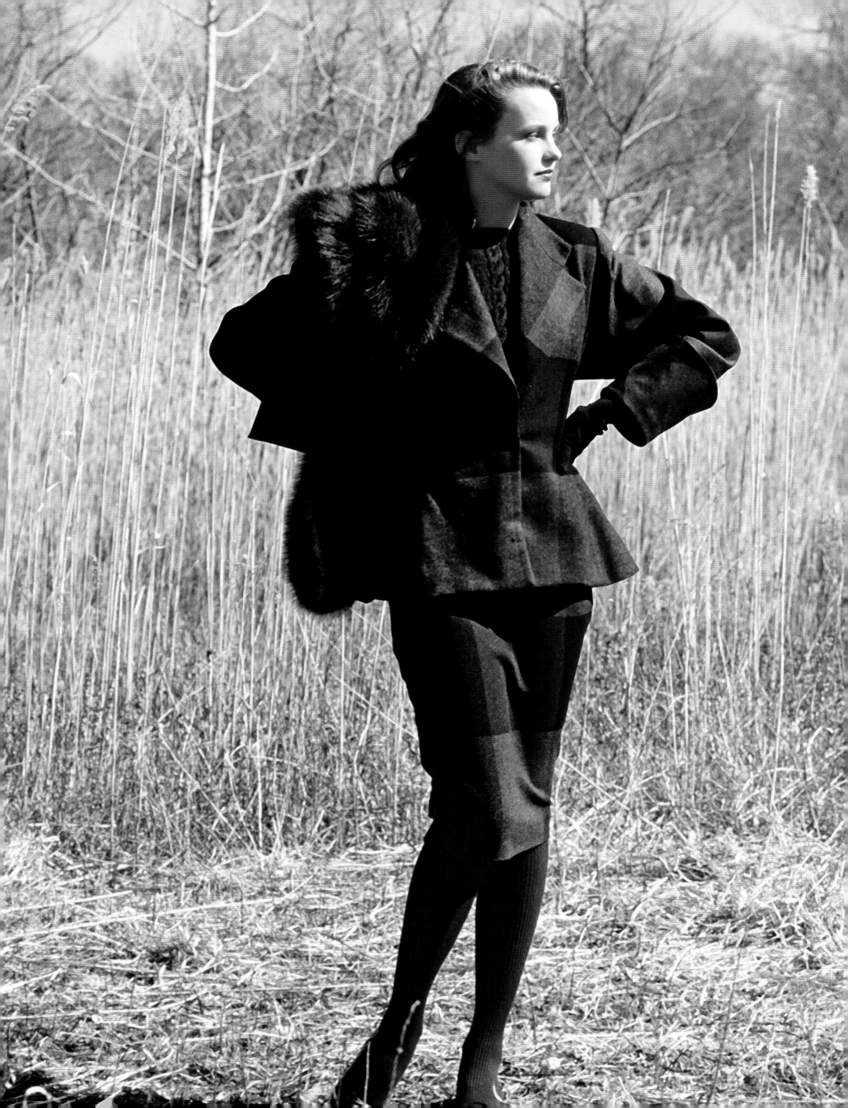

Above: An artful plaid en-
semble. Hand-knit Shetland
crewneck sweater with
heraldic crest over Scottish
tartan flannel and hand-knit
argyle socks over tights,
complete with felt top hat
and tartan ribbon. Runway,
Fall/ Winter 1982.

Opposite: Sable fur coat.
Fall/ Winter 1982.

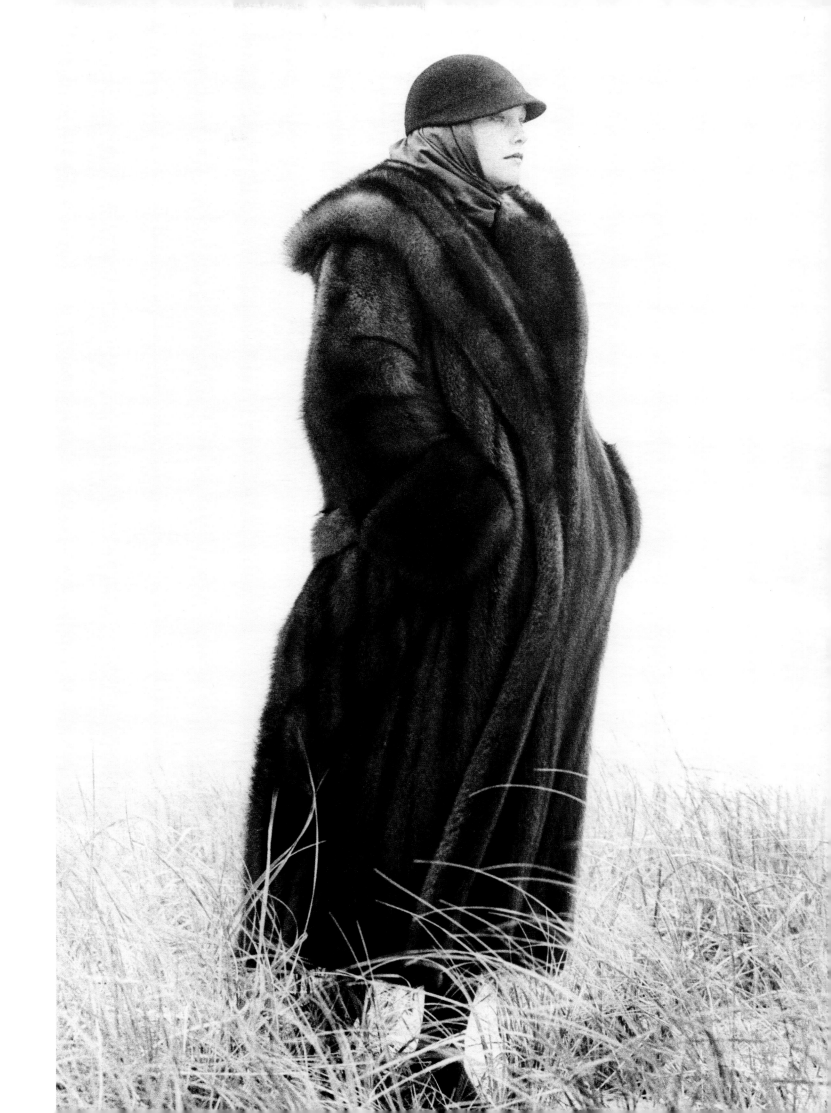

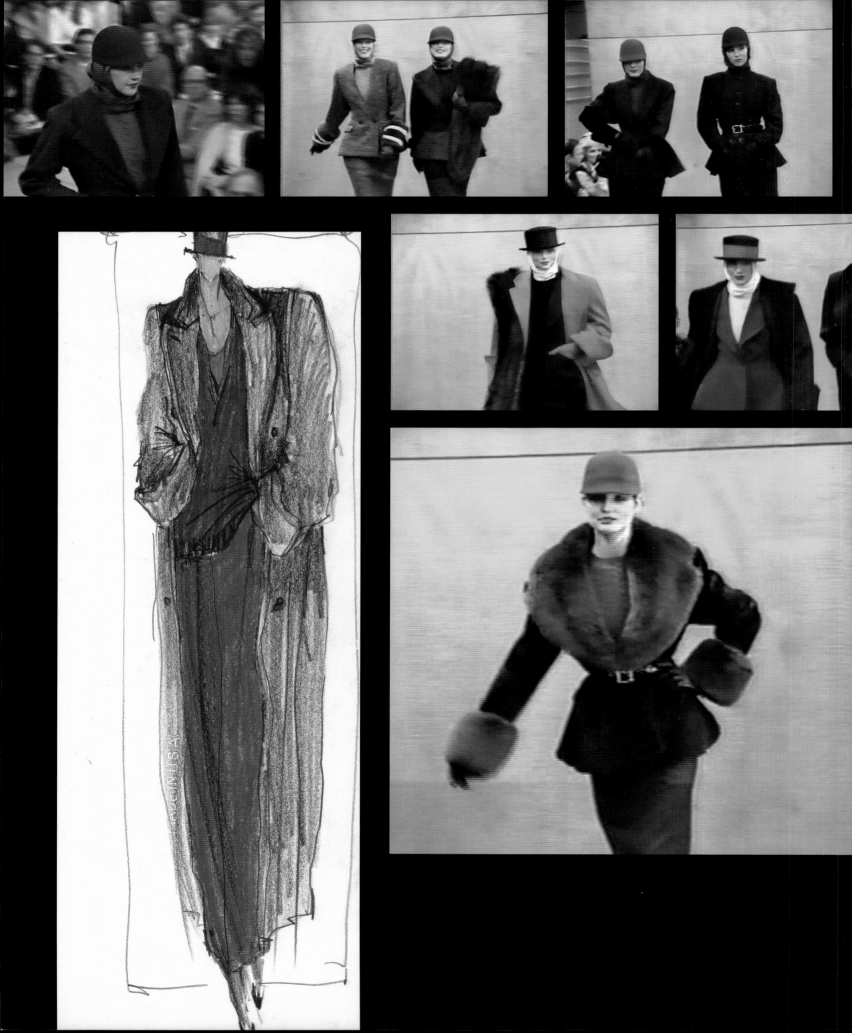

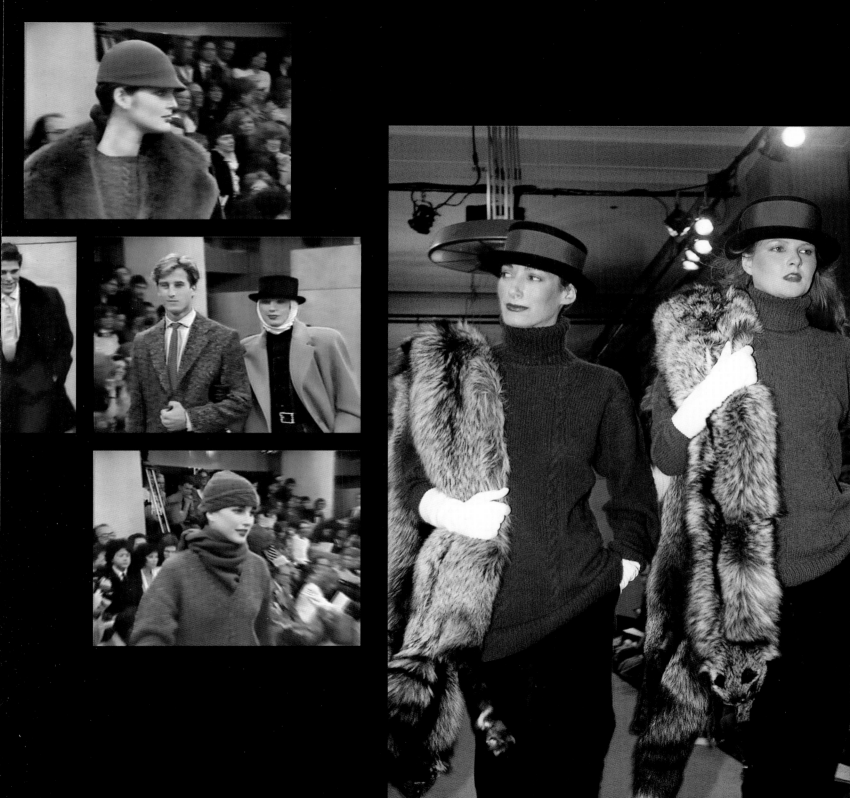

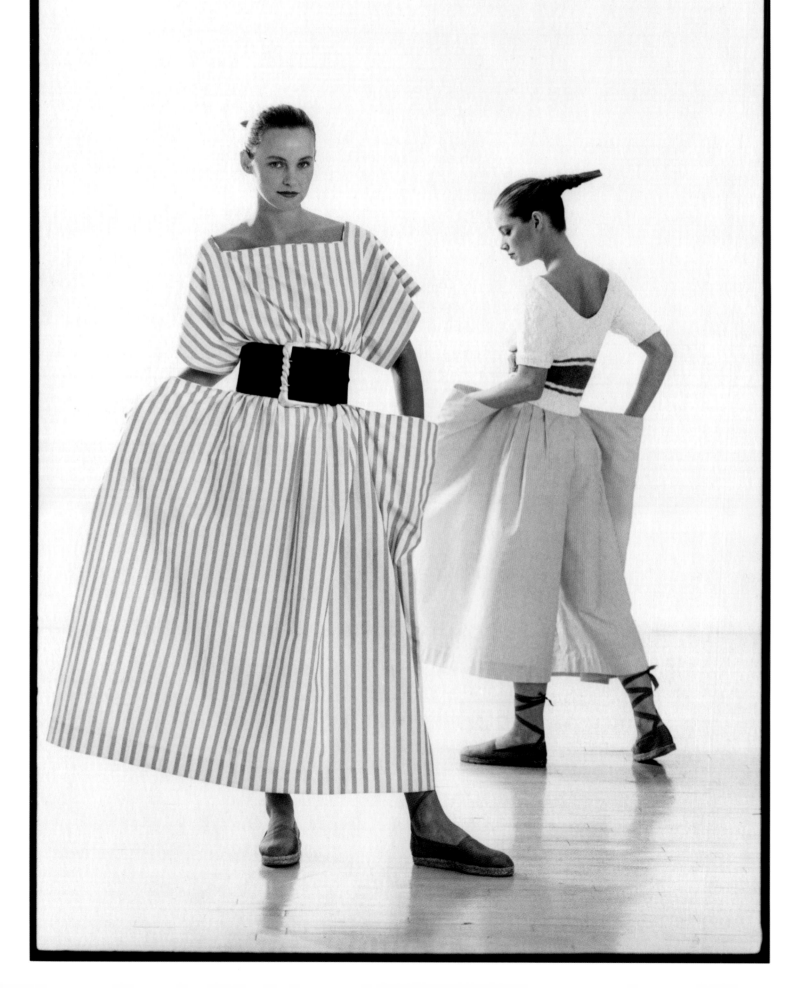

SPRING/ SUMMER 1983

Perry had been increasing the volume of his collections over the past several seasons, but for his Spring 1983 "Espana" collection, he decided to express volume in a lighter way with fine Italian Solbiati and Etro linens—and less construction. He eliminated all shoulder pads, focusing on a high waist, cinched with 5-inch-wide faille belts, which had big decorated with metal buckles. It was an extreme look—complemented by other extremes: the widest, ankle-grazing skirts or rounded pants, the biggest, flattest brimmed hats, the highest platform espadrilles. Then he added cropped little featherweight jackets with flaring backs, which barely touched the top of the belt. In addition, he showed beautifully pristine white shirts with giant blousing sleeves, tucked into the heightened waistbands of the full skirts and the toreador pants. The whole thing took on a festive Spanish air as they went along, creating color blocks of red, yellow, black, and white. Perry also showed big, easy, geometric dress shapes in striped or plaided linen or cotton with deep square box pockets set in the sides. When the models twirled on the runway, keeping their hands in their pockets, the pockets stood out, according to the New York Times, "like Dutch-boy pants." In addition, Perry created some clever sleight-of-hand, trompe-l'oeil knits: sweaters with knitted-in cravats, lace collars, intarsia roses, and an exquisite satin-beribboned sweater.

Perry had chosen to go "against the grain" this season, by presenting big shapes, while WWD had been touting the idea of a closer "fit," so there were some negative jabs at his "can-you-top-this" proportions, but his customers were mad for it. For his menswear collection, Perry found fabric at the linen mills he primarily used for his women's line: the deeply hued stained-glass plaids for his jackets, and Indian summer-colored linens he used in his shirts were far from the standard men's material. For more formal occasions, Perry amped up some summer classics, combining a cool, unlined white linen jacket with the jolt of a chartreuse shirt and shocking pink tie.

Square neckline silhouettes, with pockets that fan open, reminiscent of classic Dutch trousers. 5-inch-wide belts cinch the waist. Spring/ Summer 1983.

Following pages: Spring/ Summer 1983. Left, illustration by Kenneth Paul Block.

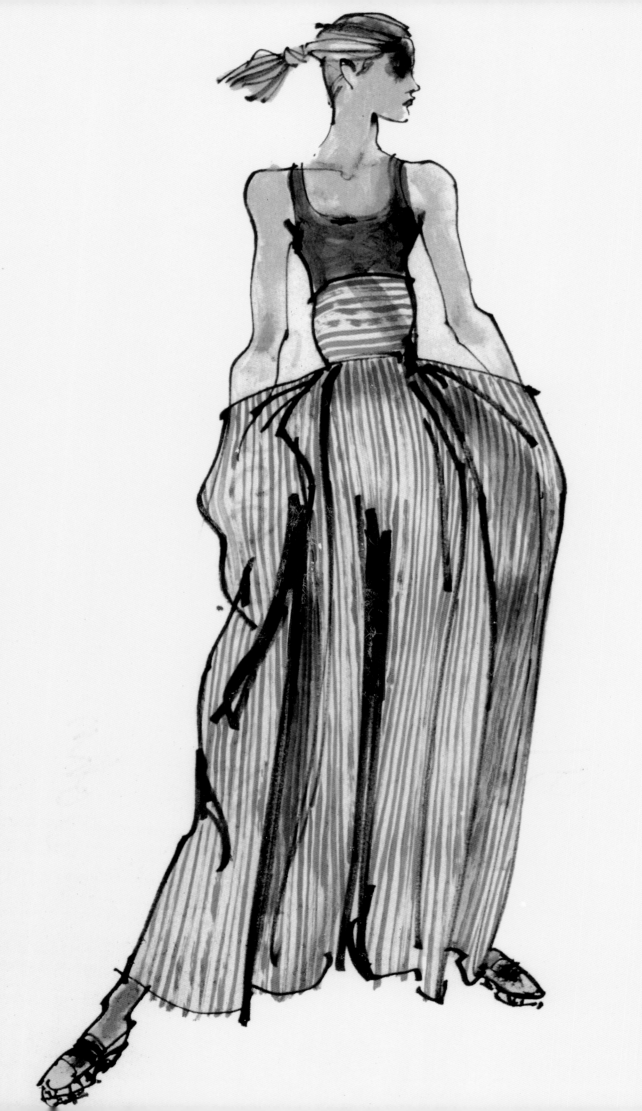

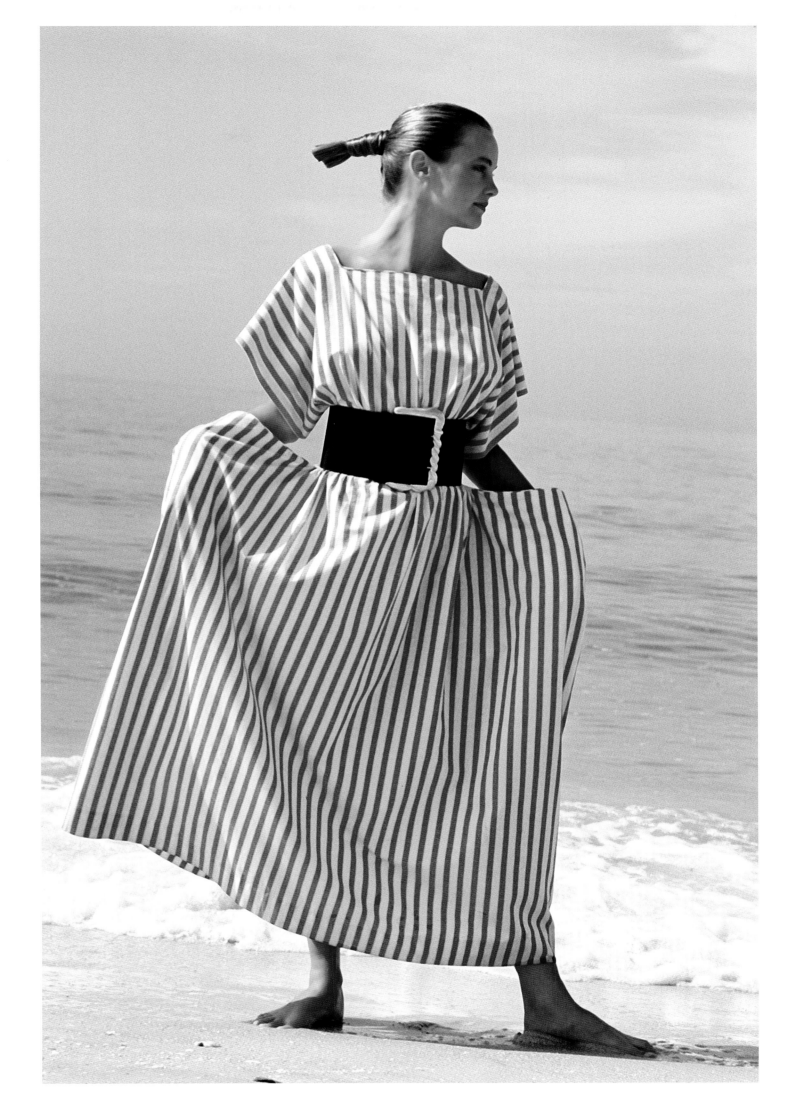

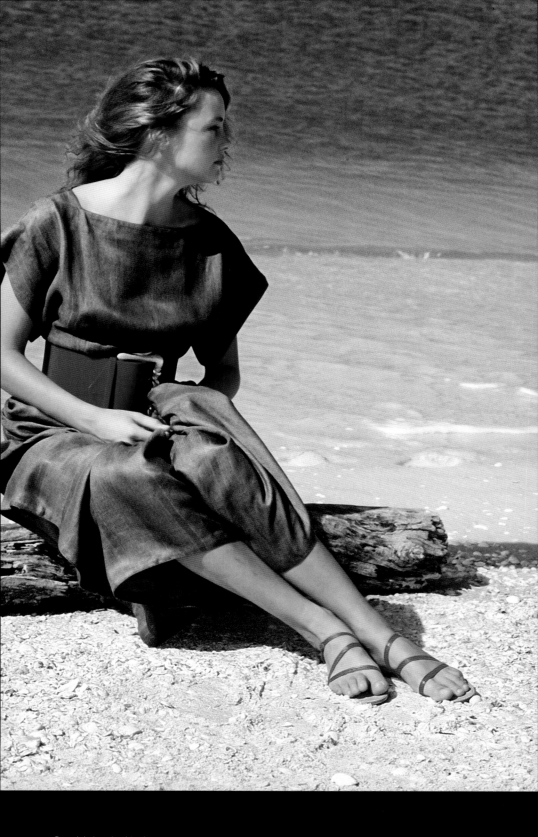

Spanish-inspired looks.
Right, flat-brimmed hat
by Patricia Underwood.
Spring/ Summer 1983.

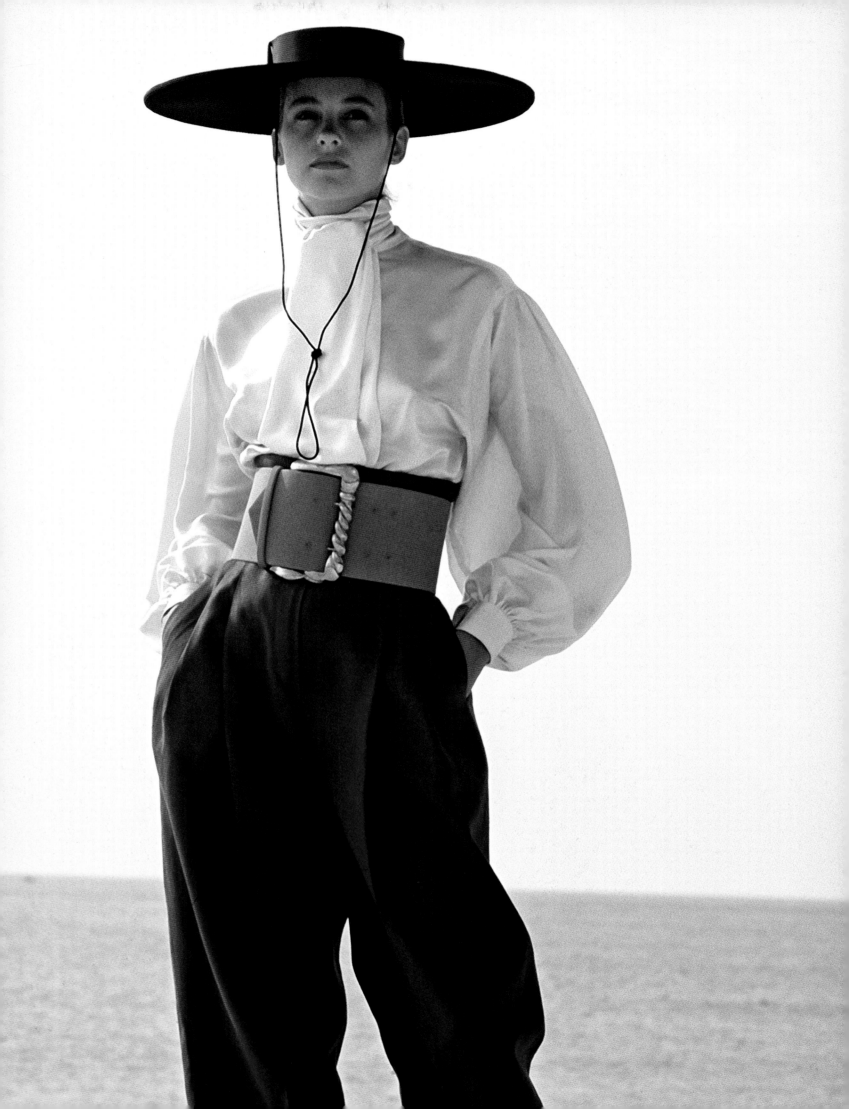

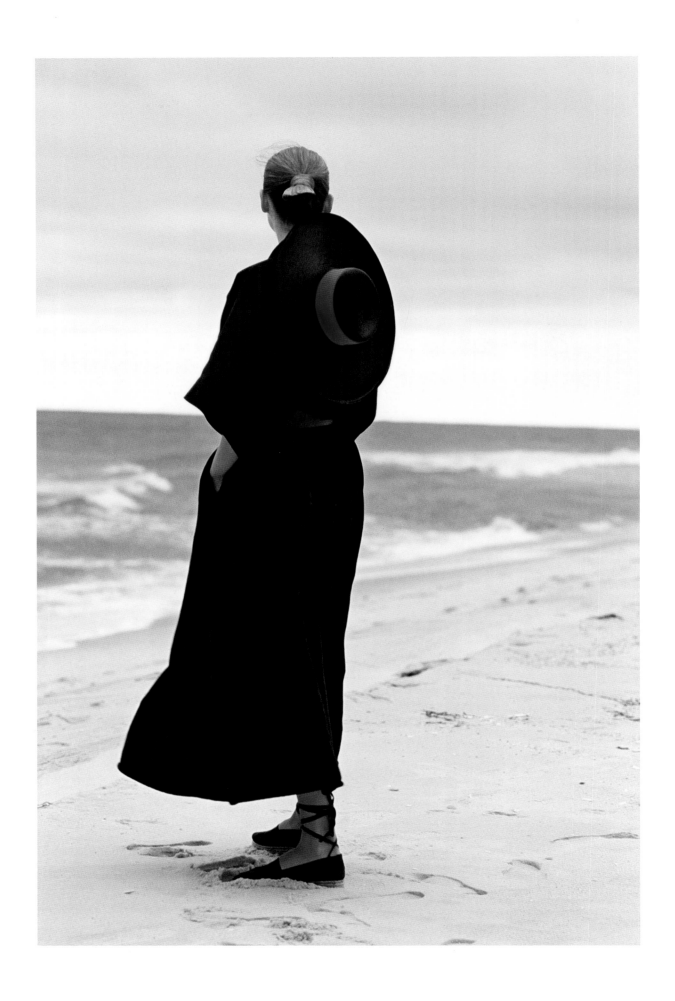

Spring/ Summer 1983.

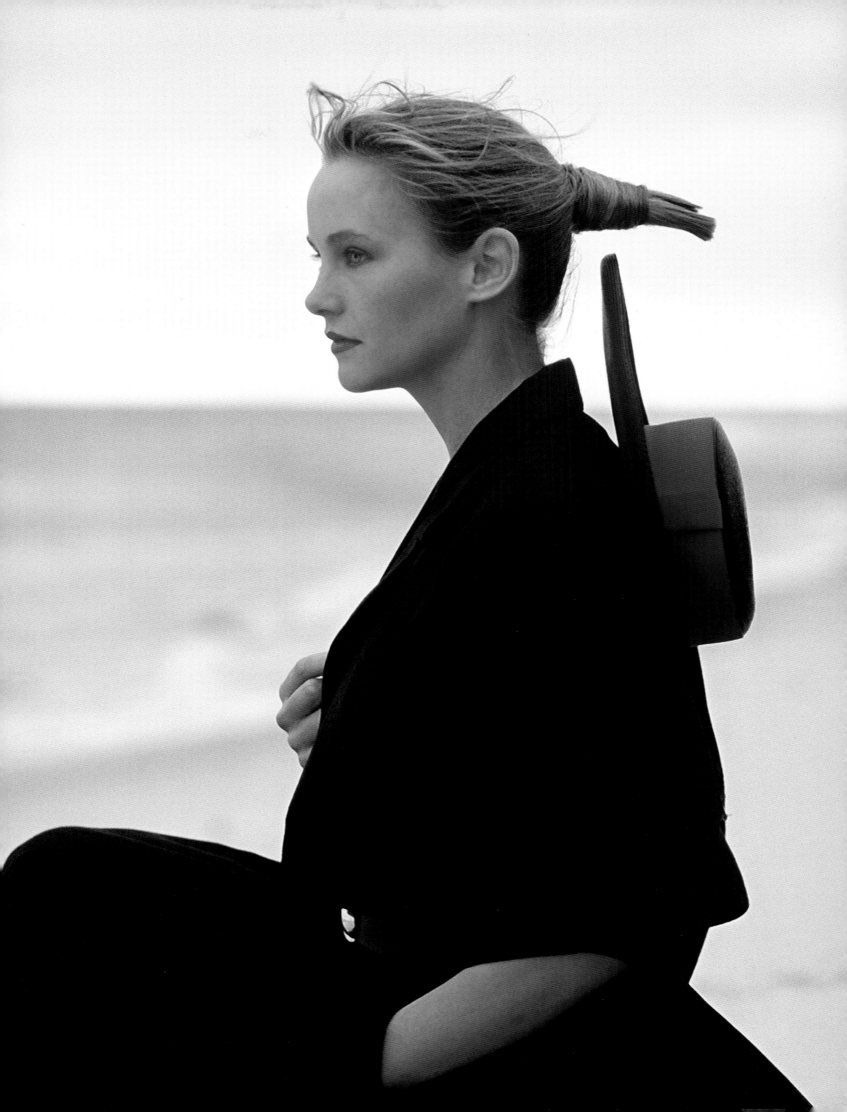

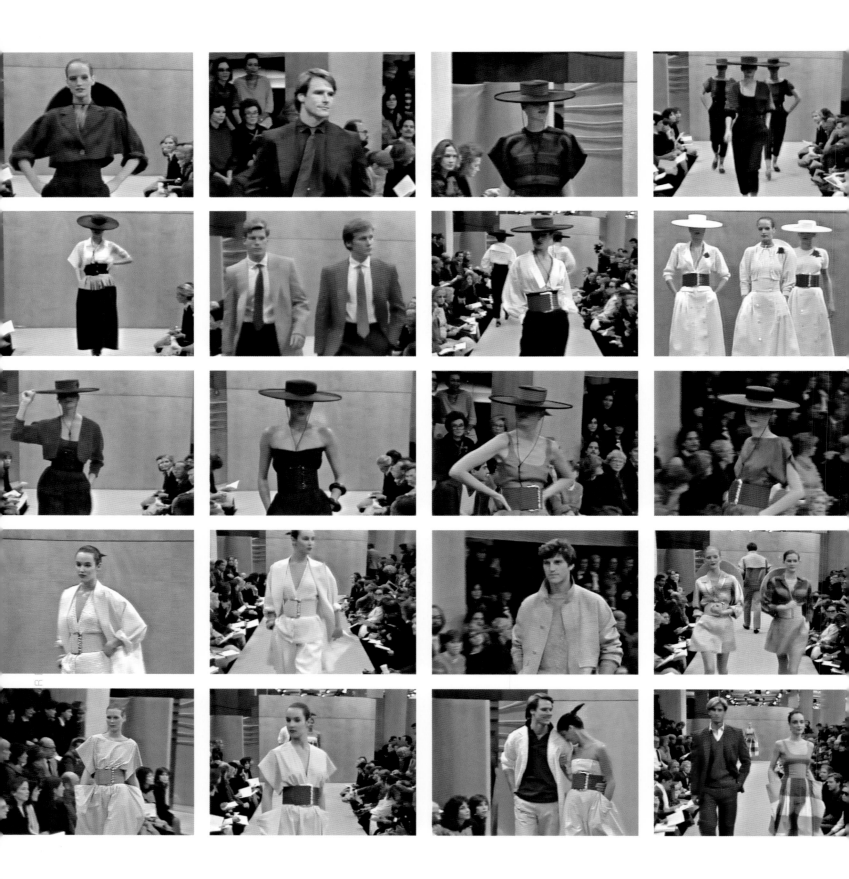

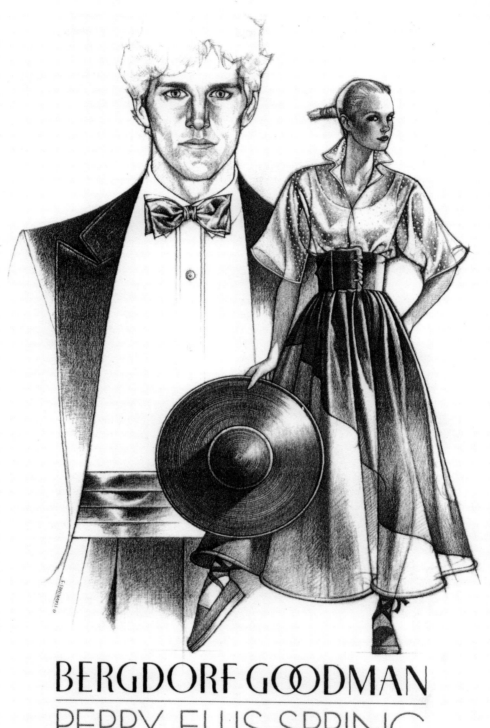

BERGDORF GOODMAN
PERRY ELLIS SPRING

Opposite: Video stills
from the runway. Spring/
Summer 1983.

Above: Illustration by
George Stavrinos.

Following pages: Perry's
flawless proportions:
cropped single-button jack-
et over high-waist pants.
Spring/ Summer 1983.

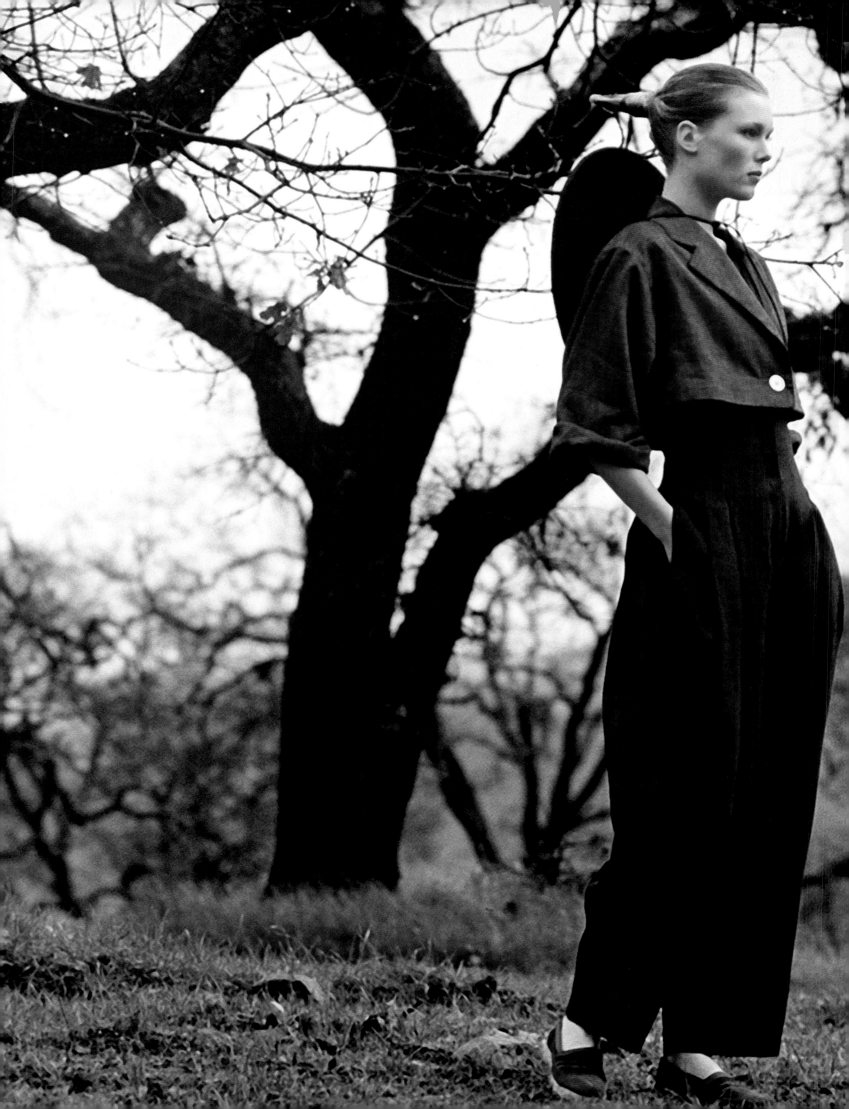

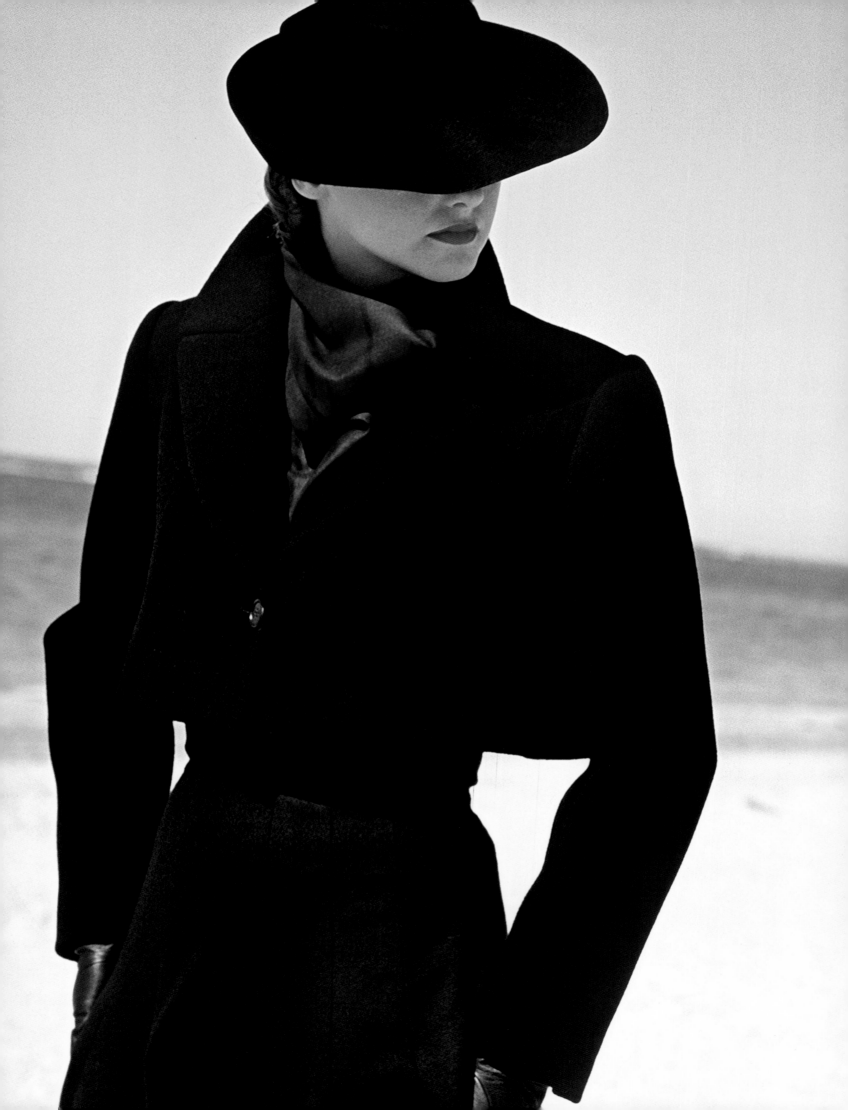

FALL/ WINTER 1983

In April, Perry showed his finely tailored Fall 1983 collection building upon and refining some of the proportions he first introduced in the spring: a slim waist, under a short, cropped, fly-away jacket, which dusted the tops of high-waisted and bias-cut skirts and pants. The skirts looked especially good with dolman-sleeved satin blouses with a high ascot "kerchief" neck, tied in back. Perry also did a lithe gored coat fastened with a single button that created a singularly graceful shape; a plaid Inverness cape; a bare, almost tank-top, black evening dress with a dramatically flaring ankle length skirt. And, of course, there were his superlative sweaters: from feminine cashmeres—whose off-the-shoulder necklines were banded and bowed with a satin, to his crowd-pleasing hand-knits in black and white zebra or tiger patterns, with full dolman sleeves. He created absolute magic with furs, treating sheared beaver with a "Fair Isle" yoke, or patterning it with pinstripes or windowpane checks in a dashing haberdashery mode. He even managed to create a whole new "hybrid," turning a sheared beaver coat into a fiercely beautiful tiger stripe.

There was a "Winter Nautical" mood to the show, as well, with a sequence of navy blue and winter-white jackets, coats, and cashmere sailor sweaters: sharp double-breasted, brass-buttoned steamer coats and pea jackets, a white suit with a long wrap skirt—and most fabulously, a white mink coat with middy collar. Perry's menswear was in the nautical mode, too, with navy greatcoats and blazers and an immaculate white double-breasted suit over a crisp white shirt and giant polka-dot tie. The audience was thrilled with his expertly tailored collection, which had graduated to a more mature sensibility.

Perry continues to refine his sophisticated tailoring —cropped jackets over high-waists, for Fall/ Winter 1983.

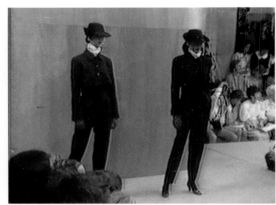

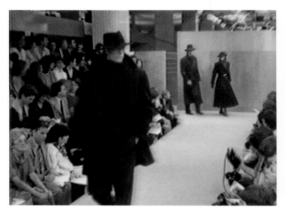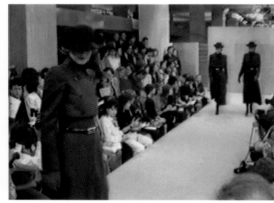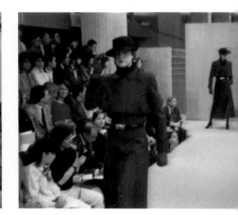

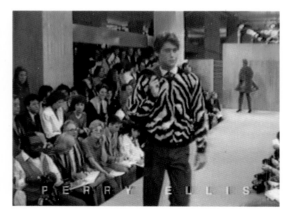

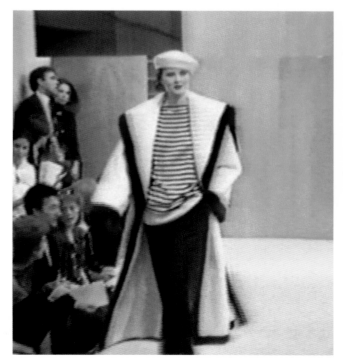

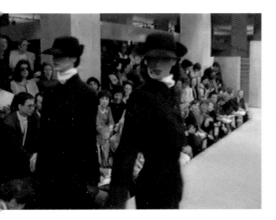

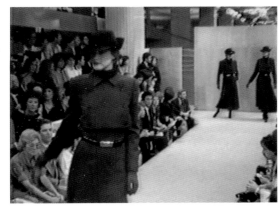

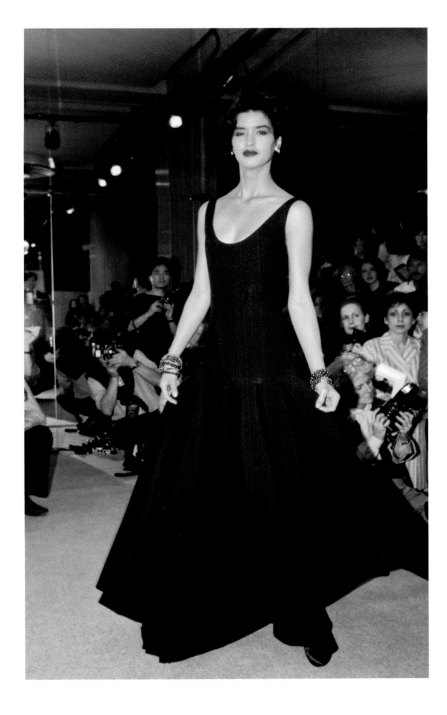

PERRY ELLIS

Video stills from the
runway. Fall/ Winter 1983.

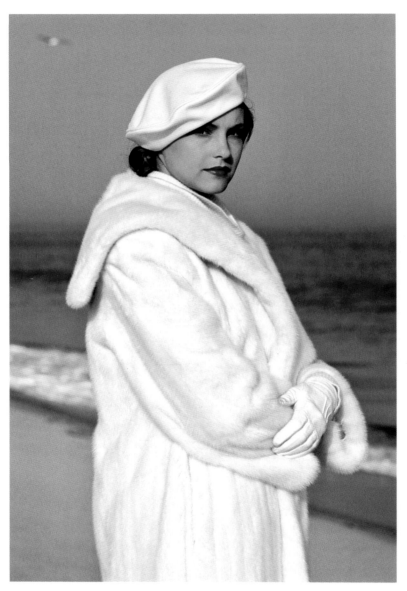

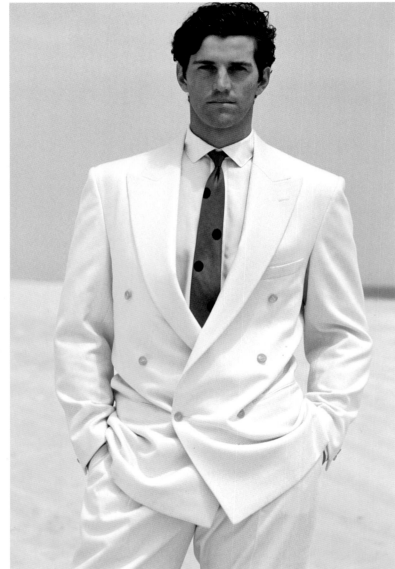

Above: White mink nautical coat with middy collar. Fall/ Winter 1983.

Right: White flannel suit complete with horn buttons and coin-dot tie. Fall/ Winter 1983.

Opposite : Navy cloak in melton wool, with navy sweater banded in deep red. Fall/ Winter 1983.

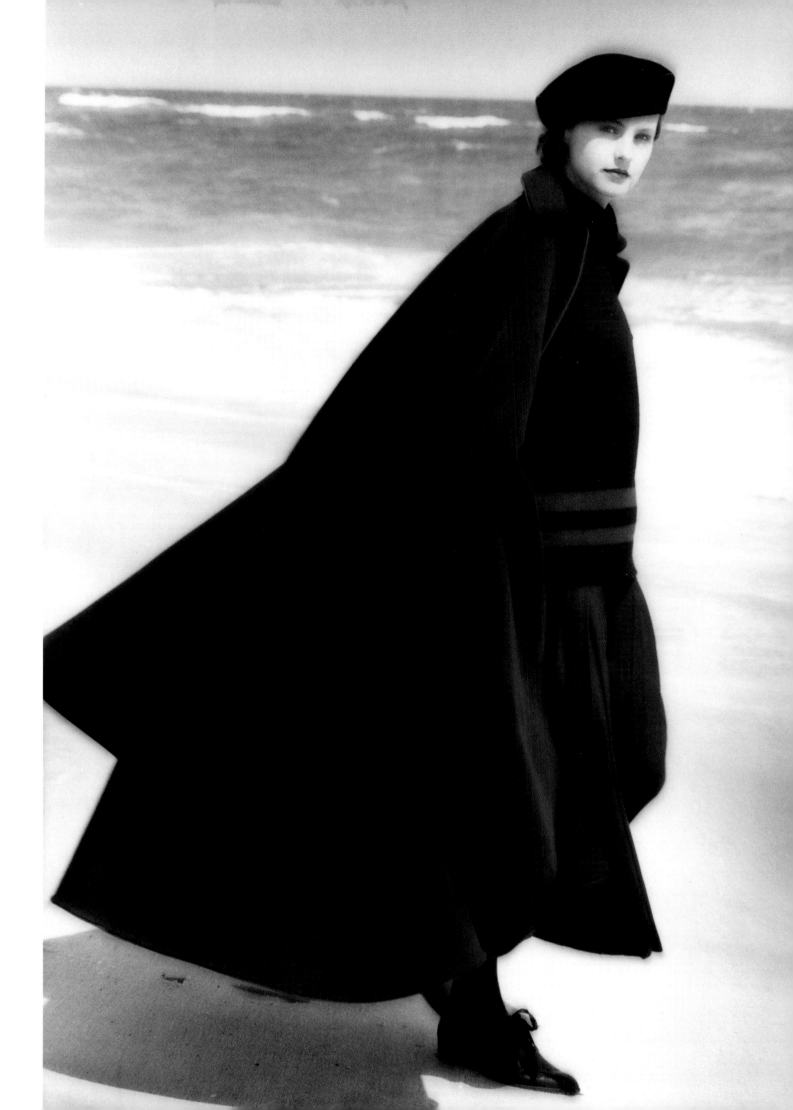

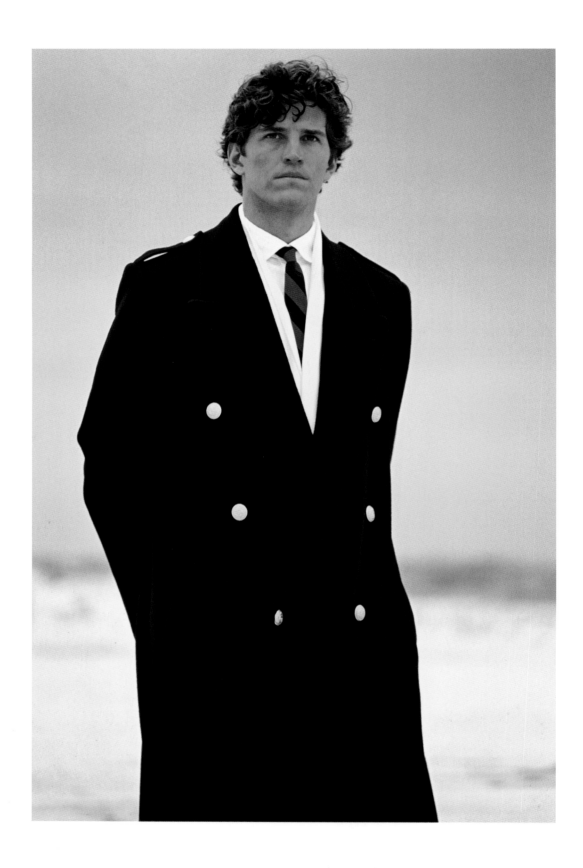

Double-breasted cash-
mere coats with broad
shoulders and brass
buttons. As Perry often
did, he offers a classic
look with slight variation
catering to both men and
women. Fall/ Winter 1983.

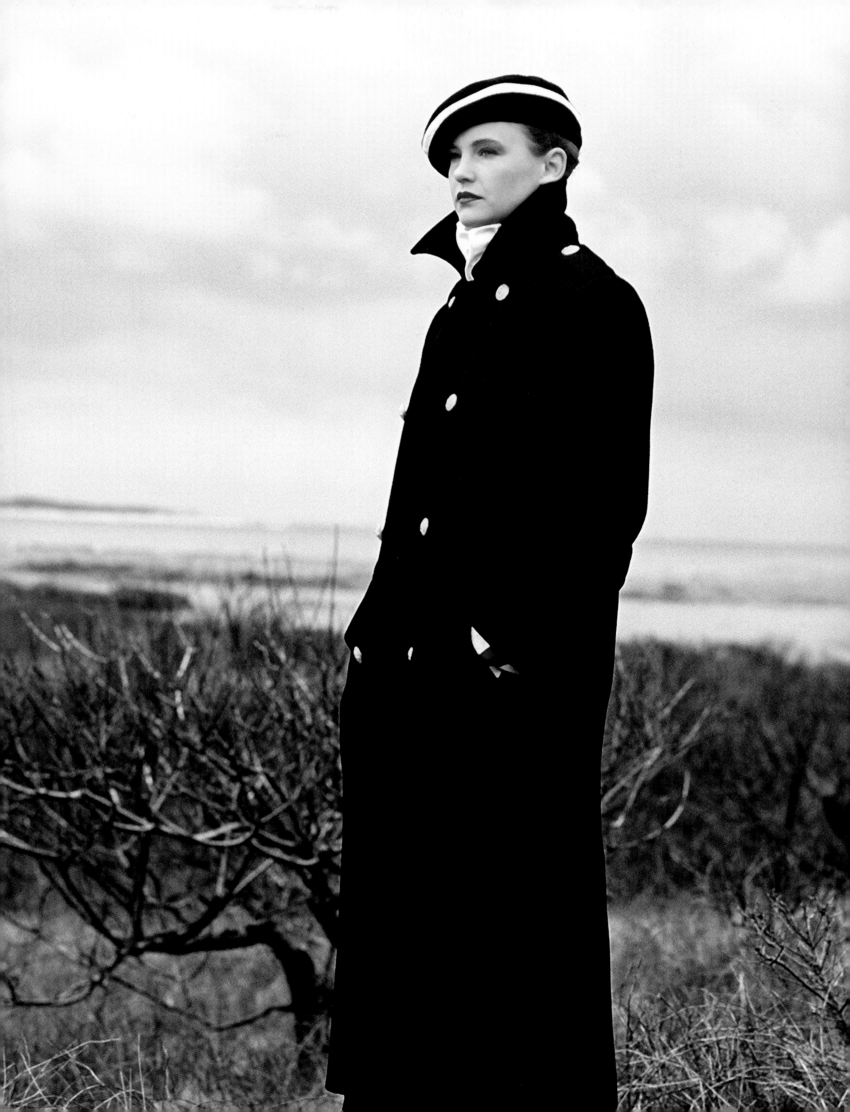

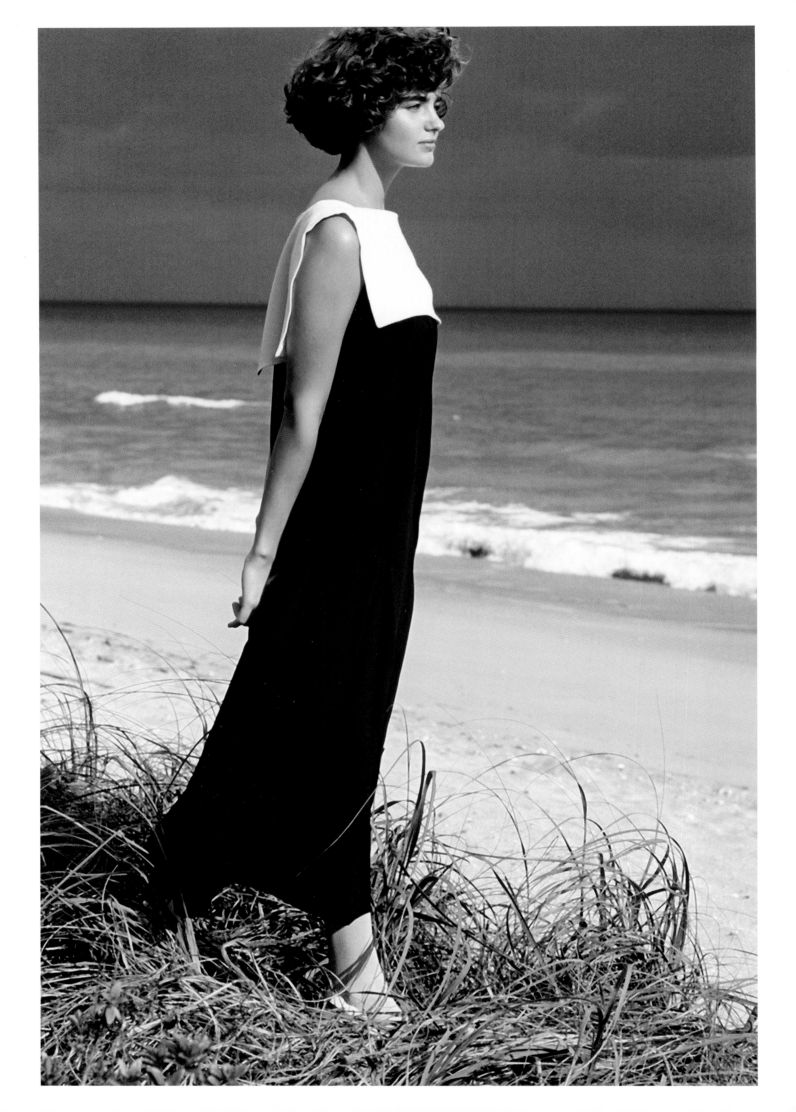

SPRING/ SUMMER 1984

Perry infused his sportswear with a softer sensibility this season, using silks and other fluid fabrics to create a more feminine, romantic appeal. His clothes were simple, un- constructed and upbeat, done in the subtle earth colors of the rugged Australian Outback.

There were back-belted linen dusters and trench coats over pants, culottes, and skirts and longish elegant dresses—with hems that hung a bit longer than those of the coats. It was noted by the critics that in this collection Perry finally "mastered the dress,"[5] showing himself to be as talented at silhouettes as he was with his traditional sportswear, with a sassy little group of short tucked and pleated white silk "tennis" dresses and a silk-banded linen shift. After sampling the sun-burnt earth notes, Perry shifted directions and turned to the sea, offering up a myriad of sailing references, which he revealed were influenced by the recent America's Cup races. His collection for both men and women were relaxed versions of classic regatta wear, with a long, "ingénue" middy dress in navy, with a white sailor's collar—and natty navy and white Henley stripes, as well as polka dots on his blazers and shirts and pants.

The sailing spirit proved popular for both women and men, and retailers raved about the collection, calling it one of Perry's very best. The rest of the enthusiastic audience which included the usual actresses, plus newcomer Terri Garr, Carol Channing, and Ron and Doria Reagan, who had become friendly with Perry when he designed their clothes for President Reagan's inaugural.

Perry's sleek take on the sailor dress. Spring/ Summer 1984.

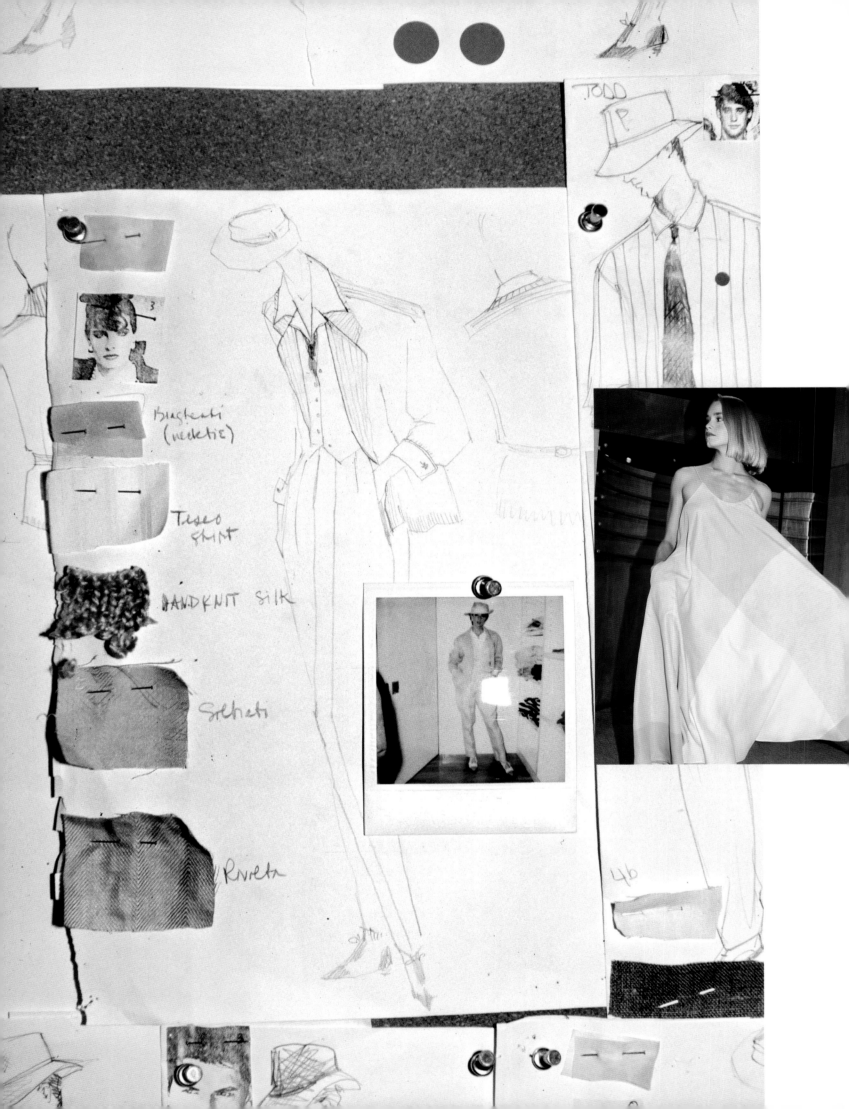

TODD
P

Brasteati
(necktie)

Teseo
shirt

HANDKNIT Silk

Stcheti

Rivieta

3

46

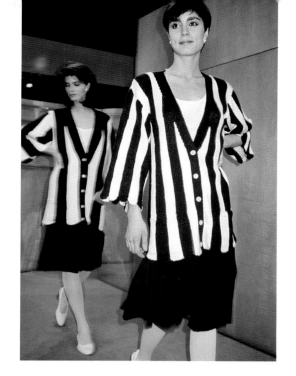

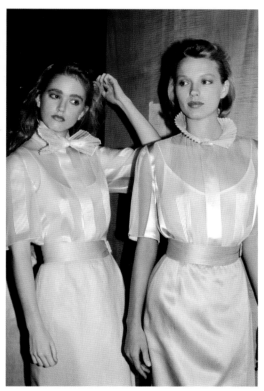

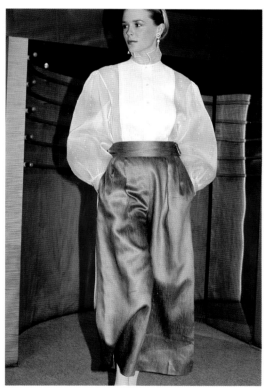

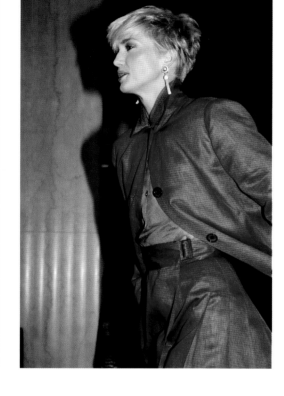

Backstage boards reveal
the line-up of runway looks,
each paired with the original
sketch for its design.
Polaroids of fabric swatches
and pairing accessories are
also included as a guide.
Spring/ Summer 1984.
Sketches by Jed Krascella.
Runway, Spring/ Summer
1984. Photographs by
Roxanne Lowit.

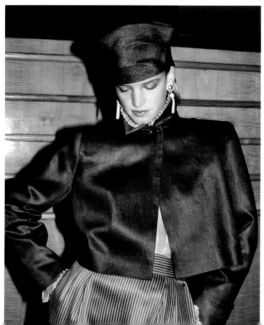

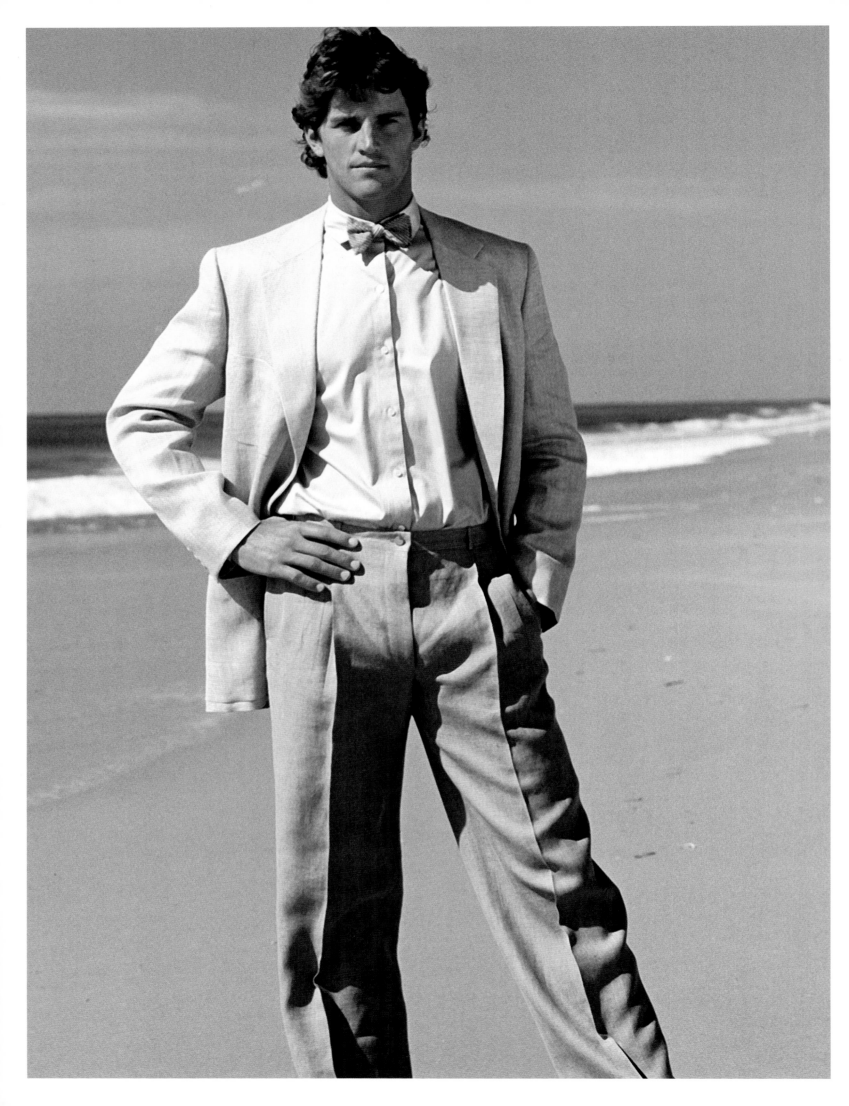

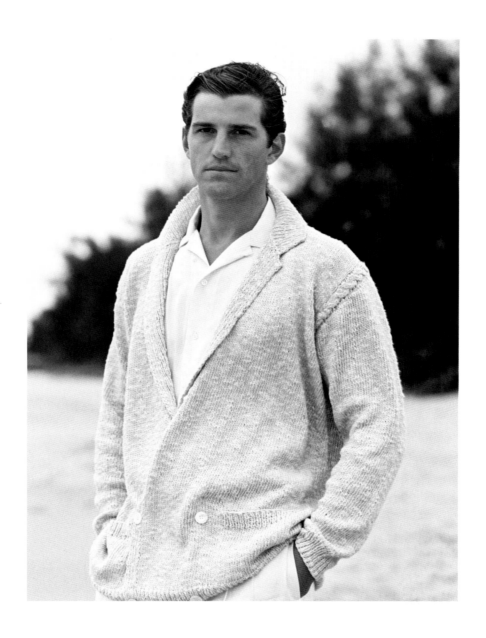

Menswear, Spring/ Summer
1984.

Following pages: Playful
and sophisticated dots are
woven through out this
multi-textured Spring/ Sum-
mer collection—dressed-up
on a silk chiffon blouse (left)
then echoed in a casual
cotton and linen sleeve-
less sweater (right). Spring/
Summer 1984.

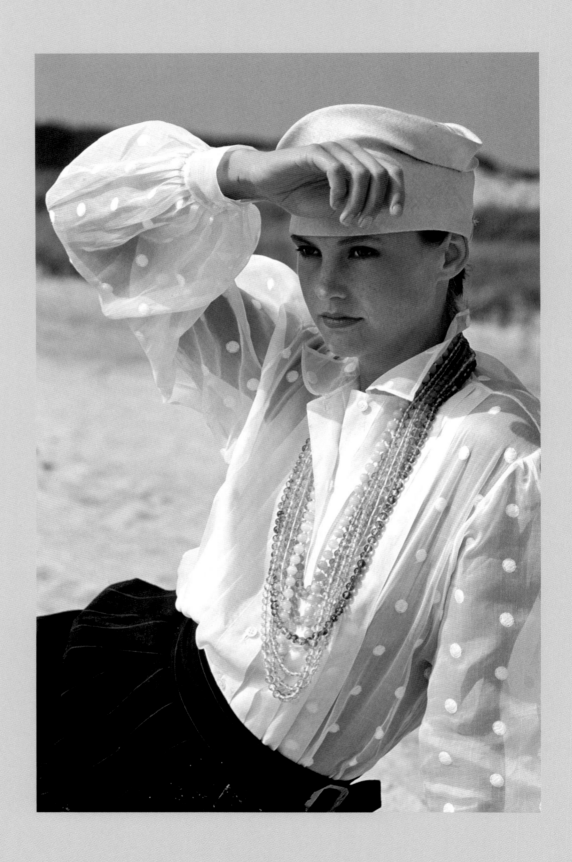

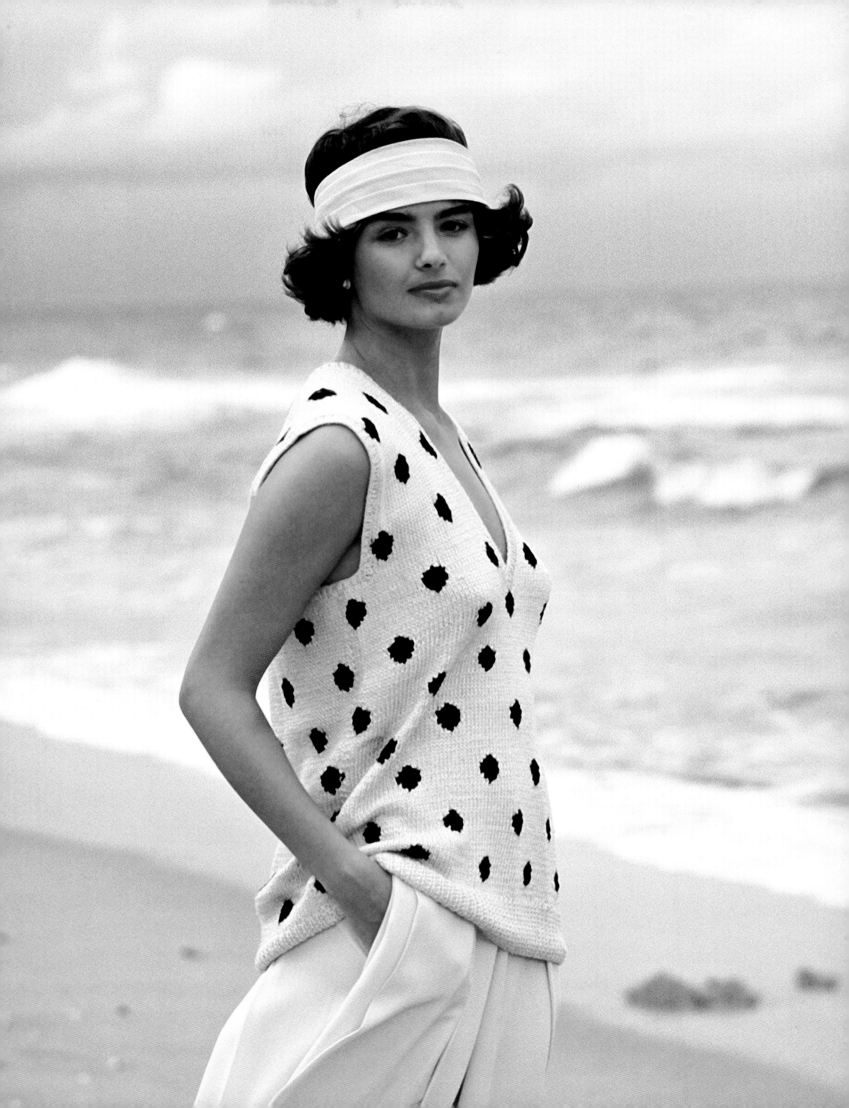

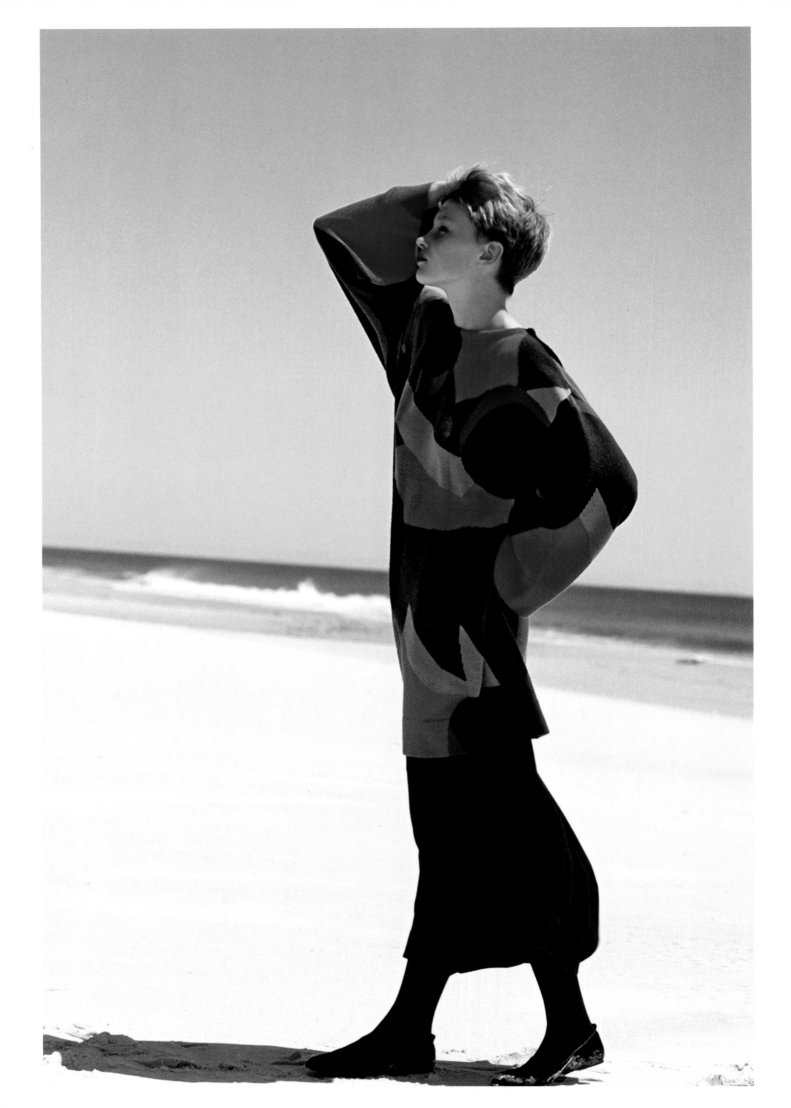

FALL/ WINTER 1984

Perry's Fall 1984 "Homage to Sonia Delaunay" collection took on a vibrant, artistic tone, as he evoked the spirit of the brilliant Russian-French abstract artist, Sonia Delaunay, whose Art Deco paintings and designs he so admired. A veritable bravura collection—whether viewed as "Art as Fashion" or "Fashion as Art"—it was spectacular from every perspective: Perry and his team seemed to liberate the colors and forms of the two-dimensional Delaunay paintings by turning them into clothing, endowing a third dimension. He played with Delaunay's geometry in his intricate intarsia sweaters, the abstract-patterned tunics, the ziz-zag bordered wool knit skirts, and his beaded Jazz Age dresses. The rich and sophisticated fabrics—wool satin, crepe de chine, velvet, alpaca—and the jarring combinations of colors and shapes—blueberry, magenta, mustard and bottle green—were eye-opening.

Equally as chic and sophisticated as the Delaunay pieces: black velvet evening dresses, jackets, and trousers; layers of cashmere cardigans, vests, and skirts; hand-knitted Art Deco Shetland Guernsey dresses, tonal plays of turquoise; royal orange, red, and jade; and understated gun-checked country classics, all laden with style.

Delaunay's art influenced Perry's menswear, as well, which featured such off-beat color combinations as a black blazer with burgundy trousers and a deep purple shirt. Most extraordinarily, there were Perry's Delaunay-inspired furs: the fur was cut into individual geometric shapes and dyed in the artist's bold and sometimes dissonant colors, then pieced back together, creating a lively and amazing work of art. The ingenuity, craftsmanship, and pure creativity displayed in this collection of clothes was said to have rivaled that of any European couturier's atelier. And when Perry came down the runway at the end of the show, the entire audience—including the journalists, retailers, and friends who were Perry's die-hard fans—cheered, whistled, and applauded for minutes on end.

Intarsia-knitted cashmere tunic—one of many pieces in the collection inspired by artist Sonia Delaunay. All Delaunay cashmeres were hand-knitted in Italy. Fall/ Winter 1984.

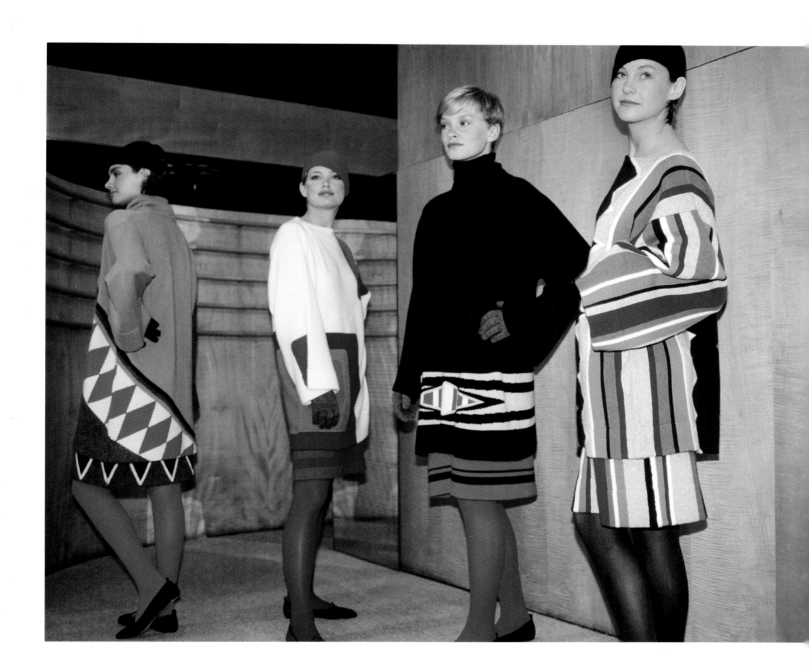

Sonia Delaunay-inspirations
in sheared mink (opposite)
and cashmere tunics and
skirts (above)—the results
achieved with the help of
fine, skilled artisans from Italy.
Each sweater's pattern was
designed in detail on graph
paper at actual size under
the direction of Patricia Pas-
tor and Jed Krascella before
being sent off to the artisans
for execution. Runway, Fall/
Winter 1984. Photographs
by Roxanne Lowit.

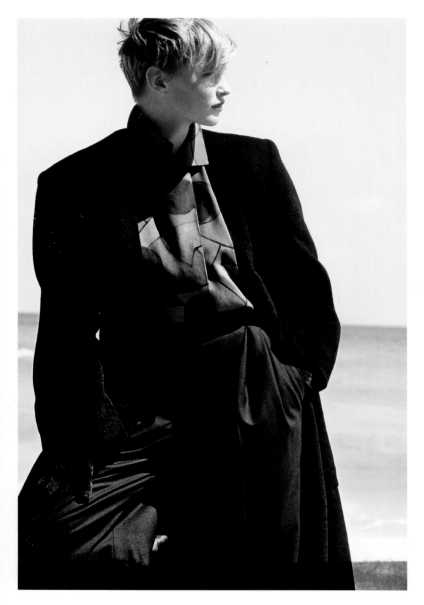

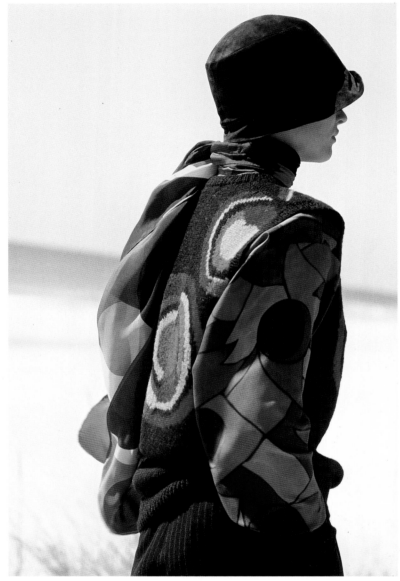

Above and opposite: The Sonia Delaunay-inspired designs extend from minks and sweaters to silk blouses, for both women and men. Fall/Winter 1984.

Following pages: A breadth of looks, this fall collection also features shades of rust, taupe, khaki, mocha, Bordeaux, and mustard. Left, fine wool gun-check shirt and Italian wool tie in plaid with covert cloth trousers; Right, authentic English balmacaan made with a twisted yarn in several shades of olive, khaki, and cream. Rather than buttoned, the cuffs are tied. Fall/Winter 1984.

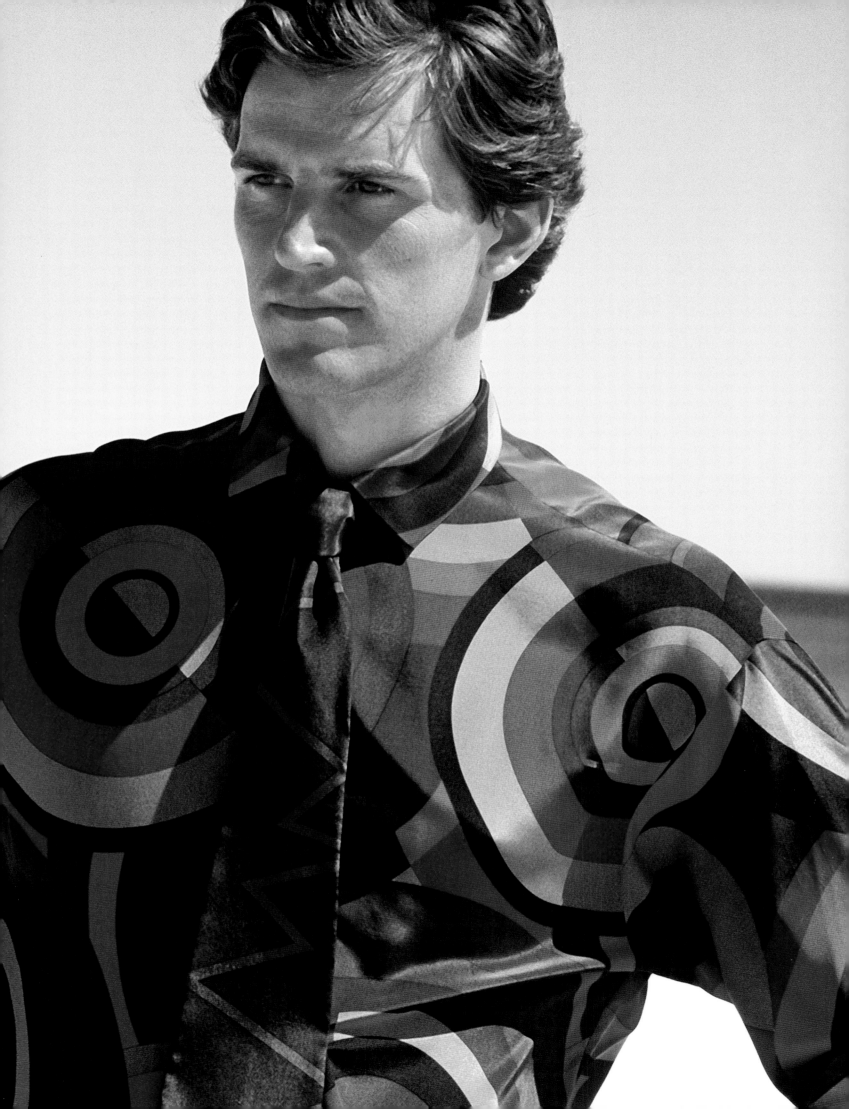

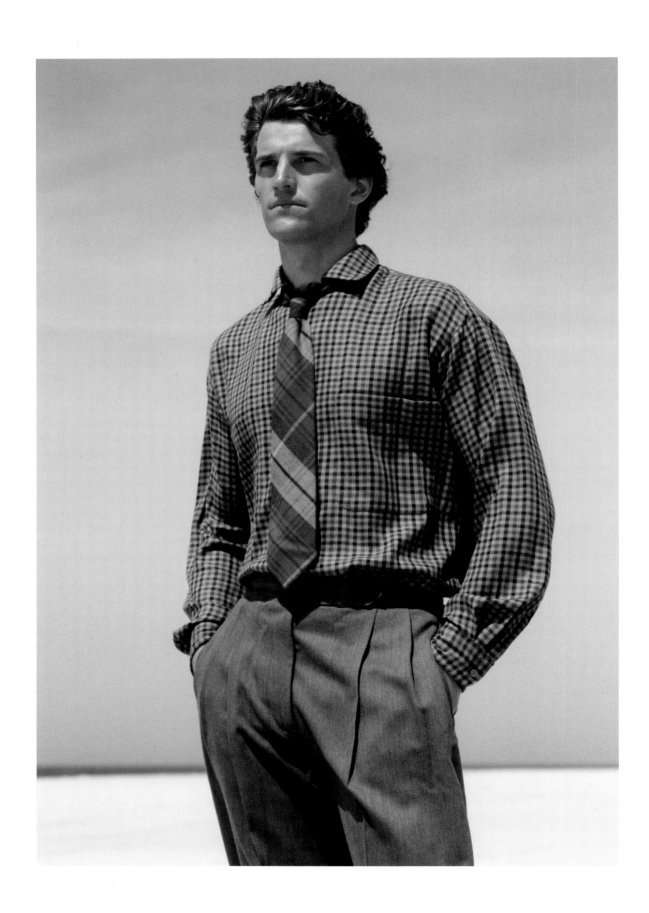

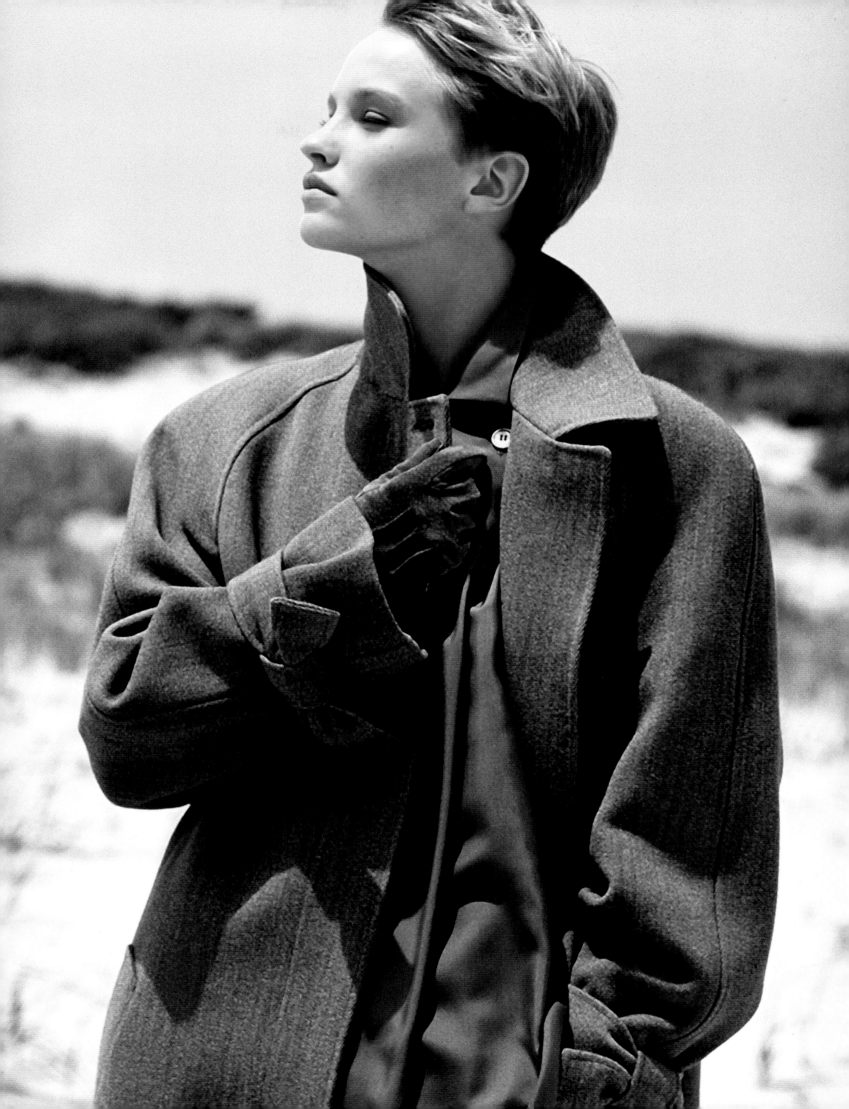

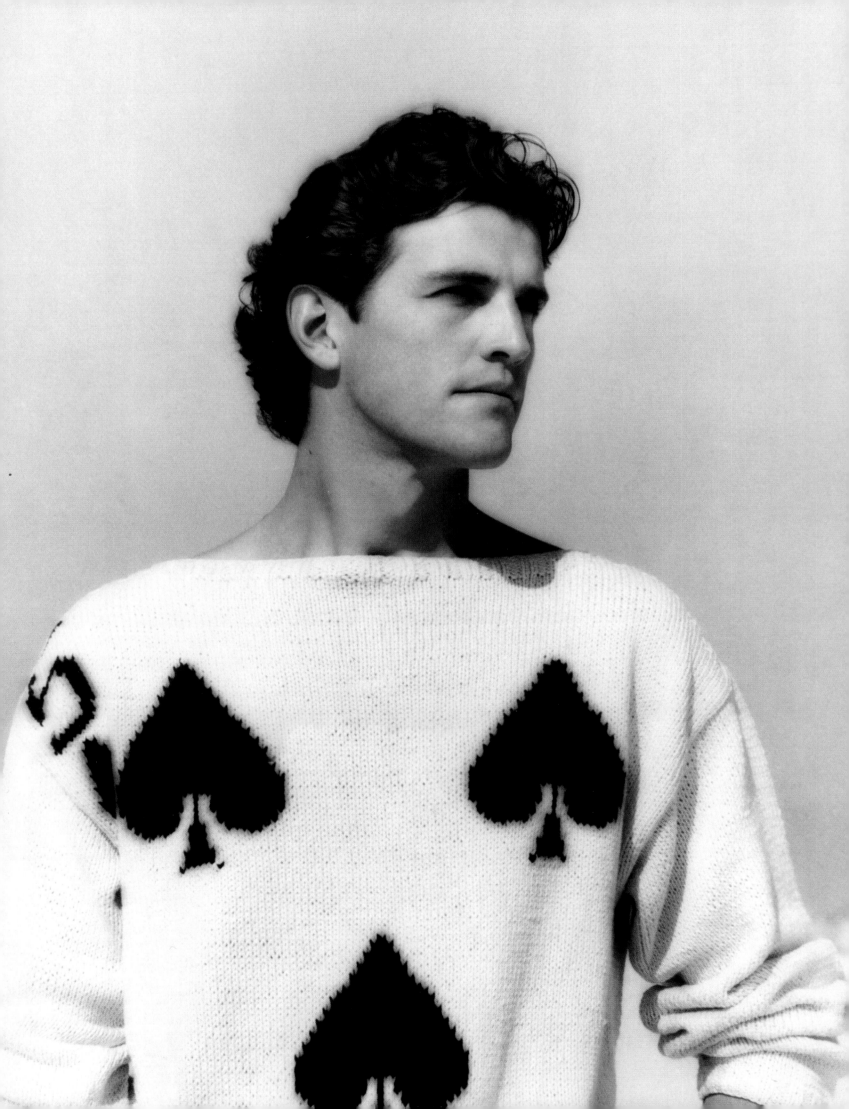

SPRING/ SUMMER 1985

Perry chose a lighthearted Hollywood theme for his Spring 1985 collection, showing an inspired group of very pretty clothes in the most American way—in dusty shades of blush pink, taupe, cream, blue, terracotta, and tan. Some had the casual ease and simplicity inherent to California, while others reflected the glamour of '40s-style, Carole Lombard–esque starlets—in silky, slightly lifted at the shoulder Adrian-inspired jackets with soft yokes and pleated backs, curve-hugging skirts, and pleated high-waisted trousers. Perry favored easy-fitting dusters over Bermuda shorts and long pants, lovely draped silk-crepe jump-suits, sexy sundresses, and slinky sweaters with scroll patterns over classic white pants. There were also clusters of gorgeous oversized gardenias bloom-ing here and there on simple crepe separates.

Perry also tried his hand at cards in this collection, with a winning group of hand-knit sweaters for men and women, patterned with card faces like a Jack of Spades or King of Hearts. At the eleventh hour, Perry had decided he wanted to create a more intimate setting for his show, so with a bold (and perhaps hasty gesture) he replaced his usual U-shaped runway with a sim-ple platform, eliminating over 100 seats in the process—not a popular move among some of the top retailers who were left standing. Nonetheless, everyone seemed to love the show.

Opposite: Hand-knit cotton boatneck playing-card sweater, part of a deck of bold, graphic knits for men and women. Spring/ Summer 1985.

Following pages: The same spring win-dowpane plaid linen in a blazer for men (left) and pants for women (right). Spring/ Summer 1985.

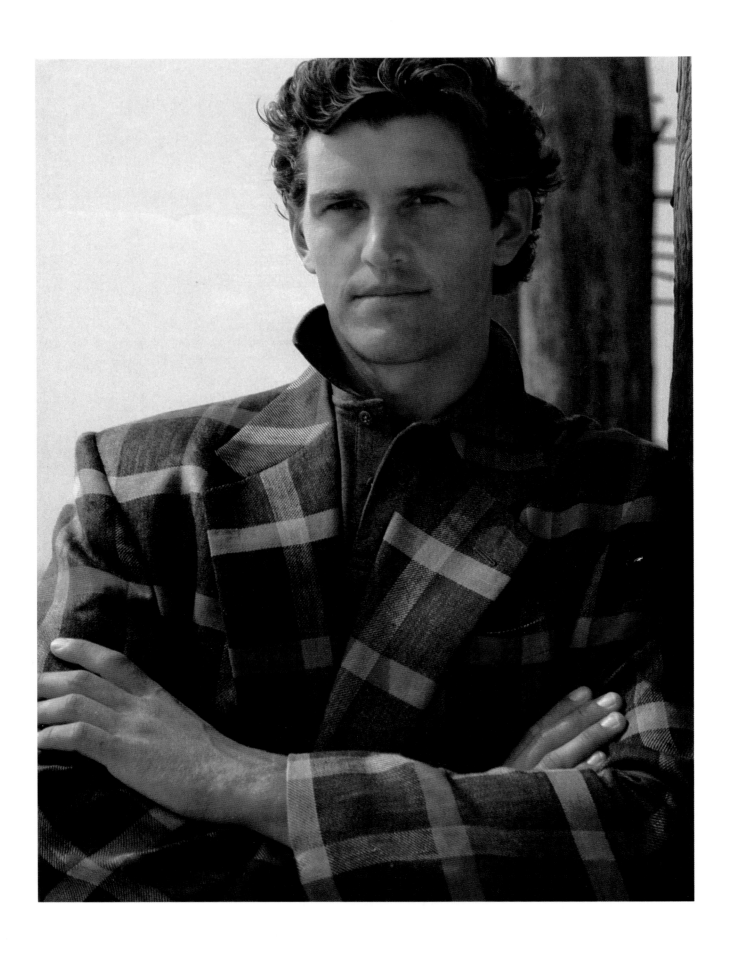

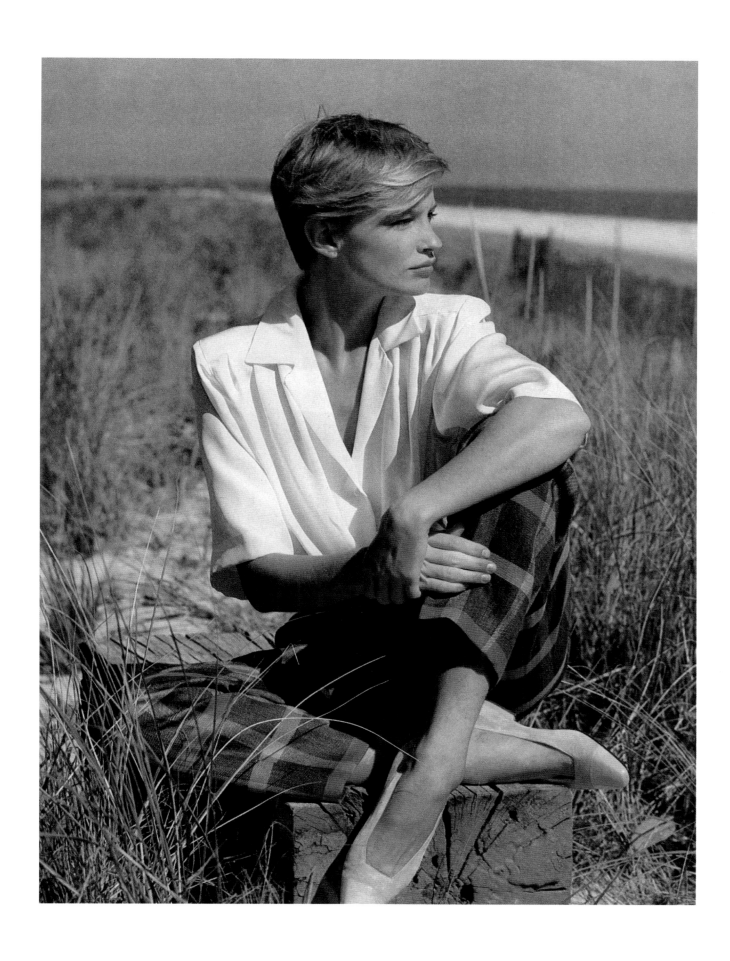

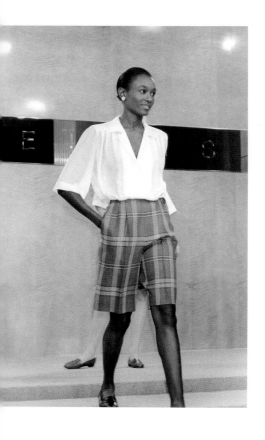

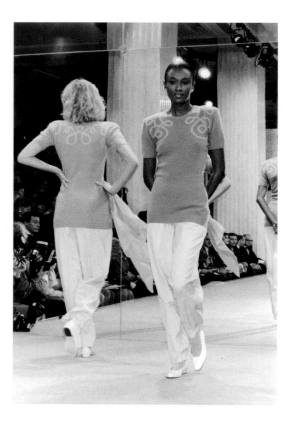

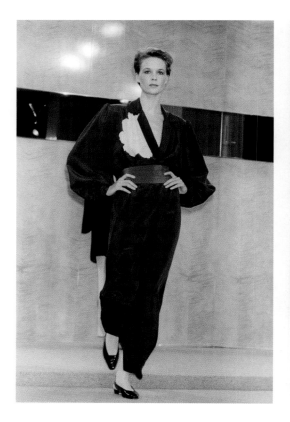

Draped necklines and
jumpsuits—both California
casual and Hollywood
glamour inspired looks.
Runway, Spring/
Summer 1985.

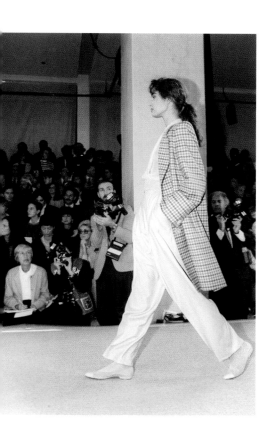

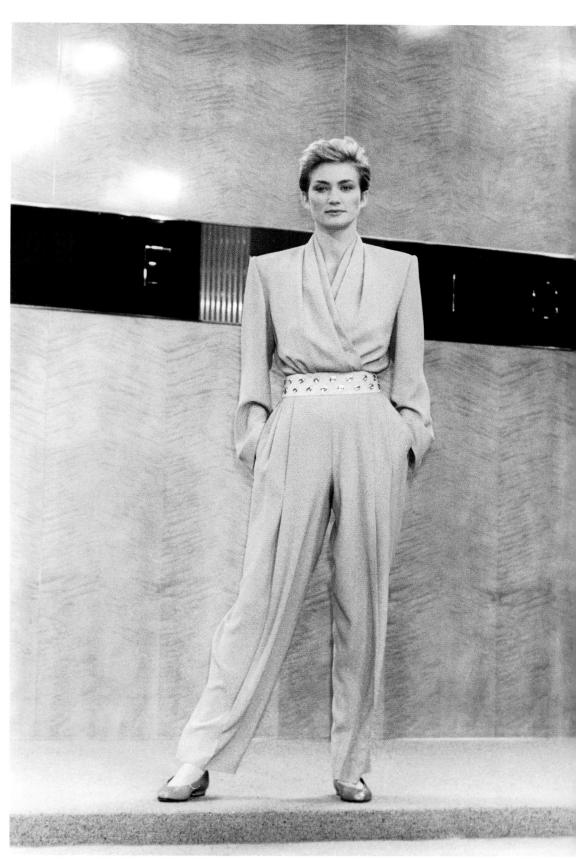

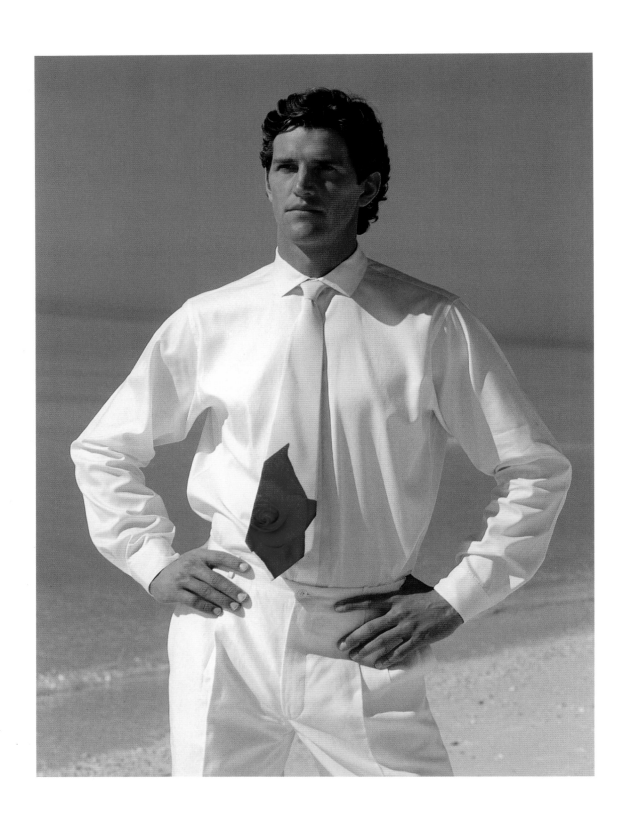

Summer whites for men and
women. Paulina Porizkova
(opposite) wears a blouse
evocative of '40s glamour
with studded suede belt
by Barry Kieselstein-Cord.
Spring/ Summer 1985.

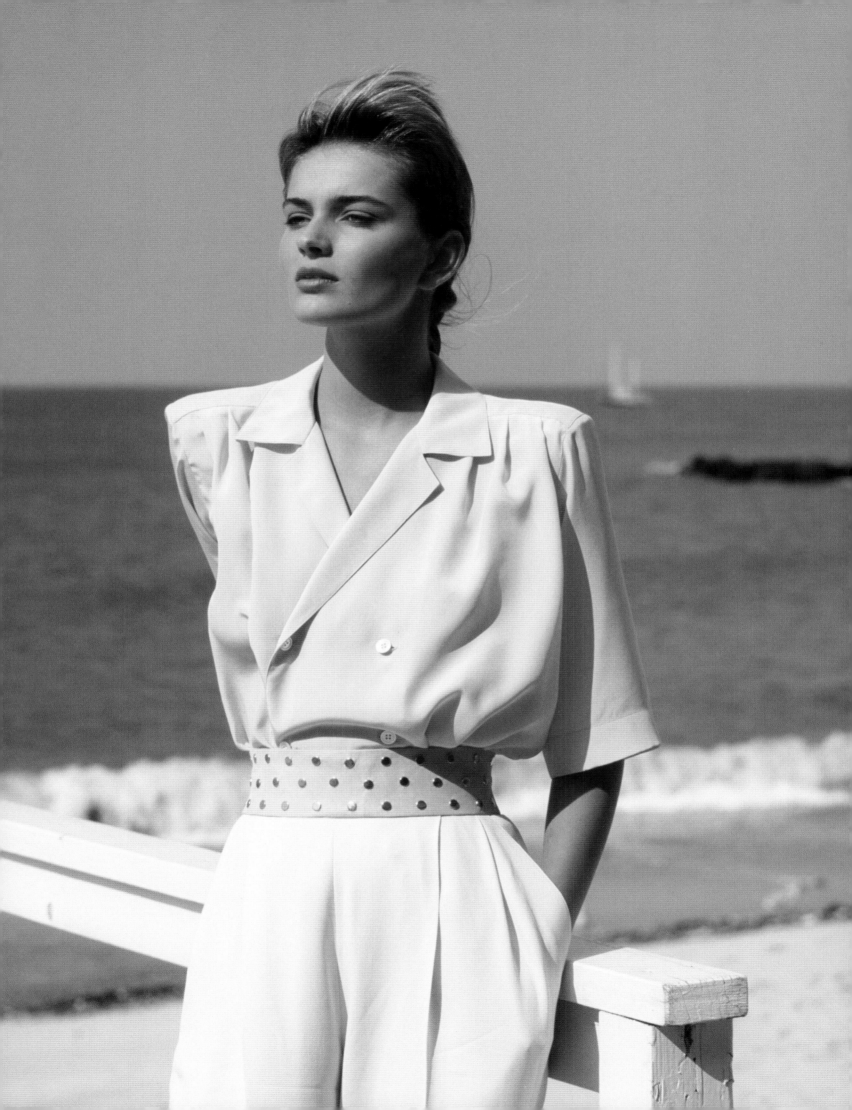

WWD

WOMEN'S WEAR DAILY VOL. 149 NO. 42
FRIDAY, MARCH 1, 1985 75 Cents

Perry Ellis

NEW YORK — Perry Ellis likes the way a sweater looks when it drapes around the body, and he's fashioned his fall collection with that in mind. Following the tone he set for spring, jackets are soft with natural shoulders, and narrow pants complete the effortless look. Here, for fall, the draped-front sport jacket in cashmere flannel over a cashmere

FALL/ WINTER 1985

Perry's Fall 1985 collection was a rich tapestry of Renaissance-themed ideas: the clear, painterly colors and the single-buttoned, draped jackets over slim pants conjured the graceful silhouette of a medieval page, yet the pieces were at once modern and pared-down. The message of his collection was simple lines, soft fabrics, and short lengths. The designer did his draped jackets in solid emerald or amethyst jersey, and also in a subtle hounds-tooth check wool-crepe. A new and softer variation on the pantsuit was his slim single-breasted high-neck navy suit with full sleeves over slouchy pants. And his wool crepe "poet's dresses" were well-versed in movement and grace. Another group of "simple little slips of dresses"—as Perry called them—a small group of young, sexy, and barely-there silk satin and wool numbers in emerald, ruby, and black also played to his pared-down simplicity. Beautiful, deeply hooded coats, full-blown capes in velvets and melton wools, bi-colored leggings, regimental striped peplum jackets, pageboy tunics, and thigh-high suede boots all contributed to the Renaissance mood. Perry's hand-knits this season took the form of tunics with extraordinary sixteenth-century unicorn tapestry designs as well as tragedy/comedy masks and feathers, violins, and fans—motifs from several of Shakespeare's plays. Even Perry's furs were Renaissance-inspired, with voluminous, bishop's sleeves and extravagant shawl-collars.

The March 1, 1985 cover of *WWD* with rendering of Perry's soft, draped jacket and slender wool-crepe pants. Illustration by Kenneth Paul Block. Fall/ Winter 1985.

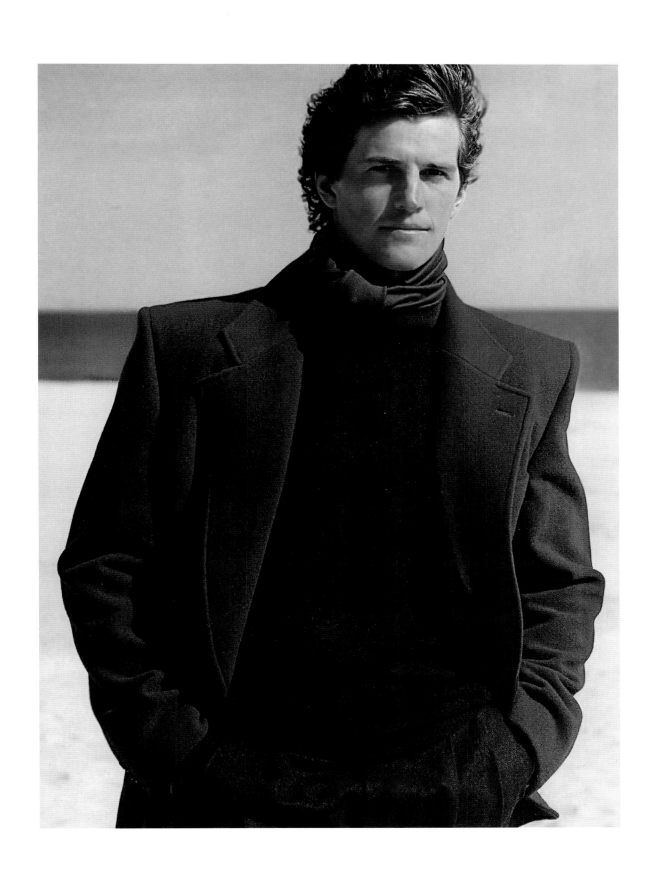

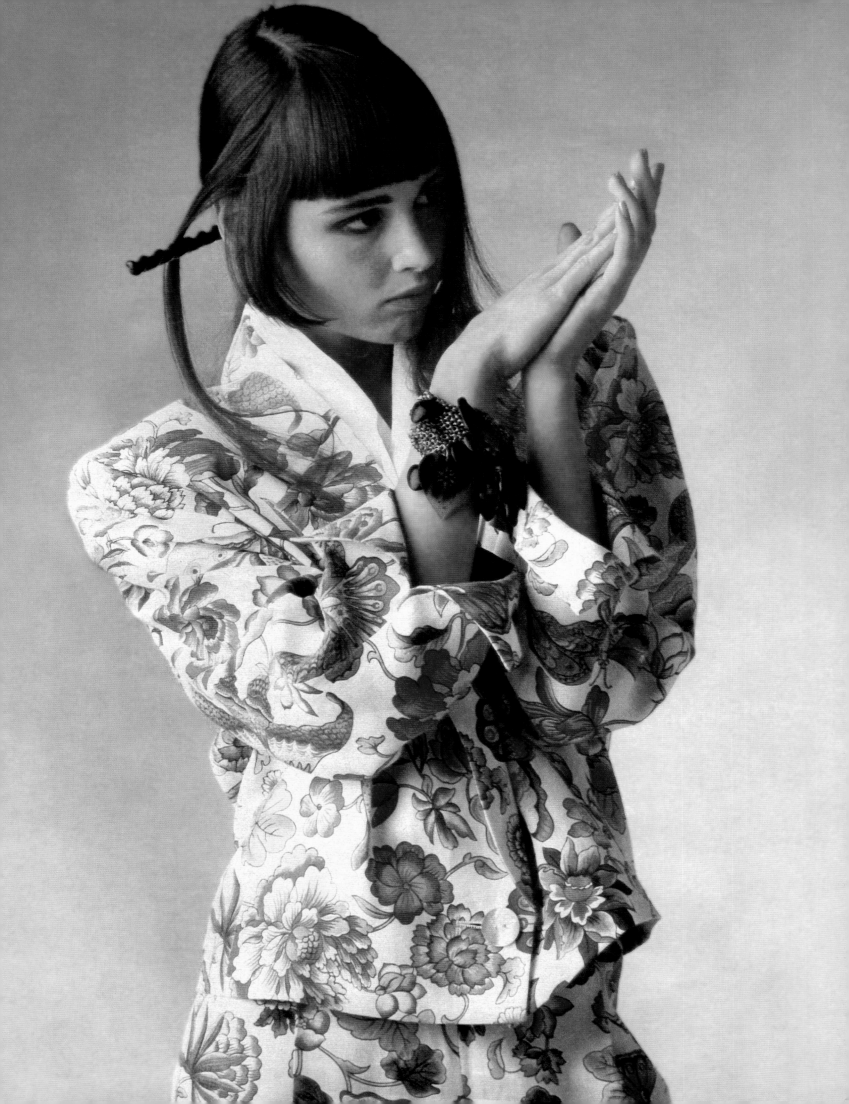

SPRING/ SUMMER 1986

Traditionally, it was his fabrics that served as a source of inspiration to Perry when he designed, but this season, for the first time, he drew upon influences from the Far East—his own superb collection of Chinese export and Wedgewood porcelain. Taking a cue from *Rose Famille*, one of his favorite patterns, he used shades of emerald, rose, indigo, and china blue, as well as smatterings of black and white, and created some of his own prints on silk and linen (brought to life by the talented Mario Raimondo), based on the porcelain's charming flower and butterfly motifs. Perry also borrowed exquisite blue willow print vases from blue and white Cantonese china, employing them as repeating motifs on everything from dresses and men's pants to lighthearted summery ties. He made a big impact with his wonderfully graphic hand-knit sweater, transposing a fiery blue dragon from vase to the front of a sweater. Perry even went so far as to play with the cables his sweaters, tweaking them to resemble the shape of a back splat on a Chinese Chippendale chair.

In this collection, Perry pulled in his silhouettes, showing short, cropped, and slightly boxy jackets, sometimes with a turned up, almost Mandarin-style collar and flipped-back cuffs. His pants were narrower, too; in some cases the waist was cinched with an obi-style sash. His body-conscious sheaths in the porcelain colors were perfect summer fare. And, along with the less exaggerated shapes, there was more fluidity: a group of skinny black knits punctuated with bright white buttons, spare black and white silk-crepe cropped tops, boleros, and baseball jackets worn with short skirts. It was a serenely beautiful collection.

Inspired by Chinese export porcelain, Perry and his team, together with Giuseppe Menta of Como, Italy, devised this exquisite print—shown here on a cropped Italian linen blazer with one pearl button. Spring/ Summer 1986. Photograph by Ulli Rose.

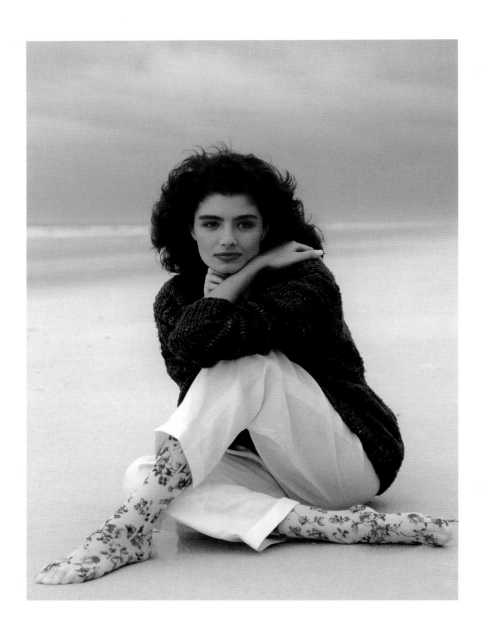

Blue and white Chinese
porcelain-inspired prints
lend delicate charm to Perry
Ellis socks (above) and cool,
sleeveless coatdresses
(opposite). Spring/ Summer
1986. Photograph (oppo-
site) by Roxanne Lowit.

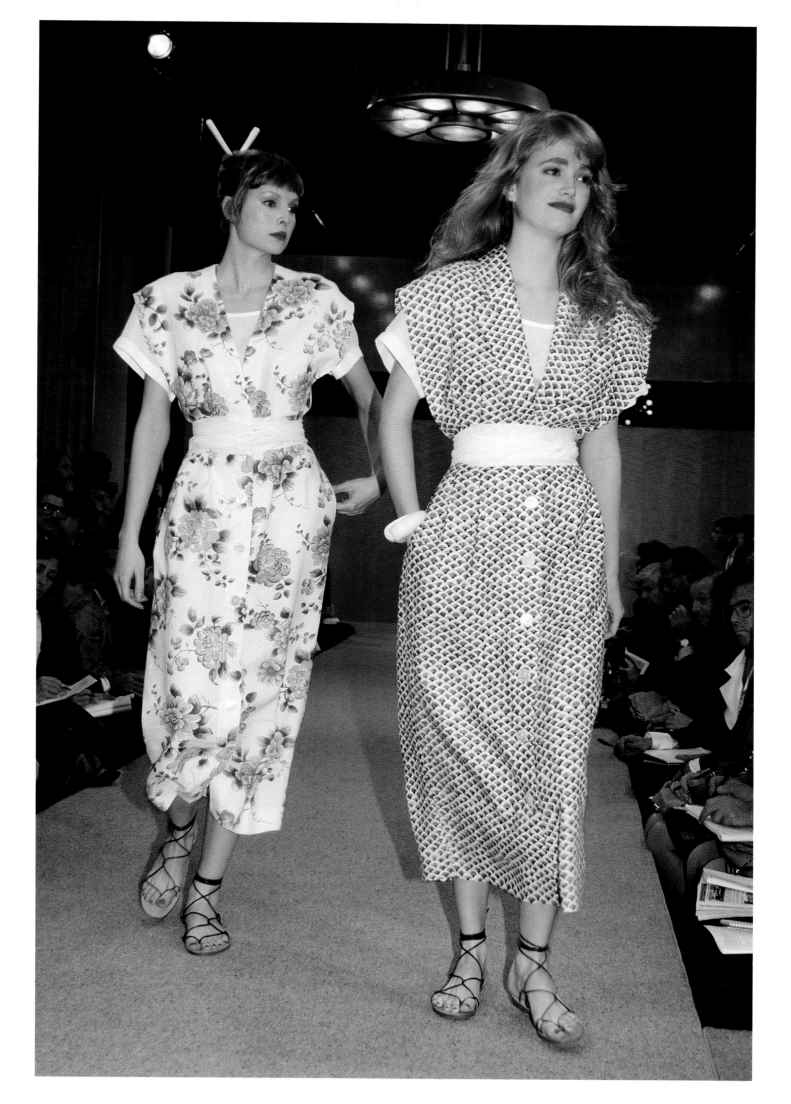

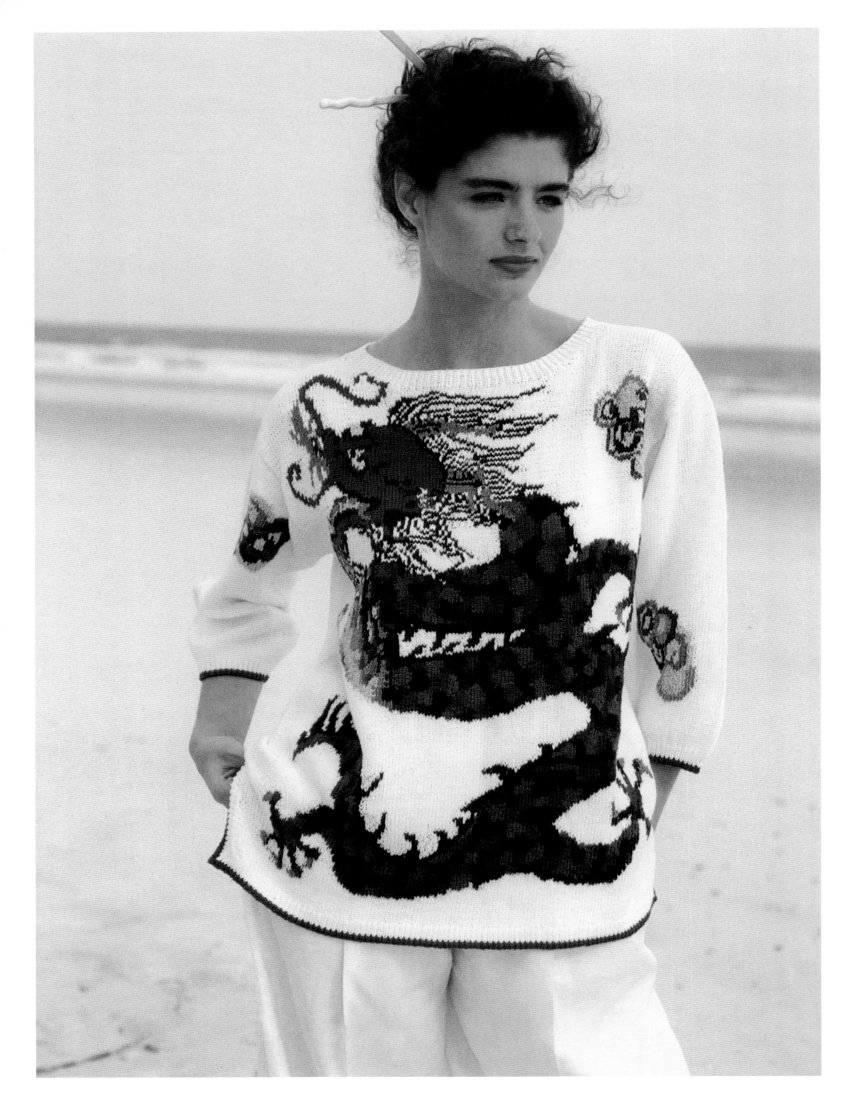

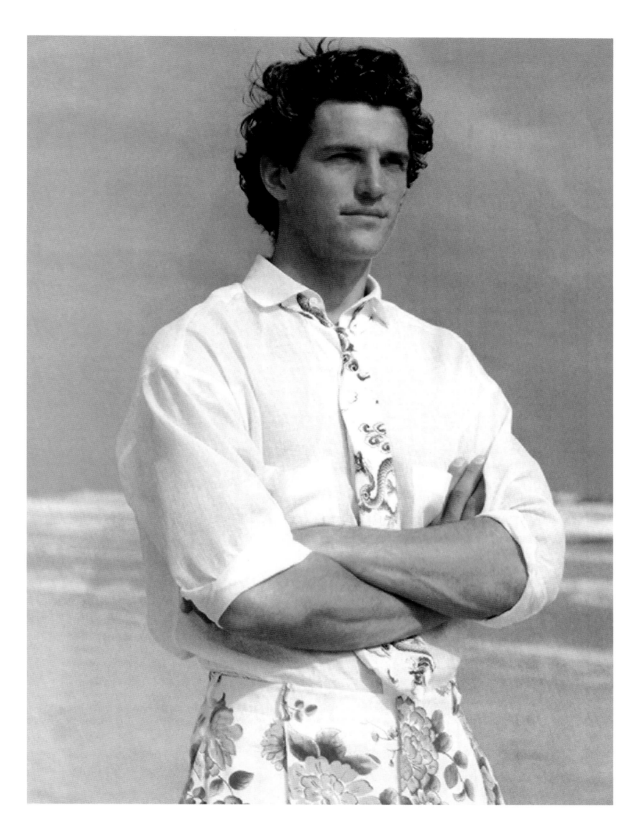

Opposite: Perry's blue dragon sweater. The blue dragon is an ancient Chinese decorative motif often used on porcelain. Spring/ Summer 1986.

Above: Blue and white Chinese print on Perry Ellis Men's tie and pleated summer-weight shorts. Spring/ Summer 1986.

FALL/ WINTER 1986

Filled with imaginative proportions and lush pastel fabrics—plus his young, yet sophisticated attitude—the Fall 1986 collection was textbook Perry Ellis. He designed send-ups of the "matchy-matchy" look—whole outfits of sweaters, skirts, gloves, shoes, and hose in different textures but the same colors. Taking his unseasonably pale colors, he "played them," to use his words, "against the familiarity of gray." With a post-collegiate polish and not a little snob appeal, Perry dubbed his clothing groups blue-blooded names: "The Seven Sisters Knits," "The Junior League Cashmeres," and "Princeton Camelhairs" all in the spirit of good collegiate fun. He also added some sophisticated new elements: long belted coats in pale colors, a show-stopping sleek, black crocodile leather jacket, charming blouson golf jackets, drop-pleated skirts for day or night, fragile georgette blouses, hand-knit sweaters in pinwheel and parasol motifs, and luxurious cashmere sweaters in crocodile prints.

For evening, he turned on the glam: black and white sequin tops in checkerboard patterns, strapless georgette dresses in black, pink satin trench-coats and matching skirts, and a pale pink cashmere sweater with matching long, hip-yoked, swirling skirt and chevron fox coat—pure Perry. Pink also worked wonderfully for Perry's menswear: he showed pink cashmere jackets for men with gray flannel pants, proving his long-held philosophy that men and women can easily borrow ideas from one another.

Sadly, this was Perry's final collection as a designer, and, as it was said at the time, it brought his career full circle. In 1978, he had started with his famous freshman "Cheerleader" show, branded with big shoulders, chunky textures, and "rah-rah" collegiate enthusiasm; and with Fall 1986, he bookended his career on the perfect polished note—a more refined and much more sophisticated collection for both women and men, but bearing the same unabashed spirit, youth, and wit that will forever mark him an "American original."[6]

Perry named this collection "The Seven Sisters" paying homage to the Seven Sisters colleges and the smart, polished style with which they became synonymous. Fall/ Winter 1986.

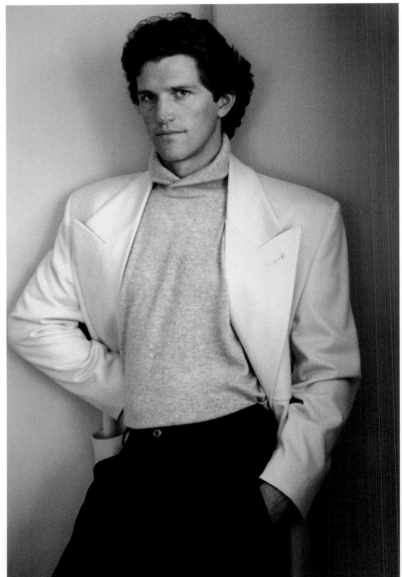

Left, camel hair belted
double-breasted coat with
mother-of-pearl buttons;
Right, men's cashmere
jacket with peaked
lapel; Opposite, left: single
breasted cashmere jacket
with peak-lapel and mother-
of-pearl buttons. Opposite,
right: Ultra-long pink cash-
mere "reefer." Spring/ Sum-
mer 1986. Photographs by
Sheila Metzner.

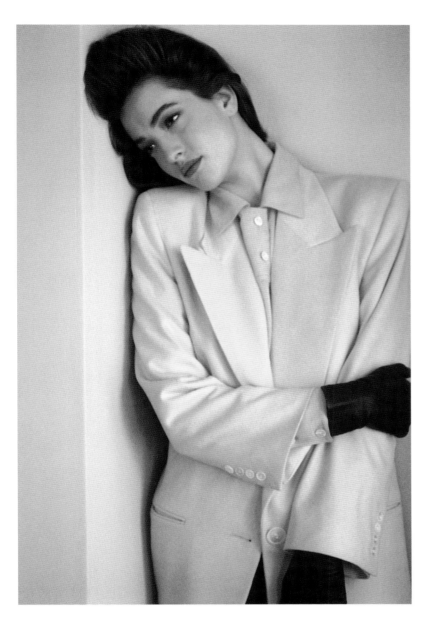
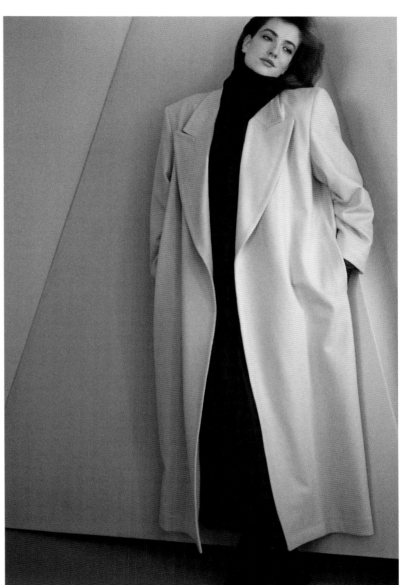

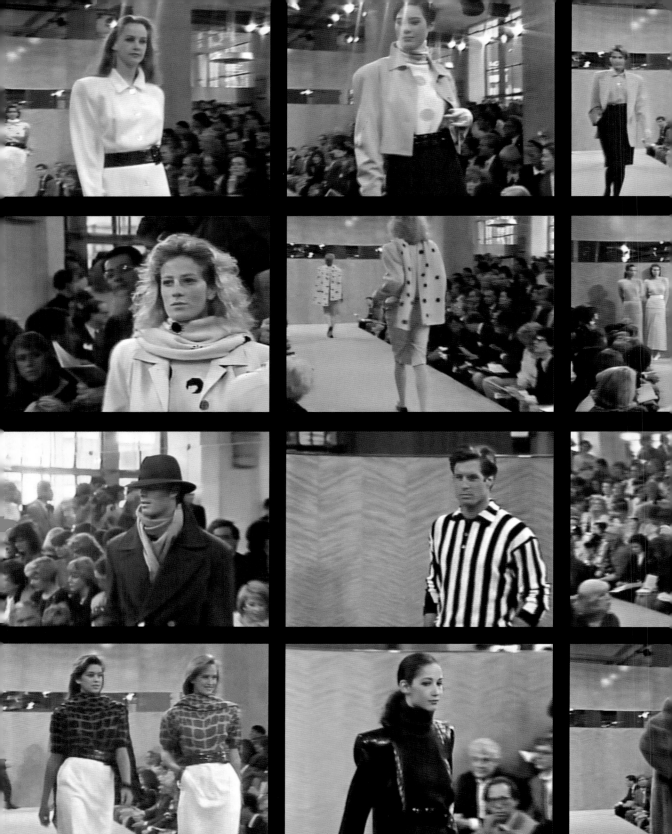

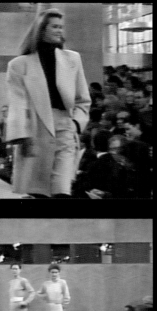

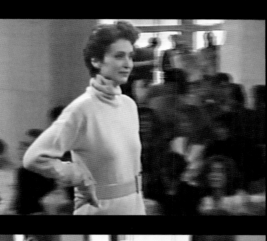

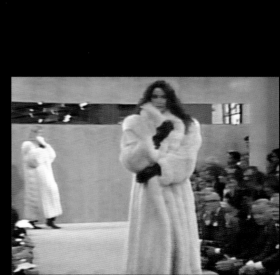

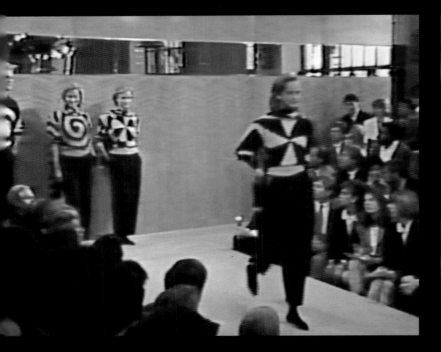

Perry's cropped pinwheel
crewneck sweaters with
matching scarves—a riff
on the childhood "sweater-
scarf "combo, hand-knitted
in heavy gauge cashmere.
Video stills from the runway.
Fall/ Winter 1986.

Opposite: Sketch (detail) by
Jed Krascella.

Following pages: Large-
scaled crocodile and giraffe-
patterned cashmere in short-
sleeve sweaters. Photograph
by Roxanne Lowit.

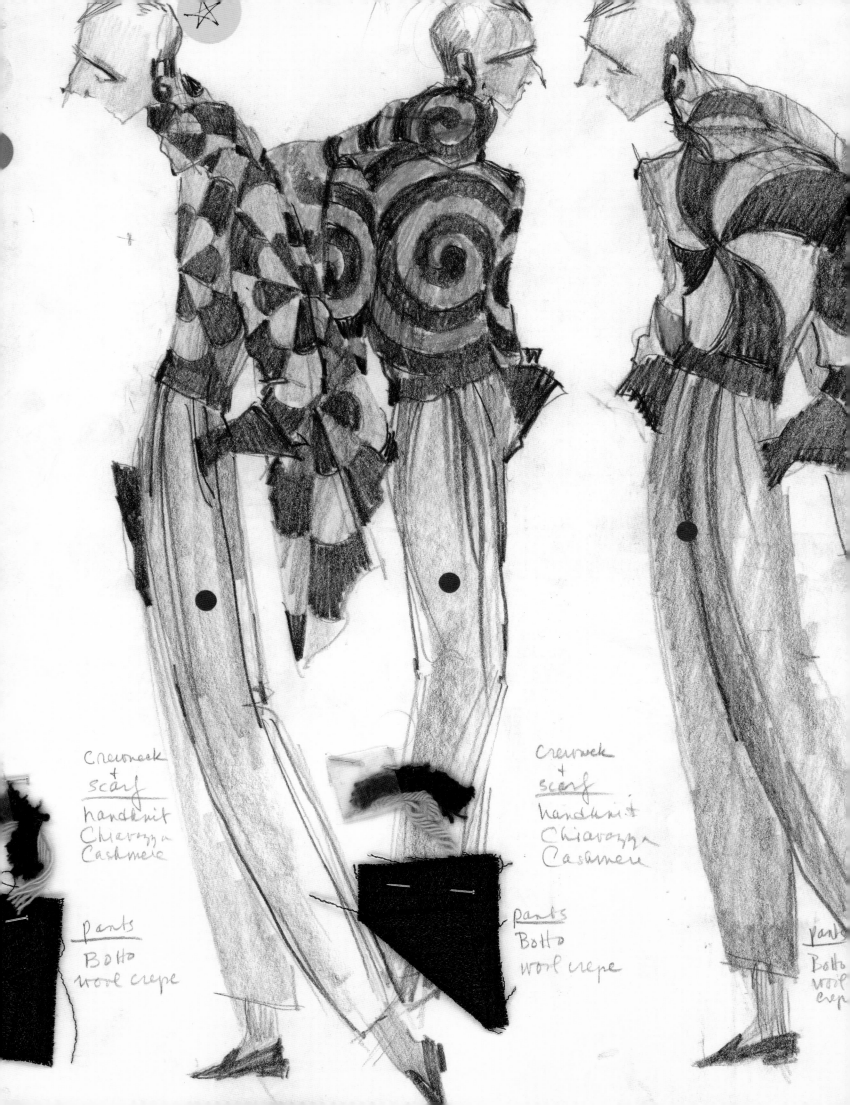

crewneck
+
scarf
handknit
Chiavozza
Cashmere

pants
Botto
wool crepe

crewneck
+
scarf
handknit
Chiavozza
Cashmere

pants
Botto
wool crepe

pants
Botto
wool
crepe

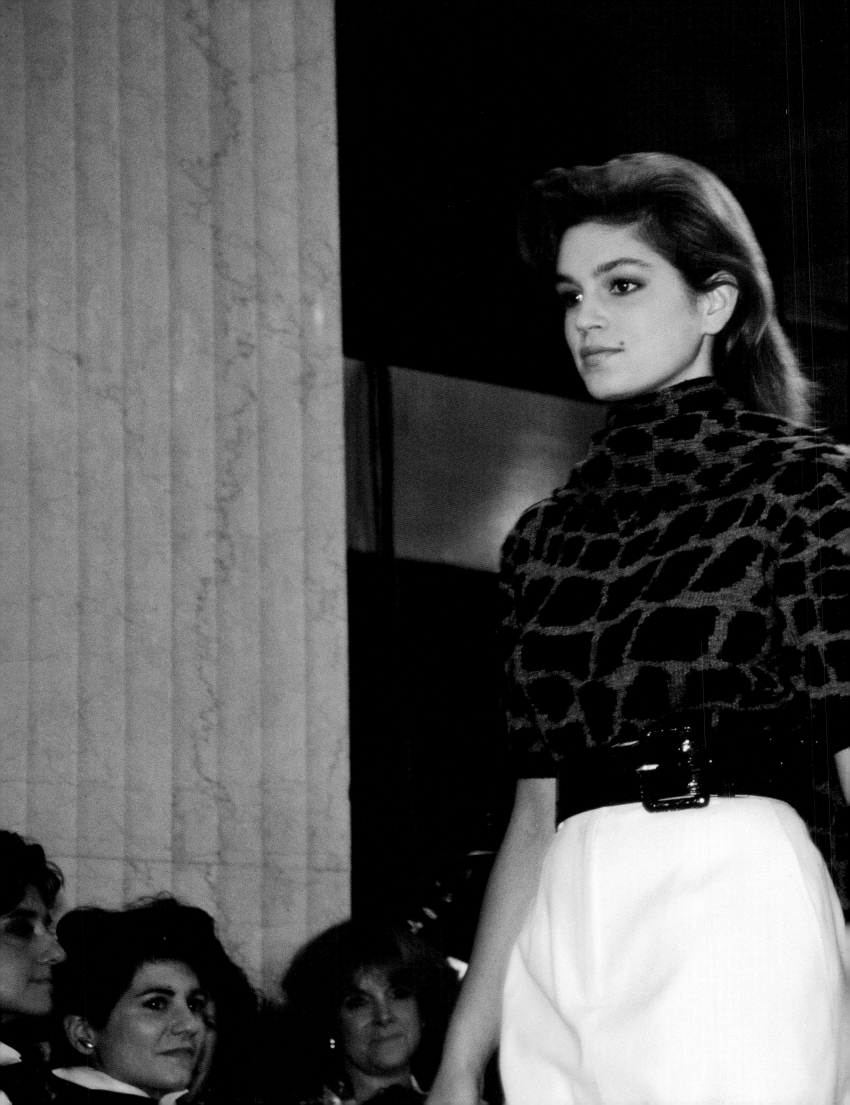

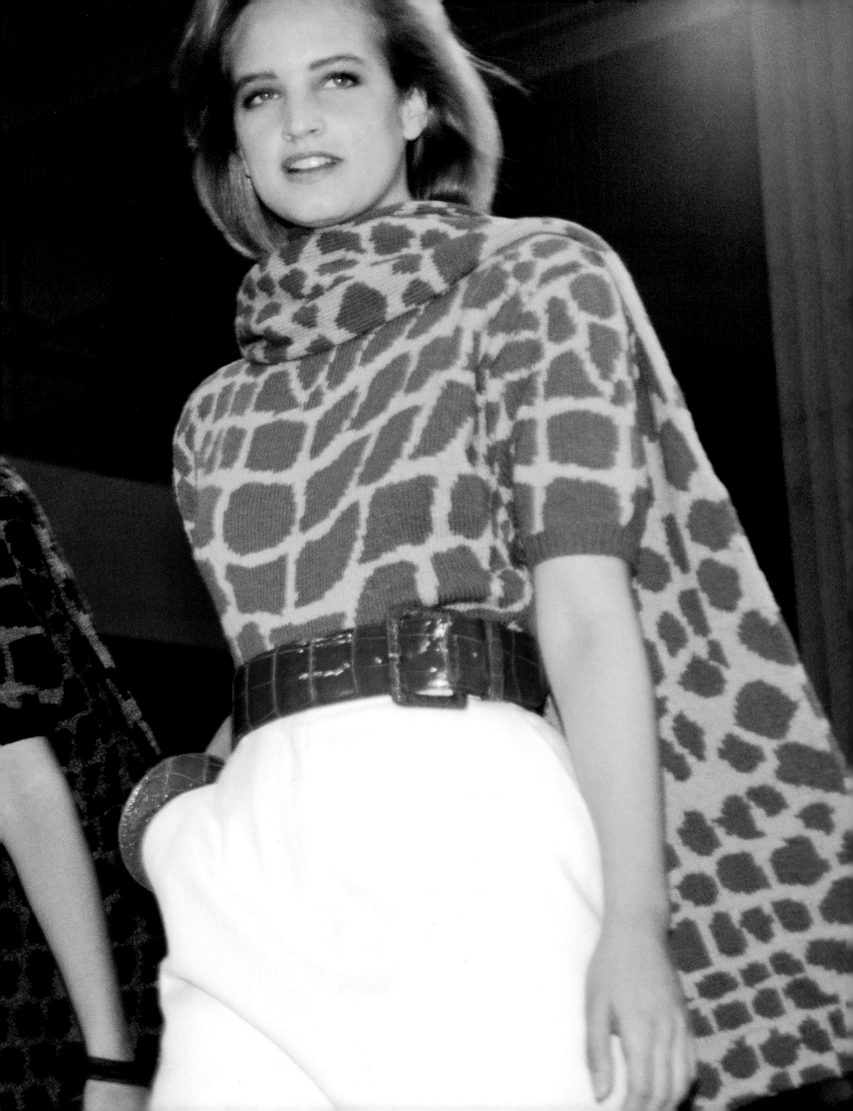

PERRY'S LEGACY

When Perry Ellis died in 1986, he had been designing sportswear collections for only ten years. But given his meteoric rise and the spirited attitude and excitement he contributed to American fashion for both women and men, it seems so much longer than that.

Apart from the adventurous women designers of the 1940s and 1950s, like Claire McCardell and Bonnie Cashin, pre-Perry American sportswear had followed a predictable pattern: classic good taste, often reflective of European designers; no-nonsense shapes; and nice, unexceptional fabrics. It was about sameness and safeness.

Perry blew in with his first big blockbuster of a fashion show in 1978, bringing a new freedom of expression to the design table that shook up the predetermined sportswear molds. He emphasized youth and creativity over everything, throwing out the unwritten mandate that American sportswear need only be clean and spare and dull (or based on St. Laurent). Perry looked at *everything* differently, sometimes subversively: Does a shirt need a cuff? Must a jacket have a button? Why can't a Shetland sweater have just one cable? With a headful of ideas, a talented young design crew, and an open-minded business team, he dared to take risks and wage an attack on the staid designer sportswear business.

For years, American designers had looked to Europe for inspiration, often quite literally knocking off the work of big-name European designers. Perry would have none of it. He insisted on starting each season from the beginning, with the fundamental and often unique ideas that he and his team generated, not tear sheets from magazines. While the essence of his clothes was always American, full of freshness, audacity, and wit, his willingness to experiment with new proportions, unusual fabric and color, textural combinations, mixes of high and low, men's shoes for women, women's fabrics and colors for men—*that* was pure Perry.

Perry was the first modern American designer who somehow made a business out of having fun. Fun was his criteria for getting dressed, theming a fashion show, naming a collection—or driving every aspect of his brand. Casual and effortless were Perry's bywords: slouchy attitudes, oversized fits, cropped pants and sleeves and waists, even hand-knitted Shetland sweater evening gowns—a relaxed and effortless way to live. He left a legacy of new proportions and exaggerated shapes for women who were young and fun—or wanted to look that way.

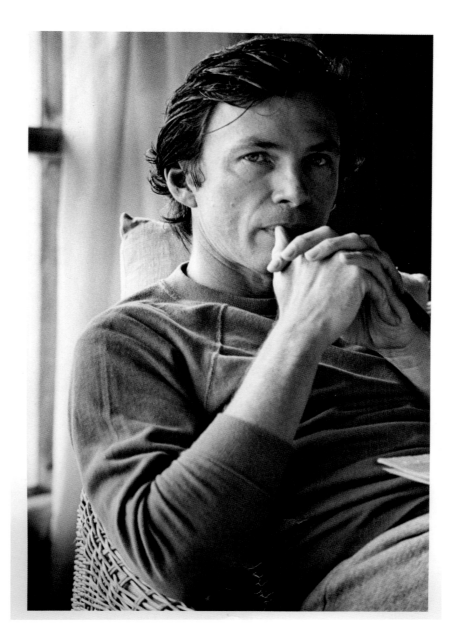

Perry Ellis, circa 1984. Photograph by Lynn Kohlman.

He had a profound influence on men's fashion, which he designed seriously for only six years. In fact, much of today's men's wear is based on the "loosened up" formality that Perry initiated. "It was a huge turning point, what Perry did," said Richard Haines, a former Perry Ellis designer and colleague. "Up to then, it had been very traditional men's wear. Suddenly there was this designer who played with pattern and proportions and was messing with very classic icons like Shetland wool and cable-knit sweaters."[1] (Twenty-five years later, those sweaters are still very much cherished by their owners, even if they no longer fit.)

Ever the inconoclast, Perry paved the way for other designers to follow suit. He helped foster creativity and "out of the box" thinking in everyone who came in contact with him, including both Marc Jacobs and Isaac Mizrahi as well as Patricia Pastor, Jed Krascella, William Frawley, Brian Bubb, and a host of others who benefited from his mentoring. Everyone who worked for him said that, from a creative point of view, it was the best work environment that they had ever been in. He influenced the whole approach to American sportswear, changing both industry and customer expectations. In so doing, he altered the way the rest of the world looks at American fashion. Perry had great foresight: "American casual" is the driving force of the majority of fashion companies today, all over the globe.

283

PERRY ELLIS

ACKNOWLEDGMENTS

Creating a book about American designer Perry Ellis nearly thirty years after his death was a daunting task and one we could not have dared attempt without the help and support of Perry's colleagues, family, and friends. The authors are indebted to all of those below, who in sharing their observations, memories, and photographs of the Perry Ellis they knew, helped us compose a portrait of a true American Original who re-shaped the way American women and men dress:

Most importantly, the *sine qua no*n to this project: Patricia Pastor and Jed Krascell Perry's *uber*-extraordinary assistant designers who were with him from the beginning as team-mates and who shared with us their colorful stories and their photographic memories of the design process from philosophy to finished product, with a lot of hilarious laughter in between. Jed's detailed design sketches, an important step in the creation of Perry Ellis collections, are to be found throughout the book, reunited with photographs of the actual clothing they anticipated. Patricia and Jed spent untold hours with the authors, ferreted out the old runway videos, unhesitatingly answered every question posed, and, fittingly, wrote the introduction to this book;

Another valuable contributor is Edward M. Jones III, who, in essence, almost single-handedly built Perry's menswear business, provided detailed information as to how that was accomplished. His many memories and contacts helped to shape our story;

Marc Jacobs, whose life was influenced by Perry and who was kind enough to pen the foreword to this book;

Dr. Mathilde Krim, co-founder of AMFAR, who spoke to us about attitudes toward AIDS in the context of the 1980s and the present;

Mort and Rob Kaplan who forged brilliant licensing partnerships for Perry were invaluable, as was their accountant Isaac Pittson;

Larry Leeds, former Chairman of Manhattan Industries, who was responsible for launching Perry's career;

Barbara Gallagher and Tyler Alexandra Gallagher Ellis shared a trove of cherished memories and photographs with us, as did Kate Barker Romm, Christine Barker and David Barker;

Carolyn Gottfried, Bobbi Queen, Etta Froio, Grace Mirabella, Polly Mellen, Edie Raymond Locke, Sandy Horvitz, Marilyn Kirschner, June Weir, Melissa Drier, Pamela Altman, Andre Leon Talley, Holly Brubach, Mary Lou Luther, Patricia Shelton, all esteemed members of the 4th estate;

Jerry Yospin, Ed Steinberg, Myra Daleng, Cathy Gempp, John Stedila, Erwin Isman, Barbara Flood, Cathy Hardwick who shared their experiences with Perry in the early part of his career;

Philip Miller, former Chairman and CEO of both Saks Fifth Avenue and Marshall Field who was able to unearth memorabilia from the two major store events he hosted in Perry's honor;

Koko Hashim of Neiman Marcus and Jean Rosenberg of Bendel, early supporters of Perry, who shared their knowledge of Perry's impressive merchandising talents;

Special thanks to Patricia Underwood, Jon Moynihan, Manolo Blahnik, George Malkemus, Barry Kieselstein-Cord, David Franks, Mark Obenhaus, Jerry Soloman, Martin Cooper, Larry Schulman, Margie and Michael Stern, and Stan Herman;

Photographers including Bruce Weber, Rico Puhlmann, Harry Benson, Sheila Metzner, Roxanne Lowit, Lynn Kohlman, Barbara Bordnick, Harry King, Peter Schlesinger and Michael Datoli helped us construct a visual world of Perry Ellis. Also, Conde Nast Publications' Shawn Waldron, Leigh Montville, Molly Wicka and Jeannie Rusten; Susan Mulcahy; Marc Fowler's digital restoration and technical wizardry saved us at many turns. Keith Tsang and Jose Villanova provided much needed help as did Michael Mcgowan with his keen forensic detective work;

Former design assistants and colleagues including: Martha Voutas, Isaac Mizrahi, Nick Gjovik, Liz Kurtzman, Nina Santisi,William Frawley, Richard Haines, Meg Cohen, Karen Oronte Golden, Judy Palachino Rosch, Joanne Coates, Kitty Hawks, Claudia Thomas, Bethann Hardison, Denise Carbonell, Sydney Brooks and Jessica Mitchell, Deidre Peterson, and Alan Tanksley;

Steven Kolb for making the CFDA facilities and his staff available during the hours of taping and screening the Perry Ellis show videos;

Erica Lennard would like to especially thank her assistant Emily Steinfeld and also express her gratitude to Elisabeth (Ryall) Halstead and Matt Norklun, the faces of many of the Perry Ellis ads, as well as the other models she photographed for Perry throughout the years;

Phil Kovacevich, who designed the book in a clean, sure-handed way that we think Perry would relate to; and Allison Power—our dauntless, dedicated poet/editor whose patience rivals that of Job.

NOTES

PERRY ELLIS: AN AMERICAN ORIGINAL

1. Epigraph, "Perry Ellis fashion represents . . .": Amy Spindler, "Perry Ellis," essay by Valerie Steele, New York: Perry Ellis International, 2000.

2. John Duka, "Designing an Empire," *New York Times*, January 3, 1982.

3. John Duka, *New York Times*, July 7, 1978.

4. Moor, Jonathan, *Perry Ellis*. St. Martin's Press, New York, 1988, 14.

5. Moor, 37.

6. Duka, "Designing an Empire," *New York Times*, January 3, 1982.

7. Patricia Pastor, interview with authors, October, 2012.

8. Carolyn Gottfried, interview with authors, September 2012.

9. Ibid.

10. *WWD*, April 16 1977.

11. Moor, 59.

12. Martha Voutas, interview with authors.

13. Ibid.

14. *WWD*, November 6, 1979.

15. Tatum O'Neal, *WWD*, April 29, 1980.

16. " . . . the love of my life": Perry Ellis's own expression. Jed Krascella, interview with authors.

17. Geraldine Stutz, *WWD*, October 8, 1980.

18. "Darling, when they stop talking about you . . .": Perry Ellis's own expression. Jed Krascella, interview with authors.

19. Bernadine Morris, "All Eyes Turn to Perry Ellis," *New York Times*, April 22, 1981.

20. Kal Ruttenstein, *WWD*, October, 1981.

21. Moor, 156.

22. *WWD*, May, 1983.

23. Pamela G. Hollie, "Levi Strauss Designer Deal," *New York Times*, January 17, 1984.

24. *WWD*, May 3, 1984

25. Jed Krascella, interview with authors.

26. Patricia Underwood, interview with authors.

27. Stan Herman, interview with authors.

28. R. Raymond, interview with authors.

29. Patricia Pastor, interview with authors.

30. Patricia Morrisroe, "The Death and Life of Perry Ellis," *New York Magazine*, August 11, 1986.

31. Mathilde Krim, interview with authors.

32. Patricia Pastor, interview with authors.

PERRY'S WORLD

1. Morrisroe.

2. Pamela Altman Brown, interview with authors.

3. Bobbi Queen, interview with authors.

Information on Tina Chow, James Terrell, Patricia Ashley, and Lynn Kohlman contributed by Patricia Pastor.

DESIGN PROCESS

1. G. Malkemus, interview with authors.

2. Jed Krascella, interview with authors.

3. Duka.

4. Jed Krascella, interview with authors.

5. Susan Mulcahy, *Drawing Fashion: The Art of Kenneth Paul Block*. Pointed Leaf Press, 2007, 129.

6. Jed Krascella, interview with authors.

FABRICS, TEXTURES, PRINTS

1. Holly Brubach, "An American Original," *Vogue*, July, 1979.

2. Moor, 130.

3. Moor, 132.

4. Patricia Pastor, interview with authors.

A NEW TAKE ON MENSWEAR

1. Geraldine Stutz, *WWD*, April 29, 1980.

THERE'S A LOT OF LOVE IN A HAND-KNIT SWEATER

1. David Lipke, "Perry Ellis' Rise to Stardom," *DNR*, January 31, 2005.

PERRY ELLIS INTERNATIONAL LICENSEES

1. Gerald Solomon, interview with authors.

2. Mort Kaplan and Rob Kaplan, interview with authors.

PERRY'S IRREVERENT FURS

1. Larry Schulman, interview with authors.

2. Jed Krascella, notes to authors.

3. Ibid.

WITH A LITTLE HELP FROM HIS FRIENDS

1. Patricia Pastor and Jed Krascella, interview with authors.

2. Patricia Underwood, interview with authors.

3. Barry Kieselstein Cord, interview with authors.

4. Moor.

5. Ed Jones, interview with authors.

PERRY'S LEGACY

1. Bee-Shyuan Chang, "Perry Ellis Still Has Something to Say," *New York Times*, April 11, 2012.

All photographs by Erica Lennard unless otherwise noted:

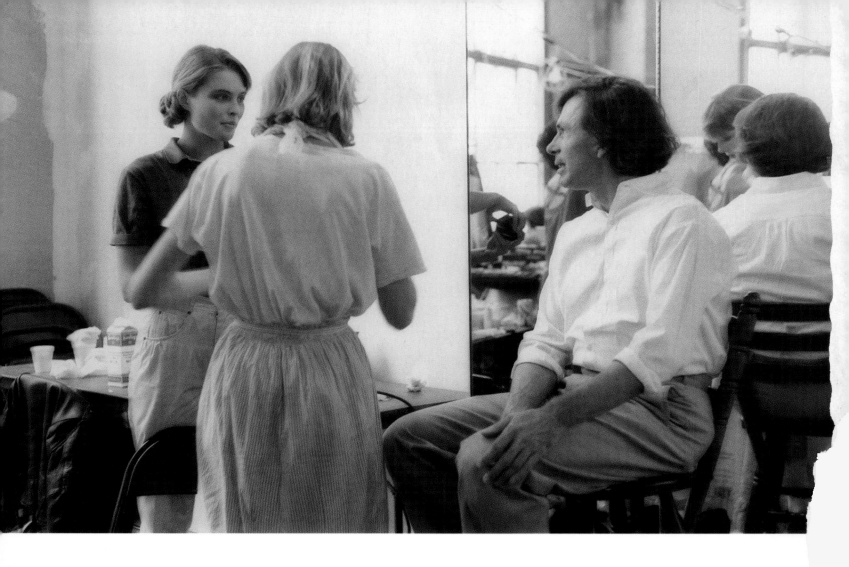

First published in the United States of America in 2013
by Rizzoli International Publications, Inc.
300 Park Avenue South
New York, NY 10010
www.rizzoliusa.com

2013 2014 2015 2016 / 10 9 8 7 6 5 4 3 2 1

ISBN: 978-0-8478-4070-0

Library of Congress Catalog Control Number: 2013942525

Printed in China

Design by Phil Kovacevich